the BAUHAUS

AND

AMERICA

the BAUHAUS

AND

AMERICA

FIRST CONTACTS 1919–1936

MARGRET KENTGENS-CRAIG

TRANSLATED BY LYNETTE WIDDER

THE MIT PRESS CAMBRIDGE, MASSACHUSETTS LONDON, ENGLAND

First MIT Press paperback edition, 2001

Revised edition of

BAUHAUS-ARCHITEKTUR:
DIE REZEPTION IN AMERIKA, 1919–1936.

Edited by Bauhaus Dessau Foundation.
© Peter Lang GmbH
Europäischer Verlag der Wissenschaften,
Frankfurt am Main, 1993.

This book was set in Garamond 3
and Geometric by Graphic Composition, Inc.

Printed and Bound in the United States of America.

Library of Congress Cataloging-in-Publication Data
Kentgens-Craig, Margret, 1948–
 [Bauhaus-Architektur. English]
 The Bauhaus and America : first contacts,
1919–1936 / Margret Kentgens-Craig.
 p. cm.
 Includes bibliographical references and index.
 ISBN 978-0-262-11237-6 (hc. : alk. paper) — 978-0-262-61171-8 (pb.)
 1. Bauhaus—Influence. 2. Architecture,
German—United States. 3. Architecture,
Modern—20th century—United States. I. Title.
N332.G33B447513 1999
724'.6—dc21 99-18804
 CIP

10 9 8 7 6 5 4 3

In architecture, . . .

[habit] by and large

determines even

optical reception.

It, too, occurs

by its nature

less in a state

of concentrated

attentiveness

than in one of

coincidental observation.

Walter Benjamin

(The Work of Art in the Age of Its Mechanical Reproduction)

Contents

Acknowledgments

The author gratefully acknowledges the contributions and assistance of the Bauhaus Dessau Foundation; Bauhaus-Archiv Berlin; Josef and Anni Albers Foundation; Archives of American Art, New York; Archives of the Museum of Modern Art, New York; Arts Club of Chicago; Avery Library, Columbia University, New York; Library of Congress, Manuscript Division, Washington, D.C.; Perkins and Women's College Libraries, Duke University, Durham, N.C.; Harvard University Art Museums; Lyons Library, North Carolina State University, Raleigh; Josef Albers Museum, Bottrop, Germany; Ruhr-University Bochum; United States Federal Bureau of Investigation; Wolfgang Werner Graphisches Kabinett und Kunsthandel KG, Bremen/Berlin; of Kristin Baermann, Robert Burns, Roger Clark, Frank Craig, George Danforth, Lisa Germany, Frank Harmon, Harwell Hamilton Harris, Michael Hesse, Martin Homann, Helmut Jahn, Philip Johnson, Henry Kamphoeffner, Alice Y. Kaplan, Joachim, Ewald, Martin, and Susanne Kentgens, Dirk Lohan, Anthony Lord, Hattula Moholy-Nagy, Gerhard Richter (Durham, N.C.), and Lynette Widder; and of Matthew Abbate and Roger Conover at the MIT Press.

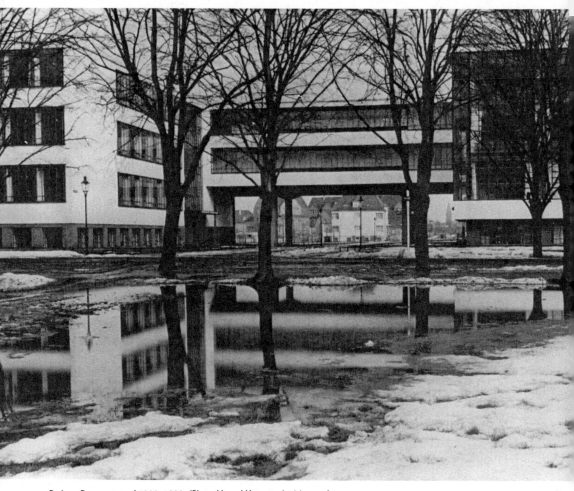

Bauhaus, Dessau, winter of 1928–1929. (Photo: Harvard University Art Museums.)

Introduction

T he Bauhaus, in 1919, was founded in Weimar by the German architect Walter Gropius. In 1925 the school was moved to Dessau, in 1932 it was moved to Berlin, and in 1933 it was dissolved.

At the end of this century, the Bauhaus remains a remarkable cultural historical phenomenon. Hardly any other artistic movement has been the subject of research and writing as extensive as this extraordinary school of design, although it existed for a mere 14 years and could boast fewer than 1,300 students. Its assimilation throughout the world can be traced through nearly eighty years in numerous buildings, artworks, objects, designs, concepts, and curricula. The movement's force has been evident during that time not only in the influence it has exercised but also in the resistance it has provoked. Few who have been exposed to the Bauhaus have been left cold by its ideas. In December 1996, the Bauhaus building in Dessau and the masters' houses, as well as the Bauhaus sites in Weimar, were added to UNESCO's international list of cultural heritage sites, thus recognizing the universal value of the Bauhaus's achievements in revolutionizing architecture, design, and art in the twentieth century.

Even in its early years, the Bauhaus's reputation extended well beyond national boundaries. The institution's basis in the unstable period between the two wars, its inextricability from the Weimar Republic, and its premature end, hastened by the Third Reich, helped raise its profile. American journals reported on the school as early as the year of its founding. The body of information grew over the following years as the Bauhaus became increasingly known in America. After its closing, many of its protagonists emigrated to the United States; thus, the school's intellectual heritage could be disseminated there as nowhere else in the world. One would expect to find a correspondingly authentic image of the historical Bauhaus there, but that is not the case. Instead, one finds a reception that tends to reduce a complex and multifaceted phenomenon to a simple formula, most often couched in architectural examples. For some, the Bauhaus became a transfigured myth, for others, a paradigm of modernism's fall from grace. The activity of Bauhaus architects in America is apparently only one explanation for this state of affairs: the appointment of Bauhaus protagonists to positions at prominent American universities, not to mention their subsequent influence, can only have been predicated on a great degree of prior acceptance. This acceptance did not arise ex *nihilo*, but rather had to be cultivated. In fact, the basis for this acceptance was created between 1919 and 1936. The key to understanding the American reception of the Bauhaus therefore is not to be sought in the émigrés' success stories nor in such impressive events as the famous New York Bauhaus exhibition in 1938. Instead, it may be found in the course of America's early contact with the Bauhaus, which itself was a vital, developing movement within classical modernism. It is the intention of this book to examine and document the course of this

process. Thus, it is not important to the author to add yet another chapter to the story of the historical Bauhaus's origins in Weimar, Dessau, and Berlin, but rather to unfold how, and with what content, the Bauhaus became known and accepted in the United States between 1919 and 1936; how specific ideas were taken up, reworked, and deployed; and how, finally, a genuine American image of the Bauhaus, one that remains influential today, resulted from this process.

This book is meant to invite a more comprehensive understanding of the United States' initial encounters with the Bauhaus and the implications of this process. It explains that by 1936, the recognition of the Bauhaus in America was the result of a consistent flow of information, of fine-tuned marketing and lobbying, and finally of a unique congruence of the demand for new ideas in the 1920s and early 1930s and their supply: the Bauhaus concepts were available at the right time at the right place. The author also discusses the history of the early reception of the Bauhaus in America as a precedent for the fame-making machinery that became a powerful commercial instrument in the professional art world after World War I.

When Ludwig Mies van der Rohe, the school's last director, dissolved the school under political duress on August 10, 1933, this act represented a deep historical gash in German culture. Any hope of further developing the Bauhaus's intellectual tradition in its native land proved vain in light of the Third Reich's political and cultural direction. As Mies himself certainly knew, the Bauhaus had nonetheless always been more than an institution that could simply be closed down; it was an idea. It was therefore able to survive the termination of its pedagogic activity and continue to propagate itself. The significance of this fact for the art and architectural history of the United States is demonstrable. The Bauhaus's end in Germany marked the inception of the *völkisch* cultural and architectural politics advocated by the National Socialists, and the end of any significant (or mentionable) public recognition of the avant-gardes. Thus, the school's closure led directly to the emigration of many members of the Bauhaus. For the U.S. reception of the Bauhaus, however, the most significant changes occurred three years later, in 1936. After that point, the Bauhaus's "Americanization" began. This process included the institutional development of Bauhaus-inspired programs, the realization of its ideas on American soil, and the integration of its artists and architects into American culture. Starting in 1936–1937, Josef Albers broadened the scope of his pedagogic and artistic influence beyond the borders of North Carolina. The year 1937 marks the beginning of Walter Gropius's professorship at Harvard and the preliminary events that would lead to Ludwig Mies van der Rohe's appointment to what was then Armour Institute in Chicago. The same year saw the founding in Chicago of the New Bauhaus, the immediate successor

to the historical Bauhaus under the direction of László Moholy-Nagy.[1] Taken to-
gether, these events mark the culmination of a 17-odd-year period over which
the Bauhaus's renown in America had grown. Thereafter, Bauhaus protagonists
would be active in transforming the American theory, pedagogy, and practice of
art, design, and architecture. As they did so, they extended the radius of their in-
fluence by encouraging other Bauhaus participants to follow their example.
These later émigrés included Marcel Breuer, Herbert Bayer, Ludwig Hilber-
seimer, Hin Bredendieck, and Marli Ehrmann. The early phase of reception,
between 1919 and 1936, is fundamental to a comprehensive understanding of
America's contact with the Bauhaus. It holds the key to insights into areas of
American Bauhaus history that have been neglected until now, and thus to in-
sights into the source of contemporary beliefs about the school.

 The Bauhaus was a complex cultural phenomenon. It was simultaneously
an idea, a school, and a movement. It culled its ideas from the medieval concept
of the building guild, from the romantic belief in the inherent creativity of man,
as well as from classicism, which encompassed Karl Friedrich Schinkel's and
Gottfried Semper's recognition of industrialization's significance for art and ar-
chitecture. It gathered inspiration from the achievements of French engineering
in the late nineteenth century and from the arts manufacturers in England. It in-
corporated Richard Wagner's concept of the *Gesamtkunstwerk*, absorbed ele-
ments of the arts and crafts movement, the Wiener Werkstätten, art nouveau,
Jugendstil and art deco, the Chicago Style, and the idiom of Frank Lloyd Wright.
Expressionism, fauvism, and cubism can be counted among its influences; prin-
ciples gathered from the program of the German Werkbund, Peter Behrens's pio-
neering experiments, and the goals articulated by the Workers' Council for Art
(Arbeitsrat für Kunst) were integrated into the Bauhaus's programs. Its commu-
nication with contemporaneous European avant-garde movements, such as De
Stijl, l'Esprit Nouveau, and Vkhutemas, located the Bauhaus solidly within the
development of pan-European modernism and guaranteed a symbiosis between
indigenous and imported ideas.[2] As progeny of the Weimar Republic and a public
institution, it was also exposed to political influence.

1 See Peter Hahn, "Vom Bauhaus zum New Bauhaus," in Bauhaus-Archiv Berlin, ed., *50 Jahre
New Bauhaus*, 10. For comparison, also see Marcel Franciscono, *Walter Gropius and the Cre-
ation of the Bauhaus in Weimar.*

2 For more in-depth information on the Bauhaus's intellectual roots, Hans Maria Wingler's com-
prehensive study is a good source. See *The Bauhaus: Weimar, Dessau, Berlin, Chicago*, xviii, 1–3.
Also see Sigfried Giedion, *Space, Time and Architecture*, 499.

The school's identity was transformed with each change of location, program, director, and teachers. The individual institutional phases in Weimar, Dessau, and Berlin can only serve as a crude parameter with which to measure the changes undergone by its content and perspective. The most obvious stages of the Bauhaus's development can be identified relatively easily. The first was characterized by Walter Gropius and his attempts to define the school's program and orientation. The periods under the direction of Hannes Meyer and Ludwig Mies van der Rohe represent further phases.[3] But changes were not only instigated by the three architect-directors. The other disciplines taught at the Bauhaus should not be neglected, nor should the other strong personalities who contributed greatly to the school's character. It is obvious that the Bauhaus as a single and homogeneous system simply did not exist. Bauhaus painters such as Johannes Itten and Georg Muche pursued different ideas than László Moholy-Nagy and Josef Albers. Ludwig Mies van der Rohe considered his work hardly in the same category with Hannes Meyer's. In the light of such comparisons, it seems less than useful to insist upon an absolute definition of the concept "Bauhaus," or to speak of the "Bauhaus Moderne" as a "coded system of rhetoric."[4] On the other hand, it is justifiable to speak of the Bauhaus if one recalls that "the teachers and, in the broadest sense, all participants in the Bauhaus were committed to a series of common principles relative to the aim, content, and methods of artistic and pedagogic activity." Therefore, "the simplification implicit in speaking about the Bauhaus as an entity in and of itself is not fundamentally incorrect."[5]

If the Bauhaus as a whole is described here as a multifaceted entity whose pedagogical core was nonetheless homogeneous, then the same may be said of the individual disciplines, including architecture as the one discipline that became the main focus of interest in the course of the American reception of the Bauhaus. And if this premise is true, what then does "Bauhaus architecture" mean? While Walter Gropius at all times disputed any statements relating to the Bauhaus as a style, contemporary discourse has adopted the term, in particular in the United States, Germany, Israel, and Switzerland, thus acknowledging that the Bauhaus was bound to its era like any other movement. A definition of its architecture derived from realized buildings is of little assistance either, as it would be founded upon relatively few examples. In the case of the Weimar Bauhaus, which included no department of architecture, only an experimental single-family house designed by Georg Muche (1923) could be cited. In Dessau, one could point to the famous Bauhaus building itself (1925–1926), the masters' houses (1925–1926), and the municipal employment office (1927–1929), all by Walter Gropius, the Kornhaus (1929–1930) and a single-family house (1926–1927) by Carl Fieger, the experimental steel house by Georg Muche and Richard Paulick (1926), the gallery-type apartment houses by Hannes Meyer (1929–1930), a small kiosk (1932) by Ludwig

Mies van der Rohe, and the Siedlung Törten (1926–1928), which represented the Bauhaus's urbanistic as well as its social concepts. These are nonetheless too few examples to comprehend the great spectrum of architectural production at the Bauhaus.

Nor can a serviceable definition be based upon the institutional substructure. Such a definition would certainly allow the inclusion of theory, design, and project work, as well as of realized buildings in other locations, including the Auerbach house by Walter Gropius and Adolf Meyer (1924, Jena), Ludwig Mies van der Rohe's Tugendhat house (1930, Brno), and his model house built for the Berlin Building Exposition of 1931, but only if the private architectural practices of the two directors were to be admitted as an extension of the work done at the school. Until 1927, there was no department of architecture at the Bauhaus. As it was understood until then, "Bauhaus" architecture, even its most important examples, was defined largely by the work of Gropius's private office. Mies van der Rohe also maintained his own office after assuming the Bauhaus's directorship in 1930. Any definition so closely tied to the institution would necessarily preclude direct predecessors or successors. The Fagus factory (1911), the projects for two glass skyscrapers (1920-1921 and 1921-1922), the buildings at the Weissenhof-Siedlung (1927), and the Barcelona Pavilion (1929) are such milestones in the work of their authors and in the history of classical modernism that they must have influenced the work at the Bauhaus. Therefore, they cannot be excluded from a definition of Bauhaus architecture.

Modernism has become a term that requires careful definition, in architecture and other disciplines. "Bauhaus modernism" is characterized in terms of period, location, ideas, and formal considerations. It was part of the "heroic age" of modernism, in German terminology *klassische Moderne*. It is distinguished from parallel movements of the 1920s by its institutionalization and by a synthetic concept, social utopianism, and optimal degree of formal-aesthetic purity and perfection far ahead of the available technological means of realization.[6]

The attempt to find a binding definition for "Bauhaus architecture" is inherently endangered by a tendency to oversimplify and to exclude on formal grounds. The most viable working concept looks at Bauhaus architecture in its broadest sense, as the complex of theories, designs, and works that came into their

3 See J. Fiske McCullough, "The House of the Bauhaus Reconsidered," 162.

4 Thomas Hasler, "Die Kirche Sankt Anna in Düren von Rudolf Schwarz," 20.

5 Karl-Albert Fuchs, "Die Stellung des Bauhauses in der Geschichte und die Bedeutung seines Erbes für die entwickelte sozialistische Gesellschaft," 440.

6 See Berthold Burkhardt, "The Conservation of Modern Monuments," 187–188.

own at the Bauhaus and which, in the 1920s and early 1930s, manifested the beliefs of the architects who determined the school's thrust.[7] Those architects were the Bauhaus's three directors, Gropius, Meyer, and Mies van der Rohe. This definition also allows consideration of other teachers, collaborators, and students.

From the beginning, Walter Gropius credited architecture with a fundamental role in the Bauhaus program. The wording of the 1919 manifesto that heralded the school's founding reads: "The ultimate aim of all visual arts is the complete building! . . . Architects, sculptors, painters . . . let us desire, conceive, and create the new structure of the future which will embrace architecture and sculpture and painting in one unity and which will one day rise toward heaven from the hands of a million workers like a crystal symbol of a new faith."[8] The concept "Bauhaus architecture" will not be used within the framework of this study in its all-encompassing sense, as defined by Gropius in his school-founding manifesto of 1919 and his 1935 publication *The New Architecture and the Bauhaus;* for Gropius's two successors, Meyer and Mies, each also impressed upon the Bauhaus their own changing concepts of architecture. In addition, these approaches were subject to transformation. Thus, in his 1923 program for a new unity of art and technology, Walter Gropius maintained that architecture "went hand in hand with technology and had developed a characteristic appearance that deviated from the old craft of building. Its identifying traits are clear, well-proportioned lines from which all unnecessary ingredients have been removed—the same traits characteristic of the modern engineered products of the machine."[9] Hannes Meyer defined architecture as "collective, the satisfaction of all necessities of life once the personal has been expunged; the realization of which . . . [is subject to] the law of least resistance and of economy; whose aim . . . it must be to achieve the optimum with regard to function."[10] Artistic expression was not Meyer's goal. Ludwig Mies van der Rohe, on the contrary, advances a spiritually borne and aesthetically ambitious concept of architecture. He understands building as "the art of building [Baukunst]," as "man's attempt to deal with his surroundings in spatial terms. . . . Thus, the art of building is not only a technical problem, a problem of organization and economy. The art of building can in fact always be equated with the spatial execution of intellectual decisions. It is bound to its time and can only be manifested in the currency of its functions and the means of its times. Knowledge of the era, its responsibilities and its means, is the necessary prerequisite to work in the building arts."[11] Thus, the intellectual and professional divergences among these three positions resulted in equally different beliefs about what should be taught at the Bauhaus and in what manner.

Nonetheless, common characteristics do exist in the work of the three directors; and it is by studying them that the kernel of what might be called Bauhaus architecture can most probably be ascertained. With few exceptions, all three di-

rectors at the Bauhaus pursued the stylistic goals of classical European modernism. They were part of the "heroic period" of the twenties during which they became recognized as avant-gardists, meaning that they were intellectual pioneers and experimentalists. All three were closely related to the Neues Bauen or new architecture movement in Germany that evolved during the 1920s as part of postwar European abstract art and of the social goals of the Weimar Republic. All three of them, although not equally, contributed important impetuses to the Neues Bauen through the Bauhaus. They were bound to the idea that a radical break with historicizing architecture and an abandonment of traditional architectural concepts was necessary. They sought a new and universal formal language for architecture by means of abstraction; denial of symmetry, ornament, and representation; and explicit visual references to the technical building process. They used their new forms to experiment with construction, using both traditional and new building materials and methods. In this sense, their architecture was meant to be more than the definition of modern form; it was intended to offer solutions for organizing contemporary work and habitation. In the early years of the Bauhaus, in the aftermath of World War I, it was even intended to transform life and the human being itself. The Bauhaus's humanistic ideological roots and utopian concepts as well as its institutionalization and sites of production distinguish it from contemporaneous European avant-garde movements: the Bauhaus centered on education, including economically viable workshop training and production. The young people who were trained in Weimar, Dessau, and Berlin were to assert themselves in a job market controlled by industry and at the same time move the new architecture into the future.

Since this book is concerned with the processes of cultural reception, the authentic character of the historical Bauhaus architecture represents only the background, helping to reconstruct the development and details of the image of the Bauhaus and its architecture formed in America between 1919 and 1936. It is an image that deviates from the original in more than its details. The word "reception" stems from the Latin receptio and means, literally, "to take hold of again; to receive."[12] As applied to cultural history, reception research investigates the en-

7 See Christian Wolsdorff, "Die Architektur am Bauhaus," 310.

8 Walter Gropius, "Program of the Staatliche Bauhaus in Weimar," quoted in Wingler, *The Bauhaus: Weimar, Dessau, Berlin, Chicago,* 31.

9 Walter Gropius, *Internationale Architektur,* 71.

10 Hannes Meyer, "Curriculum Vitae," quoted in Wolsdorff, "Die Architektur am Bauhaus," 313.

11 Ludwig Mies van der Rohe, "Die Voraussetzungen baukünstlerischen Schaffens," transcript in Mies van der Rohe Files, Library of Congress.

12 German definition of *Empfang* based upon Gero von Wilpert, *Sachwörterbuch der Literatur,* 638.

counter of a group or individual with new ideas or their physical manifestations, and traces those ideas' dissemination, acceptance, and influence. These processes must be reconstructed in their authentic form in order to be evaluated. In the case of the Bauhaus, which Hans Maria Wingler appropriately describes as "the peak and focus of an extremely complex and furcated development which can be traced back to Romanticism and continues into the present,"[13] this task is not simple. The process of transfer of artistic, intellectual, and pedagogical concepts to another cultural context is at the same time a process of acculturation and transformation. Therefore, everything that is not codified in some formulaic expression is in danger of being perceived and disseminated in modified, if not distorted, form. This condition is inherent in the nature of processes of reception, which always involve a recipient whose individual predilections determine content and values to a significant degree. These predilections thus assume a decisive role in the course and result of the process. In the end, every different recipient will arrive at different conclusions,[14] so that objective apprehension is not always possible. It is seldom that two people see the same thing in the same way. The fact that the preconditions and standards of judgment change in the course of time only complicates matters.

The process of reception can also be fundamentally influenced by the general context in which it occurs: the concrete cultural, political, economic, and societal givens of each era. Thus, the question at stake in this book is not only what kind of Bauhaus Americans perceived in the 1920s and early 1930s and how this perception emerged, but also the kind of America that existed at the time and that became interested in the Bauhaus. The routes, means, and strategies of transmission also play a role. It may be difficult to analyze processes of reception in retrospect if historical perspective is to be respected. It is even more difficult when the issues at stake, as in the case of the Bauhaus, are extraordinarily complex and have been transferred across considerable linguistic and cultural barriers. More than a ripe old age lies between the present and the period during which the Bauhaus became known in the United States. Those years, and the world war that occurred in their course, have erased much evidence.

That is regrettable, for although Bauhaus scholarship is extraordinarily prolific, it has yet to respond adequately to the question of how the Bauhaus became known in the United States and how its principles could find a foothold. Research thus far has clarified and documented the influence of the Bauhaus, including its architecture, from the moment of its protagonists' emigration. These studies have also long been dominated by earlier Bauhaus participants or their associates. With regard to the proliferation of Bauhaus principles in the United States, research has one-sidedly focused on developments that occurred as of the late thirties and has concentrated on the role of the emigrants, especially

those who were fortunate enough to continue their careers successfully on the other side of the Atlantic. Comprehensive discussion of the processes and background conditions that provided the basis for the Bauhaus's later success have been neglected in favor of partial explanations.

The American reception of the Bauhaus in the 1920s and 1930s occurred almost exclusively within expert circles. Art and architecture periodicals served as important points of exchange and forums of discussion for the information coming from Europe, including that on the Bauhaus. Some of those periodicals were certainly among the standard library fare of higher educational institutions. Because of the close connection between the early American reception of the Bauhaus and the political reception of Germany after the First World War, periodicals with other cultural or historical emphases are also relevant. The criteria for including publications in this study was their availability and relevance for an academic and professional audience. Sources such as films were also included, as were the oral accounts of people who had experienced or influenced the process of reception. The political context of this process, finally, is described by the FBI files that were kept on various Bauhaus emigrants beginning in 1939. They fall outside the chronological brackets set for this study, but the documents depict the political climate in the years immediately before Walter Gropius, Ludwig Mies van der Rohe, and other Bauhaus denizens came to America.

The American experience of the Bauhaus, it must be recalled, is neither the first nor a unilateral instance of German art and architecture's influence in the United States. A case in point is Dankmar Adler, who as a child emigrated to the United States in 1854 from the area near Weimar, and who later helped to establish the fame of the Chicago school beginning in 1881 with Louis Sullivan (whose grandfather was also German). That school's traits in turn influenced the daring skyscrapers envisioned by Ludwig Mies van der Rohe at the beginning of the 1920s, as well as the design by Walter Gropius and Adolf Meyer for the Chicago Tribune competition of 1922. There is plentiful documentation of the inspiration that Frank Lloyd Wright, who as a young assistant in the office of Adler and Sullivan had worked on the Auditorium Theater, among other projects, provided for the work of Gropius, Mies, and others. Wright's 1910 visit to Berlin on the occasion of the first German exhibition of his drawings in the Academy of the Arts reinforced this exchange. In that year and thereafter, the Berlin publishing house of Ernst Wasmuth published a comprehensive two-volume monograph of Wright's work, most likely on the recommendation of Kuno Franke, a Harvard University guest

13 Wingler, introduction to *The Bauhaus: Weimar, Dessau, Berlin, Chicago.*

14 See Jane P. Tompkins, *Reader-Response Criticism.*

professor of German extraction.[15] Wright's work could therefore reach a broader audience. Mies van der Rohe summarized the impact of these publications in few words: "The more we were absorbed in the study of these creations, the greater became our admiration for [Wright's] incomparable talent, the boldness of his conceptions, and the independence of his thought and action. The dynamic impulses emanating from his work invigorated a whole generation."[16]

The effect of Frank Lloyd Wright's work on certain buildings and designs of both Bauhaus architects can be proven. Likewise, numerous examples can be cited to describe the influence of American artists and architects on contemporaneous developments in Germany as well as the mutuality of influence between German and American art and architecture in the early decades of this century. The large American metropolises, the "modern spirit," the exaltation of technology to a science, and the rationalization of construction provided the images that contributed to the Old World's fascination with America in the first two decades of the century. By the same token, such European cultural centers as Paris and Berlin exuded an attraction responsible for many an American Wanderschaft. Thus in 1913 Patrick Henry Bruce and Marsden Hartley contributed works to the first Deutscher Herbstsalon in Berlin. Conversely, Bruce, along with the "color-painters" Arthur Burdett Frost, Jr., Stanton McDonald-Wright, and Morgan Russell, introduced the French avant-garde to the American modernists. It is not surprising that a number of American students were matriculated at the Bauhaus in its later phases and that a short time after the Bauhaus's founding, a visual artist raised in New York, Lyonel Feininger, was hired by the school. The power of his work, his personality, and the length of his tenure there, which lasted almost for the institution's entire existence, contributed to his considerable influence at the school. The eminent Bauhaus historian Hans Maria Wingler has called him "one of the great individuals at the Bauhaus."[17]

15 According to Brendan Gill, *Many Masks*, 201. The title of this first comprehensive publication of Frank L. Wright's oeuvre up to that date was *Ausgeführte Bauten und Entwürfe von Frank Lloyd Wright*.

16 Ludwig Mies van der Rohe, quoted in William H. Jordy, "The Aftermath of the Bauhaus in America," 489.

17 Wingler, *The Bauhaus: Weimar, Dessau, Berlin, Chicago*, 245.

the BAUHAUS

AND

AMERICA

The

Call

for

Rejuvenation

in

America

POLITICAL
AND
ECONOMIC
EMPOWERMENT

All the past we leave behind,
We debouch upon a newer, mightier world, varied world,
Fresh and strong the world we seize, world of labor and the march,
Pioneers! O Pioneers!
—Walt Whitman

At the end of the First World War, the United States found itself in the position of victor, strengthened and nearly unscathed but confronted with the responsibility associated with the role of a great power, a role into which the country was forced to grow. The journalist Philip Gibbs wrote in *Harper's Monthly* in 1919: "The United States of America has a new meaning in the world, and entered, by no desire of its own, the great family of nations, as an uncle whose authority and temper is to be respected by those who desire influence in their family quarrels, difficulties, and conditions of life."[1] The United States accepted its new authority hesitantly. At the beginning of the twenties a tendency toward isolationism prevailed, and thus few were inclined to allow the effects of the transformations in Europe to become felt. The war had reinforced the conviction that all evil came from outside or from strangers in one's own country. The ideological challenges experienced by the Old World disquieted only a handful of citizens. Americans had known no emperor, no aristocracy, and no bourgeoisie in the traditional sense, so that movements comparable to those in Europe had no political basis for support. The leftist movements were weak in numbers and relatively powerless. In the early 1920s, the country's Communist Party counted between 8,000 and 15,000 members.[2] The Socialist Party numbered 118,000 in 1920 and had shrunk to 11,000 only two years later. In some states, social progressivism had come to a complete standstill. Nor did the leftist parties gain membership or influence as a result of the deep depression that began at the decade's end. The position of "capitalism" remained unbroken despite the stock market crash, even after Franklin Delano Roosevelt became president in 1933 and instituted the New Deal to prompt social change.

In only a few years, between 1914 and 1919, the United States transformed itself from a debtor to a creditor nation. In 1929, the gross national product was greater than that of Germany, France, Great Britain, Japan, and Canada combined. By 1932, the country's industrialization was essentially complete and the machine, in Henry Ford's words, had become the "new messiah." During the period in which the Weimar Re-

1 Philip Gibbs, "America's New Place in the World," 89.
2 See William E. Leuchtenberg, *The Perils of Prosperity,* 108, 187.

public struggled to recover from the war and avert impending catastrophe, America's populace focused its attention on electricity, radio, Hollywood, synthetic fibers, and the acquisition of cheaper credit with which to start families, build homes, and purchase cars.[3] The events of 1927 evidence the enormity of this technical progress: radio and telephone communication was established between London and New York, the first nationwide radio station went on the air, the first television transmissions became possible, the sound movie was introduced, and the Holland Tunnel underneath New York's Hudson River, the world's first underwater tunnel, was opened.[4] Even the persistent economic crisis during the depression did nothing to lessen America's new political and economic status as the country emerged from the war to declare the "American century."[5]

POWER, STATUS, AND ARCHITECTURE

The economic and political transformations subsequent to the war were accompanied by deep-running changes in the structure of the American populace. Between 1920 and 1930, the population of rural areas was exceeded for the first time by that of the cities, a result of the exodus from the country as America began the progression that would turn it into an urban society. The "city lights"[6] attracted intellectuals and artists as well as many who came in search of work, promised hope of a better future in the metropolis by industry and big business.

The history of built architecture reflects periodic changes in styles, methods of construction, use of materials, and the structure of space. Buildings in turn contribute to the physical, social, and intellectual changes in society. Social and political systems have always used built architecture to demonstrate their culture, civilization, and power. The United States was no exception; the social and economic developments of the postwar period produced not only a reinforced sense of self-confidence but also a need to lend this self-confidence an appropriate architectural expression.[7] In this case, however, the powers at work were not those of church or state but of private enterprise. As a patron, its responsibility to the nation was different, weaker. This fact was applauded by those interested in the country's greater international openness, but not by critical circles of intellectuals and artists who foresaw the society's increasing emotional and aesthetic impoverishment as the consequence of shifts in power and values. Many were demoralized by such developments or kept a cynical distance.

The Skyscraper as Epitome of Urban Identity Nonetheless, there was consensus that America's new image would be one of strength and urbanity, and that its epitome would be the skyscraper. By the beginning

of the thirties, New York had become the paradigm of the vertical early twentieth-century American city. Structures such as the Empire State Building and Rockefeller Center signaled that the entrepreneurial spirit had not been tamed by Black Friday and its aftermath. In accordance with the spirit of the times, enthralled by the thought of cities dominated by soaring, solipsistic towers, *Architectural Forum* declared in 1930 that the skyscraper was the appropriate expression of the power and glory of the American nation.[8] The journal thus anticipated a mood slowly developing among critics and historians, a conviction that the prestige and expansion of businesses were to be measured in high buildings. The call for skyscrapers may be explained as a consequence of the fact that the country's westward expansion had reached its limits even before the end of the nineteenth century; American expansionism was henceforth transposed from the horizontal to the vertical dimension.[9]

In the article "The Relation of Skyscrapers to Our Life," Ralph Thomas Walker, a respected architect of the New York art deco skyscraper style, described the tendency toward cosmopolitan development—the urbanization of rural life and the growth of cities—as a derivative of the influence of the machine and the new means of transportation and communication. The solution he proposed to the problems that arose from increased urban density was the skyscraper as a place of work and habitation.[10] Walker's vision of skyscrapers as "cities within the city" that would incorporate residential, office, and shopping areas under one roof predicted the evolution of a community among those who shared the building. The unoccupied areas around the tower were to be used as greenbelts for sports and recreation.[11]

One model gained prominence among the many at the end of the 1920s that attempted to characterize the types and combinations of programs possible within the skyscraper. Although presented as imaginary, this vision of the future made reference

3 Dudley E. Baines, "Die Vereinigten Staaten zwischen den Weltkriegen," 292ff.

4 Robert Stern, "Relevance of the Decade," 7.

5 The phrase "American Century" was coined in the work of the same name by Henry R. Luce, 410–418.

6 As in Charlie Chaplin's 1931 film of the same name.

7 Hugh Ferriss, "Power of America," 61.

8 Paul Robertson, "The Skyscraper Office Building," 880. Criticism motivated by social and aesthetic criteria as well as prophecies of the skyscraper's demise accompanied the discussion of the building type in the United States starting in the early twenties but did nothing to arrest the trend. See William S. Parker, "Skyscraper Anywhere," 372.

9 Norbert Messler, *The Art Deco Skyscraper in New York,* 173ff. Also see Manfredo Tafuri and Francesco Dal Co, *Modern Architecture,* 206.

10 Ralph T. Walker, "The Relation of Skyscrapers to Our Life," 691.

11 The parallels to Le Corbusier's work are clear. Walker saw the combination of living and work under one roof as his model's special feature. Ibid., 693.

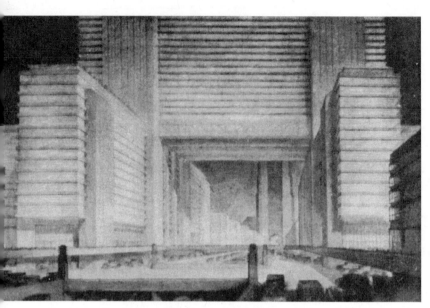

1.1 Utopian image of the urban scape in the late 1920s: Technology Center. Drawing from
Hugh Ferriss's book *Metropolis of Tomorrow,* 1929. (Photo: Princeton Architectural Press.)

to concepts that had, in part, been realized and were actively discussed in Europe.[12]
Hugh Ferriss, admired by architects of the time as "the greatest draughtsman in the
world,"[13] published his famous book *The Metropolis of Tomorrow* in 1929 in New York.
Sixty illustrations and a brief accompanying text depict his vision of the city of the
future. The city was subdivided into zones comprising functionally segregated areas
for commerce, science, art, etc.; each area was dominated by a central skyscraper.[14]

Ferriss's work met with a strong and positive response. In 1930, the historian
and critic Sheldon Cheney wrote that Ferriss had influenced the imaginations of de-
signers, students, and the public more than any architect since Sullivan.[15] *The Metropo-
lis of Tomorrow* did not merely depict a utopian vision; the book is a compendium of the
technical and stylistic knowledge and tendencies in the skyscraper architecture and
large-city planning of that time. It is a reflection of a zeitgeist that saw the skyscraper
as the epitome of American metropolitan architecture.

Art and Big Business: A "New Unity" More than the functional and social problems,
which might have ushered in a different set
of criteria, it was the high price of land in large American cities and the desire to
make profitable use of that land that determined the future of the commercial sky-

scraper.[16] Although the dominance of commerce, so obvious from a contemporary standpoint, was still debated in the late 1920s, as the trajectory it would take was still unclear, keen observers such as Edwin Avery Park envisioned its forceful expression in the skyscraper:

> There is an epic implication in man's defiance of the laws of gravity, and beauty in the naked lift of uprising steel and concrete. But the purpose of the skyscraper is not poetic. Perhaps Commercialism is a new God, only too powerful and too appealing, to whom men are building today their largest, costliest, and most laudatory structures. In this service, they are building higher and even higher, concentrating more and more activity into less of ground space, stealing light and air from their neighbors, piously recording in their structures the Exploitation that is [a] right-hand attribute of Commercialism. . . . Business rules the world today, and as long as business can best be served where many offices are concentrated in one small area, in buildings designed as machines for the efficient discharge of buying, selling, trading, banking, law disputes, gambling, and exploitation, business architecture will be supreme.[17]

Steel frame and curtain wall technologies made higher buildings possible, just as the obviation of solid wall construction eliminated the loss of precious floor area. Thus, the excessive financial burden placed upon center-city construction was countered by the maximization of residential and commercial floor area. Enormous dimensions, utility, economy, and speed had become the characteristics of the American way of life, of American civilization and of American big business. The skyscraper was the natural, technically progressive architectural equivalent of this lifestyle, just as it was the vehicle by which American business could best express its future corporate image.[18]

The latter fact is grounded in the unequivocally positive self-image that reverberates in the words of Randolph W. Sexton: "The American skyscraper . . . stands as a noble expression of the high standards and ideals of modern American business.

12 *"The Metropolis of Tomorrow,* by Hugh Ferriss," 66. Also see Tony Garnier's Cité Industrielle and the urbanistic principles of Le Corbusier as adopted by CIAM in 1933.

13 Douglas Haskell, "The Bright Lights," 55.

14 The vision is reminiscent of Le Corbusier's "Radiant City": skyscrapers at a relatively great distance from one another. They are, however, surrounded by a dense urban fabric rather than by greenery.

15 Sheldon Cheney, *The New World Architecture,* 292; and Ulrich Conrads and Hans Sperlich, *The Architecture of Fantasy,* 292.

16 Stephan I. Richebourg, "Some Thoughts on Modern Architecture," 142.

17 Edwin Avery Park, *New Backgrounds for a New Age,* quoted in Rosemarie H. Bletter and Cervin Robinson, *Skyscraper Style,* 66ff.

18 Kenneth T. Gibbs, *Business Architectural Imagery in America,* 1.

1.2 McGraw-Hill Building, New York, 1931. Raymond Hood, architect. (Photo from M. Trachtenberg and I. Hyman, *Architecture;* reprinted by permission of Harry N. Abrams, Inc.)

Strength, honesty and sincerity are the features of its design as they are characteristic of commercial enterprises."[19] In New York at the beginning of the 1930s, neoclassically clad skyscrapers were no longer seen as the embodiment of the idealized conjunction between the noble and beautiful on the one hand and the utilitarian and profane on the other. Instead, the sober, linear forms of more recently built towers were thought to embody this ideal: the Daily News Building, the McGraw-Hill Building, and, in particular, Rockefeller Center. Especially in the last case, however, artistic will is by no means the equal of commercial force. Like no other building of its time, Rockefeller Center bespeaks the powerful ideoeconomic saturation of American cultural and social systems.[20] Every aspect of this building, starting with its planning and ending with its construction, was judged by the stringent standards of economy. Even as these three buildings' completion was celebrated as a significant cultural event—"American Architecture Emerges from the Stone Age," as one enthusiastic article in *Creative Art* proclaimed—it was impossible to overlook the fact that the buildings were first and foremost witness to a new, commercially suffused "contemporary spirit."[21] High land values in American metropolises made the building of a skyscraper de facto an economic issue. The fact that skyscraper construction developed into one of the largest branches of American industry during the period discussed[22] explains the skyscraper's transformation from cultural symbol to "cathedral of capitalism." The American skyscraper thus began to appropriate the position formerly occupied by the house of God: the building that towered above its surroundings, that embodied the society's greatest good. The redefinition of the skyscraper as symbol also energized the critical discussion of its aesthetic expression and inspired a desire for modern form that would remain unslaked in the years following.

The discovery that thoughtful artistic form could be made profitable was not restricted to architecture. Increased turnover in the sale of everyday objects could also be achieved by involving artists in their production, a fact that had not escaped the notice of the entrepreneurs who founded the Association of Arts and Industries in Chicago in March 1922. In a forceful 1927 article in the *Atlantic Monthly,* Ernesto E. Calkins made a strong case for the economic necessity of "beautifully" designed products.[23] The idea was seized upon and developed further. In 1928, in a dinner address to the American Federation of Arts on the premises of the Architectural League of New York, Lawrence Weaver, president of the Design and Industries Association of Great

19 Randolph W. Sexton, *American Commercial Buildings of Today,* 2.
20 Tafuri and Dal Co, *Modern Architecture,* 209.
21 Philip N. Yountz, "American Architecture Emerges from the Stone Age," 16–21.
22 Robertson, "The Skyscraper Office Building."
23 Ernesto E. Calkins, "Beauty, the New Business Tool," 145–156.

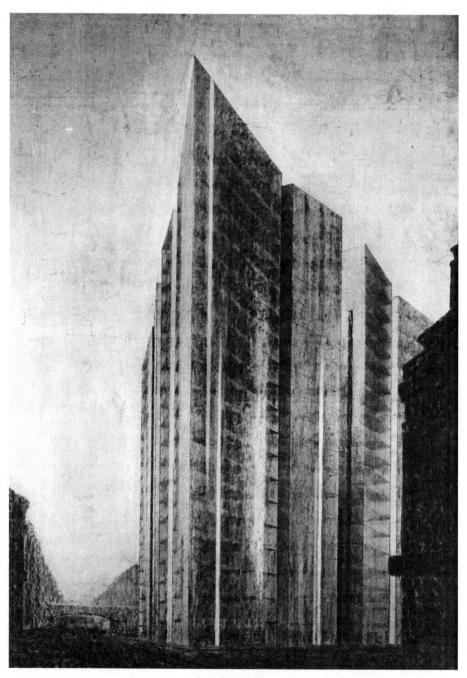

1.3 Project for a skyscraper with prismatic floor plan. Entry for the Berlin Friedrichstrasse competition, 1920–1921. Ludwig Mies van der Rohe, architect. (Photo courtesy of Dirk Lohan.)

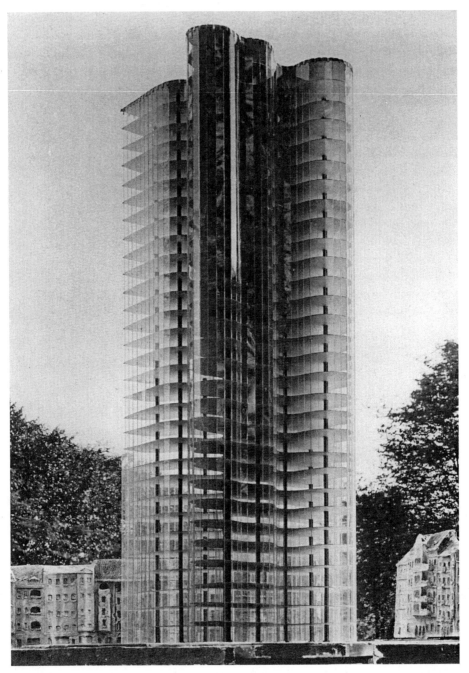

1.4 Model for a skyscraper in glass and iron, 1921–1922. Ludwig Mies van der Rohe, architect. (Photo courtesy of Dirk Lohan.)

Britain, asserted that industrial mass production was an irrevocable fact whose poten-
tial was to be exploited in the interest of art and beauty. He did not neglect to mention
that this strategy would have its pecuniary rewards. Weaver had arrived at his conclu-
sion a short time earlier during travels to France and Germany, where he had visited
the Trade Fair in Leipzig and the Berlin department store Wertheim: "[At Wertheim]
I saw acres of floor space covered with objects of modern design—fresh, sincere and
attractive—I had no doubt that I was in touch with a real development. People who
run department stores are not visionaries. . . . Every department has to make sales
commensurate with the amount of space occupied by the goods, and to return to the
common fund proper amounts to cover overhead and profit."[24]

"Beauty pays in Germany or it would not be there" is one aspect of Weaver's
argument that, he implies, should be transferred from Europe to America. Weaver does
not indicate whether he had considered any connection to those artistic and profes-
sional movements which, since the founding of the German Werkbund in 1907, had
systematically tried to introduce aesthetic standards into industrial mass production.
Had he done so, he might well have found out about the Bauhaus: in 1923, Walter
Gropius had instituted his program "Art and Technology—A New Unity" and thus
set a new course for the Weimar institution. The basis of industrial mass production
was examined and contacts with industry established, so that the workshops' products
could be sold as patented prototypes for furniture and household goods. Gropius's
interest was the establishment of the design professions in the economy and thus his
institution's financial security. As such, his aims were quite different from those of big
business. The first successful sales of licenses to industry were completed by 1928
during the Dessau period, and were consolidated with Hannes Meyer's assumption of
the directorship. In the field of architectural production at the Dessau Bauhaus, con-
nections to industrial mass productions were also pursued. By the early 1920s, a
"*Hochhaus* fever" broke out among German architects, supported by a government
announcement that as an exception from German building codes, skyscrapers could be
built in certain locations. In spring 1921, newspapers ran headlines such as "High rises
for Germany" and "The skyscrapers are coming!"[25] German architects had already be-
gun to experiment with their visionary ideas for high-rise buildings. Among those
earliest models were two daring designs for office towers by Ludwig Mies van der
Rohe, the Friedrichstrasse office building project of 1920–1921, with a prismatic floor
plan, and the glass skyscraper project of 1921–1922, with a polygonal floor plan. In-
tended for Berlin, both designs are characterized by a stringent abstraction of form.
They seem to anticipate the ultimate application of the principle of steel skeleton and
glass curtain wall construction. Mies's visions were considered utopian in Germany at
the time, but in the United States, where they were reproduced in important publica-
tions beginning in 1923, they were discussed as feasible.[26] These projects signal the

incipient rapprochement between German avant-gardists and skyscraper architecture and the beginning of a new era in the architecture of that building type in which aesthetic solutions would follow technical developments.

THE NEED
FOR HOUSING

Unlike commercial building, private and publicly funded low-cost residential building at the end of the 1920s remained largely untouched by social and economic interests, not to mention issues of aesthetics.[27] Nonetheless, such building involved a broad, economically weak portion of the population whose need for acceptable housing represented a problem of national proportions. In a response to President Franklin Roosevelt's assertion that "so many homes" had deteriorated to the point that they were no longer fit for human habitation, Oswald Garrison Villard, the editor-in-chief of the *Nation* at that time, described the desolate conditions:

In years of wandering I have seen those "homes" all over the United States—on the edges of deserts and Bad Lands, in the mining camps and coal districts, in the slums of our great cities, chockablock with some of the finest dwellings. I have studied them in back alleys of Philadelphia, hidden well behind charming post-Revolutionary facades. I have beheld them in the North end of Boston, in the pre-earthquake San Francisco, and none worse than right here in the City of New York, where there are still more than 100,000 rooms without a window that looks on anything but an airshaft. I cannot forget those shacks, miscalled homes, in which the millions of poor whites and negroes live in the South—shacks devoid of a single comfort or convenience, with corn growing to the tottering doorway, without flower, or fruit, or even a shade tree to hide the horrible bareness, the bodily and mental destitution of the Americans—with their "highest standard of living"—dwelling miserably within, under conditions European peasants would not tolerate. The existence of these dwellings alone has challenged our smug satisfaction, given the lie to our assumed superiority to all the rest of the world, and made a mockery of our assertion that ours is the best, the most progressive, and the most beneficent of

24 Lawrence Weaver, "The Need for More Art in Industry."

25 Dietrich Neumann, *Die Wolkenkratzer kommen.*

26 Walter C. Behrendt, "Skyscrapers in Germany," 365–370; anon., "Germany Adopting the Skyscraper," 111.

27 William W. Watkin, "The Advent of the New Manner in America," 523.

governments. "Many of our homes . . . not fit for human habitation"? Millions, Mr. President, millions of them.[28]

The Depression had resulted in a loss of income for many families, who were therefore dependent upon state assistance. When more than one hundred cities eliminated their social welfare programs, thousands of people were faced with expulsion from their homes. By 1932, empty lots in many cities had become crowded with "Hoovervilles," slums of provisional shelters.

There were many reasons for the fact that a standard of living compatible with the standards of that time, not to mention the American dream of a single-family house, was no more than a fantasy for much of the population. Especially in larger cities, whose peripheries had become a thicket of slums, the problem of mass housing had reached enormous proportions and was intimately bound to urban reform. Many politicians did not recognize the complexity of the problem, nor its causes or consequences; others were merely indifferent. Union or other labor-organized communal housing agencies did not exist in many areas or were too weak to effect extensive reform. Loan agencies and mortgage companies were interested in profit and were content to remain out of the market as long as governmental subsidies were unavailable. Tenants were, as a rule, passive, perhaps because they knew no other model and were possessed of little political or rhetorical power. Within a climate of ignorance, profit-taking, and inadequate social conscience, housing remained the concern of only a handful of architects, urban planners, and social workers who were far from knowing how to make their cause popular or feasible.[29]

By the beginning of the 1930s, the urgency of the situation was reflected by increased critical interest in the problem. In 1919, the economist Edith Elmer Wood had published her highly respected book *The Housing of the Unskilled Wage Earner.* Based upon her expertise in low-cost housing, which she had developed subsequent to her education at Columbia University and the New York School for Social Work, she argued that total reliance upon private philanthropy, as had been the practice until then, could not provide a solution to the housing emergency. She called instead for government intervention. In the 1920s, other well-known authors and critics spoke out increasingly for a transfer of responsibility from private funding of housing to public subsidies. Eventually, new organizations for regional planning were formed. The most famous of these groups was the RPAA (Regional Planning Association of America), a consortium of intellectuals who articulated the urgency of the problem. Among those involved were Edith Elmer Wood, the architects Frederick Ackerman, Catherine Bauer, Clarence Stein, and Henry Wright, and the Progressives Lewis Mumford and Benton MacKaye. Motivated by their belief that the appropriate housing policy could be an essential instrument of social and economic improvement, they developed a theoretical platform of regional planning and demanded that the govern-

1.5, 1.6 Housing designed for low-income families. Drawings and articles featured in the *Architectural Record*, 1934.

ment reconsider its past housing policy, create criteria for acceptable housing, and subsidize housing for the needy.[30] Those responsive to their ideas included the *Journal of the American Institute of Architects,* under the direction of Charles Whitacker, and the organizers of the seminal "Modern Architecture: International Exhibition" at the Museum of Modern Art in New York, whose third portion, on which Mumford collaborated, was devoted to the issue of housing.[31] In 1934, John Edelman of the Hosiery Workers established the Philadelphia Labor Housing Conference, an effective group who pushed for government initiatives in housing. He appointed Catherine Bauer, a vocal force of the housing movement, as its director. In 1935, Edith Elmer Wood published a comprehensive report on the conditions of life in an urban slum for the Housing Division of the Public Works Administration. The report stated that one-third of

28 Oswald G. Villard, "Issues and Men, Words and Houses," 609.

29 Albert Mayer, "Why the Housing Program Failed," 408–409.

30 Charles Butler et al., "The Planned Community," 254; Kenneth K. Stowell, "Housing and the Emergency," 253; Clarence S. Stein, "Community Housing Procedure," 221ff.; Catherine K. Bauer, *Modern Housing.* Also see Tafuri and Dal Co, *Modern Architecture,* 201ff.

31 Henry-Russell Hitchcock, Philip Johnson, and Lewis Mumford, *Modern Architecture: International Exhibition,* 179ff.

the U.S. population was housed in structures that did not fulfill the most minimal standards for human inhabitation.

When Roosevelt set out to stem the economic crisis with the New Deal's social and economic reforms, he also created a framework for public housing with his employment policy, administration, and legalization reforms. The government, finally acknowledging its social responsibility, became active at both the state and federal level in a housing market from which it had long distanced itself. Reversing a political line that had been held until then, the Roosevelt administration saw the beginning of organized and subsidized public housing in the United States. The National Industrial Recovery Act, passed in 1933, instituted a plan intended primarily to fight the suffocating unemployment but also to improve the living situation of the classes most affected by the Depression and to send a signal to industry. The law establishing the Public Works Administration, also intended to fulfill these goals, was passed in the same year. In 1934 came the Housing Act, which was to serve as the basis for public housing projects until the end of the war. Between 1934 and 1937, the government provided 129 million dollars for mass housing and housing estates through the United States Housing Authority. In 1935 came the Works Progress Administration, intended to fight unemployment in part by means of subsidized construction; the Federal Art Project provided for the involvement of artists in the design of public buildings. Thus, the New Deal provided commissions not only for craftsmen, contractors, engineers, and architects, but also for painters, sculptors, and other visual artists.[32]

It was nonetheless difficult, on urbanistic, political, and architectural grounds, to imagine that these efforts to institute social housing would meet with success. Funding was inadequate for the realization of all the projects planned. At no time did the government programs boast the political weight or the involvement of leading architects that graced comparable European initiatives.[33] While in the 1920s the mass production of housing became a major concern of the German avant-garde architects, it was never adopted on a similar scale by their American colleagues. The need for innovative solutions remained, and eventually American planners sought ideas elsewhere for a kind of building that would achieve the desired goals with fewer complications.[34]

Architects and urban planners, to whom the New Deal offered the opportunity to pursue publicly subsidized housing projects, had begun to look toward European precedents. Within the context of the American housing debate, they had come to know various models of multifamily housing and housing estates practiced in Germany, including those of the Weissenhof-Siedlung in Stuttgart (1927),[35] the Berlin Building Exposition (1931),[36] the International Building Exposition in Vienna (1932),[37] and the *Siedlungen* of Dessau-Törten (1926–1928),[38] Karlsruhe-Dammerstock (1928–1929),[39] and Siemensstadt (1929–1930).[40]

The enormous differences between American and European housing traditions were obvious from one critical glance at the Continent. Dense cohabitation had no tradition in the United States, and was seen as no more than a result of urbanization and inadequate social status; it was a characteristic of the slum. To the majority, "social housing" meant only the intervention of the state in the private sphere. As such, it was associated with unpopular socialist ideas and acquired negative overtones.[41] Once the housing problem had become a "national concern,"[42] receptiveness to the European approaches was greater. By 1932, the social concerns of the German Neue Sachlichkeit architects of the 1920s were shared by a number of equally socially engaged Americans, among them Henry Churchill, Theodore Larsen, and Buckminster Fuller, all members of the Structural Study Associates Group.[43] In 1934, Catherine Bauer published the first comprehensive comparative analysis of new European and American housing, *Modern Housing.* The author's friendship with Lewis Mumford had given rise to discussions of the European avant-garde's purist aesthetics and her introduction to the Bauhaus. Her influential body of work also championed housing schemes designed by Mumford in his capacity as architect.[44]

It must not be overlooked that knowledge of specific European precedents was not the only influence on American thought. The various governmental measures taken before 1936 effected a change in the preconditions of architecture and planning. The tenets of the modern movement were consequently able to take root more readily in the American consciousness.[45]

32 Kenneth Frampton and Yukio Futagawa, *Modern Architecture, 1851–1945,* 240.

33 Kenneth T. Jackson, *Crabgrass Frontier,* 220f.

34 See the reference to the related arguments of Henry Hope Reed in *The Yale Architectural Journal* 1 (1950) made by Frampton and Futagawa, *Modern Architecture, 1851–1945,* 340.

35 "Thirteen Housing Developments," 261–284.

36 Philip C. Johnson, "The Berlin Building Exposition of 1931."

37 Josef Frank, "International Housing Exposition, Vienna, Austria."

38 Knud Lönberg-Holm, "Planning the Retail Store," 498.

39 Ise Gropius, "Dammerstock Housing Development," 187–192.

40 Bauer, *Modern Housing,* 202ff., 313, I-A; see also her "'Slum Clearance' or 'Housing'?"

41 Frampton and Futagawa, *Modern Architecture, 1851–1945,* 238ff.

42 James M. Fitch, *Vier Jahrhunderte Bauen in USA,* 243.

43 Frampton and Futagawa, *Modern Architecture, 1851–1945,* 238.

44 "Housing's White Knight," 117.

45 Leonardo Benevolo, *History of Modern Architecture,* 2:321.

THE SEARCH
FOR MODERNITY

Europe's loss of political and economic power at the end of the First World War coupled with an increase in American power lent the New World a strength and independence it had not known before. The United States' new national self-confidence showed in its activities in the cultural sphere. The first museum of modern American art was opened at New York University in 1927; the development of "precisionism" meant a new, genuinely American form of modernity in painting. Even before, American artists had sought liberation from the long dominance of Europe and of France in particular, and countermovements developed. Thus, the members of the Society of American Sculptors, founded as a response to the National Sculptors' Society, unequivocally advocated "Americanism" in their work. In 1923, the League of American Artists published a statement formulated in terms borrowed freely from military rhetoric: "The time has arrived when the American Artist is the equal, if not the superior, of the foreign artist. . . . America is marching on to an artistic renaissance which will carry the nation to a great cultured height."[46]

An awareness of an indigenous cultural identity reverberated in contemporary literature, literary criticism, and historical and sociological studies as well.[47] In the field of architecture, a redoubled search for a contemporary "American" form of expression began despite uncertainty about that architecture's primary constituents. Whether "modern" building was only a question of new technologies or whether it implied a fundamentally different aesthetic vocabulary was a central point of contention. Inextricable from these issues was the debate surrounding the definition of a national identity. As early as 1928, George Edgell, then dean of the School of Architecture at Harvard University, declared the development of an "American architecture" to be a goal of foremost importance.[48] Two years later, Hugh Ferriss pleaded for an "American architecture" in which the "American spirit" and "American ideals" would find expression.[49] In the area of building technologies, this goal had long since been achieved; its aesthetic expression was still found wanting. Nonetheless, the question of just what this contemporary American architecture should look like was difficult to answer as long as the question of the nation's identity remained open. In 1920, the magazine *Freeman* asked directly what America's soul could be. It was a significant question at a time when the country was rallying around the flag in the aftermath of victory and, for a short time, was willing to overlook the extreme ethnic and cultural differences among its groups and regions.[50]

The Chicago Tribune Competition, 1922 The American architectural establishment believed that it could answer easily the questions of identity raised by critically and intellectually oriented journals. This con-

viction became evident in the call for a new national formal language, which peaked in the Chicago Tribune competition of 1922. Leading architecture journals were filled with calls for architects whose designs would reflect "the sound, strong, kindly and aspiring idealism which lies at the core of the American people."[51] Convinced that the architects able to meet this challenge would be American, the jury selected preliminary competition winners from the 145 American entries already received, even before the deadline for receipt of foreign entries. In the end, the 37 German and other European entries, which included designs by Ludwig Hilberseimer, Max Taut, and Walter Gropius and Adolf Meyer, claimed only a single prize, a fact that indicates the egocentric attitude of America in the early 1920s.

America's new, progressive position in the world was held to be best reflected in skyscraper architecture, as in Randolph Sexton's words: "The skyscraper, an American institution, planned to meet modern American requirements and serve modern American purposes, built of materials of modern manufacture in methods peculiarly American, has finally been made to express Americanism in its design."[52] At the same time, George Edgell described contemporary American architecture as a collection of Georgian, French, colonial, and other period-style buildings which, he contended, could all be considered modern as long as they were built "today" in a manner amenable to the "needs and functions of today," regardless of the conservative or mediocre way in which some did so.[53] The apparent contradiction between Edgell's and Sexton's positions seems more understandable if one considers that Sexton's survey ignored aesthetic issues. At that time, a building that bespoke a progressive spirit in its use of materials and its functionality did not have to be "modern" in phenotype in order to be perceived as modern.[54] It was the field of aesthetics, of how "modern" architecture should look,

46 Statement of the League of American Artists, New York, 1923, quoted in Milton W. Brown, *American Painting*, 82.

47 Stern, "Relevance of the Decade," 8.

48 George H. Edgell, *The American Architecture of To-day*, 4.

49 Ferriss, "Power of America," 61.

50 E. A. M., "Toward Internationalism in Art," 43.

51 Louis H. Sullivan, "The Chicago Tribune Competition," 156. Also see H. H. Kent, "The Chicago Tribune Competition," 378ff., and Irving K. Pond, "High Buildings and Beauty," 182.

52 Randolph W. Sexton, *American Commercial Buildings of Today*, 2. The author cites Bertram Goodhue's monumental state capitol building in Lincoln, Nebraska, as an example of an "ultra-modern" building. It is a work whose Gothic verticality, exterior decoration, and emphatic massing contain extremely historicizing elements but whose individual components—for example, its punctured windows without decorative embasures—indicate new architectural ideas.

53 Edgell, *The American Architecture of To-day*, 4ff. Also see Marvin Ross, "Shorter Notices" (review), 375.

54 Dwight J. Baum, "This Modernism," 598.

that saw the most virulent controversies, in turn further complicated by the problems of the discussion's terminology. The concept "modern" was defined differently according to the conditions of building. In American usage, it was often synonymous with "recently built." "Modernity" usually described a work of art or architecture which, in its content, dealt with new and contemporary issues, whereas "modernism" referred to the use of new formal means. "Modern" was, however, also used as a synonym for "technologically innovative" or simply "contemporary" and thus was used to describe extremely disparate contemporaneous developments. In the course of time, the concept was to undergo further cultural transformations.

In the eyes of more than a few, the aesthetic of classical modernism of the 1920s contradicted the traditional academic ideal of "beauty," conceived as the natural, true, and good. The consequences of this discrepancy are witnessed by the historicizing shells and false fronts that transformed highly technical buildings into Gothic cathedrals and Greek temples.[55] These also bear witness to the dominance of an aesthetic oriented toward historical precedent among American architects trained at the Ecole des Beaux-Arts,[56] and the emotionality with which American architects dealt with high-rise architecture at that time. The demand for "beauty" was also framed by the industrial design movement in the late 1920s, a demand made in architecture on the

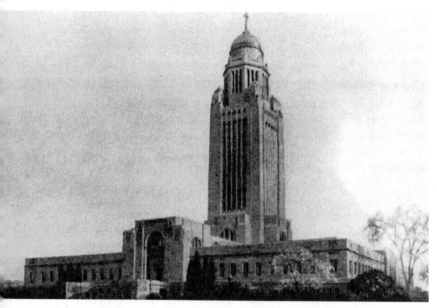

1.7 Modern architecture, as defined in the 1920s: Nebraska's State Capitol, Lincoln, 1927. Bertram G. Goodhue, architect.

grounds that higher artistic standards had to be found—but also in the hope that "at-tractive" products would increase sales. All those tendencies became apparent in the Chicago Tribune competition of 1922. Articles published in conjunction with the competition offer a full palette of acknowledged ways to combine "high buildings and beauty."[57] The first prize conferred upon John Mead Howell and Raymond Hood per-fectly embodied the dominant aesthetic ideal. The uncompromisingly modernist Euro-pean entries, such as the one by Walter Gropius and Adolf Meyer, were almost entirely ignored by reviews in professional publications.[58] Those entries had ignored the fact that, as the Neues Bauen in Europe turned decisively away from ornament and histori-cizing motifs, American skyscrapers were destined "to be the lyrical castles of Big Business, . . . endlessly distant from the simple and honest principles of the Modern Movement in Europe."[59] It took three more decades for the skyscraper to emerge as a unity of modern construction, modern function, and modern aesthetics.

It would be an oversimplification to contend that the unadulterated expression of technology in architecture was seen in America as barbaric. Unlike the situation in Europe, where the First World War had more severely shaken the belief in technologi-cal progress and had led to the regulatory integration of technology in a humanistic context, American society seemed less compelled to confront such issues. Critics such as Lewis Mumford, who remained deeply skeptical of the machine and feared that its incorporation into architecture would bring the dehumanization of Western civiliza-tion, were exceptions. In general, the sense that technology could represent a threat remained limited to the fields of industry and economics. The loss of ornamental and stylistic cladding, as Walter Gropius and Adolf Meyer proposed in their design for the Chicago Tribune tower, would be perceived rather as a loss of value. It would mean withdrawing all expressive means from a still-young historical tradition that yearned for a finer and more sophisticated cultural and intellectual life; it would have contra-dicted the conventional image of beauty that big business had propagated in order to realize its goals. On the other hand, American architecture could not retreat compla-cently to this position. The economic, political, social, and technological changes had not only produced a climate of national reaffirmation but also effected a sense of inse-

55 Leo Friedlander, "The New Architecture and the Master Sculptor," 5.

56 Martha and Sheldon Cheney, *Art and the Machine*, 7. On the commercial motivation of the movement, see Calkins, "Beauty, the New Business Tool."

57 The title of Irving K. Pond's extensive feature in *Architectural Forum*.

58 See the articles on the Chicago Tribune competition in *American Architect*, December 1922, 545–547, January 1923, 23–25; *Architectural Record*, February 1923, 151–157; and *Architectural Forum*, February 1923, 41–44, April 1923, 179–182, 378ff., September 1924, 100, January 1927, 7.

59 See Messler, *The Art Deco Skyscraper in New York*, 1.

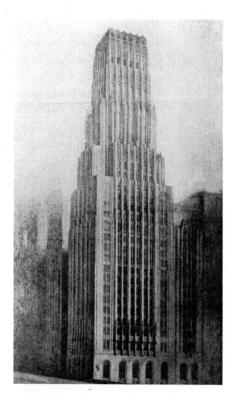

1.8 The Chicago Tribune competition, 1922. First prize: John Mead Howell and Raymond Hood, architects, New York. (Photo: *Architectural Record.*)

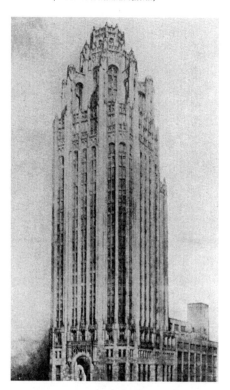

1.9 The Chicago Tribune competition, 1922. Second prize: Eliel Saarinen, architect, Helsinki, Finland. (Photo: *Architectural Record.*)

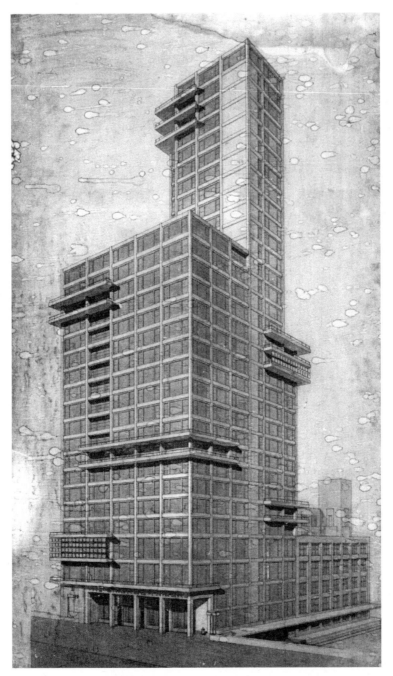

1.10 Walter Gropius and Adolf Meyer, entry for the Chicago Tribune competition, 1922.
(Photo: Bauhaus-Archiv, Berlin.)

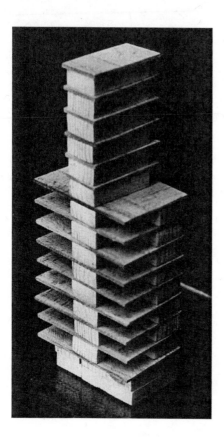

1.11 Bauhaus building blocks, Weimar, around 1924. (Photo courtesy of Hattula Moholy-Nagy.)

curity about the cultural means to deal with new demands. In this sense, the inherited concept of beauty current in America represented one of the primary barriers to the initial acceptance of the new, abstract aesthetic, which stemmed from the Bauhaus's and other avant-garde movements' search for an elemental and universally valid formal language. The dilemma that faced American architects in the 1920s is reflected in Shepard Vogelsang's 1929 musings: "Contemporary life moves so rapidly and is subject to such varied influences that a creation of a formal vocabulary constituting a style is practically impossible."[60]

In the Chicago Tribune competition, European and American solutions to an architectural problem characteristic of the 1920s clashed for the first time. The participation of Walter Gropius and Adolf Meyer also represents the first time that Bauhaus architects sought to secure a commission on American soil. It was too early for success; the European modernists' designs lacked insight into important developments in America and their implications for contemporaneous and future American architec-

ture. As such, they failed to do justice to that architecture's tradition. Nonetheless, the significance of Gropius's participation should not be underestimated. In the context of a large-scale competition of great national importance, the founder of the Bauhaus helped to prepare the basis for an increasingly attentive reception of his theories and work. Approximately three years after the Chicago Tribune competition, "German skyscraper design" was featured in the *AIA Journal*.[61] The article includes illustrations from the periodical *Deutsche Bauhütte,* for example a "Design for a Skyscraper by Professor Kreis." More than ten years later, when architectural journals began to accompany articles on Gropius with the famous photograph that showed him standing in front of his Chicago Tribune competition entry, it was a reference to this strategic moment.

Coming to Terms with the New Aesthetic If one of the effects of the First World War was a strong desire to define a particularly American culture, the war nonetheless brought with it a greater degree of openness toward Europe. After 1919, more than ever before and irrevocably, the nation found itself entangled in a web of international political and economic relationships. In these years, also, a series of movements in art, design, and finally architecture arose that contributed to a receptiveness to the ideas of the Bauhaus. In the spring of 1923, almost a year after its founding in Chicago, the Association of Arts and Industries sponsored an exhibition in the Carson Pirie Scott department store on the art of advertising. The exhibition reflected the organization's efforts to improve the quality of design in industry, a supraregional goal that demonstrates affinities to the German Werkbund's intentions. Early in 1929, the Association mounted "The Modern American Decorative and Industrial Art Exposition," another event promoting ties between art and industrial production.

Meanwhile, however, a heated and controversial discussion on modernism was raging through the American art, design, and architecture scene. In 1927 Henry-Russell Hitchcock wrote his first article on modern architecture in the new Harvard journal *Hound and Horn.* Shortly thereafter, the larger American architecture journals *Architectural Forum* and *Architectural Record* began to deal with the Neues Bauen. A wealth of articles on "modern" issues began to appear, with titles like "Modern Architecture," "The Modern House," "Modern Art," "Modern Store Alteration," "Modern Furniture and Decoration," "Modern Design," "Modern Spirit," and "Modern Materials." *Architectural Record,* the most widely circulated and most innovative journal at that

60 Shepard Vogelsang, "Copying versus Creating," 97.
61 Irving K. Pond, "From Foreign Shores," 405.

1.12 *American Architect*: changes in design and content of the journal between January 1929 and January 1930.

1.13 *Architectural Forum*, featuring Frank Lloyd Wright's and Hugh Ferriss's discussion of modern architecture, October 1930.

time, named A. Lawrence Kocher managing editor in 1927.[62] Under the direction of Kocher and editor-in-chief Michael A. Mikkelsen, the journal appeared the following year with a new and larger format, an improved index, and a modernized image, all for practical as well as philosophical reasons: the board of editors was aware that American architecture was ready for change and hoped to support change with the design and content of their publication.[63] Two other influential architecture journals, *Architectural Forum* and *American Architect,* also began modernizing their layout and content in early 1928, though less wholeheartedly than *Architectural Record.*

The new orientation of the magazines was evident in the publication, by *Record* in 1927 and by *Forum* in 1930, of Frank Lloyd Wright's five-part survey of contemporary American architecture.[64] The figure of Wright, whose popularity was then at a low point, was a reminder to the journals and their readership of an indigenous modernist tradition. The second volume of *Architectural Forum* in 1930 reflected this tendency in its choice of topics: it included articles on "Modern Railway Passenger Terminals,"

62 See "Professor Kocher Joins the Architectural Record Staff," 167. Lawrence A. Kocher had been director of the Department of Architecture at the University of Virginia, where he had succeeded Joseph Hudnut in 1926.

63 See Michael A. Mikkelsen, "A Word about a New Format," 1f.

64 Frank Lloyd Wright, "In the Cause of Architecture"; "Modern Architecture: Frank Lloyd Wright and Hugh Ferriss Discuss Modern Architecture."

"Modernists and Traditionalists," and "Modern Designers Influenced by Modern Materials." A twelve-part series in *Pencil Points,* beginning in May 1932, dealt with the "Philosophy of Contemporary Design" and included essays by leading American architects.

At the end of 1930, George Howe, Buckminster Fuller, Philip Johnson, and Matthew Nowicki founded the journal *Shelter.*[65] It became a forum for the views of the members of the Philadelphia T-Square Club, which, thanks largely to the impetus and activities of George Howe, would contribute significantly to a rapprochement with modernism during the following years.

The effect of single events on the discussion surrounding this change of heart can no longer be accurately measured; but the statements made by George C. Nimmons, a leading Chicago commercial and industrial architect, to a reporter at the 1927 AIA conference indicate the extensive influence exerted by professional publications, especially upon clients: "The demand on the part of the press for a new style of architecture, as they call it . . . has been very strong, and the effect of that has not been so much on the architect, because he knows the causes which produce loose styles of architecture, as upon the client. The client now demands a departure from the old line of work. He wants something new."[66] The feeling that change was imminent caused concern among the AIA's more conservative members. They sensed a threat to architecture posed by the alienating complications and confusion that characterized life in the 1920s, a threat that would mean a succession of ever-changing forms and a loss of clarity. In light of the transitory values of the twenties, these were not unfounded concerns. Perhaps they also express skepticism about the avant-garde's claim to the timeless and universal validity of its elemental forms. Derived through processes of intensification and simplification, these forms were intended precisely to counter the complexity of the life around them. On the other hand, it was impossible to ignore the demands of certain clients or to disregard the knowledge that architecture, like other genres of art, was subject to the changes of the times and compelled to redefine its standpoint. Still, many architects hoped that the new would be expressed with moderation, as in the streamlined forms of Bertram Goodhue, Paul Philippe Cret, Ralph Walker, Ely Jacques Kahn, and Raymond Hood.[67]

The fundamental if cautious willingness on the part of American architects in the early thirties to open themselves to the new European aesthetic was reflected in a comment in *Pencil Points* in 1931:

Finally, our conclusions as to the advent of modernism in America: from the conservatism which still seems to be in control in America, from the degree to which purely speculative solution is avoided, and from the marked acceptance with which meritorious design is received and advanced, we may safely welcome the modernist. More and more power, we may well wish, to those whose skill brings fresh solutions to

our ever-widening problems and opportunities, that they may interpret the living spirit of architecture. Whether our future be of gigantic forces of commerce and industry, corporate machines beyond the sensibilities of the individual, and whether such shall ever deny the individual's longing for beauty, we cannot say, but it is my impression that so long as the glory of Roman structure remains known to our architects, and so long the monuments of the Middle Ages afford an emotional background for the romantic imagination, beauty in architecture will be repossessed in each successive century in a new manner and with refreshed power.

The architect shall no longer work in the spirit of history but in the knowledge of its substance and by the zeal of creative research shall a new beauty come, crystalline, clean and with power to lift high the imagination.[68]

The attributes "purity" and "crystalline" lent the concept of beauty new dimensions. "Fresh," "sincere," and "attractive" were other adjectives that appeared in the course of this discussion. By the early thirties, America had clearly begun to move toward modernism; but its precise direction remained at first uncertain.

CRITIQUE OF CONTEMPORARY ARCHITECTURE

Critical awareness of the discrepancy between the ambitions and the actual condition of American architecture at the end of the twenties was largely based on the memory of the early modernist tradition in the United States, including the skyscraper idiom of the Chicago school and the prairie style of Frank Lloyd Wright.[69] The architects who had given life to the Chicago school and thus established their reputations, including Louis Sullivan, Dankmar Adler, William Le Baron Jenney, Daniel Burnham, William Holabird, Kevin Roche, and John Wellborn Root, were still active in the first decades of the twentieth century or had at least found fitting heirs to their legacies. This second generation of architects in the Chicago school shifted the emphasis of their activity from the commercial to the public sector and to the building of single-family houses.[70]

65 Author's interview with Philip Johnson, 21 September 1992. The journal initially appeared under the title *T-Square*.

66 George C. Nimmons, "Interview at the AIA Convention, 1927."

67 Stern, "Relevance of the Decade," 9.

68 Watkin, "The Advent of the New Manner in America," 530.

69 See Richard B. McCommons, "Architecture Education in America," viii.

70 Author's interview with George E. Danforth, 26 April 1992.

Sullivan's Carson Pirie Scott building is an exception to this development. By the end of the First World War, the Chicago school's prime was over. The subsequent generation did unquestionably include innovative architects whose thoughts and intentions had some commonalities with those of the European avant-garde's protagonists. Nonetheless, they seem to have been unconcerned with establishing a movement to assert their influence beyond their immediate environs. Carl Condit explains this decline as a result of decreased interest on the part of commercial clients in realizing a heroic, bold, and emancipated architecture.[71] This agenda was revitalized by the country's gains in political and economic power subsequent to the war; nonetheless, American architecture remained unable to regenerate its vitality within the strong tradition of the original Chicago school, nor could it provide convincing answers to new demands. Whether the call for revitalization, voiced repeatedly during these years, corresponded to an actual need or only to a particular group's subjective perception is irrelevant in considering its consequences. In any case, what economists might call a "latent demand" resulted in a mental inventory of all solutions proposed in the country, along with an unmistakably critical reflection on the present and future of American architecture and the search for new directions.

Professional Practice This activity was the concern of a limited circle of critical and analytical professionals.[72] They found little to recommend. Alfred Barr, Jr., spoke of a "chaos of architectural styles";[73] in his 1927 article "The Decline of Architecture," Henry-Russell Hitchcock condemned the situation:

Standing then, as we do, beyond the downslope of the nineteenth century and the apparent gap of the war, and disregarding our architecture, we are led to demand whether the time of its discard is at hand or whether, after the superficially historical wastes of the last century, it may be reintegrated or has already been reintegrated as a sound organ in an aging body. For if what passes today for architecture is but a blonde wig and gold teeth; no ghost rather, but a soulless imitation of its former body; it were better such illusions of second childhood were at once dispensed with and the possibility of a future without architecture frankly faced.[74]

Like Hitchcock, James Monroe Hewlett saw enslavement to tradition, paired with an attempt to be modern, as one reason for the stagnation. The architect was inevitably caught in a dilemma: on the one hand, experimentation and innovation were desired; on the other, the lack of tangible alternatives hindered new concepts from taking hold: "The great majority of the artists of the country today are neither extreme modernists nor are they old fogies. They desire to be modern in thought and performance but they do not wish to throw over the traditions of the past until they are sure that they have

found something better to substitute for them."[75] If Hitchcock placed his hope for change in the nation's own reservoir of creative and talented architects,[76] others nonetheless concluded that the United States did not have the energy to overcome the deficit of new ideas simply through its own efforts. The one exception of that time, Frank Lloyd Wright, was no longer considered capable of successfully revitalizing a broad-based professional field.[77]

The critics blamed the state of affairs on practicing architects' general lack of ability, dominant interest in superficial appearance,[78] and lack of an intellectual foundation. The conditions under which they worked were also the subject of complaint:[79] the client's demand that a project be individualized and the concomitant isolation and subjectivity in its conceptualization;[80] the introduction of nationalistic motifs in postwar art and architecture and the misuse of the arts as a political and commercial instrument; the low standard of craftsmanship; the neglect of aesthetic values resulting from an obsession with technical perfection;[81] the unwillingness to depart from traditional concepts of art; and indecision in evaluating other directions.[82] It is also plausible that a general sense of uncertainty in the early thirties among Americans, especially urbanites, confronted with the loss of traditional values and of authority, made it difficult for new ideas and directions to flourish.

71 Carl W. Condit, *The Chicago School of Architecture,* 182.

72 See Hans M. Wingler, *Bauhaus in Amerika,* 5. In the early 1980s, Tom Wolfe denounced the Eurocentricity of this circle as a selfish enterprise intended to recreate the chicness and excitement that they had experienced in Europe by transplanting modernism to the United States. Tom Wolfe, *From Bauhaus to Our House,* 41.

73 Alfred H. Barr, Jr., foreword to Henry-Russell Hitchcock and Philip C. Johnson, *The International Style,* 12. Even in retrospect, Barr's evaluation stands; as late as 1986, Howard Dearstyne speaks of the "bankrupcy of American architecture during the 1920's." Howard Dearstyne, *Inside the Bauhaus,* 23.

74 Henry-Russell Hitchcock, "The Decline of Architecture," 29ff.

75 James M. Hewlett, "Modernism and the Architect," 340.

76 Henry-Russell Hitchcock, "Four Harvard Architects," esp. 47.

77 Ibid., 41.

78 See Charles W. Killam, "Modern Design as Influenced by Modern Materials," 40.

79 See Richebourg, "Some Thoughts on Modern Architecture," 143.

80 Henry S. Churchill sees one reason for the tendency to conformity and convention, especially among the clients of commercial buildings, in the fear that any deviation from the predictable would have a negative effect on rentals. "The New Architecture," 553.

81 Hitchcock, "The Decline of Architecture," 30ff.

82 Barr, foreword to Hitchcock and Johnson, *The International Style,* 12.

Education Architecture schools and their protégés offered little promise of a way out
 of this stagnation. The nineteenth century's admiration for French culture
continued to hold sway over architectural education well into the first decades of the
twentieth century. Teachers, who were by no means compelled to be practicing or
reputed architects, in many cases remained faithful to the conservative doctrine and
traditional styles of the Ecole des Beaux-Arts.[83] The Massachusetts Institute of Tech-
nology had decided in 1865 to model its curriculum on the Ecole des Beaux-Arts; as
late as 1921, the yearbook of the School of Architecture at Harvard University still
included only classical designs. Even then, two years after the founding of the Bauhaus,
there was no sign in the yearbook—aside from the attention paid to issues of construc-
tion—of any concerns comparable to those of the contemporary European avant-
garde.[84] The goal of the education process was graphic facility, and the exercise most
often assigned to students was accordingly the design of a monument. The designs
were in turn evaluated by the instructors on the basis of "good taste."[85] Morris Lapidus
described his education at Columbia University at the end of the twenties as follows:

**My background from Columbia University School of Architecture was completely classi-
cal. As I was completing my architectural studies in 1927, when I graduated, we had at
Columbia a kind of insulated academic background—so much that none of the instruc-
tors or professors would even talk about the International Style, the Bauhaus and what
was going on in Europe. That was 1923–1927. Of course, the International Style was
well along by then, but Columbia University was quite reactionary, conservative. They
just did not talk about it. It was only in one lecture that we were told about it; and I re-
member that lecture so well. We were almost taken in, as if we were going to be told
some dirty stories. "We'll tell you about it, but forget it," and then we learned all about
Gropius, Le Corbusier, Mies van der Rohe and some of the De Stijl group in Holland.[86]**

Columbia University was one of the most important schools of architecture in
the country; it was also no exception in its refusal to acknowledge modern architecture.
The American architect Anthony Lord, who for a time worked with Marcel Breuer,
tells of similar experiences at Yale University.[87] Furthermore, the educational experi-
ence provided at these schools seems not to have inspired many students to extend
their studies beyond the minimum acceptable degree. Kocher points out that, accord-
ing to a study of 424 students who graduated between 1915 and 1930 from eight
architecture schools, only 15—less than 4 percent—chose to continue their studies on
a postgraduate level. By comparison, some 32 percent of medical students during that
period sought higher and more specialized degrees.[88]

As the thirties began, the discrepancy between traditional education and the new
demands of the profession continued to grow. The influence of the Ecole des Beaux-
Arts had declined noticeably. Nonetheless, there seemed to be no new fertile ground

for creative activity. A mood of stagnation asserted itself, a feeling that "something had to be done."[89] These words, spoken by George Danforth in retrospect, confirm the opinions voiced in discussions published by *Architectural Forum* and *Architectural Record*. At the center of the discussions was the problem's origin and its possible solutions.[90] Kenneth Stowell, the editor of *Architectural Forum* in 1931, formulated the demand for a qualitatively higher and more contemporary education as follows:

The coordination of efforts calls for a man of deep social consciousness, great breadth of vision, extensive technical knowledge, executive ability and unquestioned integrity. The education of such men is the responsibility of the architectural school. . . . The schools are still engaged largely in training designers or draftsmen rather than fitting men for leadership in the industry.[91]

Stowell's call for social conscience, visionary perspective, and technical competence in response to the challenges of industrial society recalls fundamental Bauhaus principles. Nonetheless, this affinity remains unspoken. Only in the mid-thirties was the Bauhaus first mentioned in these discussions as a model for the kind of architectural education that could satisfy the demands of American society. This does not mean that the Bauhaus's ideas were welcomed in academic circles. Here, as among architectural societies and practitioners, they met with opposition, perhaps in part because they were seen as an attack on the established curricula, methods, and aims of academia.

83 Sigfried Giedion, *Space, Time and Architecture,* 501, 504.

84 See Reginald R. Isaacs, *Walter Gropius,* 2:839.

85 McCommons, "Architecture Education in North America," viii.

86 Morris Lapidus interviewed in John W. Cook and Heinrich Klotz, *Conversations with Architects,* 149.

87 Author's interview with Anthony Lord, 22 March 1990.

88 Lawrence A. Kocher, "Keeping the Architect Educated," 45.

89 Author's interview with George E. Danforth, 26 April 1992.

90 Herbert Croly, "A Modern Problem in Architectural Education," 469f.

91 Kenneth K. Stowell, "Leadership and Education," 439.

The
Dissemination
of
Bauhaus Ideas:
Paths
of
Communication

he United States' experience of the Bauhaus occurred in two main phases. The first spanned the period from 1919 to 1936 and is characterized by a gradual increase in knowledge about the Bauhaus; by the crystallization of a reception that emphasized architecture above other disciplines; and by the development of a wider acceptance of certain ideas, as expressed by the growing interest in bringing some of the Bauhaus's major protagonists to the States to teach. The second phase, in which the seed sown during the first phase began to bear fruit, includes Josef Albers's emergence from a regionally circumscribed sphere of influence at Black Mountain College in North Carolina, the inception of Walter Gropius's and László Moholy-Nagy's American teaching careers, and the events that would pave the way for the entrance of Mies van der Rohe and other Bauhaus denizens onto the American scene.[1] The immigration of Gropius and of Mies also furthered the reevaluation of the Bauhaus's significance by focusing attention on its architecture. This phase peaked in the late fifties with the AIA's official recognition of these two former directors of the Bauhaus.[2]

The period between 1919 and 1936 was one of heightened sensitivity to new influences. In the thirties, especially, solutions to economic, technical, functional, aesthetic, and social problems were often sought in planning and building. At the same time, openness to European intellectual developments gradually increased. The ideas of the European avant-garde by no means entered a vacuum in the United States. Although Walt Whitman had written in 1871, "America has yet artistically originated nothing,"[3] his evaluation of the situation was pessimistic even then. Half a century later, although others still held Whitman's position, it was inaccurate. As early as 1910, Alfred Stieglitz, the immigrant son of Jewish German parents, had recognized the genuine achievements of the American avant-garde and sponsored exhibitions of such painters as Marsden Hartley, Arthur Dove, Georgia O'Keeffe, and Stanton McDonald-Wright. Dove's abstract painting *Extractions from Nature* (1910) dates from the same year as Wassily Kandinsky's earliest abstract work. It is unlikely that Dove knew Kandinsky's work; although it is possible that he had read Kandinsky's treatise "On the Spiritual in Art," his painting was his own. Nor was Dove the only American who was experimenting with abstract painting at that time. Others who broke radically with tradition to search for new directions included Morgan Russell, Georgia O'Keeffe, Charles Sheeler, Stuart Davis, George L. K. Morris, and Patrick Henry Bruce. In 1920, Stieglitz also presented the first show of

1 The substantially earlier immigration of Josef and Anna Albers in 1933 was an exception.

2 Gropius and Mies were accepted by the AIA as members in 1954 and 1955 respectively. Their receipt of the AIA Gold Medal in 1959 and 1960 represented an official acknowledgment of their status in the States.

3 Walt Whitman, "Democratic Vistas," quoted by Barbara Rose, *American Art since 1900*, 11.

American works expressive of a social and democratic vision of art. These works depicted such "modern" themes as unemployment, strikes, and city and street life. Stieglitz's activities exposed immensely important intellectual currents and provided stimulus for new thought.

The landmark Armory Show, an exhibition of European and American art mounted in New York in 1913, styled after the Cologne Sonderbundausstellung of 1912 and organized in consultation with the German art historian Wilhelm R. Valentiner, had depicted modernism as a recognizable new movement. In 1920 and 1921, exhibitions of modern American art were shown in Philadelphia; in 1921, New York's Metropolitan Museum of Art presented a "Modernist" show; and even in Dallas a comparable exhibition was organized. Parallel developments occurred in the architectural scene. Aside from the two dominant movements of neo-romanticism and neoclassicism, a new modern aesthetic was pursued by a few, largely independent American architects such as Irving J. Gill, George Howe, Albert Kahn, and, in the 1930s, George Fred Keck and Harwell Hamilton Harris. These few examples suffice to show the vitality of the American artists who worked in a modern idiom independent of European developments. There is no question that these artists and architects also contributed to greater receptiveness to the Bauhaus, as did the other European avant-garde movements that were gradually becoming known in America, most of which shared at least some of the Bauhaus's ideas and characteristics.

With regard to architecture and design, émigrés from various European countries contributed to that development, in particular those who came from Austria in the 1910s and 1920s, among them Joseph Urban, Rudolf Schindler, Richard Neutra, and Frederick (Friedrich) Kiesler. Both Schindler and Neutra shared Gropius's and Mies's profound admiration for Frank Lloyd Wright's work. Both abandoned ornament in architecture in favor of a plain, rational style, thus becoming the first Europeans to introduce to the United States, through their realized works, the aesthetics of a style that in 1932 would be dubbed international. Although the reception of the Austrians was not closely intertwined with that of the Bauhaus protagonists—partially due to their different regions of activity—there were notable points of connection, especially in New York. Due to its close intellectual and artistic proximity to Europe, this city stood out as the very catalyst of European-European and European-American exhange and mutual influence.

In addition, an increasing volume of information about the Bauhaus itself began to appear in books, journals, films, exhibitions, and through direct communication between Americans and Europeans. While the primary points of direct contact were limited to a few locations in the country—New York, Boston and Cambridge, Chicago, and Black Mountain College among them—the diverse media disseminated the information and transported the discussion onto the national stage.

IMPLICIT
INFORMATION

Information on the rise of the French, Dutch, and Russian avant-gardes described prin-
ciples and visual qualities that also applied to the Bauhaus. This information was enor-
mously important to the reception of the Bauhaus, even where it did not mention it by
name, because it placed the Bauhaus in a larger historical and artistic complex. Among
the issues thus put into circulation:

- The maturation of one specific idea among many that had arisen from the expe-
 rience of the war: that older values had proved inadequate to resisting collapse,
 and that radical reform was imminent.[4]

- The visionary and revolutionary character of the avant-garde, its shift away from
 purely artistic interests and its integration of art into the structure of a new
 societal, social, and universal consciousness.[5]

- The interpenetration of activity in all artistic genres and the cooperation of
 craftsmen and artists under the primacy of architecture to close the gap between
 craft and industrial production.[6]

- A call for a solid craft-based training as prerequisite to artistic training. Students
 in the arts were to learn the skills appropriate to the demands of the era and its
 means of production.[7]

- The primacy of communal over individual projects and the establishment of the
 community as the fundamental and superordinate unit in urban planning.[8]

- The development and realization of urban planning and architecture according
 to concerns of hygiene—that is, concerns of light, insulation, air, and greenery—
 and according to social dictates, such as standardization in the construction of
 houses and housing communities, and the assumption of low-rent tenants in the
 calculation of acceptable building costs.[9]

- A design methodology for residential districts that excluded subjective, stylistic,
 and arbitrary forms.[10]

4 See Herman George Scheffauer, "Dynamic Architecture," 324. This early article on the work of
 Erich Mendelsohn appeared in *Dial*, a "magazine for literature, philosophy and religion."

5 Bruno Paul, "Modern Art," 98.

6 Ibid. Also see Scheffauer, "Dynamic Architecture," 328.

7 Leo Friedlander, "The New Architecture and the Master Sculptor," 8.

8 Charles Butler et al., "The Planned Community," 253. Also see Ralph T. Walker, "The Relation of
 Skyscrapers to Our Life," 691.

9 Wilhelm Kreis, "The New City of Tomorrow," 197f.; Butler et al., "The Planned Community,"
 253; Josef Frank, "International Housing Exposition, Vienna, Austria," 325–338.

10 Kreis, "The New City of Tomorrow," 198; Butler et al., "The Planned Community," 253.

- An attempt to achieve new, concise forms by omitting the "nonessential."[11]
- The visual elimination of stolid weightiness in a building's massing, achieved by defining exterior walls as the skin of a frame structure.[12]
- The advocating of steel, glass, and concrete as the appropriate contemporary building materials.[13]
- The development of expressive architectural forms that were "primarily free from the influence of the past" and appropriate to the knowledge and technology "characteristic of this era's civilization."[14]
- The acknowledgment of the machine aesthetic and industrialized construction technology.[15]

The majority of the articles mentioned here that contributed to the growth of the Bauhaus's fame were published between 1927 and 1932, the year in which American architecture began to demonstrate a marked interest in the European avant-garde. It was also the year in which European and American tendencies within the new architecture were brought together in the show "Modern Architecture: International Exhibition." It is safe to assume a high degree of receptiveness to new trends during this approximately five-year period and, consequently, a particular interest in information from Europe on the Bauhaus.

De Stijl, L'Esprit Nouveau, and Vkhutemas The Bauhaus was by no means the only significant European avant-garde movement of the twenties; and it represents only one, if by far the most important, German movement of that time. American professional circles were often concerned with pan-European modernism and did not bother to differentiate the individual movements from one another. After 1928, interest in the international scene grew markedly. France, Holland, and Germany were most often discussed,[16] but comparable experiments in other countries such as Russia were not overlooked. Reports on De Stijl and L'Esprit Nouveau were concerned with principles and characteristics these movements happened to share with the Bauhaus. They were even, on some occasions, directly compared to the Bauhaus. It may therefore be assumed that growing knowledge of other avant-gardes profited the reception of the Bauhaus.

At the end of the twenties, the magazine *The Arts* presented a series of detailed articles on the Moscow avant-garde, including the Vkhutemas group, founded in 1920, which was the Russian group most comparable to the Bauhaus: it had attempted to develop a modern architecture during the six years of Lenin's New Economic Policy. In his 1929 article "Notes on Russian Architecture," Alfred Barr, Jr., informed his American audience about the movement, its direction, aims, and architectural production, and also about its exchanges with its western European comrades-in-arms. Barr noted the particular influence the Bauhaus had over Russian experiments, a postulate

he supported using the examples of the Moscow College of Art and Technology and the Leningrad Institute of Engineering. Barr did, nonetheless, admit that the Dessau Bauhaus's demand for "perfect efficiency" and "clarity in defining goals" seemed lacking among the Russian avant-gardists. One case of the Dessau Bauhaus building's immediate influence was, according to Barr, to be found in the work of Moisei Ginzburg.[17] There was less awareness at that time that the artists of the Russian avant-garde exercised in turn a considerable influence on the Bauhaus and, consequently, on American culture. Among several cases of direct contact between those artists and Bauhaus denizens, the most famous is probably that of Wassily Kandinsky who, one year after his emigration to Germany in 1921, joined the Bauhaus and remained one of its most influential teachers during the entire course of its existence. El Lissitzky lived in Berlin from late 1921 until 1925 and collaborated with Ludwig Mies van der Rohe on the publication *G*. Kazimir Malevich visited the Bauhaus in 1927 and met with Walter Gropius and László Moholy-Nagy, who had published his suprematist manifesto and his writings on the "extra element" in the series of Bauhaus books.

Although the work of the Russian avant-garde went almost unnoticed in America and thus could inspire little, the influence of the Dutch and French avant-garde was obvious. Alfred Barr, Jr., and Henry-Russell Hitchcock were enthusiastic about the work of Le Corbusier and J. J. P. Oud and became its proponents and interpreters in the New World.[18] The fact that French and Dutch avant-gardists were their own spokesmen in America, too, as the Russians were not and the Germans were only later, contributed much to their growing fame. In 1925, the *Little Review*, the most influential of the so-called "little magazines,"[19] published a lengthy article by Theo van Doesburg on the "Evolution of Modern Architecture in Holland."[20] The author explained the nature and origin of modern art and architecture, presented the major representa-

11 Francis R. Yerbury, *Modern European Buildings*, 5. Also see Scheffauer, "Dynamic Architecture," 324, and Irving K. Pond, "From Foreign Shores," 403.

12 Scheffauer, "Dynamic Architecture," 324.

13 Walker, "The Relation of Skyscrapers to Our Life," 694.

14 Parker M. Hooper, "Twentieth Century European Architecture," 209, and Howard T. Fisher, "New Elements in House Design," 403.

15 Museum of Modern Art, *Machine Art*, 1–37; Douglas Haskell, "Grain Elevators and Houses," 486; and Fisher, "New Elements in House Design," 403.

16 Events in other European countries, such as Austria and Scandinavia, were noted, but not as consistently or with such detail as for the countries mentioned above.

17 Alfred H. Barr, "Notes on Russian Architecture," 103, 105.

18 Henry-Russell Hitchcock, "The Architectural Work of J. J. P. Oud," 98, and Alfred H. Barr, "Dutch Letter."

19 Robert Stern, "Relevance of the Decade."

20 Theo van Doesburg, "Evolution of Modern Architecture in Holland."

2.1 Le Corbusier during his first stay in the United States, 1930. From left to right: Henry-Russell Hitchcock, the architects Jacobs and Soby, Le Corbusier. (Photo from H. Searing, ed., *In Search of Modern Architecture.*)

tives of De Stijl, and outlined the group's principles in sixteen points. In 1928, Hitchcock wrote an article on the work of Oud that appeared in *The Arts.*[21] Articles in journals such as these reached only small but nonetheless significant audiences. Only a few years later, the large, established professional journals began to publish articles on the De Stijl movement.[22]

The English-language publication of Le Corbusier's *Vers une architecture* was "enormously influential" on the reception of European modernism.[23] At the time of its publication in America, it was not an easily digested book: the spectrum of critical response ranged from alienation and rejection to acceptance and acknowledgment. Hitchcock's review in *Architectural Record* in early 1928 referred to the book's relationship to the German scene and to the architecture of the Bauhaus; the point of tangency he noted was the Weissenhof-Siedlung in Stuttgart.[24]

It is safe to assume that increasing awareness of European avant-garde movements related to the Bauhaus helped to increase knowledge of the Bauhaus itself. The nature of the image ascribed to the Bauhaus in the process is another story. The parallel reception of many modernist currents did not exclude recognition of their differences, but in some cases these differences were simply ignored. The great distance between the centers of activity in Europe and the American audience also blurred them. Even people who had visited the places and works in question did not always bring an authentic image home. This was especially true of the early years of European modernism's reception, when little was known in America about new developments and the relationships among them. It is also possible that the Stuttgart Weissenhof-Siedlung, understood as an early vehicle for the introduction of the European avant-garde to America, enhanced the tendency to gloss over differences. By juxtaposing architects of diverse persuasions, the exposition may have falsely propagated a sense of closure in the

European movement. As revolutionary as this exposition was for American reception, it may also have misled its audience.

Film Among those media in the United States that set the trends in aesthetic preference, film assumed particular importance in the twenties. Following the success of such films as *The Cabinet of Doctor Caligari*, the medium was not only recognized as a new art form, but the spaces and architecture it depicted became significant in the visualization of the new metropolis. In film, fantastic visions of life in the metropolis could be united with the desire for the modern in the new architecture of the metropolis. Cinema, as Luis Buñuel stated in 1927, had become "the faithful translator of the architect's most daring dreams"; only in cinema "could . . . one of the central utopias of architectural modernism be realized, the belief that form and function could logically and clearly be conjoined."[25] The broad influence that the architectural images of the twenties and thirties had on the audience is also discussed by Donald Albrecht:

[The cinema of the twenties and thirties] offers a challenging new perspective on modern architecture, as well as an unusual case study of how mass culture assimilates radical visions in the arts. . . . No vehicle provided as effective and widespread an exposure of imagery as the medium of the movies. Statistics of cinema attendance during the first half of the century suggest the ability of the movies to rival, if not actually surpass exhibitions as a major means of promoting new design concepts. . . . More than any other visual medium, film, by virtue of the size of its audience and its growing influence over culture as a whole, helped to shape popular perceptions of architectural modernism.[26]

In an article written towards the end of the twenties, Harold Miles contended that the influence of the filmic medium would not only influence popular taste, but also have a direct effect on artists and architects themselves.[27] Film thus assumed the role of mediator of architectural ideas. These ideas would be more or less consciously

21 Hitchcock, "The Architectural Work of J. J. P. Oud," 97–103.

22 Arthur W. Colton, *"Dutch Architecture of the Twentieth Century"* (review of the book of this title by Mieras and Yerbury). Also see the issues of *Architectural Forum* from 1929, especially Horner and Fischer, "Modern Architecture in Holland."

23 William H. Jordy, *American Buildings and their Architects,* 5:125.

24 Henry-Russell Hitchcock, *"Towards a New Architecture,* by Le Corbusier," 91. Also see Herbert Lippman, *"Towards a New Architecture,* by Le Corbusier."

25 Dietrich Neumann quotes Luis Buñuel and Juan Antonio Ramírez in *Filmarchitektur,* 7.

26 Donald Albrecht, *Designing Dreams,* xii ff.

27 Harold Miles, "Architecture in Motion Pictures," 544.

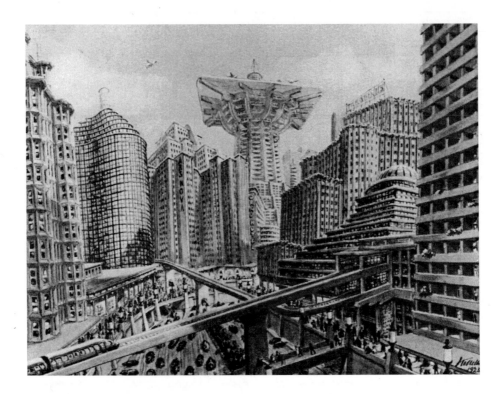

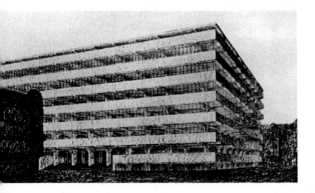

2.2 *(top)* Architectural sketch by Erich
Kettelhus for the film *Metropolis.* Second
version: City with Tower, 1925. (Photo:
Stiftung Deutsche Kinemathek, Berlin.)

2.3 Project for an office building in
concrete, 1922–1923. Ludwig Mies van
der Rohe, architect. (Photo courtesy of Dirk
Lohan.)

received and reflected upon by the audience, depending on its degree of sensibility and knowledge.

Film directors and designers also absorbed impulses from the real world and used them for their sets. The film *Sunrise,* directed by Friedrich Wilhelm Murnau in 1926, is such a case. Murnau arrived in New York in 1926 and moved on to Los Angeles. He reworked his vision of a modern European city in this American production, one of the earliest filmic realizations of this kind of cultural vision in America.

Film's ability to influence the rapprochement between architects and modernism and to incorporate real precedents and designs into its images is well illustrated by Fritz Lang's 1926 film *Metropolis.*[28] Lang, whose father was an architect and who had briefly attended engineering courses,[29] infused this epic with his vision of a futuristic city. The graphic quality and stylistic formal language of *Metropolis*'s utopian urban architecture point to various influences. Lang apparently had been inspired by the New York skyline on his 1924 trip to America: the skyline was reinterpreted as an urban backdrop of densely built blocks and burgeoning skyscrapers.[30] Certain sketches recall early modern buildings or projects in Berlin. One depicts a skyscraper with a rounded glass curtain wall facade. If somewhat stiff and clumsy, it does bear a resemblance to Mies van der Rohe's 1922 project for a polygonal skyscraper in steel and glass.[31] Another building in *Metropolis* strongly recalls the formal facade pattern of another Mies project, the office building in concrete (1922–1923), with its alternating horizontal bands of glass and opaque material and its visible, evenly spaced columns.

Because it incorporates the formal and technological principles of avant-garde European architecture, *Metropolis* can be regarded as a stylistic bridge between Lang's expressionist film *Die Niebelungen* and the four subsequent films he made before his immigration, all, as he states somewhat ironically, in "fully developed Bauhaus decor."[32] Lotte Eisner also finds a direct relationship between *Metropolis* and the

28 The film was made at the Decla studio in Berlin, with which Lang had become associated in 1919. The artistic directors were Otto Hunte, Karl Vollbrecht, and Erich Kettelhut (sketches). The German premiere took place on 10 January 1927 in the UFA-Palast.

29 Albrecht, *Designing Dreams,* 62. Rosemarie Bletter and Cervin Robinson maintain in their book *Skyscraper Style* (66) that Lang had studied architecture before deciding to become a director. The inconsistent biographical information is not in itself important, as both books are in agreement about the most significant fact: that Lang's interest in architecture was more than amateurish and that this interest is reflected in *Metropolis.*

30 Paul M. Jensen, *The Cinema of Fritz Lang,* 59.

31 This iconographic relationship has been detailed by Albrecht, *Designing Dreams,* 63. The emphasis on the building's reflective properties undermines the sense of weightlessness that interested Mies. The upper-story setback deviates from Mies's strictly cylindrical model and may be a reference to the highly articulated brick skyscrapers of Fritz Höger.

32 Albrecht, *Designing Dreams,* 62. The choice of the word "decor" does seem unfortunate.

Bauhaus, noting the formal geometry of the film's mise-en-scène, a strategy related to the New Sobriety movement (Neue Sachlichkeit).[33]

The American premiere of *Metropolis* took place in New York's Rialto Theater on 13 August 1927.[34] Some ten thousand people are said to have lined up during the first week of its run to see the film, and its popularity did not soon abate.[35] Philip Johnson saw the film at that time,[36] and more than likely he was not the only architect to see it. Reviews made mention of the film's architecture, sometimes without noting its utopian and fictional character. There were moments, according to the critic of the *Spectator,* in which *Metropolis* achieved true greatness, to which its "beautiful architecture" contributed.[37]

Two years after the film's American premiere, Hugh Ferriss's *The Metropolis of Tomorrow* was published. The book's third section includes sketches of buildings and a poem that recall the same projects of Mies cited by *Metropolis.* Ferriss's Technology Center, with its parallel buildings holding the street wall, incorporates constructional principles and an aesthetic formal language that Mies had used six years earlier in his design for an office building in concrete: horizontally oriented rectilinear volumes with narrow side walls and long front facades, flat roofs, alternating facade banding of glass and an opaque material, and an almost complete departure from classical tripartite articulation. In these respects, Ferriss's drawing also refers to Richard Neutra's design for an office building in the 1927 book *Rush City Reformed.*[38]

Another sketch depicts a skyscraper whose frame construction resembles Mies's skyscraper in glass and steel of 1921–1922. This association is strengthened by the fact that the building is shown under construction. The sketch, and a poem that Ferriss includes elsewhere in the book, also bring to mind Mies's earliest, near-expressionist office tower project for Friedrichstrasse (1920–1921). The poem is entitled "Night in the Science Zone":

Buildings like crystals.
Walls of translucent glass.
Sheer glass blocks sheeting the steel grill.
No gothic branch: No Acanthus leaf:
No recollection of the plant world.
A mineral kingdom.
Gleaming stalagmites.
Forms as cold as ice.
Mathematics.
Night in the Science Zone.[39]

The architectural principles published later by Ferriss but written in the early thirties also parallel fundamental thoughts of Mies van der Rohe's writings. In 1930, Ferriss wrote: "Architecture is more than 'the science and art of building.' It is a record of civilization. Our way of living is shown, in large measure, by the kind of buildings

we build."[40] Ferriss was well acquainted with the European avant-garde.[41] Since 1913, he had worked for various New York architects who were in contact with their European colleagues.[42] His *Zoning Envelope Studies* were produced in collaboration with Harvey W. Corbett,[43] who had met Gropius on his 1928 visit to New York and had been introduced to Frederick Kiesler by Katherine Dreier. Prior to his emigration in 1926, Kiesler had been a member of the De Stijl movement and coeditor of the journal *G*, through which he had known Mies van der Rohe since 1925;[44] he had made Moholy-Nagy's acquaintance in Berlin in 1923. In New York, he met Philip Johnson and Henry-Russell Hitchcock. Kiesler was in contact with a number of American architects who followed European developments: it was he who supplied Sheldon Cheney with the image of the German Pavilion in Barcelona that is included in *The New World Architecture*.[45] Corbett shared Kiesler's interest in modernism, and Ferriss belonged to the well-informed circle around Corbett.[46] Able to translate his impressions

33 Lotte Eisner, *Fritz Lang*, 89.

34 Peter Bogdanovich, *Fritz Lang in America*, 124.

35 Jensen, *The Cinema of Fritz Lang*, 58.

36 Author's interview with Philip Johnson, 16 October 1990.

37 Iris Barry, "The Cinema: Metropolis," 540.

38 Hugh Ferriss, *The Metropolis of Tomorrow*, 131, and Richard Neutra, *Wie Baut Amerika?*, 73.

39 Ferriss, *The Metropolis of Tomorrow*, 124. The poem may also be compared to Taut and Scheerbart's *Glasarchitektur*, which was still influential in Mies's work, if in a technologically and aesthetically transformed way. See Norbert Huse, "*Neues Bauen*," 42. For a discussion of further similarities between *Metropolis* and *The Metropolis of Tomorrow*, see Ulrich Conrads and Hans Sperlich, *The Architecture of Fantasy*, 158ff.

40 Hugh Ferriss, "Power of America," 61. Compare this with Mies, "Baukunst und Zeitwille" and "Die neue Zeit." Mies was not the only German architect with whom Ferriss's work has affinities. In a 1929 *Encyclopaedia Britannica* article on architectural rendering, Ferriss praises Erich Mendelsohn as an architect who can draw and paint as well as he can design ("Architectural Rendering," 310). In format, image-text relationship, structure, and, in part, content, *The Metropolis of Tomorrow* strongly resembles Mendelsohn's book *Amerika*, which had been published some two years earlier. Most persuasive in this regard is a comparison of two images of skyscrapers. See *Amerika*, 69, and *The Metropolis of Tomorrow*, 81.

41 See "Modern Architecture," a 1930 publication that includes a discussion by Ferriss and Frank Lloyd Wright.

42 Jean F. Leich and Paul Goldberger, *Architectural Visions*, 16.

43 See Adolf K. Placzek, ed., *Macmillan Encyclopaedia of Architects*, 2:54. Corbett made Kiesler an associate in his New York architecture firm after Kiesler's immigration to the United States.

44 The June 1924 issue of *G*, published in Berlin by Hans Richter, names Kiesler as coeditor along with Mies and former Bauhaus student Werner Graeff.

45 Sheldon Cheney, *The New World Architecture*, 127.

46 Thomas H. Creighton, "Kiesler's Pursuit of an Idea." See Bletter and Robinson, *Skyscraper Style*, 77f. On the personal relationship between Mies and Kiesler, see Mrs. Kiesler's telegram to Mies

of the work of prominent avant-gardists into drawing and to publish them in an enor-
mously popular book,[47] Ferriss was one of the most important recipients and propaga-
tors of the Neues Bauen, which had already left its mark on *Metropolis.*

In the thirties, the architectural and aesthetic principles of the Bauhaus became
evident in Hollywood movies, especially those produced by Paramount and its strong
coterie of German immigrants. Under the direction of Hans Dreier, the studio's art
department was transformed into a kind of Bauhaus theater workshop. Its definition
of modern studio style read like a repertoire of stylistic components derived from the
Dessau masters' houses: horizontality, elegant compactness, and white, undecorated
planes.[48]

EXPLICIT INFORMATION
ABOUT THE BAUHAUS

Established Bauhaus literature often presumes that little was known about the Bau-
haus during its existence as a school. The following will prove that this contention is
untrue for the United States—unless this assertion is weighed against the much
greater familiarity that began in the late thirties. Many events, exhibitions, and publi-
cations about the Bauhaus or directly related to it may be cited prior to 1930. The fact
that they may only have reached an attentive minority does nothing to detract from
that fact.

The importance of single authors, their articles and books, certain journals, exhi-
bitions, films, works, and personal contacts for the dissemination of knowledge about
the Bauhaus is difficult to judge in retrospect. Much evidence that may be significant
is no longer accessible. The relevant information needed to reconstruct the process of
reception was dispersed to distant corners of the world by Bauhaus émigrés and de-
posited in so many places that any near-comprehensive survey of it would cost enor-
mous time and resources. Not all sources that could provide insights into the Bauhaus
as a historical institution have yet been catalogued. This book is intended to help open
eyes, as Josef Albers might have said, and to inspire greater attentiveness among those
who deal with the relevant material. The appended bibliography compiles a consider-
able number of formerly unlisted publications on the Bauhaus. The material that ac-
crued during the eighteen years studied here is impressive in its sheer mass. Its
cumulative effect on the American architectural profession helps explain how the
Bauhaus, and especially its architecture, could develop such power.

Among these many modes of dissemination, some must be granted special status
for their efficacy. These would include Hitchcock's *Modern Architecture: Romanticism and
Reintegration,* published in 1929; the "Modern Architecture" exhibition of 1932; and
the two publications that accompanied the latter, the exhibition catalogue and the

book *The International Style.* Other events should be weighted because of their pioneering efforts, even if the radius of their influence cannot compete with that of larger publications and events. Among these would be, for example, the lecture given on 25 May 1927 by former Bauhaus pupil Helmut von Erffa in the Gaulois Galleries in Chicago: it was the first time that the Bauhaus was presented formally in the United States.[49]

In attempting to achieve an overview of the journals, books, oral reports, exhibitions, lectures, and depictions of work that carried information on the Bauhaus to America between 1919 and 1936 and thus acted as catalysts in the process of reception, the reader is confronted with the density of detail. Debate within the country's architectural circles has long involved the Bauhaus, beginning at the end of the twenties. This circumstance should not obscure the fact that the Bauhaus was only a small part of all topics discussed, and that a highly developed sensibility was needed to evaluate information correctly.

Periodicals An increased awareness of the Bauhaus in the United States, especially in the early years, may largely be attributed to periodicals. Unlike most daily newspapers, these reached a supraregional audience, were not compelled to report on daily occurrences, and were extremely tenacious in their pursuit of new movements. In the early twenties, periodicals were without doubt the most important means of communication for the American reception of the Bauhaus. At that time, linguistic and technical barriers almost unimaginable today stood in the way of direct and rapid transatlantic communication. This created a dependence on reports in the printed media.

Periodicals owed their success as reliable sources of information first and foremost to their authors. Among those journalists who, long before 1933, were conversant with European developments was Walter Curt Behrendt. In the early twenties, the *Journal of the American Institute of Architects* had in him a writer who could cover the avant-garde on the basis of his extraordinary knowledge. In Germany, he had been an editor of *Die Form* and a member of the avant-garde architectural society Der Ring.

on the occasion of her husband's death and Mies's answer, December 1967 (day not noted), Mies van der Rohe Files, Library of Congress.

47 Sheldon Cheney confirmed the great influence that Ferriss's book had on his American colleagues: "Hugh Ferriss deserves more credit than any architect since Sullivan for stirring the imaginations of designers, students and the public" (*The New World Architecture*, 144). Also see the review "*The Metropolis of Tomorrow*, by Hugh Ferriss," 66.

48 Albrecht, *Designing Dreams*, 79.

49 Bauhaus-Archiv Berlin, ed., *50 Jahre New Bauhaus*, 94.

Behrendt was the author of the first article on Mies van der Rohe published in America, in 1923. Entitled "Skyscrapers in Germany," it described the concepts behind Mies's two visionary skyscraper projects of the early twenties, the one polygonal in plan, the other prismatic. Following on the heels of the skyscraper debate incited by the Chicago Tribune competition only a short time before, the large reproductions of the plans in the article must have attracted notice, although the designs had been unrealized. Behrendt later became an influential teacher when he was appointed a professor at Dartmouth College in 1934.

Among the group of early émigrés who were able to reach a broad audience through magazine articles was the Danish architect Knud Lønberg-Holm. In the early twenties in Berlin he had been party to the movements that would develop into classical modernism, and he became an important link between the European and American scenes after his emigration. He was a catalyst in the reception of European modernism during his tenure in the late twenties at the University of Michigan, beginning in 1928 as American delegate to CIAM (Congrès Internationaux d'Architecture Moderne), and after 1929 as an editor of *Architectural Record.* His articles on new European architecture, many of which appeared in *Architectural Record* in 1930–1931, introduced American audiences to important projects by Mies van der Rohe and Walter Gropius, and emphasized those projects' technical aspects, well before the "Modern Architecture" exhibition in New York. The article entitled "Glass: Technical News and Research" (October 1930) was especially informative because of its broad scope and wealth of illustrations, among them Mies's Friedrichstrasse skyscraper and Gropius's Dessau Bauhaus and municipal employment office. Many of the paradigms of the Neues Bauen presented by Lønberg-Holm were also among the work selected by Hitchcock and Johnson to represent the International Style in 1932. Little attention was paid in those years to Lønberg-Holm's conviction that building could effect the total reorganization of life, a belief that placed him much closer to Hannes Meyer and Mart Stam than to Gropius and Mies.

Among those authors who were already assimilated as first- or second-generation Americans but still maintained a close bond to German culture was Herman George Scheffauer. Scheffauer published several substantial articles on the Bauhaus, including the 1923 "Building the Master Builder: The Staatliches Bauhaus of Weimar" in the journal *The Freeman* and the 1924 "The Work of Walter Gropius" in the *Architectural Review.* He wrote not only about architecture but about the entire spectrum of German—which for him meant Berlin—culture: theater, film, visual arts, and literature. He was one of the first in America to write about the Bauhaus and one of the few who understood its holistic approach. Though his articles appeared in a time of considerable aversion against all things German, he was nonetheless unable to secure broad recognition for the Bauhaus, as is reflected in reviews of his book *The New Vision in the German Arts* (1924), a compilation of earlier articles from the *Dial,* the *Freeman,* and the *Forum.*[50]

A third significant group to supply relatively early and accurate information on current events in European art and architecture, including the Bauhaus, were foreign newspaper correspondents. They had the opportunity in Germany to experience Berlin's rise as a cultural center and to communicate these exceptional events to American readers. Their reports helped to bridge the distance that the majority of Americans kept from German culture after the First World War. As a result, aversion was replaced by greater tolerance and sometimes respect by the early thirties. In place of earlier warnings not to become slaves of the cultural bombasts of Berlin and their propaganda,[51] the advice given to tourists interested in culture was to enjoy the manifestations of the zeitgeist in Berlin.[52] A 1931 statement by Helen Appleton Read, a New York art dealer and critic for the *Brooklyn Daily Eagle* newspaper, reflects the friendlier climate:

Making excuses for going to Germany is no longer necessary. In fact, those of us who have been trying, somewhat ineffectively, to persuade our friends that Germany is making a vital and individual contribution to twentieth century civilization, both artistically and socially, are now in the position of finding that going to Germany is the fashion. The reaction is a mingling of the pleasant I-told-you-so spirit and regret that our enjoyment of an exclusive pioneering connoisseurship has been overtaken. What surer indication that Germany has arrived, popularly speaking, can there be than *Vanity Fair's* recent endorsement to the effect that Berlin is the capital which "travelers who know where to go" now frequent.

Going to Germany means increasingly going to Berlin just as going to France means going to Paris. . . . The significant manifestations of the contemporary spirit are concentrated in Berlin since as a world capital it attracts the talent and energy that before the founding of the republic were divided between the capitals of the several principalities.

The secret of Germany's stimulating effect is largely due to the fact that she is learning from past mistakes. She is bending all her energies towards evolving a system which optimistically she believes will provide a securer basis for human happiness than was possible under the old political order. Germany, seen in this light, is a challenge to the future.[53]

Read, a keen observer of the German art scene in those years, kept her compatriots up-to-date on current events. She experienced the evolution of the German capitol

50 Lloyd Goodrich, *"The New Vision in the German Arts,* by Herman George Scheffauer,"* 60.

51 Ibid.

52 Helen A. Read, "Exhibitions in Germany," 6.

53 Ibid., 5f.

in the twenties into a European cultural metropolis and attributed this evolution to, among other things, the stimulating effect of the Weimar Republic's liberated atmosphere on artists' creativity. Even as Read wrote these lines, Germany was suffering from an already-deep international economic crisis, inflation, unemployment, violent confrontations between right and left, and the impending dissolution of its democratic government. Her political prognosis should not merely be dismissed as a miscalculation based upon her foreign perspective: Philip Johnson, who was acquainted with her, still relates that she was a decided proponent of the Nazi Party in the years of its rise.[54] Better-initiated observers recognized the signs of the times more accurately and knew that the future provided little reason for optimism. The country developed, as Read anticipated, in response to its challenges, but not as she hoped. Read's artistic judgment was fortunately much better than her political acumen. That she represented an exception in her metier in this respect is proven by the insightful articles she wrote between 1929 and 1931, including those on Ludwig Mies van der Rohe's work. Her reading of Mies anticipated analyses that others would later claim as their own. One of the cultural high points of Berlin mentioned in Read's reports was the Building Exposition of 1931. "It was the most exciting thing," maintained Johnson in retrospective acknowledgment of her judgment. "Mies was really riding high."[55] The city of Berlin was to remain the focus of American journalism in the years thereafter.

At the beginning of the thirties, the New York journal *Art News* published a series titled "Berlin Letter" by Flora Turkel-Deri, who also reported on the activities of the German art scene, including exhibitions by Kandinsky and Klee and an architecture exhibition by Gropius in the Berlin Architekturhaus. *The Arts,* another New York art journal, published the "Berlin Notes" of the painter Adolph Glassgold as an intermittent series; and the London art periodical *Apollo* regularly published Oscar Bie's "Letter from Berlin" in the course of 1929. A writer on art and music, Bie was himself from Berlin and had taught at the Hochschule für Musik there. He was well informed about German art and architecture, and his acquaintance with the Bauhaus, Gropius, and Mies was impressive, as evidenced by his July and October reports. Although Bie distanced himself from the pure and abstract forms of the Neues Bauen, as represented by the Dessau Bauhaus, Gropius's residential building in Spandau-Haselhorst, or Mies's Alexanderplatz project, he clearly respected the achievements of these two architects.

Other authors also contributed to the early fame of the European pioneers and the Bauhaus. Irving Pond, for example, the president of the American Institute of Architects, explained the new direction of architecture in Germany to his readers through his reviews of German magazines. Texts and illustrations from *Wasmuths Monatshefte für Baukunst, Der Baumeister, Der Neubau,* and *Deutsche Bauhütte* thus found their way into the *AIA Journal.*[56]

One of the most important proponents of the Bauhaus and of several Bauhaus

architects practicing in the United States was Henry-Russell Hitchcock. In 1927, the year of his graduation from Harvard University, he embarked on his second European tour and had thus the opportunity to familiarize himself with the avant-garde at its height. Shortly thereafter, he began to write essays on modern architecture for *Hound and Horn* and *The Arts,* later reprinted in larger periodicals. Through these channels, he was able to arouse American interest in the methods and meaning of the European avant-garde. Hitchcock particularly admired Oud and Le Corbusier, but he also considered Gropius and Mies to be the greatest German architects of that time and allotted them a prominent position in the 1932 exhibition "Modern Architecture," which he curated with Philip Johnson. Influenced by his younger colleague Johnson, his initially moderate interest in traditional and avant-garde architecture slowly moved toward the revolutionary camp.[57] He finally became one of the most competent and influential supporters of the European "pioneers" in the States.

By 1929, another influential American critic began to contribute to the discourse on avant-garde ideas: Douglas Haskell of the *Nation.* Whereas Hitchcock's focus in German architecture was especially on Gropius and the Dessau Bauhaus, Haskell most admired Mies van der Rohe. Thus, the information provided by these two authors proved complementary.

In the thirties, the circle of journalists interested in the Bauhaus and its protagonists grew, and their articles bear witness to their increasing knowledge of the movement's specifics. Among the most important authors, besides those already mentioned, were Alfred H. Barr, Jr., Philip Johnson, Catherine Bauer, George Howe, Joseph Hudnut, Albert Mayer, and George Nelson, as well as the British journalists Herbert Read and Morton Shand who published in *Architectural Review.* In the course of the early thirties, Sigfried Giedion and Gropius himself also began to participate directly in the discussion.

Besides those devoted exclusively to art, design, and architecture, a remarkable spectrum of other journals also offered Bauhaus-related material between 1919 and 1936. The individual character and focus of the respective journal determined the

54 Author's interview with Philip Johnson, 21 September 1992. He also stated that Helen Read had "taken" him to a "Nazi rally."

55 Helen A. Read, "Exhibitions in Germany" and "Germany at the Barcelona World's Fair." Also, interview with Philip Johnson, 21 September 1992.

56 Pond, "From Foreign Shores," May 1924 and November 1925. *American Architect* also made similar reference to German periodicals. In Swartwout, "Review of Recent Architectural Magazines," the June and September 1923 issues of *Moderne Bauform* were discussed. The commentary is, nonetheless, extremely negative. Throughout the mid-twenties, German periodicals remained an important source of information for their American counterparts.

57 Vincent Scully, "Henry-Russell Hitchcock and the New Tradition," 10.

choice of themes, the thrust of the content, and the perspective from which it was judged. Certain British publications that were standard items in American university libraries assumed a role comparable to their American equivalents, though their influence on American readers was difficult to pinpoint. On the whole, a survey of the articles related to the Bauhaus from those years produces a mosaic of numerous bits of information and commentary. The correspondence between its evolving image and the historical realities of the Bauhaus in Weimar, Dessau, and Berlin depended on more than the density of information. In fact, at the beginning of the thirties, when information on the Bauhaus was no longer rare, the image of the institution transmitted to the United States was less authentic than it had been a decade earlier. The development of a highly selective and focused interest group meant that the reception of the Bauhaus was dominated by architecture, especially by Gropius and Mies.

Periodicals targeted to architects were the most influential for the critical reception of the Bauhaus in America in the second half of the period studied here. A traditionally significant source of information for architects, they followed national and international trends and movements in an era characterized by relatively limited means and paths of communication. It was also an era in which visual communication was crucial, which translated into using the most expansive and highest-quality illustrations possible. It was comparatively difficult to learn anything about modern European architecture from books, since the relevant publications were hardly available, even in larger cities. The American architect Anthony Lord recalls having known only one architectural bookshop in New York City where he could find them.[58] On this vast continent, it was a major undertaking to visit distant shops, exhibitions, and built works. Even the expansion of the highway and railroad networks in the twenties changed that only gradually.[59]

Architecture periodicals had, even then, developed different focuses and functions. They offered interested readers material for research, teaching, and publications, historical references, information about new ideas, movements, and developments, as well as innovations in technology, methods, and materials. They gave notice of events, exhibitions, symposia, and recommended literature and offered a forum for exchange and criticism. The influence of the periodicals went far beyond the information or advertising they contained by providing the space in which trendsetters, tastemakers, and other forces in the field of architecture and design could act.

An "amalgam of visual and textual information,"[60] architecture publications are influential in two ways. Photographs, drawings, and sketches are just as important as the text; because of the linguistic barriers inherent to international communication, visual means are often most important. By its nature, the subject is more directly and impressively conveyed by visual information, as is true of all the visual arts. Illustrated magazines were also extremely important for the reception of the Bauhaus in the 1920s and 1930s because the majority of artistic and architectural ideas were absorbed uncon-

sciously. The high technical and artistic quality of the illustrations in the large architectural journals in the early twenties only added to that effect.

Among the most important professional publications of that day were *American Architect*,[61] *Architectural Forum*,[62] the *Architectural Record*,[63] the *Journal of the American Institute of Architects*,[64] *Shelter*,[65] and *Pencil Points*, known today as *Progressive Architecture*.[66]

The way in which *Forum* and *Record* dealt with the European avant-garde made them most significant as trailblazers. This was only true, however, after their layout had been modernized and their thematic focus correspondingly reoriented—in the case of *Record* in 1928, and in that of *Forum* in 1930. In the wake of these changes, both publications became more attentive to new European architecture and to the Bauhaus. Ironically, this was also a period when the experimental phase of the new European movements was already over and they were already in decline. With regard to the Bauhaus, both publications began to concentrate on the personalities involved or a recapitulation of their work; alternately, they covered technical issues. The roots of the Bauhaus's *Weltanschauung* and its socio-political implications remained marginal topics. When big-name architects such as Gropius and Mies were discussed, their relationship

58 Author's interview with Anthony Lord, 22 March 1990. Lord mentioned a bookshop in New York whose name he pronounced "Weiner." Philip Johnson also remembered the store but no longer knew how its name had been spelled. Interview with Philip Johnson, 21 September 1992. The English pronunciation seems to indicate that the name was "Wiener."

59 Kenneth T. Jackson, *Crabgrass Frontier*, 167ff.

60 Bill Katz and Linda S. Katz, *Magazines for Libraries*, 107.

61 Founded in 1876 in New York; one of the four largest architecture periodicals in the United States.

62 Founded in 1892 in New York as *Brickbuilder*. The title was changed in vol. 26, no. 1.

63 Founded in 1891 in New York; one of the most widely read and circulated periodicals. It focused on American architecture, but the more important international projects were also included. Katz and Katz, *Magazines for Libraries*, 108.

64 Founded in 1913 in New York. The periodical, which since 1983 has appeared under the name *Architecture*, is the official organ of the largest society of architects in America and includes extensive articles on contemporary architecture, usually within the United States and often public commissions, as well as information of professional interest. The *AIA Journal* was and is known for its illustrations, high-quality color photographs. Its circulation in 1912 was already 61,000 per issue. Joseph Wilkes, ed., *AIA Encyclopedia*, 1:181.

65 Published by the T-Square Club of Philadelphia from 1930 to 1939; suspended between 1932 and 1938. Also published under the title *The Club's Journal*.

66 Founded in 1920 in Cleveland, Ohio. In the twenties, *Pencil Points* was known as the "best architectural journal for young draftsmen." Lawrence A. Kocher, "The Library of the Architect," 221. Today, the journal is published as *Progressive Architecture* and is still one of the most important architectural periodicals, known for excellent documentation, the newest technical information, and its strong international orientation.

2.4 Post–World War I architecture journals in the United States.

to the Bauhaus was often reduced to a mere biographical note. It was only in the mid-thirties, with the start of debate on architectural education, that the Bauhaus was again discussed in connection with them as a complex pedagogic and artistic phenomenon.

Among the other journals, *Pencil Points* initially maintained a more conservative point of view, focusing on technical and artistic design; but in the mid-thirties it published several articles that were significant for the reception of the Bauhaus. Another journal was important for Mies van der Rohe's growing fame in the United States, the *Journal of the American Institute of Architects*. Beginning in 1932, the Bauhaus's principle that the new architecture was to be based on modern scientific research, pursued especially under Hannes Meyer's directorship, was discussed in the newly founded magazine *Shelter*. The avant-garde of the Northeast used these magazines as a forum to debate the issues of the industrial age and as a mouthpiece to advocate pressing causes, including low-income housing.

Of the English periodicals sold in the United States and often found in academic libraries there, *Architectural Review*[67] deserves special attention. It achieved great importance in the mid-thirties, especially for the reception of Marcel Breuer, Walter Gropius, and László Moholy-Nagy. The *Architect's Journal* and the *Journal of the Royal Institute of British Architects* should also be mentioned here in connection with the reception of Gropius.

Influential art magazines that covered the European avant-garde included the American *Art in America*,[68] *The Arts*,[69] *Art Bulletin*,[70] *Art Digest*, *Art News*,[71] and *Magazine of Art*,[72] as well as the English magazines *Apollo*[73] and *Studio*, later known as *International Studio*.[74] In these periodicals, the reception of Bauhaus architecture profited from previous and sometimes in-depth exposure to the Bauhaus's visual arts, especially that of the painters who had already been famous before the Bauhaus's establishment, such as Kandinsky and Klee; of those who were American citizens, such as Lyonel Feininger; or of those who lived in the States, such as Josef Albers. *The Arts* reported about various European avant-garde movements as early as the mid-twenties. Articles from 1929 and 1931 by Helen Read on Mies van der Rohe exemplify its vanguard

position. Others first became interested in the Bauhaus in the wake of the right-wing surge in Germany and the closing of the school in Dessau. The *Magazine of Art,* for example, began to include articles on German architecture and reviews of exhibitions in 1932. This list of examples, however, obscures the fact that art journals, except for *Art News* and *The Arts,* were by no means among the trailblazing proselytizers of the Bauhaus's ideas. Some of them declined to engage in the debate at all, such as *Art World,* a magazine that touted itself as "A Monthly for the Public Devoted to the Higher Ideals" and "a distinctly American magazine."[75]

Prior to 1936, a rather less significant role was played in the reception of the Bauhaus by industrial design periodicals, such as *Commercial Art and Industry,* and by certain home decorating magazines such as *House and Garden,*[76] *House and Home,* and *House Beautiful.*[77] For the most part these began to absorb certain avant-garde ideas and to make them accessible to a broader audience at the end of the thirties, as part of the establishment and popularization of modernism in the United States.

The role of the reputed academic and literary-intellectual vanguard journals was quite a different matter. Among them were journals dedicated to art and literature,

67 Founded in 1897 in London. The magazine assumed a decisive position among its peers; it was known for its interest in early modernism, its thorough and timely articles, its international orientation, and its excellent texts and illustrations.

68 The first art publication in the United States, it was founded in 1913 by the German art historian Wilhelm (William) R. Valentiner.

69 Founded in 1920 in Brooklyn, New York, and absorbed in October 1931 by *Arts Weekly.* Articles on traditional and contemporary art and architecture, with an international orientation.

70 Founded in 1912 in New York. This exceptionally important art journal was the American counterpart to the English *Burlington Magazine.* Its repertoire included articles on architecture.

71 Founded in 1902 in New York; it offered current reports on the American art scene, especially in New York.

72 Founded in 1926 in New York. It featured articles on contemporary American art, with occasional art historical articles; known today as *Arts Magazine.*

73 Founded in 1925 in London. *Apollo* has since then offered specialized, high-level, well-documented articles that concentrate primarily on England but sometimes also include an international focus.

74 Founded in London in 1893. Articles on international, but primarily British, art of the twentieth century.

75 Milton W. Brown, *American Painting,* 85. *Art World* was founded in October 1916.

76 Founded in 1901 in New York as a "magazine for creative living." See Katz and Katz, *Magazines for Libraries,* 562.

77 Founded in 1896 in New York; one of the best-known and most popular of home design magazines aimed at a broad, younger audience. Katz and Katz, *Magazines for Libraries,* 562f.

2.5 The magazine *Creative Art*, July 1931, featuring an article by Julius Meier-Graefe as part of the series "The Contribution of Germany to European Art."

such as the *Freeman*,[78] the *Little Review*,[79] and *Hound and Horn*.[80] Others focused on architecture, such as *Perspecta*[81] and *Connection*,[82] and yet others examined questions of general social and cultural interest. Among the latter were *Current Opinion*,[83] the *New Republic*,[84] *Dial*,[85] the *Nation*,[86] the *New Yorker*,[87] and the English *Spectator*.[88] Despite the fact that these publications had only tangentially to do with architecture, their role in disseminating the Bauhaus's philosophy should not be underestimated, especially those magazines that featured various authorities in the disciplines of the visual arts, design, or architecture. Their authors were, at least in part, drawn from the well-known intellectuals, architects, historians, and critics who also published in larger magazines. Among them were Catherine Bauer, Henry-Russell Hitchcock, Douglas Haskell, and Lewis Mumford. Philip Johnson published his very first article on architecture in the *New Republic*.[89] As a rule, these journals were published in places where new artistic trends were noticed quite early. Many of these places, including New York and the Ivy League university cities on the east coast, were in fact the geographic points around which the reception of the Bauhaus was consolidated.

The Bauhaus-related articles that appeared in the journals mentioned above are not usually characterized by an emphasis on a particular discipline, but rather by an interest in the Bauhaus's fundamental artistic, philosophical, and political aspects. Most remarkable is that these periodicals were vanguard enough to discover the Bauhaus in the first place. *Current Opinion,* for example, published a report on the Weimar Bauhaus in the year of the school's founding. The fact that these journals were so far ahead of their peers is not surprising. The smaller journals interested in avant-garde cultural and artistic developments were known for their acumen in perceiving trends and changes in the general mood, for noting new developments well before they had been noticed by a wider audience, and for their readiness to provoke and to risk the consequences.[90] The vanguard journals presented art, design, and architecture of high quality and experimental nature. Both these notions went against the American grain, the former because it challenged the principles of egalitarian democracy and the latter because it threatened the status quo of a country striving for conformity.[91] Along with the relevant art publications, they paved the way, especially in the second half of the

twenties, for the reception of the Bauhaus's architecture. The *Little Review,* which Milton W. Brown called "the best expression of the Chicago Bohemia" because of its "anarchistic revolt, . . . catholic rebelliousness and . . . cult of unintelligibility,"[92] proved worthy of being called vanguard with its coverage of the first "Machine Age" exhibition. *Hound and Horn* was the forum of, among others, Johnson, Hitchcock, and Lin-

78 Founded in 1920 in New York as a journal for "intellectuals" in the broadest sense of the word, with a great range of themes covered.

79 Founded by Margaret Anderson and Jane Heap in 1914 in New York in response to "revolution in the Arts," the journal was intended as a forum for the new tendencies in American and European art and literature. The last issue appeared in May 1929. See Heap, "Lost: A Renaissance," 5. Robert Stern calls the *Little Review* "the most influential of the so-called small press." See Stern, "Relevance of the Decade," 9.

80 Founded in 1927 in Cambridge, Massachusetts, the journal was in existence for only a few years as "A Harvard Miscellany." It was intended to serve the students and faculty of Harvard University as a forum for intellectual exchange among the various disciplines.

81 *Perspecta,* a publication of Yale University, is the oldest of the many periodicals published today by architecture schools. It is characterized by its exceptional graphics and layout as well as its critical, scholarly articles by distinguished authors. See Katz and Katz, *Magazines for Libraries,* 112.

82 A magazine published by Harvard University with professional graphics and a high academic standard.

83 Founded in 1888 in New York; published until 1913 under the title *Current Literature.* The magazine was intended for the intellectual reader with a broad interest in international art, culture, science, and politics.

84 Founded in 1914 in Washington, D.C., it was one of the most famous weeklies with liberal leanings and included high-quality articles on politics, science, film, books, and other cultural matters. Katz and Katz, *Magazines for Libraries,* 819. Around 1931, it presented itself as "A Journal of Opinion."

85 Founded in 1880 in New York as a literary and political journal for information, criticism, and discussion.

86 Founded in 1865 in Marion, Ohio. The magazine was known for its broad spectrum of articles, including those on art and architecture, with a liberal to left political orientation.

87 Founded in 1925 in New York. Literature, journalistic reporting, reviews, and commentary on political events, film, art, architecture, sports, etc. "The finest in American periodical publishing." Katz and Katz, *Magazines for Libraries,* 521.

88 Founded in 1828 in London. Aligned with the mainstream conservatives in the United States, the magazine offers insights into the British understanding of America. Katz and Katz, *Magazines for Libraries,* no. 4937.

89 Philip C. Johnson, "Modernism in Architecture." The tendentially leftist journal *The New Republic* already enjoyed considerable political power in the early twenties on the basis of its contributors and texts.

90 See Denise Scott Brown, "Little Magazines in Architecture and Urbanism," 223. Also see Peter Eisenman, "The Big Little Magazine," 74.

91 Rose, *American Art since 1900,* 66.

92 Brown, *American Painting,* 7.

2.6 *The Architectural Record,* October 1929, featuring the article "New Construction Methods" by Robert Davison.

coln Kirstein. *The Arts* was equally pioneering, with articles by Read, Johnson, Barr, and Mumford on De Stijl, L'Esprit Nouveau, Vkhutemas, the Bauhaus, and the Neues Bauen in general. *Creative Art,* another art journal that reported on the German avant-garde at an early date, published texts by, among others, Haskell, Kirstein, and Read. Many of the smaller magazines were discontinued or at least lost their exclusive position as the larger magazines began to cover modernism in the late twenties.

When considering periodicals of a more general orientation, it is important to recall that political and economic issues comprised an essential part of their content and that, after World War I, they looked upon the defeated aggressors with sharply critical eyes. The numerous articles on Germany published in 1920 and 1921 reflect this fact: they offered analyses of the causes of war and defeat, of the economic situation, of reconstruction measures, reparations, hopes for the future and diplomatic activity, suspicion of German intrigue, espionage, and suspicions of secret alliances with Moscow. During these years, for example, *Current Opinion* contained one or more articles on Germany each month. It was inevitable that foreign correspondents took notice of certain cultural events and movements, especially of an institution that was as dependent on the political climate as the Bauhaus was in those years.

Above and beyond the usual reference to the most important American indexes and bibliographies,[93] this study systematically examined relevant American and British periodicals for articles that might have influenced the reception of the Bauhaus. This survey included more than one hundred articles published between 1919 and 1936, from lengthy articles to brief memos, a third of them in British publications and the rest in American. The majority of material was found in architecture periodicals, such as *Architectural Record, Architectural Review, Architectural Forum, Pencil Points, Architects' Journal,* the *RIBA Journal,* the *AIA Journal, American Architecture, Architecture,* and *Shelter/T-Square.* An equal number of articles was to be found in the political, social, and general cultural magazines with a broader thematic spectrum, such as the *Nation,* the *New Yorker,* and the *New Republic,* and the art and art history magazines *Magazine of Art, Art Digest, Art News, The Arts, Apollo, Creative Art,* the *Museum of Modern Art Bulletin,* and *International Studio.* The remaining articles were distributed among the small

vanguard journals *Little Review, Hound and Horn,* and the *Freeman,* and the house and home journals *House and Garden* and *House Beautiful,* not to mention other categories of periodicals.[94]

The influence of the individual articles cannot be gauged only quantitatively. Other factors were also decisive, such as the specific theme under discussion, the name and reputation of the author and journal, the moment and general context of publication, the receptiveness of the readership, the circulation and accessibility of the journal, the placement, layout, and comprehensibility of the text, its reinforcement through illustrations, and the general state of development of the critical discussion. From this survey, it was obvious that American reception was, in those years, focused almost exclusively on the Bauhaus's big names rather than on the school as institution. When examined for their stances on these issues, the various journals displayed different tendencies. Thus, the English periodicals *RIBA Journal* and *Architects' Journal* devoted more space to Gropius and his architecture than to Mies van der Rohe or the Bauhaus. This observation hardly comes as a surprise, considering the year of publication and the

93 These are, first, *The Architectural Index* (annual), complete index of *Arts and Architecture, Architectural Forum, Architectural Record, House and Home, Interiors, Progressive Architecture;* selective index of *AIA Journal.* Second, *Art Index* (quarterly). Third, *Avery Index* (1958, 1973), the most comprehensive architecture index in the United States, with references to the year of a periodical's founding; comprehensive index of *American Architect* (1876), *Architectural Forum* (1892), *Architectural Record* (1891), *Progressive Architecture* (1920). In the edited and expanded second edition (1973), the works of the "most famous architects...are comprehensively listed," so that it may be considered a bibliography in and of itself (see *Avery Index,* 1973, 1:iv). Fourth, *Index to Art Periodicals.*

Bibliographies on the Bauhaus: Library of Congress, "Bauhaus" database, 1990. North Carolina State University, School of Design, *Bauhaus: Selected Bibliography.* Robert B. Harmon, *The Bauhaus.* The bibliography in Wingler's *The Bauhaus: Weimar, Dessau, Berlin, Chicago.*

Bibliographies on Mies van der Rohe: Robert B. Harmon, *Ludwig Mies van der Rohe,* and D. A. Spaeth, *Ludwig Mies van der Rohe* (both 1979). Shorter bibliographies are included in Philip C. Johnson, *Mies van der Rohe* (1947), and Franz Schulze, *Mies van der Rohe: A Critical Biography* (1985).

Bibliographies on Gropius: Sigfried Giedion, *Walter Gropius: Work and Teamwork.* This bibliography contains errors and countless incomplete dates but is worthy of mention as it was compiled by Gropius himself. Reginald R. Isaacs, *Walter Gropius: Der Mensch und sein Werk.*

The compilation of a bibliography of relevant periodical articles that are not yet included in the aforementioned indexes provided a surprising amount of information. The search proved extraordinarily difficult in the case of periodicals that were issued in small numbers so that copies are rare, as in the case of *Shelter (T-Square), Creative Art,* or the Harvard *Connection.* Even the famous Avery Library of Columbia University in New York owns at present only one issue of *T-Square* and four of *Creative Art.*

94 The sequence of this list reflects the frequency of articles relevant to the Bauhaus in these journals. It is to be noted that many of them have only been compiled in bibliographies for certain years and are still not completely listed in the existing indexes. Were a complete bibliography compiled, the understanding of their relative engagement in disseminating information on Bauhaus architecture might easily shift.

themes of the articles: they are more frequent during the years Gropius spent in England. The articles correspondingly tend to refer to his English buildings and proposals. These biographical circumstances are also reflected in *Architectural Review*. By that time, Morton Shand had established himself as an exceptional translator and supporter of Gropius's work; other friends in England also wrote about him, including Maxwell Fry, James M. Richards, and Sigfried Giedion. Finally, his own texts and publicity activities in his temporary home contributed to his image as an eminent architect of the Neues Bauen. Mies, on the other hand, was received with the greatest respect in the *AIA Journal, Hound and Horn,* and *The Arts*. Here, too, his connections to the authors, among them Walter Curt Behrendt and Philip Johnson, carried over to the publications. The Bauhaus as institution was usually foregrounded in the articles that appeared in socially or politically engaged journals. This fact can be explained by the close observation to which all noteworthy events in Germany were subject after the war. Their broad interests and sharp sense of the new served these journalists and correspondents well. Art and art history journals also focused more on the Bauhaus as institution than on its individual protagonists. In summary, the magazine-propagated reception of the Bauhaus between 1919 and 1936 began immediately following the Bauhaus's founding. A broader influence was first apparent some time later, however: in the case of Gropius around 1928, the year in which he left the Bauhaus and visited America for the first time; and in the case of Mies around 1930, the year in which he became the director of the Bauhaus and the Tugendhat house in Brno was completed.

Another source of information on the Bauhaus was, and continues to be, the daily newspapers in the United States, especially the *New York Times, Chicago Tribune,* and others published where the Bauhaus's protagonists settled. Their influence varied regionally, however, their authors and readers were not always within the sphere of professional reception, and most began to offer a special architecture section quite late as opposed to their literary sections. These factors make it difficult to assess their contribution to reception within the profession.

Books In the period between the Bauhaus's founding and the immigration of Gropius and Mies, a number of books appeared on the American market that contributed to the Bauhaus's growing fame and helped create a framework for an understanding of its ideas. One of the first of these was Erich Mendelsohn's 1926 *Amerika. Bilderbuch eines Architekten,* a photographic diary that recorded the buildings and life of the great American metropolises from the perspective of a European avant-gardist. The book was written in German but nonetheless became famous in the States.

In 1927 came Richard Neutra's *Wie baut Amerika?,* in which he presented his futuristic vision of the "Rush City Reformed." The largely theoretical conclusion discusses new methods of construction, including building with standardized concrete

panels and steel or reinforced-concrete frames. At that time, Neutra's attitude toward materials and construction was closer to the experiments of the Dessau Bauhaus than to the traditional wood-frame and masonry construction common in America.[95] The intellectual and aesthetic relationship between the designs in "Rush City Reformed" and avant-garde European architectural visions is especially apparent in the design for an office building that Neutra described as "the opposite of the monumental office tower," "with a ground floor obstructed by wind-resistant cores." He cites the "stiff frame, amenable to horizontal extension" and the "cantilevered floor slabs along the columnless short front"[96] as characteristic of the building. This project's formal and constructional commonalities with Mies van der Rohe's early project for an office building in concrete are as follows:

- the revealing of the constructional system on the facade;
- its cubic, horizontal massing and exterior dimensions;
- its cantilevering floor slabs on the narrow sides and set-back columns;
- the elimination of any concluding cornice line;
- the alternation of horizontal glass and concrete bands in the facade.

In the text of *Wie baut Amerika?*, Neutra discusses themes that were also the subject of the Bauhaus architects' work, including the need to affirm the present and the given conditions of the era "which are imposed on the creative worker like his fate"; this translated into an urgent need to come to terms with the machine and the requirements of mass society.[97] The book was published by the noted house of Julius Hoffmann. The 4,400-run first edition was immediately sold worldwide and garnered enthusiastic reviews in Europe and America. It made "an interpretation of Modernism and its expression in architecture" accessible to an American audience, as Pauline Schindler said.[98] The term "interpretation" describes precisely the way in which information was assimilated by most of the book's audience: only a minority could read the German text, so that most were limited to the visual information. The same year saw the English translation of Le Corbusier's *Vers une architecture,*[99] a book that described the fundamentals of European avant-garde architecture.

Henry-Russell Hitchcock's *Modern Architecture: Romanticism and Reintegration,* published in 1929, offered the first comprehensive presentation of the European move-

95 Henry-Russell Hitchcock, *"How America Builds"* (review), 594.

96 Henry-Russell Hitchcock included the design in *Modern Architecture* (plate 58). The original illustration is in Richard J. Neutra, *Wie baut Amerika?,*73, plate 95.

97 Neutra, *Wie baut Amerika?,* 1, 13.

98 See Thomas S. Hines, *Richard Neutra and the Search for Modern Architecture,* 64ff.

99 The translation is *Towards a New Architecture,* trans. Frederick Etchells (New York, 1927).

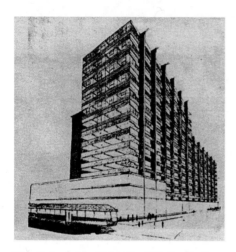

2.7 Design for a business center, 1927. Drawing from
Richard Neutra's book *Wie baut Amerika?*

ment for the American market.
Hitchcock discussed the move-
ment's historical evolution and
lineage, its intellectual basis, prin-
ciples, methods, techniques, and
materials. He analyzed the individ-
ual permutations of the "new man-
ner," as he called it, in the leading
countries, and distilled the central
ideas of its protagonists. These
included, among others, Le Cor-
busier, Walter Gropius, André
Lurçat, Ludwig Mies van der Rohe,
J. J. P. Oud, and Gerrit Rietvelt.[100]
In the chapter "The New Pioneers:
Germany," he described the
Bauhaus, its activities and inten-
tions, its directors, and some of its
more prominent teachers. The book includes illustrations of Gropius's Fagus factory
and Dessau Bauhaus building as well as Mies van der Rohe's Wolf house in Guben.
Via Hitchcock's publication, much of the essential material contained in the two books
mentioned earlier was integrated into the American reception of the Bauhaus.[101]
Hitchcock most admired Oud and Le Corbusier among the "new pioneers," but he also
credited Gropius and Mies with being the most important German architects within
the movement. The sanction granted by Hitchcock's professional authority was an
important step in increasing recognition of the Bauhaus in the United States.[102]

 The New World Architecture by Sheldon Cheney followed in 1930. Of greatest
concern to the author was the relationship between the Neues Bauen and the machine
as a new dominant factor in human habitation. He mistakenly believed that the Euro-
pean architecture, which he characterized as functionally oriented, hard-edged, clear,
precise, and based on machine aesthetics, was still in its infancy. Cheney developed a
palpable affinity for the Neues Bauen, although its discipline, sobriety, and lack of
ornament seemed extreme to him. He hoped that this contemporary tendency was no
more than a preliminary to a less stringent aesthetic, and that a mode of decoration
would develop from the essence of the new forms.

 Cheney found this rational, functional machine architecture best embodied by
the German avant-garde in general and by the Bauhaus in particular. He did not
see Mies's adamant commitment to architecture as *Baukunst*[103] (building arts) and
Gropius's work as fundamentally different approaches within European modernism,
as Philip Johnson did at that time. Instead, he considered them to be architects of

one and the same school, that of the Bauhaus. The differing positions of the two lead-
ing Bauhaus architects on art as a means of influencing life and on issues of the archi-
tect's social responsibility were ignored. This generalized view led Cheney to direct his
skepticism toward the "anti-decorative" style of both architects:

There are anti-decorative Modernist architects—unbending Fuhctionalists and Rational-
ists—who damn out the decorative Modernism of Wright and Hoffmann almost as bit-
terly as they assail the weakly historical Eclectics. They find their gods in the machine,
and they even set up actual machines as better models for house building than any
prototypes in the field of architecture: they insist upon the efficiency, the plainness, the
clean strength, the reasonable directness, of automobiles, airplanes, and steamships, of
electric ranges and refrigerators, as a new starting point and a final inspiration for home
building. They want the noticeable machine-house. Some of them claim to be anti-
aesthetic; others set up an aesthetic of their own, decorativeness, scorning ornament,
but recognizing "art" values in proportioning, sculptural massing, precise adjustment,
and right coloring.[104]

In another statement, Cheney expresses his admiration for Gropius's Dessau
Bauhaus, in which, he claims, the architect realized a new vision of twentieth-
century architecture. Even more than Hitchcock, he praised Gropius's and Mies's posi-
tions within the movement of the Neues Bauen. The book contains illustrations of
significant works by both architects, for example Mies's Weissenhof apartment build-
ing, the German Pavilion in Barcelona, and his design for an office building in con-
crete, and Gropius's Werkbund Exhibition administration building in Cologne, the
Dessau Bauhaus, the masters' houses, his Weissenhof house, and the theater in Jena.
Cheney's positive evaluation of the Bauhaus also exceeded Hitchcock's. He attributed
an absolutely exemplary status to the institution as a school "for architecture and
handicraft":

I count their scorn for aesthetics and decorativeness merely a different sort of aesthetic
and a passion for a deeper decorative quality—for organic decorativeness—let me
record that I believe that no other school anywhere is giving to its students a firmer
foundation for creative endeavor in the fields of modern architecture and craftswork.
No school can create genius or talent; but no other is so likely to leave unblanketed the

100 Hitchcock, *Modern Architecture*, 160, 162.

101 Ibid., plates 38, 50, 39.

102 See the various reviews of the book, such as those by Alfred H. Barr, Donald D. Edgell, and
Oscar G. Stonorov.

103 Author's emphasis.

104 Cheney, *The New World Architecture*, 254–255.

native creativeness which the student brings with him, or so likely to open a clear vista to the possibilities of naked beauty in the materials and uses of the machine age.[105]

Only one year after Hitchcock's *Modern Architecture,* Cheney had published an equally prominent book that also served to introduce the American public to the works of Mies and Gropius and pronounced the Bauhaus extraordinarily worthy of attention.[106] It was nonetheless unable to offer the much-desired overview of the European avant-garde, to evaluate the divergent currents, or to provide a binding definition of modern architecture.[107]

These failings were in a sense corrected by two related 1932 publications by Hitchcock and Johnson. Expanding upon work done previously, including that of Hitchcock himself, these publications were the book *The International Style: Architecture since 1922,* conceived simultaneously with the New York Museum of Modern Art exhibition "Modern Architecture: International Exhibition" of the same year, and the exhibition catalogue, edited in collaboration with Barr and Mumford. Inasmuch as the book and the catalogue differ in sections of the text and in numerous images, they offered in tandem a broader spectrum of exemplary works and information on the "style." Both publications include seminal works of architecture and interior design by Bauhaus protagonists.

In the book *International Style,* the Bauhaus is represented by four architects or artists: Albers, Breuer, Gropius, and Mies.[108] One interior each by Albers and Breuer are illustrated, a living room by the former and an apartment/bedroom by the latter, both built for the Building Exposition of 1931 in Berlin. The brief accompanying text on the work of Albers notes the break with tradition apparent in the wooden chairs depicted, a characteristic considered typical of most Bauhaus products. The text accompanying the Breuer project makes no reference to his relationship to the Bauhaus.

Few architects or artists are represented by more than one piece of work; thus Mies van der Rohe's five projects indicate his special status. The projects illustrated are his apartment house for the Weissenhof-Siedlung in Stuttgart (1927), the Lange house in Krefeld (1928), the Barcelona Pavilion (1929), the Tugendhat house in Brno (1930), and the apartment for Philip Johnson in New York (1930). Gropius is represented by three illustrations, which show the Dessau Bauhaus (1926), the employment office in Dessau (1928), and the Dessau-Törten Siedlung (shop and apartment house, 1928). The text also mentions the Fagus shoe factory in Alfeld an der Leine.[109]

Barr was correct when he predicted in the foreword to *The International Style* that the book's importance would be "possibly . . . epochal."[110] Its influence on the reception of the new movement by design professionals can hardly be overestimated.[111] The book became a standard in design libraries; it was received by a circle much broader than that of the exhibition's visitors. Its influence was reinforced by its extremely convenient format, which reflected the exhibition in the images and essay-like descriptions of

selected works; in biographical sketches of the lives and work of the architects represented; and in both general and short individual bibliographies. As was appropriate to its less programmatic thrust, the exhibition catalogue discusses the relationship between the works shown and the Bauhaus in greater detail.[112]

Theories and works of architecture related to the Bauhaus also received their due in *Modern Housing,* a classic work by Catherine Bauer published in 1934. The author had worked with the Regional Planning Association of America since 1930, had participated in housing committees, and was counted as a foremost authority on the subject even before the book's publication. *Modern Housing* was interested in the possibilities that the Neues Bauen seemed to promise with regard to public housing and housing estates. The book contains exhaustive studies of multifamily housing and housing estates in many countries of central and northern Europe. Bauer devotes particular attention to German architecture, perhaps because of a trip to Europe on which she had met Otto Bartning, Walter Curt Behrendt, Richard Döcker, Sigfried Giedion, Hugo Häring, Fritz Schumacher, and Martin Wagner. In her examination of the basics and feasibility of various house, apartment, and estate types, she deals with the essential issues of public housing, issues she saw in much the same way as Ernst May, Bruno Taut, and Gropius had: urban forms, rationalization, building codes, construction methods, floor plan typologies, principles of interior furnishings, and the particular social, economic, psychological, hygienic, technological, and aesthetic factors influential in building and habitation. She also describes for her readers the themes that ran through the progressive central European estate housing of the twenties—view, insulation, ventilation, standardization, the aesthetic of flowing space and of modern construction—and illustrates her contentions with concrete examples. Among those examples are the multifamily dwelling at Weissenhof by Mies van der Rohe as well as

105 Ibid., 303–304.

106 Ibid., 104, 303, 306. Quotations: 254–255, 303–304. Illustrations, Mies: 17, 261, 127, 312. Gropius: 305, 104, 303, 304, 307, 234, 254, 17, 352. (Sequence corresponds to mention in text.)

107 See Johnson, "Modernism in Architecture," and the review "*The New World Architecture* by Sheldon Cheney."

108 All in all, the publication includes more than sixty architects or partnerships from 16 countries and examples of their work. Of these, 21 are German architects, interior architects, or partnerships.

109 Henry-Russell Hitchcock and Philip C. Johnson, *The International Style,* 29, 101, 107, 181–191, 143–147.

110 Alfred H. Barr, Jr., foreword to Hitchcock and Johnson, *The International Style,* 11.

111 Gillian Naylor, *The Bauhaus Reassessed,* 172.

112 See Henry-Russell Hitchcock, Philip Johnson, and Lewis Mumford, *Modern Architecture: International Exhibition,* 57ff., 111ff.

the Siemensstadt housing units, the Dessau Bauhaus, and a design by Gropius for a housing tower dating from the twenties.[113] *Modern Housing* also contained an extensive list of references to other literature including numerous German publications, among which were *Bauhausbauten Dessau* and the Werkbund-sponsored journal *Die Form,* described as an especially valuable source of information. In her book, Bauer provided largely new information to the United States on Gropius, Mies, and the Bauhaus; and she did so only one year after the Bauhaus's closing and two years before Harvard University attempted to secure one of these two architects as professor.

In 1935, the English translations of two books by former Bauhaus habitués were finally published, *The New Vision: From Materials to Architecture* by László Moholy-Nagy and *The New Architecture and the Bauhaus* by Walter Gropius. The former is a compilation of the author's Bauhaus lectures and conveys his view of the pedagogic and professional tenets and goals pursued by the school. The latter book provided American architectural circles with detailed, authentic—from Gropius's perspective—information on the curriculum, teaching structure, educational goals, understanding of architecture, and fundamental artistic-philosophical perspective of the Bauhaus as implemented and later recalled by the school's founder.

All these books could be found in the large university libraries and on the recommended reading lists published by architectural periodicals. Numerous reviews provided the basis for the publications' influence and ensured that the intellectual heritage of the Bauhaus would find its way to an American professional audience.

Bibliographic Sources Bibliographies, reading lists, and reviews in periodicals and books became an increasingly available source of information on the Bauhaus in the twenties. It was primarily up to the larger architectural journals, especially *Architectural Record,* to acquaint their readers with publications by Bauhaus architects. Among the authors who thus made the American public aware of the Bauhaus, Henry-Russell Hitchcock should be mentioned first. In 1928 and 1929, respectively, he reviewed Neutra's *Wie baut Amerika?* and Gropius's *Internationale Architektur,* as well as other contemporaneous architecture periodicals.[114]

Pauline Fullerton, head of the Department of Art and Architecture of the New York Public Library in the late twenties, was also well informed about all newly published books on the Bauhaus. She compiled reading lists for *Architectural Record* that included not only titles but also brief synopses. Her July 1928 review of the reference work *Die Baukunst der neuesten Zeit* by Gustav Adolf Platz cited the book as one of the most important sources of information on new European architecture: "A discussion of the new movement in architecture, followed by more than four hundred illustrations of various types of buildings, predominantly German. There is a brief dictionary of architects and their works and an index of text and plates."[115] Platz's book became the very

publication that guided Johnson on his first architectural tours through Europe. The works by Gropius it mentioned are *Staatliches Bauhaus in Weimar, 1919–1923*,[116] the first Bauhaus book *Internationale Architektur* (1925), and the seventh Bauhaus book, *Neue Arbeiten der Bauhaus-Werkstätten* (1927). Mies van der Rohe's article "Industrielles Bauen," which first appeared in the magazine *Zeitschrift für elementare Gestaltung,* is also cited. In addition, Platz mentions the texts published in 1926 by the architecture group Der Ring in the journal *Bauwelt.* In 1929, Hitchcock also recommended to his readership that they study *Baukunst der neuesten Zeit.* Probably only the minority was equipped with the linguistic ability to follow Fullerton's and Hitchcock's advice (or to read the texts Platz recommended). Philip Johnson, who had acquired German language skills in Heidelberg, and Alfred Barr, Jr., who could at least read German, were notable exceptions. The exceptionally comprehensive and high-quality images in Platz's work nonetheless offered even those American readers without the required language skills at least a look at the Neues Bauen in Germany.

Important bibliographic references to Bauhaus architecture also appeared in other places. Lincoln Kirstein, who curated an exhibition in late 1930 devoted exclusively to the Bauhaus, included a selected list of Bauhaus books in the exhibition catalogue.[117] By the time Hitchcock and Johnson's *International Architecture* was published in 1932—and without a bibliography!—anyone interested enough was already privy to a great deal of information on the German avant-gardists. This fact is witnessed by a bibliography compiled in the same year by Catherine Ann Keynes, presumably a Columbia University student, for a course in the Department of Library Services: *Certain Aspects of Modern Architecture, as Exemplified in the Theories and Architectural Works of Erich Mendelsohn, Jacob Johannes Pieter Oud, André Lurçat, Walter Gropius and Mies van der Rohe.*[118] A number of significant publications prior to 1936 also included suggested readings on the Neues Bauen and on Bauhaus architecture; the most informative of these publications was Catherine Bauer's *Modern Housing.*

113 Catherine K. Bauer, *Modern Housing* (plates 27-A; I-A; 37-A).

114 Henry-Russell Hitchcock, "How America Builds. Wie baut Amerika? by Richard Neutra"; Hitchcock, "*Internationale Architektur,* by Walter Gropius"; and Hitchcock, "Foreign Periodicals."

115 Pauline Fullerton, "List of New Books on Architecture and the Allied Arts," 85.

116 Coauthored by Karl Nierendorf.

117 He mentioned the Bauhaus books 1, 2, 8, 9, 10, 11, 12, 13, and 14.

118 Carbon copy of a typewritten manuscript, New York, 1932, listed in the *Avery Index to Architectural Periodicals,* 1973, under the headings "Mies" and "Gropius" (9:691; 6:630). According to the information given by Avery Library on August 5, 1991, this manuscript, which should be

Exhibitions While texts and illustrations in printed media can offer only a substitute, exhibitions offer the opportunity to encounter a work of art firsthand. American exhibitions were an invaluable source of information in the dissemination of the Bauhaus's architectural and artistic work and exhibition techniques. In New York, which was then in its ascendancy as the center of the visual arts, a forum for European modern art, and later for the art of the Bauhaus, existed even before 1919. Alfred Stieglitz can be credited with opening the doors to abstract painting and other innovative tendencies when he began to exhibit the works of young American and European modernist painters in his studio in 1910. Exhibitions of this sort would be shown uninterruptedly thereafter; 1912 saw the first presentation of works by Lyonel Feininger, who would later join the Bauhaus.[119] (In 1913, his painting *Raddampfer I* was sold to the Detroit Institute of Arts.) In February and March 1913 the Armory Show took place, an exhibition considered momentous in the development of modern art in America. Inspired by the Cologne Sonderbundausstellung of 1912,[120] this was the first comprehensive U.S. exhibition of modern European and American art, including works of the cubists and the fauves. It drew some 300,000 visitors and was instrumental in paving the way for modernism. German presence was not desired in the show, but at least one later Bauhaus teacher and painter, the Russian Wassily Kandinsky, was there presented to the American public. In 1920, the collector Katherine S. Dreier cofounded the Société Anonyme with Marcel Duchamp and Man Ray. Its mission was to introduce European modern art to America, and it was responsible for organizing one-man exhibitions in the United States for Kandinsky in 1923 and for Paul Klee in 1924.

In the latter year Klee and Kandinsky joined their Bauhaus colleague Lyonel Feininger and the painter Alexey von Jawlensky to found the group Blue Four, with the aim of exhibiting their work together in the United States. Their small solo and group shows, like the ones sponsored by the Société Anonyme, were limited to New York and a few west coast cities, such as Los Angeles and San Francisco. Beginning in 1924, the Blue Four were represented in the United States by Emmy Esther (Galka) Scheyer, an art dealer and friend of theirs from Braunschweig. She had first met Klee and his wife Lily in 1920. The following year she paid the Klees a visit in Weimar, accompanied by Jawlensky; from then on, she continued to visit the Bauhaus, where she got to know Feininger and his wife Julia, as well as Kandinsky.[121] In 1925, a few months after coming to the United States, the group showed their first exhibition, at the Daniel Gallery on New York's Madison Avenue. The gallery was owned by Charles Daniel, son of German immigrants from Essen, and had opened in 1913. The show's 50 works included paintings, watercolors, and prints. Although it was reviewed in the *New York Times,* the *Sun, Time,* and *Art News* and attracted a good number of visitors, sales were zero—probably one of the reasons why Scheyer left New York for California in 1926.[122] In Hollywood, she turned her house into a gallery accommodating her own art collection and established close contacts with film directors, movie stars, collectors, and famous European émigrés,

including Rudolf Schindler and Richard Neutra who had been living and working in Los Angeles since the 1920s. In addition to her exhibitions, lectures, and sales contacts, her attractive personality paved the way for her German avant-garde friends.[123]

These initiatives were reinforced by the appointment of a German art historian, Wilhelm (William) R. Valentiner, to the directorship of the Detroit Institute of Arts in 1924. Valentiner, who would serve in this position for more than twenty years, had been a member of the Novembergruppe, a revolutionary organization of artists, painters, sculptors, film directors, composers, and writers founded in 1918 in Berlin.[124] Other members of this group included Mies and Gropius. Valentiner had met several Bauhaus architects and artists, among them Feininger and Gerhard Marcks, in the Arbeitsrat für Kunst (Workers' Council for the Arts), another leftist group that sought social and political reform through art. Like the Novembergruppe, the Council was short-lived, but some of both organizations' artistic and pedagogic concepts were integrated into the program of the Staatliches Bauhaus in Weimar a short time later.

Although Valentiner's expertise was primarily in seventeenth-century art, he was a great advocate of expressionism. His link to the Bauhaus, which he visited in 1924, was the Weimar work of Marcks, Klee, Feininger, and Kandinsky. He maintained an extensive correspondence with these artists, collected their work, and was a friend of Feininger. He brought their work to America for the first postwar art exhibition in the United States, curated by Valentiner at the Anderson Galleries in New York in 1923 under the title "A Collection of Modern Art." The show included sculpture, watercolors, graphic works, and oil paintings. The Berlin art dealers Ferdinand Möller and J. B. Neumann, who had traveled to New York for the event, showed an interest in opening their own galleries in America, as their distinguished colleagues Julius Böhler, Paul Cassirer, and Frank Washburn Freund had already done. The New York audience withheld their support from Valentiner, however. They had little understanding at that time for the expressionists' difficult subjects and dramatic artistic method. As in architecture, French precedents still dominated the taste in art.[125] One of Valentiner's few strong supporters was the architect Albert Kahn, an émigré from the southern part of

stored in the so-called "vertical files," cannot be located. These files were formerly open to the public, and the manuscript has been missing since that time.

119 Christian Schädlich, "Die Beziehungen des Bauhauses zu den USA," 68.

120 An exhibition by the "*Sonderbund* of West German art lovers and artists" of works of predecessors and representatives of the European avant-gardes.

121 Christina Houstian, "Minister, Kindermädchen, Little Friend," 31.

122 Vivian Endicott Barnett, "Die Gründung der Blauen Vier und ihre Präsentation in New York 1924–1925."

123 Kunstsammlung Nordrhein-Westfalen, "The Blue Four," exh. leaflet, Düsseldorf, 1998.

124 Margaret Sterne, *The Passionate Eye*, 397. The group was named after the November revolution in Germany and the German-speaking region of Austria which led to a political overthrow of the monarchy and thus to the Weimar Republic.

125 See Sterne, *The Passionate Eye*, 144.

the German Rhine region who in the early twenties infused Detroit's most famous industrial building, Ford's River Rouge plant, with the aesthetics of classic European modernism. In turn Valentiner advised Kahn, whose art collection included several fine paintings of Paul Klee, in his acquisitions.[126]

Katherine Dreier continued her efforts in the cause of modern art in late 1926 at the Brooklyn Museum in New York, with an "International Exhibition of Modern Art," a comprehensive show incorporating works by 106 contemporary artists from 19 countries, including a section on German modern art. In a letter to Klee she announced the event as significant for the American art scene, emphasized her satisfaction with the positive response and growing interest of the director of the Brooklyn Museum, and expressed her hope that the exhibition would signal the arrival of modernism for the conservative American museum scene. In the show, Dreier included profiles of many Bauhaus artists and of its workshops. Sigrid Weltge Wortmann correctly notes that the presentation of Gropius, as it may be inferred from the full-page advertisement in the exhibition catalogue, would hardly have been acceptable to him had he known about it.[127] The Bauhaus was presented as an "Academy of Arts and Krafts"— "Krafts" was presumably a misprint. That characterization did not take into account the school's attempts to orient its production toward industry rather than handicrafts since its move to Dessau. Dreier also condensed the Bauhaus's various programmatic phases in the exhibition and publicity for it, thus causing some confusion. For example, the "pottery workshop" which was included in the exhibition had long since been discontinued by 1926; and Lothar Schreyer, who was listed as a participant in the school, had left it in 1923. Nonetheless, Dreier's initiative was an important step in the Bauhaus's growing recognition, particularly since it was backed up by various other exhibits of modern art that the Société Anonyme organized throughout the late 1920s and early 1930s.

Exhibitions are an extremely effective medium for the presentation of architecture. Even if this seems an obvious statement today, not only because of the popularization of architecture museums in the 1980s and the growing number of architectural exhibitions in art museums and galleries, it should not be forgotten that the architectural exhibition was entirely new in the twenties. In contrast to the visual arts, architecture was not associated with aesthetic or artistic objects in those days, but rather with technology, industry, and commerce. Thus, architectural objects had no place in museums or galleries.[128] Accordingly, the true building expositions represented milestones in the reception of the modern movement. The Weissenhof Exposition of the German Werkbund in Stuttgart in 1927, the world's fair in Barcelona in 1929, the German Building Exposition in Berlin in 1931, and the International Building Exposition in Vienna in 1932 were among the most significant of these events. When, in the late twenties, American galleries and museums opened their doors to avant-garde architecture and thereby elevated architectural works to the status of art, a new dimen-

2.8 Advertisement, included in the catalogue for the "International Exhibition of Modern Art" at the Brooklyn Museum, 1926. (Photo: Barry Friedman.)

sion was added to architectural discourse. Most of these events were not in and of themselves spectacular, but even modest initiatives attained a greater influence by virtue of their innovative spirit.

The New York "Machine Age Exposition" of 1927 was pioneering in many ways: devoted to the American and European avant-garde, it confronted the American public for the first time with the concept that the machine could provide a formal aesthetic code. It also displayed photographs and models of European avant-garde buildings that bespoke a machine aesthetic.[129] The exposition conveyed the close relationship between developments in modern art and advancing industrialization in Europe and the United States. It emphasized work from Germany, Russia, and the United States; German architecture was only poorly represented in the accompanying text, but the fact that reviewers often mentioned its impressive formal quality implies that the visual material of the show balanced the textual inadequacies and allowed the audience to gain some insight into the work.[130] Walter Gropius's work, including the Bauhaus atelier, the masters' houses in Dessau, and the city theater of Jena, comprised a significant portion of the architecture selected for exhibition and illustration. The curators had undoubtedly recognized the value Gropius attributed to the machine and its influence on the new architecture. Only four years earlier, following the reorientation of the Weimar Bauhaus to the "unity of art and technology," he had asserted: "We want an architecture adapted to our world of machines, radios and fast motor cars, an architecture whose function is clearly recog-

126 Grant Hildebrand, *Designing for Industry.*

127 Sigrid Weltge Wortmann, *Bauhaus Textiles*, 195.

128 Carl W. Condit, *The Chicago School of Architecture*, 215.

129 See "Machine-Art Exposition." The exposition ran from 16 May to 28 May 1927 in a building at 119 West 57th Street.

130 Herbert Lippmann, "The Machine-Age Exposition," 325.

nizable in relation to its forms."[131] An untainted fascination with the machine and a faith in the future resound in these words, a faith that a new understanding of time, space, productive energy, and social order would be achieved.

The exposition was shown only in New York, but the catalogue was published in Margaret Anderson and Jane Heap's magazine *The Little Review.* The show's positive reception in the press broadened its sphere of influence. The "Machine-Age Exposition" inspired speculation on an artistically important, universalizing movement in the United States. The journal *The Arts* phrased it as follows:

A movement which includes Saarinen, Mendelsohn, the Perret Brothers, Hoffmann, Garnier, Gropius, Lurçat, Vesnin, the Tauts and others, is not a fad. It is a beginning that will inevitably grow into an art as structurally direct and "debunked" as the Romanesque period of Europe or the eighteenth century architecture of the pre-United States. It is to the very great credit of the Machine-Age Exposition that it has offered New York the opportunity to consider this.[132]

New York would in fact be the city that would most closely experience the development of the new "movement" in America, even if that movement assumed a different form than described here.

In the exhibitions of the twenties, the Bauhaus was often represented by individual artists or groups, divorced from the school's overall concept and regrouped in other categories such as painting, sculpture, graphics, and theater design. In 1930–1931, however, the first exhibitions devoted exclusively to the Bauhaus were mounted. The first of these was launched by the Harvard Society for Contemporary Art, founded in 1919 by a group of Harvard students, Edward M. M. Warburg, John Walker, and Lincoln Kirstein. The show ran from December 1930 to January 1931 in Cambridge under the curatorship of Kirstein. His results indicate that an insider was at work. He had studied at that university and, like his two prominent colleagues Hitchcock and Johnson, had published in *Hound and Horn, Creative Art,* and other periodicals. Through his acquaintance with Barr and Johnson, Kirstein was well informed about the Dessau Bauhaus in its late-twenties permutation, but apparently not *as* knowledgeable about the school's earlier phases. He exhibited objects from various periods and genres, expressing the universalizing concept behind the Bauhaus that many American observers had all but forgotten at this time. The prevalent impression that the school was purely an architectural institution had also influenced Kirstein. This may be the reason that his catalogue text to some extent reverses the multidisciplinary depiction of the school created in the show: "Mies wishes to make the best school in the world for those who are interested in architectural development" and "Besides its role of official architect for the town of Dessau, the Bauhaus has published the Bauhausbücher."[133] In this Kirstein in fact reflects a development that occurred under the direction of Mies van der Rohe, who strongly emphasized architecture. Nevertheless, it

only corresponds to one brief phase of development and one isolated pedagogic component of the school. A glossing-over of time frames and concepts is also evident in Kirstein's incorrect characterization of Mies's architecture as consistently functionalist.

The exhibition was visited by members of the university as well as by other locals. The new art and architecture, represented in a broad spectrum of work from the collections of Philip Johnson and the John Becker Galleries in New York, was a great source of intellectual inspiration. On view were architectural photographs and models, objects, oil and watercolor paintings, sample of graphics and typography, the Bauhaus-bücher, and folios with lithographs and woodcuts. Bauhaus painting was represented with works by Feininger, Johannes Itten, Kandinsky, Klee, Marcks, Moholy-Nagy, Georg Muche, Oskar Schlemmer, and Lothar Schreyer; its architectural orientation by Gropius's Dessau Bauhaus and Mies van der Rohe's German Pavilion of the Barcelona world's fair. Marcel Breuer and Hannes Meyer were mentioned in the text.

This exhibition's positive influence on the Bauhaus's fame in the United States was increased by its presentation shortly thereafter in two other centers of artistic and intellectual exchange: from January to February 1931 in the John Becker Galleries in New York;[134] and in March 1931, together with three other exhibitions, in the Arts Club of Chicago.

The latter venue was considered to be the most renowned and influential of the countless clubs of this type in America. It could afford to ignore broad-based popularity and to present exhibitions that museums would have considered too risky. Unparalleled in its progressive and intrepid attitude, the club could compete with Chicago's Art Institute in terms of the quality of its exhibitions.[135] Unquestionably, the Arts Club of Chicago can take credit for being a harbinger of coming developments. The third venue of the Bauhaus's first solo U.S. exhibition thus guaranteed its entrance onto the established national art scene. This important moment in the history of the Bauhaus in America was, in a sense, commemorated twenty years later, when Mies van der Rohe received the commission to renovate the club's space.

The catalogue, of which only a few copies still exist, and the discussion of the event in periodicals extended the exhibition's sphere of influence as well.[136] Despite

131 Walter Gropius, quoted by Eric Stange in "MIT Has Designs on Bauhaus."

132 Lippmann, "The Machine-Age Exposition," 326.

133 Lincoln Kirstein, introduction to *Catalogue of an Exhibition from the Bauhaus, Dessau, Germany*, 3.

134 The address was 520 Madison Avenue, according to the "Calendar of March Exhibitions" in *Creative Art*, March 1932.

135 Forbes Watson, "The Arts Club of Chicago," 341ff.

136 The exhibition is noted in *Art News* 29 (January 1931): 12 and *Art Digest* 5 (15 January 1931): 27–28. The catalogue is reproduced in the appendix, above in this volume.

THE PRESIDENT AND DIRECTORS OF

THE ARTS CLUB OF CHICAGO

REQUEST YOUR PRESENCE ON

FRIDAY, MARCH THE THIRTEENTH

FROM FOUR TO SIX O'CLOCK

FOUR EXHIBITIONS

PAINTINGS BY GEORGES ROUAULT
SCULPTURE BY HENRI MATISSE
FLOWER, ANIMAL AND STILL LIFE PAINTINGS
EXHIBITION FROM THE BAUHAUS,
DESSAU, GERMANY

TEA WILL BE SERVED
ONE GUEST MAY
ACCOMPANY EACH MEMBER

THIS CARD MUST BE
PRESENTED AT
THE DOOR

2.9 Bauhaus Exhibition at the Arts Club of Chicago, 1931. (Courtesy of the Arts Club of Chicago.)

their limited scale, the significance of the three Bauhaus exhibitions must be considered great for the reception of Bauhaus architecture. They were the very first exhibitions in the United States devoted exclusively to the Bauhaus; they conveyed a relatively authentic sense of the school's program and work; they introduced Mies van der Rohe's and Gropius's work to American architectural circles, and two of them took place in cities whose major universities would pursue both these architects only six years later. Furthermore, they provided Philip Johnson, who had assisted the gallery owner John Becker in acquiring the models for the exhibition, with an opportunity to present himself as an expert on the Bauhaus and to gather experience for the coming "Modern Architecture" exhibition of 1932.

A new development at the end of the twenties on the New York City exhibition scene would have pronounced consequences for the reception of the Bauhaus: the Museum of Modern Art began preparations for its first exclusively architectural exhibition, which would present the Bauhaus in a way that emphasized its significance outside of the visual arts. Thereafter, the emphasis on the school's architecture became so predominant that the Bauhaus's programmatic complexity would hardly be recalled. Although the Museum had been founded in November 1929, it was only in the spring of 1932 that it opened its Department of Architecture, and thus marked definitively

the beginning of an era in which those Americans who had cast their lot with the avant-garde would be able to assert their demand for a high artistic standard in architecture. The department's establishment underlined the programmatic unity of art and architecture, and, by suspending disciplinary isolation, the museum embraced an essential tenet of the Bauhaus. With the new institution, the rules governing the perception of architecture also changed: the aesthetic qualities of certain works, for example, could only be communicated using new and effective media. Such architecture as Mies van der Rohe's profited enormously from large-format photographs, original drawings, and models.

On 10 February 1932, the landmark show "Modern Architecture: International Exhibition" opened at the Museum of Modern Art, organized by Barr, Hitchcock, and Johnson. The exhibition was to set the course of the American reception of the Bauhaus thereafter.[137] Barr wrote the foreword to the accompanying publications, the exhibition catalogue and the book *International Style*. Lewis Mumford was also involved in the project. As a kind of American substitute for the Weissenhof exposition which had taken place five years earlier, Hitchcock and Johnson presented their perspective on the leading European avant-gardists as well as the premier American architects of the new style. Their intention was to document the stylistic affinities among the new architects and to demonstrate the international prevalence of those affinities. The Americans chosen included Frank Lloyd Wright, George Howe and William Lescaze, Richard Neutra, Raymond Hood, and the Bowman Brothers. Works by Clauss and Daub, R. G. and W. M. Cory, Frederick Kiesler, Kocher and Frey, Thompson and Churchill, and Oscar Stonorov were also represented. The architects practicing in Europe were Gropius, Mies, and Oud. Among the objects shown was a model of the Dessau Bauhaus building with perceivable interiors.[138] A biography and a list of works was given for each protagonist of the "Style."

Mies van der Rohe was especially prominent, represented by six images in the exhibition catalogue, including the project for the Kröller-Müller house of 1912, the project for a country house in brick of 1922, the Weissenhof apartment house of 1927, the Barcelona Pavilion of 1929, the Tugendhat house in Brno of 1930, and the building for the Berlin Building Exposition of 1931 (for which a floor plan is reproduced). Furthermore, the text discusses the designs for a skyscraper in steel and glass of 1921 and for an office building in concrete of 1922, workers' housing in Berlin of 1925, the Wolf house in Guben of 1925–1927, and the Lange house in Krefeld of 1927–1930.

137 The exhibition was shown in five rooms of a midtown Manhattan office; the new Museum of Modern Art was not completed until 1939. The exhibition ran from 10 February to 23 March 1932.

138 The model still exists and is part of the collection of the Bauhaus-Archiv Berlin.

Walter Gropius is also represented by six images in the catalogue, among them the workers' housing in Pommern of 1906, the Fagus shoe factory in Alfeld of 1910–1914, the Dessau Bauhaus building of 1925–1926, the Siedlung Törten and the Dessau employment office of 1926–1928 and 1928 respectively, and the Lewin house in Berlin-Zehlendorf of 1928. Floor plans also depict the experimental houses at the Weissenhof exposition. The text makes reference to the machine hall at the Werkbund Exposition of 1914 in Cologne, to the masters' houses in Dessau (1925–26), to the Dammerstock and Siemensstadt housing estates (1927–1928 and 1929–1930 respectively), and to the bachelor's apartment first exhibited in 1930 at the Salon des Arts Décoratifs in Paris and later at the German Building Exposition of 1931 in Berlin.

The exhibition reflected the broad typological range of both architects' work, from multifamily dwellings and public housing to luxurious single-family houses, from school administration and factory buildings to an honorific exposition pavilion with artistically designed interior and exterior spaces. As the placement of Gropius's work in a room aside from the main exhibition floor reveals, the organizers had departed from their former positions toward the founder and first director of the Bauhaus.

The third portion of the exhibition dealt with housing and was curated by Lewis Mumford. It described and illustrated the social motivation and aims of the modern movement. It was Mumford's intention to demonstrate the international consensus among modern architects with regard to the International Style's fundamental principles, and to make a case for modernism in the United States.

During the six-week run of "Modern Architecture: International Exhibition," 33,000 people attended, only half as many as visited Chicago's Central Park movie theater during the same time period. Nonetheless, this number represented an above-average attendance if one considers the total of 200,000 visitors to the Museum of Modern Art in its first year, 1929.[139] The ranks of those who saw the exhibition first-hand grew considerably during the show's three-year tour of 13 other cities, most of them on the east coast.[140] A slightly revised version with more easily transportable objects traveled throughout the States for six years.[141]

The event sent only modest ripples through the popular media, including the *New York Times* and the *New York Herald Tribune,* as well as through the architectural media.[142] Gropius's work received mixed reviews. There was greater consensus about Mies's work: the reactions were largely positive. The Tugendhat house was the object of the greatest admiration. Catherine Bauer considered it one of the most beautiful modern buildings in existence. Harold Sterner wrote:

The architecture of Mies van der Rohe is the most distinguished in the exhibition. It is marked by a restraint and beauty of proportions that are lacking in the work of most of his contemporaries. He is the least prone to caricature or to advertising the technical

methods by which he obtains the results; he has accepted the modern idiom more calmly, as though he understood that radicalism per se offers scanty nourishment to the artist, however excellent it may be as a stimulant.[143]

As Franz Schulze pointed out, "Modern Architecture: International Exhibition" was met with ambivalence in the professional community. Ralph Flint's article in *Art News* picked up the spirit of Barr, Johnson, and Hitchcock's approach: "No matter how monotonous or repetitious or otherwise uninspiring the new style may appear to be in its lesser manifestations—there can be no doubt about its magnificent simplicities and structural logic for large scale work—it is probably the most powerful lever in getting us away from our jumbled aesthetic inheritances that could have been devised."[144] A rather sober reaction came from H. I. Brock, who in the *New York Times* made no effort to hide his disagreement with Barr, Johnson, and Hitchcock's enthusiasm for the "new style." Douglas Haskell, in *The Nation,* reflected upon the historical meaning of the style and raised the question of whether the architects in the show would stay together or diverge. He concluded that the style was only "the beginning not the end of modern imagination."[145] In *Shelter,* Knud Lønberg-Holm, Arthur T. North, and Raymond Hood criticized the shallow formal basis of the style's definition.[146]

The rather reserved reactions in the architectural press of the time did not reflect the enormous effect the exhibition had on the American architecture scene. When such writers as James M. Fitch later described this event as a "sensation" or "explosion," it is more likely in reference to its long-term influence. If the International Style as defined in 1932 is compared with the image of Bauhaus architecture at the time of Gropius's

139 Philip C. Johnson, "Where Do We Stand?"

140 The exhibition traveled to the Philadelphia Museum of Art; Wadsworth Atheneum; Sears Roebuck, Chicago; Bullock's Wilshire, Los Angeles; Worcester Art Museum; Buffalo Fine Arts Academy; Rochester Memorial Art Gallery; Albright Art Gallery; Cleveland Museum of Art; Toledo Museum of Art; Cincinnati Art Museum; School of Architecture and Fogg Art Museum, Harvard University; and Milwaukee Art Institute.

141 Vittorio Magnago Lampugnani, *Encyclopedia of 20th-Century Architecture,* 161.

142 The following articles dealt critically with "Modern Architecture: International Exhibition": Harold Sterner, "International Architectural Style"; Catherine K. Bauer, "Exhibition of Modern Architecture at the Museum of Modern Art"; anon., "Modern Architecture Comes to Front in Three Simultaneous Exhibits"; Ralph Flint, "Present Trends in Architecture in Fine Exhibit."

143 Sterner, "International Architectural Style," 553.

144 Quoted in Franz Schulze, *Philip Johnson,* 80.

145 Douglas Haskell, "What the Man about Town Will Build," 441–443.

146 Symposium "International Style, Exhibition of Modern Architecture, Museum of Modern Art," *Shelter,* April 1932, 6, quoted in Schulze, *Philip Johnson,* 82.

and Mies van der Rohe's arrival in America, the two are almost identical, a fact that affirms Fitch's position. Only such a high estimation of the show's significance can explain why the Columbia University Graduate School of Architecture mounted an authentic reconstruction of the event in the spring of 1992.[147]

One year later, the influence that Hitchcock and Johnson had begun to exercise on American practice by formulating the International Style was palpable outside of New York. Two projects by George Fred Keck on view at the 1933–1934 international exposition "A Century of Progress" in Chicago reflected this influence: the "House of Tomorrow" of 1933 and the "Crystal House" of 1934. Keck would later teach at the new School of Design that succeeded the New Bauhaus in Chicago.

Over the course of the years in which the "Modern Architecture" exhibition, including the work of the two major Bauhaus architects, was on view in New York and other major American cultural centers, the era of the Bauhaus had reached its end in Dessau and Berlin. In 1933, when the institution closed its doors forever, the Museum of Modern Art signaled its solidarity by purchasing Oskar Schlemmer's painting *Bauhaustreppe,* painted from memory, and hanging it in the museum's foyer. An epilogue to the Bauhaus that appeared in *Art Digest* mentioned the fact that Schlemmer and other artists formerly connected with the school were now blacklisted.[148]

In 1933 the New School for Social Research in New York put up a small exhibition of architectural work that included works by Le Corbusier and Mies.[149] From 6 March through 30 April 1934, a second and larger "Machine Art" exhibition was shown in New York, this time at the Museum of Modern Art. Produced by Philip Johnson, the exhibition introduced the aesthetic of the machine, of machine parts and machine-made products. At the same time, it explained machine art in the context of its historical development and significance. Most of the more than four hundred household, kitchen, laboratory, and office objects and scientific instruments were the work of American designers. Like the functional objects designed and produced at the Bauhaus after 1923, these objects sought to bridge the gap caused by the technological and industrial developments of the nineteenth century between artistic vision and its realization. Many of the objects exhibited recall the Bauhaus's prototypes in their unadorned geometric form and their use of materials. The significance of these prototypes for the aesthetic at stake here, however, was not evident in the exhibition, which only included two Bauhaus products: the stacking side table and tubular steel chair by Marcel Breuer.[150]

Again, the Museum of Modern Art earned mixed reactions for an unusual show. Not all of the reviews were as harsh as the one in *The New Yorker,* which compared the exhibition to a "hardware store . . . run by Brancusi and Léger." Johnson's friend Helen Appleton Read for example, took a supportive position in likening the show's fine installation to the Bauhaus's exhibition techniques, "given, however, a personal and less doctrinaire interpretation."[151]

The treatment of younger or avant-garde architects by conservative institutions, once effectively publicized, also did much to increase the renown of ideas, movements,

works, and personalities. Thus, the exclusion of the younger generation of American architects from the 1931 fiftieth anniversary exhibition of the Architectural League of New York motivated Barr and Johnson to mount the counterexhibition "Rejected Architects." It included work by Walter Baermann, Clauss and Daub, William Muschenheim, Stonorov and Morgan, Elroy Webber, and Richard Wood. One year later, when George Howe and William Lescaze were excluded from the League's next exhibition, they both resigned and had Edward L. Bernays, the publicist who worked for Howe, Barr, and Johnson, write a sharply worded article on the League's reactionary treatment of its members who deviated from the traditionalist line. The article appeared in February 1932 in a Sunday edition of the *New York Times* and was nationally syndicated, achieving far greater notoriety than that of the contemporaneous "International Style" exhibition.[152] The discussion of modernism that was thus stimulated may well have created an increased sensibility for the Bauhaus's values.

A series of important New York art exhibitions dealing with modern art of the early twentieth century were initiated in 1935 by the Whitney Museum's "Abstract Painting in America," followed in 1936 by the Museum of Modern Art's "Cubism and Abstract Art" and "Fantastic Art, Dada, Surrealism." The collection of Albert Gallatin, which was acquired by the New York University museum in 1927, also included a number of works by contemporary European modernist painters.[153]

Points of Contact In a letter to Paul Klee, his former colleague Lothar Schreyer at the Weimar Bauhaus recalled one of his regular nightly visits to his friend's studio: "There were hundreds of pictures stacked in portfolios. On some of them, a note was affixed reading 'reserved for America.' Those were the works that you held in high esteem."[154]

147 **The exhibition "The International Style: Exhibition 15 and the Museum of Modern Art" ran from 9 March through 2 May 1992. Interview with Philip Johnson, 16 October 1990. See the exhibition catalogue edited by Terence Riley,** *The International Style: Exhibition 15 and the Museum of Modern Art.*

148 **"Closing of the Bauhaus at Dessau,"** 7.

149 **Matthias Boeckl, ed.,** *Visionäre und Vertriebene,* **346.**

150 **Museum of Modern Art,** *Machine Art,* **cat. nos. 279, 281. Breuer's name was not mentioned, only that of Thonet, the producer. Both entries were devoid of any reference to the Bauhaus. The reading list included in the catalogue, however, did mention the Bauhaus: it recommended Gropius's** *Staatliches Bauhaus, Weimar 1919–1923* **and Gropius and Moholy-Nagy's** *Neue Arbeiten der Bauhaus-Werkstätten,* **Bauhausbücher 7.**

151 **Schulze,** *Philip Johnson,* **99.**

152 **As recalled in Philip Johnson,** *Writings,* **44.**

153 **Helen Langa, "Modernism and Modernity during the New Deal Era," 277.**

154 **Lothar Schreyer,** *Erinnerungen an Paul Klee,* **109ff.**

Obviously, America was on the minds of the Bauhaus denizens. Lyonel Feininger's arrival at the Bauhaus immediately after the school's founding had already signaled that, inasmuch as it meant the presence of an established American artist there. The painter remained an influential personality at the school throughout its years in Weimar, Dessau, and Berlin. Although Feininger had moved to Europe at age sixteen and had adopted Germany as his home country, his influence as an American should not be underestimated. He helped to establish close and long-lasting relationships to American friends and supporters even in the early Weimar years; these relationships guaranteed that reliable information on the Bauhaus reached the other side of the Atlantic.

Among the first ascertainable signs of American interest in the Bauhaus was a 1922 letter from Carl Zigrosser of New York, who requested a portfolio of Bauhaus works. Another letter from the United States reached the Bauhaus in 1923; its sender, named A. E. Emperle, requested a personal interview with Walter Gropius, intended for publication in a New York art journal. The appointment was never granted, but Emperle was nonetheless able to receive information on the Bauhaus. Another relationship developed between the school and Herman Sachs, an early director of the Chicago Industrial Art School who was involved in the establishment of the School of Industrial and Fine Arts in Dayton, Ohio, of which he was the Educational Director. Gropius took advantage of this connection to seek financial support for needy Bauhaus students. Sachs's answer to this letter is unknown, as is the content of a letter from the Bauhaus's administrative secretary to the Berlin office of the *New York Herald,* in which art works of needy students were offered for sale in America. There was, however, a response to a plea for money made by Gropius and sanctioned by the masters' council in 1923, in which a group of wealthy Americans were asked to support the school. The letters, translated into English by Lyonel Feininger, were sent to Charly Fuge in Georgetown, Seattle, Washington; to Willy Hearst in San Francisco; to John Rockefeller in Tarrytown, New York; and to the banker Paul Warburg in New York. Obviously, Gropius was counting on enough time having passed since the war for the American public to respond favorably to a German request. The time had not yet come, however, when a letter from the Bauhaus would suffice to awaken interest among Americans who were not already closely acquainted with the school.[155]

At this time, Walter and Ise Gropius met Dorothy Thompson, the correspondent for the *New York Evening Post* in Berlin, with whom they remained in contact over the following years. Thompson, who had close ties to artistic and intellectual circles in both countries, reported on the December 1926 opening of the Dessau Bauhaus as part of her assignment to cover political and cultural events in Germany. Since she was recognized in her native country as one of the most influential forces in political journalism,[156] it is logical to infer that her articles were well received.

In 1924 Alfonso Janelli, an employee of Frank Lloyd Wright, visited the

Bauhaus and discussed Wright's influence on the Bauhaus with Adolf Meyer, partner in Walter Gropius's office.[157]

Another American who found her way to the Bauhaus quite early in its history was the art collector Katherine S. Dreier. Dreier's family was of German descent, and she maintained her personal and professional relationship to Europe throughout the twenties and thirties by keeping a studio in Paris and traveling each year. The Bauhaus became one of her regular stops. During a stay in Weimar in 1922, she bought works by Klee and Kandinsky, nominated the latter to the position of "Honorary Vice President" of the Société Anonyme, and secured for him his first one-man show in America one year later. Dreier remained in contact thereafter with other Bauhaus denizens, including Lucia Moholy.[158] She contacted Klee again in 1926, announcing another visit to the Bauhaus—this time in Dessau—in order to prepare for two art exhibitions planned for the same year: the "Sesqui-Centennial Exposition" in Philadelphia and the "International Exposition of Modern Art" at the Brooklyn Museum. "This second event," she wrote to Klee, "is of particular importance, for our museums are very conservative, and the fact that a museum in the ranks of the Brooklyn museum will now arrange this exhibition with my assistance is a matter of great significance. Director Fox begins to get interested in modern art."[159] Dreier, by now president of the Société Anonyme, thus became an instrumental American contact for the institution, in particular for the painters Klee, Kandinsky, and Feininger, long before Philip Johnson even set foot in the Dessau Bauhaus.

That event finally occurred in 1928, after the art dealer Israel Ber (J. B.) Neumann had convinced him to visit Germany. Together with Barr, Johnson traveled to the mecca of modernism and met with several of the Bauhaus masters. Between 1911 and 1923 Neumann had been the owner of the Graphisches Kabinett, a well-known art gallery in Berlin, which in 1919 featured some of Gropius's work in a show of unknown architects.[160] Moving to New York City in 1924, he became the director of the gallery New Art Circle and published illustrated art catalogues under the title *Artlover*. For many years, J. B. Neumann served as a bridge between the circle of moderns around the Museum of Modern Art and the German art scene. Johnson returned to the Bauhaus

155 Correspondence in the Staatsarchiv Weimar, quoted by Schädlich, "Die Beziehungen des Bauhauses zu den USA," 60.

156 C. Zuckmayer, "Als wär's ein Stück von mir," 465.

157 Lloyd C. Engelbrecht, "Chicago—eine Stadt auf der Suche nach einem Bauhaus?," 28.

158 Weltge Wortmann, *Bauhaus Textiles*, 161ff.

159 Katherine S. Dreier, letter to Paul Klee, 30 March 1926, Felix Klee-Nachlass, Klee Nachlassverwaltung, Bern.

160 Walter Gropius, letter to J. B. Neumann, 22 April 1957, Gropius file, Bauhaus-Archiv Berlin.

2.10 J. B. Neumann, director of the gallery New Art Circle, New York, and promoter of German art in the United States. (Photo courtesy of Graphisches Kabinett and Kunsthandel Wolfgang Werner KG.)

several times on subsequent visits to Germany, including trips in 1931 and 1932 with Henry-Russell Hitchcock, whom he had met a short time earlier in Paris and with whom he had already begun to plan the "Modern Architecture" show for the Museum of Modern Art. A letter from Johnson to Barr describes one of those trips to Dessau: the invitation from Feininger, a conversation with Kandinsky on Barr's essay on abstract art, an impressive encounter with Paul Klee and the young designer Marcel Breuer, who shared Gropius's utopian inspiration and interest in propaganda and had already made a name for himself at the age of 26 with the design for the famous tubular steel chair. Johnson spoke with equal admiration about Gropius, who had by then already left the Bauhaus: this was a man, he stated, who kept his eyes on the big picture and possessed the magnetism to convince people of his ideas.[161]

By the end of the twenties, transatlantic communication on cultural matters had become noticeably more intensive. Beyond their traditional contact with England, France, and Italy, American circles turned toward other countries as well, especially Denmark, Finland, Holland, Sweden, and Germany.[162] Americans involved in architecture and the arts traveled increasingly to Europe in order to inspect the new developments in person. These travelers included Alfred H. Barr, Jr., director of the Museum of Modern Art; Catherine Bauer and Norman Bel Geddes, recognized personalities on the American architecture scene; Robert A. Davison, secretary of the staff of the Institute for Housing Research at Columbia University in New York; Simon Guggenheim, head of the leading company in the copper industry in the United States and an eminent art collector; Frederick Gutheim, editor of architecture and urban planning for the *Magazine of Art;* Henry-Russell Hitchcock, Edwin Horner, and Sigurd Fischer, critics and a photographer for *Architectural Forum;* Pierre Jay, head of the Fiduciary Trust Company in New York; Philip Johnson; and Joseph Urban. In the spring of 1929, Parker Morse Hooper, editor of *Architectural Forum,* commissioned one of "the leading American architectural photographers and critics," Sigurd Fischer, to go to Europe to report on the new architecture in Holland, Denmark, Germany and Sweden.[163] On

their return to the United States, Fischer and others were able to introduce the American architecture world to the European avant-gardists, their theories, work, publications, and significant exhibitions, organizations, and journals. One significant consequence of these initiatives was the "Modern Architecture" exhibition of 1932, which came about after an extensive European trip by Hitchcock and Johnson. The exhibition reflected a degree of knowledge about German architecture that would have been inconceivable without direct contact with the buildings of the European avant-garde and its leading protagonists, such as Gropius, Mies, and Otto Haessler.[164]

By the end of the twenties, the Dessau Bauhaus belonged among the attractions of Europe. According to the records kept by its administration, the institution had 100–250 visitors, among them Americans, each week.[165] Barr described the Bauhaus's magnetism in 1937: "Ten years ago young Americans visited the Bauhaus at Dessau as a place of pilgrimage where the philosophy and practice of modern design were in the process of clarification. They talked with Gropius, Kandinsky, Feininger, Klee, Moholy-Nagy, Josef Albers, Bayer and Breuer, as with a new order of men engaged in transforming the artistic energies of our time from a rebellious into a constructive activity."[166] Even if Barr emphasized art and design at the Bauhaus in his recollections, architecture was obviously the primary interest of the American visitors. In the winter semester of 1931–1932 and the summer semester of 1932, more guests came from the United States than from all other foreign countries combined. The Dessau Bauhaus's journal, which was in the private archive of Mies van der Rohe until it was turned over to Hans Maria Wingler, proves this.

The following entries refer to American visitors in the winter semester of 1931–1932:

4.11.31 Walter John Hutchausen, N.Y.

23.11.31 . . . Bauhaus visit by Dr. Bills and Mrs. Bills, San Francisco

161 Philip Johnson, letter to Alfred Barr, Jr., undated and without the letter writer's address, Mies van der Rohe Archive, Museum of Modern Art, New York, Correspondence.

162 C. W. Killam, "Modern Design as Influenced by Modern Materials," 40. Lawrence A. Kocher had already stated a case in 1923 for a broad international exchange of architectural ideas, especially with regard to education and training. See his "Interchange of Architectural Ideas," 475. Kocher's conviction of the necessity of international communication was reflected in the extensive selection of European (including German) literature in his recommendations for the architect's library. See Kocher, "The Library of the Architect."

163 Parker M. Hooper, "Twentieth Century European Architecture," 209.

164 Interview with Philip Johnson, 16 October 1990.

165 Hans M. Wingler, *Das Bauhaus*, 9.

166 Alfred H. Barr, Jr., Document no. 366, Alfred H. Barr, Jr., Papers, Archives of American Art, New York.

24.11.31	Prof. Morrison Fitch, Harvard School of Architecture, visits the Bauhaus.
30.11.31	. . . visitors: Mai (?), New York; Helen Mysotzki, Baltimore.
1.12.31	Concert by Imre Weisshaus (Budapest): Contemporary music and its developmental potentials; collaborator: Henry Cowell, composer, California, . . .
3.12.31	2nd evening by Imre Weisshaus
17.12.31	Visit by O.K. Mutesius, New York.
31.1.32	Visitor to the Bauhaus: Walter John Hutchausen, New York.
10.3.32	B. Sommer, visitor from New York.

For the summer semester, the following guests were listed:

20.4.32	. . . Davis Barr from Berkeley, Cal., European Importations, visits the Bauhaus.
24.4.32	Visitor . . . Henriette Kingsley (USA).
12.5.32	. . . Documentations in the New York Times may be carried out.
19.5.32	. . . John Justin Cou, Cleveland, Ohio.
Until 24.5.	various guests from Cleveland.
1.7.32	Visit by the legation secretary A v. Wirthenau, Washington.
5.8.32	Visitor: among others, Jan Rovedlova, Baltimore.
15.8.32	Visitor: Prof. Fischer, Carnegie Institute of Technology, Pittsburgh.
30.8.32	. . . The newspapers are taking a stand on the Bauhaus issue. There are more visitors to guide around each day, among them: . . . Anna M. Seipp, New York, B. L. Baiswald, Michigan, Alice Seipp, Senator, airplane pilot; J. Ostsander, Michigan; James W. Barbershown, New York.
7.9.32	Visitor: Prof. Fr. A. Cutbert, University of Oregon.
21.9.32	. . . Visitor: Ralph B. Busser, American consul, Leipzig.

For most American visitors, professional associations with firms or institutions are noted along with place of residence. To judge from these notations, many of the guests were professors at large universities, such as Harvard, the Carnegie Institute of Technology, and the University of Oregon. On their return to the United States, these people could provide solid information on the Bauhaus under the direction of Mies and were thus able to contribute to a more enlightened reception of his work.[167] The temporal correspondence between the American Bauhaus visits on the one hand and the increase of information on Mies available in the States proves that his tenure as director had a greater influence on his growing renown in that country than has often been assumed.

After the First World War, European architects and artists felt an increasing need to experience the United States firsthand. In 1924, the Bauhaus teacher and painter Georg Muche spent several weeks in New York. Katherine Dreier introduced him to American artists there and asked him to paint for an exhibition of the Société Anonyme, of which she was the president. The group regularly mounted small modern

art exhibitions during the 1920s and 1930s, mostly in the cultural centers of the east coast. Also in 1924, the director Fritz Lang and the architects Martin Wagner, Erich Mendelsohn, Werner Hegemann, and Friedrich Paulsen visited various American cities, as did Ernst May in 1925. Some two years earlier, Gropius had also toyed with the idea of visiting the States. In a letter to an American friend, he admitted: "I have for years wished to make my acquaintance with America because I know that many ideas to which I subscribe have flourished in your country much more than they have here. A trip to America would be especially important for me."[168] Hoping to finance his trip through lectures, Gropius established contact with other Americans. It was not until 1928, however, that he could realize his wish, thanks to the financial support of his former client, the businessman Adolf Sommerfeld, and possibly of the Carl-Schurz Association in Berlin. This trip, undertaken with Sommerfeld and Ise Gropius, was extraordinarily important for Walter Gropius's connections in the United States. He came into contact with people who would, only a few years later, play a decisive role in his appointment to Harvard University and in the further reception of the Bauhaus in general.

On 7 April 1928 the group arrived in New York. Gropius's aim was to become conversant with the structure and organization of the building industry and organizational processes in American timber construction. The seven-week trip continued to Washington, Chicago, Kansas City, Los Angeles, Detroit, Dearborn and Pontiac, Michigan, and other locations. It led to encounters with prominent representatives of American urban planning, the building industry, the cultural scene, and architecture. Gropius came to know many architects and people involved with universities as well as many businessmen and members of the building industry. He met Albert Kahn in Detroit and Richard Neutra in Los Angeles. In New York, he established contact with important professional organizations, businessmen, and government officials, including the construction firm Thompson, Staret, Harris, Hegemann & Butts; the Taylor Society, involved in industrial production and productivity; the Dow Service, which was responsible for assessing construction costs; the New York City Planning Commission, and the National Bureau of Standards. In New York, he also met Barr, Mumford, Albert Lasker, and Ross McIver, the architects Harvey Wiley Corbett and Henry Wright, the housing experts Clarence Stein and Carol Aronovici, the urban planning pioneer Ernest Goodrich, the journalist and writer Henry Louis Mencken, the banker Felix Warburg, and the chairman of the board of the New York Trust, Pierre Jay. The acquaintances that would prove most significant to Gropius's future in the United States

167 "Die letzten Semester des Bauhauses," in Peter Hahn, *Bauhaus Berlin*, 31–38, 55–61.

168 Walter Gropius, letter to Herman Sachs, dated 27 January 1922, Staatarchiv Weimar, quoted in Schädlich, "Die Beziehungen des Bauhauses zu den USA," 65.

2.11 Walter Gropius, portrait taken during his trip through the United States, 1928. (Photograph presumably by Ise Gropius; print by Markus Hawlik, 1997, after original negative. Bauhaus-Archiv, Berlin.)

were with Joseph Hudnut, later dean of the architecture school at Harvard University; Lawrence Kocher, editor of *Architectural Record;* and Robert Davison of the research institute on housing at Columbia University. Davison had never before heard of Gropius.[169] It is safe to assume that both parties benefited from these encounters, all of which Gropius recorded in his travelogue: Gropius certainly relayed information on developments in German architecture and building as well as on the Bauhaus. In retrospect, he described his first trip to America as a journey of experiences, but it was more than that: it laid the foundations for his future career. Even before embarking on the trip, he had written to Dorothy Thompson describing the planned visit and asking for letters of introduction, not only to important private citizens but also to members of the American press.[170] His desire for publicity in the United States was also apparent in a conversation he had with a German newspaper correspondent whom he had met a few days after his arrival in New York. He complained that the media attention he expected and to which he was accustomed had been absent thus far because the New Yorkers had not been advised of his visit in a timely manner.[171] Initially he had intended to give lectures, but at that time he was not fluent enough in English. So he postponed the plan for a second trip.[172] Back in Germany, he wrote J. B. Neumann: "I have returned from America with precious gains, and I have truly come to love this country."[173]

Gropius maintained his American contacts after his return to Berlin. Various pieces by both his wife and himself in professional publications kept him in the public eye. The first two articles were written by Ise Gropius. Discussing the Karlsruhe-Dammerstock housing development and the theme "Modern Dwellings for Modern People," they were published in *Architectural Forum* in 1930 and *House Beautiful* in 1931, respectively. In March 1931, an article by Walter Gropius in *Architectural Forum* entitled "The Small House of Today" gave him the opportunity to aquaint a broader readership with his ideas for future housing and living. In addition, his avid correspondence and reciprocated hospitality were part of his efforts to keep his new American acquaintances in tow. On his return to Europe, new friends joined the fold, including Dorothy Elmhirst, an impresario of the liberal American journal the *New Republic.* Together with her husband, she assisted German intellectuals who emigrated to England or the United States. On making the acquaintance of Ise and Walter Gropius in 1933, she set about finding work for the Bauhaus's founder in America.[174] With his

169 Reginald R. Isaacs, *Walter Gropius*, 2:499, 506, 591ff.

170 Walter Gropius, letter to D. Thompson, 4 March 1928, Gropius file, Bauhaus-Archiv Berlin.

171 Isaacs, *Walter Gropius*, 2:504.

172 Gropius, letter to Thompson, 4 March 1928, Gropius file, Bauhaus-Archiv Berlin.

173 Walter Gropius, letter to J. B. Neumann, 12 June 1928, Gropius file, Bauhaus-Archiv Berlin.

174 Isaacs, *Walter Gropius*, 2:716.

own statements, Gropius tried as best he could to influence the image ascribed to him and, concomitantly, to the Bauhaus. Likewise, he attempted to control the image of himself that others propagated in the United States. After he had been interviewed in London by George Nelson in 1935 for an article in *Pencil Points,* he wrote a letter attempting to influence Nelson and the publication.[175] He had certainly succeeded in making himself known in American architectural circles by 1936, when he competed with Mies for a professorship at Harvard University.

Even if the American public took little notice of his visit, the trip nonetheless had a long-term influence. Gropius's efforts to woo the American public and to maintain his American acquaintances raises the question of the extent to which he had considered the idea of working in the States immediately after his resignation from the Bauhaus. The way in which he represented himself as an innovative architect and the immodest emphasis he placed on his own achievements, as exemplified in a letter he wrote to Robert Davison prior to his return to Europe, would speak for that assumption. In the letter, he discusses the discrepancy between his own achievements in residential building and those of America. He, Gropius, was unable to find a single colleague in the States "who was truly interested in completing the research into residential building materials and construction processes which I, Gropius, began some 15 years ago in Germany," and he advised, "you must continue to search for men and women of perspicuity who will invest themselves in your research program."[176] These words must have made it easy for Davison to reach the conclusion that he had found his man in Walter Gropius. Gropius continued to market himself: he informed his American friends shortly after his return to Berlin of a competition success and of the conferral of an honorary promotion.[177] The meaning of public relations and marketing had been clear to Gropius since the Dessau Bauhaus, when he had founded an incorporated company to market the school's products. In 1926–1927, the company's business manager was the second-highest-paid employee of the Bauhaus.[178]

The fact that the Bauhaus's founder was hardly loathe to go to America was later the object of Alfred Barr's wit, when he called Gropius a "voluntary exile."[179] Gropius's efforts to establish contacts in the United States may also be understood within the context of the enthusiasm, which had developed in the years of economic distress in postwar Germany, then prevalent for the American lifestyle, for its skyscrapers, music, film, clothing, and cars. For artists, as Winfried Nerdinger states, America exercised a great attraction as precedent and epitome of a new, entirely contemporary form of society and lifestyle unbalasted by history and untainted by any political and social bonds to the prewar period.[180] In Gropius's case, this fascination was not limited to intellectual and artistic stimuli but also included the initiatives that prepared for his entry as an architect into American practice and teaching.

From the early twenties on, there was a group of German émigrés in the United States who were well acquainted with the European avant-garde and were able to intro-

duce this knowledge into an American context. Among them were not only the people involved in the German art scene mentioned above, such as Wilhelm R. Valentiner or J. B. Neumann, and authors such as Walter Curt Behrendt or F. E. Washburn Freund, but also former Bauhaus denizens. Helmut von Erffa, who had been a student at the Weimar Bauhaus from 1921 to 1922, went to America to study art and architectural history at Harvard University from 1929 to 1933 and later to teach there. Another who left Germany after studies at the Weimar and Dessau Bauhaus between 1921 and 1928 was the painter Werner Drewes. Beginning in 1934, he worked as a teacher of drawing and graphics at several American institutions of higher education, including a stint from 1934 to 1936 at the Art School of the Brooklyn Museum in New York. The activities of these people proves that the traffic between the Bauhaus and the United States was by no means one-way.

Hitler's accession to power in 1933 caused a dramatic wave of emigration. If not all who left the country were forced to do so for political reasons, there were nonetheless many among them who had lost all hope of professional advancement or whose lives were threatened. The forced closing of the Bauhaus in the summer of 1933 was recognized by many as a prefiguration of the dramatic changes that would be made into German cultural life. And rightly so: early in 1934, Hitler ordered the "intellectual and ideological education and training of artists" to be placed under surveillance. In his speech at the 1934 Nuremberg party rally, he banned all forms of modernism. In 1937, Josef Goebbels proclaimed a "völkische Kulturpolitik": art by Germans for the German people. The officially prescribed art of the Third Reich was exhibited that year in Munich in the "Grosse Deutsche Kunstausstellung." At the same time, just across the park, a mammoth traveling exhibition was mounted. Entitled "Entartete Kunst," or "Degenerate Art," it defamed and ridiculed some of the most significant German contributions to modern art in this century, among them numerous works by expressionist and Bauhaus artists, as "un-Germanic."[181] Under the jurisdiction of Goebbels,

175 Walter Gropius, letter to George Nelson, dated 14 September 1935, quoted in Isaacs, *Walter Gropius*, 2:846.

176 Gropius, letter to R. L. Davison, New York, 26 May 1928, in Isaacs, *Walter Gropius*, 2:507, 512.

177 Isaacs, *Walter Gropius*, 2:532.

178 Naylor, *The Bauhaus Reassessed*, 144.

179 Alfred H. Barr, Jr., letter to Josef Albers, 20 April 1937, Alfred Barr, Jr., Papers, Archives of American Art, New York. Barr later reversed at least halfway on this judgment, which he also extended to include Josef Albers and Marcel Breuer; he may have "gone too far," as he said himself in his letter to Albers.

180 Winfried Nerdinger, *Walter Gropius*, 14.

181 The exhibition "Grosse Deutsche Kunstausstellung" opened on 18 July 1937 in Munich at the Haus der Deutschen Kunst. The exhibition "Entartete Kunst" opened the next day, at the former

president of the Reichskulturkammer, a manifesto ("Regierungsrichtlinien für Kunst von 1937 im Fünf-Punkte-Manifest") was published in *Deutscher Kunstbericht* to outline the new policies:

- prohibition of boxlike architecture;
- removal of all public sculptures not accepted by the German public;
- removal of all artwork revealing international or Bolshevik tendencies from museums and collections;
- negation of all artists with Marxist or Bolshevik affiliations;
- immediate dismissal of museum directors who "wasted" public funds on the purchase of "un-Germanic" art.

The assault was clearly formulated to target the Bauhaus. German artists and architects knew how to interpret the rhetoric: the attributes "left-wing," "international," and "modern" were synonyms for "un-Germanic" and "undesirable." Although not explicitly included in the above list, "Jewish" meant the same. The threat was real of losing one's career and, in the case of Jewish Bauhaus associates, one's life, in spite of evidence that the Nazis made exceptions to their rules when convenient and that a number of artists and architects were ready to collaborate with the regime. The remarkable outpouring of creativity and of historical studies that resulted from the emigration of artists and art historians has been attributed by Erwin Panofsky, perhaps the most influential among the latter, to "the providential synchronism between the rise of Fascism and Nazism and the spontaneous efflorescence of the history of the arts in the United States."[182] Panofsky relates the exodus of more than seventy art historians from Germany, most of them linked by Jewish ancestry or their affiliations with the left wing or with modernism. In addition, numerous German artists, architects, critics, scientists, scholars, writers, and other intellectuals, many of them leading figures in their disciplines, emigrated to the United States. Those who came before 1936 also included the art historians Richard Bernheimer, Werner Friedländer, and Richard Krautheimer, as well as Josef and Anni Albers, Xanti (Alexander) Schawinsky, Ellen Auerbach, Fritz Gorodiski, Hilde Hubbuch, Margarethe Koehler, and other Bauhaus affiliates.[183] Among the other emigrants were the painter George Grosz, the architect Werner Hegemann, the photographer Alfred Eisenstaedt, the composers Hanns Eisler, Erich Korngold, Ernst Toch, Kurt Weill, and Arnold Schönberg, the actress Lotte Lenya, the director Billy Wilder, and the writers Kurt Riess, Stefan Heym, Ernst Toller, and Erika and Klaus Mann.[184] A number of reputable German gallery owners, mostly from Berlin, opened businesses in New York, among them Karl Nierendorf and Curt Valentin. They and other less famous immigrants contributed greatly over the following years to the development of a sensibility for new currents in their respective disciplines. Whether they came to the United States as true exiles or for a new profes-

sional future, there was a tremendous loss of artistic and intellectual energy that the Nazis caused Germany to endure during those years.

The political occurrences in Germany were covered by the American press. In many cases, the newspapers published a portrait and professional biography of the new immigrants,[185] and commented on the political situation in Germany and its effect on cultural life. As early as the beginning of 1931, *Art News* reported on the governmental orders to remove all paintings and sculptures by modern artists from public spaces. Works by Ernst Barlach, Otto Dix, Oskar Kokoschka, Wilhelm Lehmbruck, and the Bauhaus artists Feininger, Kandinsky, and Klee were affected by this law. These vindictive actions were sanctioned under the credo that the spirit of these works was not national and had nothing to do with the so-called cultural basis of the Germanic race.[186] An article in the *Museum of Modern Art Bulletin* of June 1933 reported that the SA had forcefully removed the students and teachers of the Berlin Bauhaus from the old factory building in which they had taken shelter. Lessons were now held in the apartments of the professors. While the government had yet to offer an explanation for the attack, it was clear that the school's future would be uncertain.[187]

"History is the propaganda of the victors," said the exile writer Ernst Toller bitterly in those dark years. If at the time the closing looked like the final defeat of the Bauhaus, future developments proved this expectation wrong. As we know in retrospect, the premature end of the school at the hands of the Third Reich contributed greatly in fact to the further power of the school's ideas.

Students An important catalyst for the propagation of knowledge about the Bauhaus in the United States came from people who had been in contact with its course of studies and pedagogy. This circle included American students or auditors

Institute of Archaeology. A recreation of "Entartete Kunst" was developed by Stephanie Barron for the Los Angeles County Museum of Art and was shown there 17 February–12 May 1991, and in Berlin at the Altes Museum under the title "'Entartete Kunst.' Das Schicksal der Avant-Garde in Nazi-Deutschland," 4 March–31 May 1992. Stephanie Barron, ed., "Entartete Kunst," pp. 12, 13.

182 Erwin Panofsky, "The History of Art as a Humanistic Discipline."

183 Folke Dietzsch, *Die Studierenden am Bauhaus*, vol. 2, supplement 39: Emigrations.

184 Wolfgang Glaser, ed., *Americans and Germans*, 125ff.

185 See, for example, Bruno Paul's article "Modern Art: Interior Architecture" in *Architectural Forum*, January 1929, as well as Isaacs, *Walter Gropius*, 2:511ff.

186 Flora Turkel-Deri, "Weimar Museum Shelves Moderns," 6.

187 *The Museum of Modern Art Bulletin* 1 (June 1933): 4.

who, according to the account given by one of them, Bertrand Goldberg, had entered the Bauhaus because of its industrially and technically oriented educational program:[188]

Irene Angela Hecht came to Weimar from Chicago and attended lectures there before she matriculated in the Bauhaus in 1925 and moved to Dessau with the school. In the same year, she married Herbert Bayer, later a Bauhaus teacher with whom she worked photographically and technically. Her own artwork is difficult to identify because the collaborative work, stamped only with the name "Bayer," is usually attributed to her husband. Irene Bayer first returned to the United States in 1947, two years after her divorce.

Howard B. Dearstyne from Albany completed the foundation course and began his studies in carpentry at the Dessau Bauhaus starting in 1928. In 1930, he entered the architecture department. When the Dessau Bauhaus was closed, Dearstyne also moved to Berlin and continued his studies in the architecture department there. Because of his previous studies at Columbia College in New York, he was one of those students who arrived already with considerable credentials. Dearstyne, who was friendly with Ludwig Hilberseimer and Wassily Kandinsky, was taken on as a private student by Mies after he closed the Bauhaus. He was the only American to return to the States with a Bauhaus diploma conferred by Mies. There, his educational background secured for him a series of jobs with leading architecture offices, including that of Wallace K. Harrison in New York.

Edward L. Fischer arrived at the Dessau Bauhaus from Philadelphia at the same time as Howard Dearstyne and studied advertising and typography for two semesters.

Two of Lyonel Feininger's sons, who had been born and raised in Germany, also studied at the Bauhaus. Andreas studied at the Weimar Bauhaus between 1922 and 1925 and participated in various events in 1925 and 1931–1932. His work as architect and photographer gave him the opportunity to contribute to the New York exhibition "Foreign Advertising Photographer." His brother Lux was enrolled at the Dessau Bauhaus between 1926 and 1929. Interested in theater and music, he joined Oskar Schlemmer's stage workshop and the Bauhaus jazz band. In addition, he took classes with Albers, Kandinsky, Klee, and Moholy-Nagy. By 1929 he had decided to focus on painting. The Feiningers left Europe before the outbreak of the war and returned to the United States.

A whole group of American students entered the Dessau Bauhaus in the winter semester of 1931. Among them were:

Michael van Beuren of New York City. He participated in the courses offered by the architecture and interior design department for two semesters before moving to Berlin with Mies in 1932.

Julius Henry Buchman from Valley Falls studied the same subjects as van Beuren.

Lawrence H. Jaase from La Grange, Illinois, began the foundation course as a guest student and remained for a second semester.

Martha Havemeyer from Colorado Springs audited courses in photography and also remained a second semester.

Elsa Hill-Hempl from Ann Arbor spent a semester in the foundation course and then switched to the Department of Architecture and Interior Design for a second semester.

Lila Koppelmann, nee Ulrich, from Chicago also spent a semester in the foundation course and a second semester as a guest student in the Department of Architecture and Interior Design.

Virginia Weisshaus from Spokane enrolled and shortly after married the Bauhaus teacher Heinrich Bredendieck. They emigrated to Chicago in 1937.

Charles W. Ross from Auburn completed the foundation course and subsequently participated as a guest student in courses in the advertising workshop and in the Department of Architecture and Interior Design. His wife, Nancy Wilson Ross from Washington, participated as auditor in the free painting class.

Among the last students who were able to matriculate in the Bauhaus were these:

Bertrand Goldberg of Chicago spent a semester in the Department of Architecture and Interior Design in Dessau before moving to Berlin with the school. There, he participated in its final phase.

William J. Priestley only studied at the Berlin Bauhaus in 1932–1933 as a guest student in the fourth and fifth semesters of interior design.

Nathalie Swan of New York arrived at the Bauhaus too late to complete her studies: she was only able to visit the classes in architecture and interior design at the Berlin Bauhaus for one semester in 1932–1933.

John Barney Rogers of Norfolk could experience little more than the Bauhaus's swan song in Berlin during his semester in the summer of 1933.[189]

Most of the American students spent their vacations at home. Enough is known about some of them to establish how energetically and effectively they influenced the course of the American reception of the Bauhaus. Mies considered them envoys of the

188 Kevin Harrington, in an interview with Bertrand Goldberg, Bauhaus Symposium, 50.

189 Information on American students gathered from the data of Stiftung Bauhaus Dessau, Archiv Sammlung, as of December 1996.

school's cause, as his April 1931 letter to Philip Johnson reveals. He asks Johnson to receive Howard Dearstyne during a vacation stay and to name others whom Dearstyne "could inform about the current intentions and aims of the Bauhaus."[190] Mies was apparently very interested in recruiting young Americans and invested much effort in this during his directorship. A year later, he requests, through the Circle of Friends, that Johnson assist in attracting American students to the Bauhaus: "We believe that it is time to advertise [the Bauhaus] in America. Would it not be possible for you to insert a brief announcement of the upcoming semester in the appropriate newspapers and to mention the fact that at the present, of our 189 students, eleven are Americans and four English, and that altogether, one third of the student body are foreigners?"[191] Mies apparently expected to improve the school's financial security and international visibility by establishing close connections to the United States.

The web of contacts established in 1930–1931 between the Dessau Bauhaus and the United States peaked with Mies's extremely interesting initiative to open a branch of the Bauhaus in New York. According to a release that he circulated to American institutions, his aim was to overcome the Bauhaus's provincialism and to incorporate the school more emphatically into the international architectural scene. The foreign branch was to be academically and professionally tied to the Dessau parent institution via a rotation system for teachers and students. The facility was to be financed by tuition. Richard Neutra, who had been a guest professor at the Bauhaus a short time earlier, was asked by Mies to conduct preliminary negotiations on the American side. According to the journal *Deutsche Bauhütte,* the initiative was stymied, apparently because Americans preferred artisan-crafted furniture to the products of a cooperation between the Bauhaus and industry.[192]

Under the directorship of Mies, additional guest faculty was drawn from the United States, among others Richard Neutra who came in 1930. His recollections of his stay in Dessau appear to be general impressions rather than a specific account of the program and teaching experience: "I found . . . much to learn amongst the students and teachers. I had absolutely no experience with European students, but then, there were all kinds of young people at the school . . . and I sensed a restlessness among them which had been prevalent since the departure of the last director (Hannes Meyer)." Back in New York, Neutra lectured on the Bauhaus at the opening of the new auditorium at the New School for Social Research. He especially emphasized the achievements of the Bauhaus's founder Walter Gropius.[193]

In the Bauhaus's final phase, Mies was forced to run the formerly public institution as a private school. The enormous concomitant financial difficulties led him, like Gropius before him, to turn to fundraising, a practice then uncommon in Germany. Again, he wrote to Johnson for help: "We know that it will not be any easier in America to raise money but nonetheless, we believe that your personal initiative would succeed in raising a couple of thousand dollars for the Bauhaus. This would be an enormous help and would insure the school's continued existence." Emphasizing the

successful studies completed by young Americans at the Bauhaus, Mies argued that the school's continued existence would be not only in the German but also in the American interest. In the same letter, he authorized Johnson to act officially as the Bauhaus's American representative.[194] Political developments overtook these activities: Mies was only able to maintain the course offerings for a few months after writing this letter. The majority of American students experienced the Bauhaus only in a relatively re-duced form and, at the bitter end, came to identify Mies van der Rohe with the school for which he fought at all costs. Until then, colleagues from America came to conduct seminars: even in January 1933, Katherine Dreier gave a lecture at the Berlin Bauhaus.

Although the Bauhaus was never transplanted to American soil as the indepen-dent institution envisioned by Mies, it did arrive after all in another form. In 1933, Josef Albers, one of the Bauhaus's leading masters, emigrated to the States, where he continued to expand upon his Bauhaus theories and experiments at an American school. He was the first Bauhaus professor to receive a position in the United States, at Black Mountain College in the western part of North Carolina, a school founded by John Andrew Rice with a group of students and teachers in the year of Albers's appointment. The school was intended to be a means of testing the idea of a communal education in the arts. Albers's wife Anni, who had been one of the leading textile artists at the Bauhaus, went with him.

Josef and Anni Albers's contact with Black Mountain College had been estab-lished through Philip Johnson, whom they knew from his visits to the Bauhaus. Ulrich Schumacher, the director of the Josef-Albers-Museum in Bottrop, Germany, recalls a conversation with Anni Albers in which she told him how they had met Johnson again in Berlin in 1933 and described to him the terrible conditions in which many Bauhaus affiliates found themselves after the school's closing. Because of her Jewish background, Anni Albers was mortally threatened by the political developments. As a result, John-son, who had seen and admired her experimental loomwork, established the contact that would lead to their emigration a short time thereafter.[195] During the course of the following years, Anni Albers became internationally known as a first-class textile artist and Josef Albers expanded on his color theory, his painting, and his pedagogic pro-

190 Ludwig Mies van der Rohe, letter to Philip Johnson, dated 16 April 1931, Mies van der Rohe Archive, Museum of Modern Art, New York, Correspondence.

191 Ludwig Mies van der Rohe, letter to Philip Johnson, dated 19 May 1932, Mies van der Rohe Archive, Museum of Modern Art, New York, Correspondence.

192 Brief article in Deutsche Bauhütte 13 (24 June 1931). See Schädlich, "Die Beziehungen des Bauhauses zu den USA," 67.

193 Richard Neutra in The Canadian Architect, 15 May 1970, 57–66.

194 Ludwig Mies van der Rohe, letter to Philip C. Johnson dated 22 February 1933, Mies van der Rohe Archive, Museum of Modern Art, New York, Correspondence.

195 Author's interview with Ulrich Schumacher, 24 January 1992.

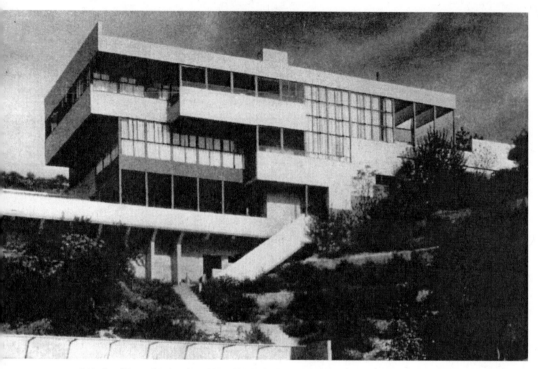

2.12 Lovell house, Los Angeles, 1927–1929. Richard Neutra, architect. (Photo from M. Trachtenberg and I. Hyman, *Architecture;* reprinted by permission of Harry N. Abrams, Inc.)

gram, based upon the Bauhaus foundation course. His teaching was so influential that it had repercussions for almost all significant schools in the country over the course of the decades to come.

A number of other leading Bauhaus artists and architects came to America within a few years. In 1936, Alexander (Xanti) Schawinsky joined the Black Mountain faculty. That same summer Lyonel Feininger taught at Mills College in Oakland, and in the following year moved back to the States permanently. In 1937 came the emigration of Walter and Ise Gropius, László Moholy-Nagy, Marcel Breuer, and Hin Bredendieck. In 1938 Ludwig Mies van der Rohe, Ludwig Hilberseimer, Walter Peterhans, Herbert Bayer, and Marli Ehrmann arrived. By the time World War II broke out, a considerable part of the Bauhaus elite had left Germany.

Work The designs of the European avant-garde had remained in the shadow of more traditional projects during the Chicago Tribune competition of 1922; but between 1927 and the early thirties, a number of works that manifested modern architecture's program were realized in the United States. Some were by American architects,

others by émigrés who applied their European training and experience to their new home.[196]

Richard Neutra's Lovell Health House was built in Los Angeles between 1927 and 1929. It was the first documented use of a steel-frame structure in a single-family house. The architect, an Austrian immigrant, had already realized some of the aesthetic principles of the Neues Bauen in his 1927 Jardinette Apartments in Los Angeles, but it was the Lovell House, with its airiness and flowing spaces, that shared more stylistic common ground with the European avant-garde. Its explicit relationship to the Bauhaus was rooted not only in the architect's design and construction principles but also in his brief participation in the institution. (At Mies's invitation, Neutra taught for a month in Dessau as "visiting critic.") In the twenties and thereafter, Neutra's work helped pave the way for the aesthetics of the European modernists.[197]

The Swiss architect William Lescaze, a student of Karl Moser, applied similar principles to a skyscraper he designed with George Howe between 1929 and 1932: the Philadelphia Savings Fund Society Building. The PSFS building is akin to the Lovell House in its technical and stylistic characteristics, so that a direct influence seems plausible. It is likely that such well-read architects as Howe and Lescaze would have known of Richard Neutra quite early from his book *Wie baut Amerika?*[198] Because of its adherence to the standards of the International Style, the PSFS building was included by Hitchcock and

2.13 Construction site of the Lovell house. Fourth from right, Richard Neutra; far right, Gregory Ain; next to him, Harwell Hamilton Harris. (Photo courtesy of Lisa Germany.)

196 Lescaze came in 1920, Neutra in 1923. See Lampugnani, *Encyclopedia of 20th-Century Architecture*, 200, 245.

197 Arthur Drexler and Thomas Hines, *The Architecture of Richard Neutra*, 8.

198 William H. Jordy, *American Buildings and Their Architects*, 5:154.

2.14 Philadelphia Savings Fund Society Building, 1929–1932. George Howe and William Lescaze, architects. (Photo courtesy of K. Baermann.)

Johnson in their exhibition "Modern Architecture." In a summary report on a meeting of the T-Square Club of Philadelphia, M. E. Levinson characterized the building as the first proper skyscraper, designed on the basis of a modern understanding of architecture. Its realization, he continued, represented a step toward better skyscraper architecture. The author cited the issue of "truth" in frame and curtain wall construction.[199] Faced in granite, limestone, and semi-glazed black brick, the building represents more than a successful realization of a "modern understanding of architecture": as a successful synthesis of modern American and avant-garde European design elements, it is a landmark in the architectural history of this century and represents the beginning of a new aesthetic whose ability to do without historicization and self-conscious monumentality was perceived as a challenge. The building's design and execution, both exterior and interior, show the marked influence of contemporary German design and architecture. It represents the first step toward a "stripped down classical style" that culminated in Mies van der Rohe's Seagram Building.[200] Two projects are mentioned in the literature as sources for the building's overall appearance and for the design of its individual components: Gropius and Meyer's design for the Chicago Tribune competition of 1922, and Ernst Otto Osswald's 1922 design for the 18-story Stuttgart Tagblatt Tower, which had been published in the United States in 1929.[201] The PSFS building was chosen for the important annual exhibition of the Architectural League of New York but probably inspired little enthusiasm. The majority of American architects were still not ready to accept this architecture at the time.

Only recently has part of the credit for the PSFS's success finally been given to the man who was responsible for the building's interior design, the architect and industrial designer Walter Baermann. He had emigrated to the United States in 1929 to escape economic depression and unemployment in Germany and was hired by Joseph Urban. He met with immediate success as an industrial designer: in 1932, he was

2.15 Lamp for Mutual Sunset Company,
Brooklyn, 1934. Walter Baermann, designer.
(Photographed beside Marcel Breuer's Wassily
chair; photo courtesy of K. Baermann.)

included in *Fortune* magazine's list of the twelve top industrial designers, along with Raymond Loewy and Henry Dreyfuss.[202] Hired by Howe and Lescaze as designer for the PSFS building, Baermann was concerned with the stylistic consistency of the interior and exterior of the skyscraper. Baermann is a convincing example of those Europeans who, even if they did not come directly from the Bauhaus, were strongly influenced by it and thus contributed to the dissemination of its ideas in the United States. His product designs of the early thirties, in the period during which the PSFS was planned and built, show a remarkable stylistic affinity for the work of Marianne Brandt and Hans Przyrembel of the Dessau metal workshop and the work of Marcel Breuer in the cabinetmaking workshop. This is apparent, for example, in his lamp designs of that era.[203] His 1934 drawings of two houses intended for mass production incorporate his understanding of Gropius's ideas about mass-produced variable low-cost housing units, as realized in Dessau-Törten between 1926 and 1928; of Marcel Breuer's designs for two small

199 M. E. Levinson, "This Modern Architecture," 23.

200 Kenneth Frampton and Yukio Futagawa, *Modern Architecture, 1851–1945*, 240. The authors speak of the building as "a primarily transitional work bridging the monumental ideas of the American Beaux Arts and the functional efficiency of European modernism." They also (348) quote William Jordy's opinion that "in the development of the bare bones aesthetic of the modern skyscraper design, the PSFS is the most important tall building erected between the Chicago School of the 1880s and the metal and glass revival beginning around 1950."

201 Frampton and Futagawa, *Modern Architecture, 1851–1945*, 348, and John Zukowsky, ed., *The Many Faces of Modern Architecture*, 187.

202 Walter Baermann in *The News and Observer* (Raleigh, N.C.), 24 January 1965.

203 See the photographic images of the 1932 "Desk Lamp" for Kurt Verson Company, New York; the 1934 Lamp for Mutual Sunset Company, Brooklyn, N.Y.; and the metal chairs in the private archives of Christine Baermann, Raleigh, N.C.

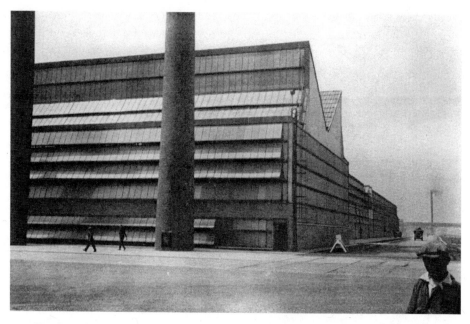

2.16 River Rouge Glass Plant, Ford Motor Company, Dearborn, Michigan, 1924. Albert Kahn, architect. (Photograph by Ise or Walter Gropius, 1928; print by Markus Hawlick, after original negative. Bauhaus-Archiv, Berlin.)

home types, Bambos 1 and Bambos 2, both of 1927; and of Mies's open floor plan and modular design strategies as applied in the model house for the Berlin Building Exposition of 1931 and other works. This particular work of Baermann's shows how the ideas of different Bauhaus architects could become blurred when an intermediary tried to realize them on his own. The confusing effect on the American observer can only be imagined.[204]

Some of the new elements that began to establish themselves in American architecture, such as the use of prefabricated systems, the aesthetization of technology, reserved formal language, and the opening of the floor plan, were employed in industrial architecture by Albert Kahn, who had emigrated to the States from the German Rhineland. In the River Rouge Glass Factory, built in 1924 in Dearborn, Michigan, for the Ford Motor Company, he achieved a functionalist architecture that recalls the precise cubic forms of Mies van der Rohe's work in the fifties and sixties[205] and elements of Gropius's aesthetic vocabulary for the 1911 Fagus factory. Like the latter, River Rouge demonstrates a new form of industrial architecture. Although not as airy as the Fagus factory, Kahn's plant with its corner towers and cornice shows consideration for expressive formal elements. Its stern formal language and affirmation of Ford's economic views, rooted in the rise of the automobile industry,[206] relates the elegant

building to the most important contemporaneous program of the Weimar Bauhaus, the creation of a new unity of art and technology. Kahn's building was completed in the same year as the conferral of the directorship at the nearby Detroit Institute of Arts on the German art historian Wilhelm R. Valentiner. As a member of the arts commission of the Institute, Kahn was one of Valentiner's most reliable supporters even in such controversial matters as the presentation of the expressionists or issues of a German director's legitimacy at an American museum. Nonetheless, Kahn was not an avant-garde architect in the European sense and his interest in radically new approaches to architecture remained marginal.[207]

The building for the New School for Social Research (1930–1931), which began to offer an ambitious program of continuing education in social and political science during the twenties and thirties taught by a faculty that included prominent immigrants, was the Austrian architect Joseph Urban's contribution to a series of European-influenced tall buildings. The building has a modest, unornamented facade, structured by horizontal band windows that are placed equidistant and continue around the building's corners. The color scheme of the interior spaces recalls the compositions of the early De Stijl movement and precedents from the Bauhaus workshop for wall painting in Dessau and Berlin, which, under the directorship of Hinnerk Scheper in 1925–1928 and 1931–1933, had studied the use of monochromatic surfaces to emphasize architectural planes. In these respects, the building was a pioneering achievement in line with European movements. It was nonetheless subject to harsh review by critics who subjected it to the criteria of a preconceived International Style. They contended that the building plagiarized the new style rather than applying its

2.17 The New School for Social Research, New York, 1930–1931. Joseph Urban, architect. (Source of photograph unknown.)

204 Published in "New Housing Designs and Construction Systems," 27.

205 Lampugnani, *Encyclopedia of 20th-Century Architecture*, 183ff.

206 Frampton and Futagawa, *Modern Architecture, 1851–1945*, 241.

207 Compare Grant Hildebrand, *Designing for Industry*, 218.

principles.[208] Antonin Raymond, Paul Grotz, and Frederick Kiesler were other émi-grés whose European training had already left its mark on various built works in America by the end of the thirties. But there was no sign that would have indicated the immediate influence of these men on a broader circle of architects.

The first actual work of a Bauhaus architect on American soil, Mies van der Rohe's design for Philip Johnson's New York apartment, dates from 1930. After the completion and approval of the drawings, furniture and other components of the de-sign for the living room, bedroom, dining room, and dressing room were sent to New York later that year. Lilly Reich was responsible for the correspondence and presum-ably was also involved in the design.[209]

In the course of the twenties, a genuine modernism had developed in American architecture that went beyond the technology-determined achievements of the Chicago school and the overturning of historical building strategies by Frank Lloyd Wright. Buckminster Fuller was a protagonist in this movement. He completed the first version of his Dymaxion house in 1927, a prototype for the serial production of an unconventional dwelling whose form and typology was uninhibited by tradition. Its rationality linked it to the technology-oriented members of the European avant-garde movements of the twenties. The work, which radically questioned the usual conceptions of building volume and structure, was published in *Shelter* in 1932.[210]

In addition to Fuller, there was a generation of American architects at the begin-ning of the thirties who experimented with the same aesthetic formal language, the same new materials, plans, and construction methods as the Europeans. These included Harwell Hamilton Harris, whose 1934 house for Pauline Low in Pasadena, California, designed with Carl Anderson, and 1935 house in Fellowship Park, Los Angeles, proved that he had moved beyond the influence of Wright, Neutra, and Mies to establish his own version of modernism. Other American architects who broke with the traditional-ists were Albert Frey and Lawrence Kocher with their Aluminaire House of 1931, as well as Alfred Kastner, a Hamburg-trained architect, and Oscar Stonorov with the Carl Mackley houses of 1932. Neutra's influence, like that of Rudolf Schindler, was at least initially limited to southern California;[211] the work of Howe and Lescaze was an excep-tion on the east coast; and Albert Kahn's experiments remained largely within the genre of industrial architecture. Some of these architects collaborated at times, as in the case of Howe, Kahn, and Stonorov, but they did not establish a school. Nonetheless,

208 Philip C. Johnson, "The Architecture of the New School," 393ff. Also see the less critical article "A Building for Adult Education" by Alvin Johnson, director of the New School.
209 Philip Johnson Files, Museum of Modern Art Archive, New York.
210 Frampton and Futagawa, *Modern Architecture, 1851–1945*, 240.
211 Lisa Germany, *Harwell Hamilton Harris*, 19.

in each case, their buildings were well publicized and respected as embodiments of the technology and aesthetic of the European avant-gardes in America. Although they did not immediately inspire contemporary building, and the avant-garde ideas were first accepted once they appeared in the context of European imports, the role of these American works in opening the public's eyes to the new architecture cannot be overlooked.

3

The
Image
of the
Bauhaus
as
Received
in
America

T he American reception of the Bauhaus has been a focus of international reception research in recent years. This book is especially concerned with the reception by a professional and knowledgeable American audience at the time of the school's institutional existence, as a source of revolutionary concepts in design education and the production of architecture, design, and art. The great majority of American recipients in those years had no opportunity to experience the Bauhaus in Weimar, Dessau, or Berlin firsthand. Instead, they depended on secondary sources of information such as literature, exhibitions, films, and oral reports. Any experience of art that occurs via substitution, however, is problematic, especially in the case of architecture. Some of architecture's essential elements—site, function, aesthetic, structure, and construction—may be conveyed by the surrogates offered by various media, but the relationship of these elements in a three-dimensional building cannot be. Even the most accurate image and most precise description cannot replace the experience of space. If it is only possible to "picture" a building, it must be assumed that the impression made is more or less imprecise and that any judgment on that basis is risky. This is especially true of the avant-garde architecture. The specific qualities of certain buildings can only be inadequately captured and communicated in photographs, models, drawings, or verbal descriptions. Philip Johnson pointed to this fact when he related his first impression of Mies van der Rohe's Tugendhat house in Brno to an American friend: "It is a three-dimensional thing which simply can't be seen in two. It is without question the best looking house in the world."[1] Which architect who has not been there would dare to contradict?

Another difficulty associated with any attempt to understand the Bauhaus and its history at a remove arises from the many transformations it underwent during its history. Until the mid-thirties, no coherent, detailed account of the genesis and development of the Bauhaus experiment was available in the United States. Information on its architectural endeavors was especially difficult to find, so that interested architects were left to sift through relatively limited, irregular reports scattered in diverse publications and containing often incomplete and incorrect information. It is therefore safe to assume that only a small circle of people were able to reconstruct an authentic image of the institution and its programs. In fact, an examination of the normative publications proves that the image they presented of the Bauhaus, its principles, aims, and achievements, not to mention of the entire architecture department, deviated significantly from reality.

1 Philip Johnson, quoted in Franz Schulze, *Philip Johnson*, 68.

The impressive number of reports in the American media between 1919 and 1936 on the Bauhaus and its individual participants, especially Walter Gropius and Ludwig Mies van der Rohe, should not be allowed to obscure the fact that these articles represented only a small portion of the respective publications' total volume during this period. On the other hand, an evaluation of their influence should not be based on quantity alone. In the case of the Bauhaus, this would be misleading, and would downplay the significance of the early phase of its reception in the United States. Johnson's contention that the Bauhaus and its architects were almost unknown in this country before his 1932 exhibition "Modern Architecture" and book International Style is therefore highly questionable.[2]

Even before 1932, a large amount of information on the Bauhaus, in particular on the works of its leading architects, was already available. Well-curated exhibitions referred to the Bauhaus; significant texts by renowned authors appeared in well-regarded and -circulated publications. Its architecture was often presented with exceptionally good illustrations. The sharp contrast between those images and the many traditionalist or historical images was apparent even on leafing through architecture journals and books. This was certainly true of Mies van der Rohe's model of a skyscraper in glass and iron (1921),[3] his design for a department store in Berlin (1928),[4] the Barcelona Pavilion (1928–1929),[5] and the Tugendhat house (1928–1930),[6] or of Walter Gropius's administration building at the Cologne Werkbund exhibition (1914),[7] the Fagus shoe factory (1911),[8] and the Dessau Bauhaus (1926). These buildings were so different from the buildings normally published during the twenties in terms of phenotype, construction, use of materials, and abstract formal language that these articles and images could not have escaped the attention of competent readers. Sometimes, the designs and realized buildings in this new architectural idiom may have been dismissed as follies, utopias, or, in the worst case, perversions. Nonetheless, it is conceivable that a handful of professionals took notice of the progressive concepts they embodied. This was particularly true at the end of the twenties, when these ideas were reinforced by the context of the entire avant-garde movements, and the receptive climate for the ideals of European classical modernism had improved.

Furthermore, it is possible to cite incidents of a single significant receptive moment in which initial contact with a work later proved to be an essential experience. The prominent American architect Harwell Hamilton Harris, who died in late 1990, had exactly such an experience at Frank Lloyd Wright's Hollyhock House in Los Angeles, which he visited as a young art student. The building's sculptural qualities impressed him so deeply that he decided to become an architect.[9] Another eye-opening experience was his first encounter with Mies van der Rohe's Barcelona Pavilion in the pages of Die Form: it inspired him to rephrase his understanding of architecture as a three-dimensional construct of

planes and to design using a modular system.[10] Harris belonged to the first generation of American architects who recognized the importance of the avant-gardes in Europe and America and were quick to engage specific ideas. He worked for a time in Richard Neutra's office and was involved in the Lovell House in Los Angeles. Among those Americans who later achieved a superregional reputation, he was one of the first to adopt some of Mies's fundamental design principles. Because this did not entail any deviation from his own, individualistic line, but rather the selective adoption of ideas wherever they seemed logical within the context of his own system, a case study of his work would be a productive way to establish the influence of Bauhaus-related ideas on American architecture.

The following pages offer an insight into the image of the Bauhaus as presented to a competent and interested recipient in the United States between 1919 and 1936. Consideration will be given to the information on the Bauhaus that was available between 1919 and 1936; the way in which the initially authentically received image of the Bauhaus's architecture became progressively stilted; and the way in which a shift in perception occurred in favor of the heavily edited image of a Dessau school created by Gropius. By 1936, this image had been elevated to a myth, supporting the subsequent emigrations of those who had been staffing in the roles of its heroes. With few exceptions, there is a clear correlation between the results of the early reception of the Bauhaus and the brilliant American careers of a few of its protagonists. America did not discover any new star, and a number of Bauhaus people were either overlooked or given marginal attention. This applies to many aspects of the program as well, as the focus of interest shifted more and more to what was in demand.

2 Author's interview with Philip Johnson, 21 September 1992.

3 See the plan in Walter Curt Behrendt, "Skyscrapers in Germany," 368; the illustration in Irving K. Pond, "From Foreign Shores," May 1925, 158; and Knud Lønberg-Holm, "Glass," 328.

4 Large-format illustration in "Reducing Dead Load, Saving Time and Increasing Control," 490.

5 Helen A. Read, "Germany at the Barcelona World's Fair," 112, 113; Sheldon Cheney, The New World Architecture, 127. Cheney cites Mies as the architect of the pavilion but erroneously states that the fair was in Seville.

6 Three illustrations in Lønberg-Holm, "Glass," 352, 353.

7 Two illustrations in Herman George Scheffauer, "The Work of Walter Gropius," 54.

8 Illustration in ibid., 53. Also see Henry-Russell Hitchcock, Modern Architecture, plate 38.

9 Author's interview with Harwell Hamilton Harris, 22 April 1990. Compare Lisa Germany, Harwell Hamilton Harris, 18.

10 Author's interview with Harwell Hamilton Harris, 11 March 1990. The analysis and open admission of his artistic origins and inspiration in the works of others evidences his exceptional intellectual and personal qualities. Were such qualities more widespread among artists and architects, it would likely be easier to trace the path of such processes of reception.

FOUNDING

Few of the texts that deal directly with the Bauhaus or its protagonists discuss its artistic, philosophical, and political roots or Gropius's motivation for founding it. One of the earliest of all articles on the Bauhaus, "Revolution Reflected in the 'New' Art of Germany," published in *Current Opinion* in 1919, listed the developments that had most obviously contributed to the Bauhaus's founding: the initiatives of the German Werkbund, the reciprocal influence of revolution and art in the aftermath of the German November Revolution, the subsequent founding of the Arbeitsrat für Kunst, and the transposition of concepts implemented by the council's Berlin section under Gropius to the Bauhaus as institution. In describing the ideas and aims of the Bauhaus, the article's author quoted its founder:

The wall of conceit that separates the artist from the workman must disappear, . . . for in the last analysis we are all working men, and only now and then arises among us a genius who is worthy of the artist's name. That is a gift of god which might come to the humblest craftsman as well as to the most educated academician. Away with the snobbery of art—let us all learn to be laborers for the common good in the great democracy of tomorrow.[11]

In addition to discussing the Bauhaus's orientation toward educational and social reform, the article mentions the general artistic aims pursued by Gropius in founding the Bauhaus. It makes clear that these aims were derived from the *Bauhütten* (guilds) of the Middle Ages.

Before the 1935 English-language versions of Gropius's and Moholy-Nagy's comprehensive texts on the Bauhaus, there was a tendency to see the school as a response to the pragmatic concerns of postwar Germany. In support of this argument, the issues cited were the need to rejuvenate the German crafts tradition which had been so severely damaged by the country's defeat; the wish to support the applied arts; the efforts to alleviate the housing shortage; the recognition of the need for mass-produced quality goods and therefore the need to develop prototypes; and the movement toward educational reform for artists and architects so as to facilitate their professional integration. All this was to occur in accordance with the democratic spirit of the new republic.[12] An exception to this line of argument was Philip Johnson's "Historical Note" in the *Modern Architecture* catalogue, in which he cited art historical precedents and influences.[13]

PHASES OF
EXISTENCE

It is incorrect not to distinguish between the different periods of the Bauhaus; the Bauhaus under Gropius's directorship was different from the Bauhaus under Hannes Meyer, and again the Bauhaus that I directed was different in nature from the latter.[14]

This apparently simple statement was made by Mies in 1933. It was necessary to point out the difference between the various Bauhaus periods in Germany because, from a politically influenced vantage point, the contours of the Bauhaus's Weimar, Dessau, and Berlin permutations began to fade. It would have been helpful to bring this message to America as well, for two of the most noteworthy changes in the image of the Bauhaus before 1936 involve the perception of the school's location and character. There was an obvious tendency to identify the Bauhaus with only one of the three phases of its existence, that of Dessau.

Weimar On founding the Bauhaus in April 1919 in Weimar, the city of *German* classicism, Walter Gropius presented a utopian manifesto calling for an architecture of the future in which all the arts would be united. To this end, a new kind of artist was to be trained; the crafts were to be the basis of his creativity. To teach him and to instruct him in production, Gropius assembled artists and craftsmen in material-specific workshops. In addition, all students would attend an obligatory course in the elementary issues of aesthetic design. They would be allowed to enjoy a free and experimental approach to the material of design and to unfold their creativity, learn self-criticism, hone their senses, and attain a degree of self-assuredness in dealing with the methods specific to the various visual arts. In 1923, Gropius was forced to recognize that the realities of technological civilization demanded a reorientation of his crafts-based program. In order to unify art with technology at the Bauhaus, the workshops were now to develop functionally and aesthetically considered products and

11 "Revolution Reflected in the 'New' Art of Germany," 256. The collaboration attempted at the Bauhaus among craftsman, artist, and architect is also represented in Scheffauer, "The Work of Walter Gropius," 50.

12 See, in particular, Milton D. Lowenstein, "Germany's Bauhaus Experiment," 1; P. Morton Shand, "Scenario for a Human Drama," 39; George Nelson, "Architects of Europe Today: Gropius," 424f.; "The Bauhaus" (*Art Digest*), 27f.; "Revolution Reflected in the 'New' Art of Germany," 256.

13 Philip C. Johnson, "Historical Note," in Henry-Russell Hitchcock, Philip Johnson, and Lewis Mumford, *Modern Architecture: International Exhibition*, 18ff.

14 Ludwig Mies van der Rohe, letter to Ministerpräsident Freyberg, Staatsministerium Dessau, 13 July 1933, Stiftung Bauhaus Dessau, Archiv Sammlung.

STAATLICHES BAUHAUS WEIMAR
Ehemalige Großherzoglich Sächsische Hochschule
für bildende Kunst und ehemalige Großherzoglich
Sächsische Kunstgewerbeschule in Vereinigung

3.1 Bauhaus Weimar, letterhead. (Bauhaus Dessau
Foundation.)

prototypes for industrial mass production.
Thus, the Bauhaus became Gropius's an-
swer to the problem of the appropriate
artistic education in the machine age. The
painter Johannes Itten, who originated the
famous foundation course in Weimar and
thus contributed greatly to the initial character of the school there, left as a result of
this programmatic shift and the consequent friction between him and Gropius. The
aim of creating a communal life at the Bauhaus remained even after the changes in the
course of studies.

Only few sources of information in the United States, among them the earliest
publications and those from around 1935, mention the first years in Weimar. The
differences in philosophical orientation, professional aim, and pedagogic orientation
between the program before 1923 and that of later phases was consequently little pub-
licized. The school's further development under the banner of a unity between art and
technology was also largely ignored.[15]

If Weimar was mentioned at all in the literature after 1925 and before the publi-
cation of *The New Architecture and the Bauhaus,* it was only as a result of an author's
desire to offer a complete bibliography. An exception to this rule was Hitchcock's *Mod-
ern Architecture,* which discussed the expressionism championed at the Weimar Bauhaus
by the painters Kandinsky, Klee, and Feininger, and the emphasis placed on interior
design in the early phases of the architectural course of studies. Hitchcock rightfully
cited Henry van de Velde's pedagogic and architectural influence on the Bauhaus.
Nonetheless, he did not recognize the revolutionary step taken in the school's found-
ing, an achievement that had been appreciated by earlier articles. He speaks of Gropius
merely "assuming the directorship" of the "Weimar School of Art" and of its "reorgani-
zation" as the "Bauhaus Institute." Thus, he implies a philosophical and institutional
continuity that did not exist in reality.[16] The first explicit and detailed depiction of the
difference between the Weimar and Dessau periods was Gropius's *The New Architecture
and the Bauhaus,* and the publications that followed the book.

The first German democracy was christened in Weimar in the same year as the
Bauhaus. The Weimar Republic lent the name Staatliches Bauhaus zu Weimar to the
school, which identified itself with democratic ideals. Ironically, this city was more
than vaguely involved in the destruction of both democratic institutions. The Bauhaus
was put under pressure by reactionary forces in 1925 and closed by the conservative
government, a fact that went almost unnoticed in America.

Dessau The majority of the Weimar students and teachers accompanied the Bauhaus
to Dessau. The teacher Gertrud Grunow, the sculptor Gerhard Marcks, the
first master of the theater workshop Lothar Schreyer, and the architect Adolf Meyer,
who was also Gropius's partner, did not stay on or had already left the school earlier.
The official opening at the new location was on 1 April 1925. Under the leadership of
Fritz Hesse, the city had competed with other cities, including Frankfurt-am-Main, to
attract the Bauhaus. Dessau, a court seat in the eighteenth century, had become an
emerging industrial city in the early twentieth century, in part because of the Junkers
aircraft factory. It seemed an appropriate location for a school that was dedicated to
collaboration with industry. One of the decisive factors in favor of Dessau was the gen-
erous offer of land and money made to the Bauhaus for the construction of several mas-
ters' houses and its own school buildings. These buildings offered an exceptional
chance to manifest the school's pedagogic and artistic programs. Gropius designed the
main building, and the Bauhaus's workshops designed and executed the interior fin-
ishes. On 4 December 1926, some seventy years ago, the Dessau Bauhaus building was
completed. Almost immediately, it was to become one of the architecture incunabulae
of modernism. Its lasting cultural and historical significance was underlined in Decem-
ber 1996, when it was inscribed in the list of world cultural heritage sites of the
United Nations Educational, Scientific and Cultural Organization (UNESCO).

During the period of this study, an image of the Bauhaus developed in the
United States which identified the Bauhaus almost overwhelmingly with Dessau and
with an abstract, constructivist, functionalist idiom.[17] This view held sway for a long

3.2 Bauhaus Dessau, letterhead. (Bauhaus Dessau Foundation;
reproduced by permission of VG Bildkunst, Bonn, 1999.)

15 Those articles that considered the Weimar Bauhaus, at least in the sense of its position and its
significance as a center of Gropius's activity, were: "Revolution Reflected in the 'New' Art of
Germany," 255f.; Herman George Scheffauer, "Building the Master Builder," 304f.; Scheffauer,
"The Work of Walter Gropius," 50. These three articles appeared before the Bauhaus's reloca-
tion to Dessau in 1925. The following articles were published between 1932 and 1936: Douglas
Haskell, "The Closing of the Bauhaus," 374f.; George Nelson, "Architects of Europe Today:
Gropius," 424; James M. Richards, "Walter Gropius," 46. Nelson, who only briefly discusses
Weimar, rightfully states that the school first achieved its fame in Dessau. Richards's article,
published after *The New Architecture and the Bauhaus*, attributes significance to the Weimar
phase in the definition of the school's character.

16 Hitchcock, *Modern Architecture*, 187f.

17 *Avery Index* 6 (1958): 236; 1:177; 15:369ff.

time: even in 1958, the *Avery Index* noted under the heading "Weimar. Bauhaus" "see Dessau. Bauhaus." The heading "Bauhaus" contains only the reference "See Dessau. Bauhaus." It is not until the 1973 edition that the references are better differentiated: the heading "Bauhaus" reads "See Dessau Bauhaus, Weimar Bauhaus." None of the articles listed in the *Index* under "Weimar" is dated prior to 1960. The one-sidedness of the attention given to the Dessau Bauhaus was not based on a high esteem for the achievements of that school, but rather on a lack of knowledge about the evolution and transformation of the Bauhaus as an institution: both Milton D. Lowenstein and Catherine Bauer state that the school was founded in the city of Dessau.[18] Misunderstandings were related to polemics that grew up around a decontextualized, ahistorical image of the Dessau Bauhaus. The school was finally identified with this phase of its existence alone. For example, Edwin A. Horner and Sigurd Fischer did not mention Weimar at all in the article "Modern Architecture in Germany," which discusses the school and building in Dessau.[19] An article by Gropius himself may also have contributed to the misconception. In "The Small House of Today" (1931), the following short biographical note was included: "Mr. Gropius, a prominent figure in European architecture and founder of The Bauhaus at Dessau, Germany, gives a clear exposition of the new planning and building methods."[20] Although the facts were correct at the time—the Bauhaus was located in Dessau when the article was published—the omissions in the information led readers who knew nothing about the Bauhaus's history to draw false conclusions.

Aside from the confusion caused by the Bauhaus's two moves within a relatively short period of time, a second factor led to the overwhelming identification of the school with its Dessau period: the school building itself. This was the largest realized work of the architecture propounded by the Bauhaus, and a work of exemplary quality. It bespoke the zeitgeist of which the school also was a product, and embodied Gropius's program. The building immediately became synonymous with the idea. By giving the building the same name with which he had already christened the movement and the institution, Gropius made the three inextricable. The fact that the architect of the Bauhaus building was also the founder of the Bauhaus school and the initiator of the international Bauhaus movement left the impression that there was only *the* Bauhaus. No other building produced by the German avant-gardes was as widely and prominently published in the United States before 1936 as the Dessau Bauhaus building.[21] It represented the movement's epitome and was the emblem of the Bauhaus's vision.[22] Even the building's dedication ceremony in December 1926 encouraged this reading. The event was reported in the international press. The building was recognized as an exemplary piece of classical modernism, but little reference was made to the sources, precedents, and implications of this new architecture.[23] Neither was the discrepancy recognized between Gropius's choice of an avant-garde formal-aesthetic vocabulary for the building and its inadequate, largely nineteenth-century construction methods and materials.[24] On the contrary: Robert Davison, in his 1929 *Architectural*

Record article "New Construction Methods," presents a photograph of the building on the title page, thus falsely suggesting a cutting-edge building technology.[25] The relatively great number of American visitors to Dessau after 1927 increased the Bauhaus's reputation. Among them was Philip Johnson, who summarized his impression of the Bauhaus building as follows: "It is a magnificent building. I regard it as the most beautiful building we have ever seen . . . the Bauhaus has beauty of *plan,* and great strength of design. It has a majesty and simplicity which are unequalled. . . . We are reveling in having finally reached our mecca."[26] Johnson included a model of the Dessau Bauhaus building in the 1932 "Modern Architecture" exhibition. Obviously, he was keenly aware of the complex being nonhierarchical, without defined front or back or side facades. In order to grasp this architecture, one has to walk around it, Gropius had once recommended.

More than verbal descriptions or the rare model, photographic images created the perception of the Bauhaus building in the minds of Americans, particularly the artistic pictures taken by Lucia Moholy. The majority of shots featured in American journals were reenactments of her angles, the most famous one focusing on the transparent corner of the workshop wing. The interior of the building, and thus its quality

18 Lowenstein, "Germany's Bauhaus Experiment," 1; Catherine K. Bauer, *Modern Housing,* 221.

19 Edwin A. Horner and Sigurd Fischer, "Modern Architecture in Germany," 41. Oscar Bie followed the same pattern in his "Letter from Berlin" in *Apollo,* in which he reported on the Bauhaus stand at the Berlin Advertising Exhibition of 1929: "Here everything centers around the Dessauer Bauhaus" (229).

20 Walter Gropius, "The Small House of Today," 266.

21 Illustrations in "Machine-Art Exposition," 27; Horner and Fischer, "Modern Architecture in Germany," 45; Robert L. Davison, "New Construction Methods," 361; Hitchcock, *Modern Architecture,* plate 50; Cheney, *The New World Architecture,* 104, 303, 304, 307; "Dessau, the Glass-Walled 'Bauhaus,'" 873f.; Richard A. Morse, "Where Are These Modern Buildings?," 377; Henry-Russell Hitchcock and Philip Johnson, *The International Style,* plate 143; "Bauhaus Closed," 16; Bauer, *Modern Housing,* plate 27a; Nelson, "Architects of Europe Today: Gropius," 426ff.; "Bauhaus, at Dessau, Designed by Walter Gropius," 236; Frederic E. Towndrow, *Architecture in the Balance,* 139. Model in Hitchcock, Johnson, and Mumford, *Modern Architecture: International Exhibition,* 67. Sketches in Francis Keally, "Sketches of Three Buildings in Germany," 176. Text only in Bie, "Letter from Berlin," 229; Hitchcock, *Modern Architecture,* 189.

22 Frank Whitford, *Bauhaus,* 198, as well as Adalbert Behr, "Das Bauhausgebäude in seiner Bedeutung für die Entwicklung der neueren Architektur," 464.

23 Herman George Scheffauer's article in the English-language edition of the *Berliner Tageblatt, Monthly Edition,* as quoted in Christian Schädlich, "Die Beziehungen des Bauhauses zu den USA," 62; and the discussion of Dorothy Thompson in the section "Points of Contact," chapter 2, above. Gropius was fully conscious that the event was perceived in this way. On 27 April 1926, he wrote to the Reichskanzler Hans Luther: "The Bauhaus is famous well beyond Germany" (quoted in Reginald R. Isaacs, *Walter Gropius,* 1:370).

24 Margret Kentgens-Craig and Stiftung Bauhaus Dessau, eds., *The Dessau Bauhaus Building,* 8.

25 Davison, "New Construction Methods," 361.

26 Philip C. Johnson, letter to Louise Johnson, 18 October 1929, quoted in Schulze, *Philip Johnson,* 55.

as a *Gesamtkunstwerk*, was rarely shown. The exhibition model, which to some degree allowed a view of the interior, and George Nelson's extensive article on Walter Gropius in a 1936 issue of *Pencil Points* were exceptions.

In 1926 the institution was also able to promote itself through exhibitions in foreign countries. Only slightly earlier, in 1925, *Internationale Architektur,* the first of fourteen Bauhaus books, was published. Like the twelfth book, *Bauhausbauten Dessau* (1930), it was an important textual and photographic documentation of the approach to architecture conceived by its author, the founder of the Bauhaus Walter Gropius. Both works, which ensured the Dessau Bauhaus's further exposure in the American press, if only at a considerably later date, were included in the reviews and suggested reading lists published by the professional journals.[27] The name "Bauhaus" now appeared in three different permutations: as an idea, an institution, and the embodiment of both. The fascination with the new school building had its problematic sides, too, because with the adoration of the object came a regression of critical reflection. Thus, 1926 may be considered an instrumental year for the school's American reception.

Certain important changes in the Dessau program went unnoticed in America, among them the greatest success of the Bauhaus's entire pedagogy. In the new location, the soundness of the educational program conceived by Gropius to develop creativity on the basis of artistic sensitization and craftsmanship became clear. The Dessau Bauhaus saw the professional success of the first generation of Bauhaus-trained students. A group of highly talented young people emerged from behind the first generation of masters to become significant artists and masters themselves. Among them were Josef Albers, Herbert Bayer, Marcel Breuer, Hinnerk Scheper, Joost Schmidt, and Gunta Stölzl. The Bauhaus's extraordinary success in pedagogic terms and its promise of generations of exceptional artists and designers make its untimely end in 1933 so tragic.

The strong personal component of the Bauhaus's success was recognized in America. Although initial interest was more generalized, increasing attention was directed to those personalities who were already famous, especially the two leading architects Mies and Gropius. The concentration on the big names reflects a shift from a mode of reception focused on the Bauhaus's content to an emphasis on personalities. Along with the almost exclusive association of the Bauhaus with its Dessau permutation and with the school building's architecture, this tendency reduced a complex, dynamically transforming pedagogic, artistic, and social concept to a discipline-specific, temporally bracketed, and personality-bound fragment.

On 22 August 1932, the city council of Dessau, by then dominated by National Socialists, ordered the despised Bauhaus, branded as "un-Germanic," "Bolshevik," "Jewish," and "internationalist," to close in September 1932. Unlike its departure from Weimar, the closure of the Bauhaus in Dessau was well publicized in the United States. Articles in the *Nation, Architectural Forum, Art News,* and other journals expressed distress and concern for the political interventions.[28] There were also voices that com-

mented with polemic satisfaction on the school's end. A letter to the editor of the *Nation* reads: "The simple-minded Nazis are patriotic if nothing else and no doubt view with alarm the prospect of the havoc to be wrought in their picturesque towns and villages by the widespread construction of such buildings as are likely to be produced by the graduates of the Bauhaus."[29] After only six years, the Bauhaus left its quarters in Dessau. The icon of modernism was no more than an empty shell. After the event had been digested, the closure prompted some in the United States to consider whether the school's educational program was only relevant in a German context or whether it might be applied to American institutions.[30]

Berlin The Berlin Bauhaus was established by Ludwig Mies van der Rohe as a private "school and research institute."[31] It was even less known in the United States before 1936 than was the Weimar Bauhaus.[32] The last chapter of the Bauhaus's history took place in the barely adequate rooms of an abandoned Berlin telephone factory beginning in the late summer of 1932. It lasted less than a year and was doomed from the start. This mood was reflected in most articles on it in American periodicals, which tend to sound more like obituaries for the Dessau Bauhaus than reports on the school's new phase. Only a few periodicals, among them *Architectural Forum* and *Art News,* which had followed the end in Dessau, reported on the efforts to continue the school in Berlin.[33] Mies van der Rohe was credited with an efficient move and the speedy reinstatement of the school's activity:

Herr van der Rohe and his colleagues brought about a solution of the school's problems in an unbelievably short time, an empty factory building being quickly adapted into classrooms and workshops in which teachers and students soon resumed their activities. No attention was paid to the exterior graces of the house but an atmosphere of energy, co-operation and good-will still marks the whole school.[34]

27 On Gropius's first book, see Henry-Russell Hitchcock, "*Internationale Architektur,* by Walter Gropius," 191; Hitchcock, *Modern Architecture,* 241; Bauer, *Modern Housing,* 314. On *Bauhausbauten Dessau,* see Bauer, *Modern Housing,* 314, in which the book is recommended as a source of information.

28 See the articles "Closing of the Bauhaus at Dessau" *(Studio);* "Bauhaus Closed"; Haskell, "The Closing of the Bauhaus"; Flora Turkel-Deri, "Berlin Letter."

29 B. C. Flournoy, "The Closing of the Bauhaus," 533 (letter to the editor, *The Nation,* in response to Douglas Haskell's article of the same name).

30 Turkel-Deri, "Berlin Letter," 1.

31 The definition of the school in the director's words. Ludwig Mies van der Rohe, letter to Oberregierungsrat Diels, Gestapo, 8 June 1933, Stiftung Bauhaus Dessau, Archiv Sammlung.

32 George Nelson, "Architects of Europe Today: Van der Rohe," 458ff.

33 "Bauhaus Reopened," 20. Also see "Bauhaus" *(Museum of Modern Art Bulletin),* 4.

34 Turkel-Deri, "Berlin Letter," 1.

3.3 Bauhaus Berlin, letterhead.
(Bauhaus Dessau Foundation.)

Little was said of the program. Even when Mies's role as the school's director was mentioned, the character of this period remained largely obscure. Neither Gropius nor Moholy-Nagy resisted this tendency in their retrospective works of 1935. This omission is understandable in the case of *The New Vision:* the book is based on lectures Moholy-Nagy had given between 1923 and 1928 at the Bauhaus. It is intended as a personal evaluation of his own Bauhaus experiences. It is uncertain why Gropius, in his book *The New Architecture and the Bauhaus,* makes no mention of Mies's contribution in Dessau and Berlin. The generalized use of the terminology "the new architecture" and "the Bauhaus" seems to promise that his book would be a comprehensive discussion of the Bauhaus as a whole and its relationship to modern architecture. The text, however, presents the Bauhaus only from the point of view of its founder and first director, and excludes everything that does not conform to his beliefs. The fact that the extremely improvised and short-lived Berlin Bauhaus was far from the ideals of its earlier golden years, and that it produced no comparably important works, still does not justify the omission. Nonetheless, the "school and research institute" established in Berlin under the most difficult conditions continued almost uninterruptedly the work done in Dessau. The fact that most of the faculty would stay with the school ensured the continuity. The only courses that were discontinued were those for which no teachers were available after the departure of Alfred Arndt and Joost Schmidt.[35]

Organizational barriers could be overcome, but the political realities of the time could not. In a statement made on 10 August 1933, Mies informed the Bauhaus's students of the institution's immediate dissolution.

Reports on the Bauhaus and its final year crossed the Atlantic much less frequently after the establishment of the Third Reich. Douglas Haskell lamented this in the *Nation:* "In the autumn I mentioned in one of my columns on architecture in *The Nation* the ominous closing by the Nazis of the famous Bauhaus. The Bauhaus later reopened in Berlin, but Berlin offers no shelter today. No news has come through yet about the school."[36] Various factors could have been responsible for the delayed and reduced reporting. It may be that the events involving the Bauhaus occurred too rapidly between 1932 and 1933 to be followed from America. The attention paid to Germany was, moreover, concentrated on the larger political picture in these years: the Nazis' rise had been consolidated and on 30 January 1933 Hitler was named chancellor

by Hindenburg, the president of the Reich. The dictatorship's restrictive measures limited the flow of information out of the country.

THE
DIRECTORS

The Bauhaus owes its achievements and its reputation most of all to the people who invested their talent in the school. Gropius himself was obviously a major force: he had a gift for hiring other innovative thinkers, artists, and pedagogues and for holding these strong, ambitious personalities together over the course of years. During the approximately fourteen years of the Bauhaus's institutional existence, the school had two other directors, Hannes Meyer, from the spring of 1928 until the summer of 1930, and thereafter Ludwig Mies van der Rohe, until the school's dissolution in August 1933. All three served at least in part—and in the case of Hannes Meyer, entirely—during the school's Dessau period. Despite changing directorship and the concomitant programmatic transformations, the Dessau Bauhaus is characterized by continuity. Its institutional structure as a school of design remained constant, as did its legal status as a public amenity, its core curriculum, and the general intentions behind its educational program. The faculty also lent the school a certain continuity: the painters Josef Albers, Lyonel Feininger, and Wassily Kandinsky, the painter and typographer Joost Schmidt, and, aside from a brief interruption, Hinnerk Scheper, the master of the workshop for wall painting, all taught during the entire Dessau period.

All three directors were architects by profession whose programs were anchored in the rationalist heritage of the nineteenth century.[37] Nonetheless, every change of directorship meant transformation. Gropius, Meyer, and Mies were extremely different in their family backgrounds and personalities, their *Weltanschauung,* their professional thinking, and their leadership styles. Their tenures at the school created new conditions for the pedagogic program and teaching at the Bauhaus, all of which sent ripples through the student body and faculty. For this reason, the Dessau period is the most heterogeneous in the institution's history.

Americans were quick to recognize that the Bauhaus owed its exceptional status and magnetism largely to the group of people who came together and contributed

35 See especially Hans M. Wingler, *The Bauhaus: Weimar, Dessau, Berlin, Chicago,* 561. The *Avery Index* of 1958 and 1973 reflects the extensive exclusion of the Berlin Bauhaus from American reception in those critical years and in the decades that followed: in neither edition does "Bauhaus. Berlin" appear as a separate listing, nor is it noted under the heading "Bauhaus."

36 Douglas Haskell, "The German Architects," 449.

37 Josef Albers, Lyonel Feininger, Wassily Kandinsky, and Joost Schmidt remained at the Bauhaus for the entire Dessau period. Paul Klee and Gunta Stölzl left the Bauhaus in its last year in Dessau. Hinnerk Scheper was on sabbatical for part of the time. But all of them worked under all three directors. Wingler, *The Bauhaus: Weimar, Dessau, Berlin, Chicago,* 614.

their creativity, experience, and energy to the school. But credit, or even attention, was not necessarily given according to the importance of their contribution to the Bauhaus's success. In the reception of the twenties, interest in the big names increased, especially in the personalities of Gropius and Mies. The prevailing identification of the institution with these two directors bespeaks an increasingly selective perception of the Bauhaus's activities and a tendency to be captivated by proven and successful leaders. In contrast to these two, the fame and popularity of the Bauhaus's other representatives varied considerably during the seventeen-year period studied here. The image of most other Bauhaus denizens remained pale or obscure, despite the important functions they had at the school. The identification of educational institutions with their directors is typical in our didactically oriented society, and the reception of the Bauhaus is no exception. Nonetheless, this stilted view is particularly unjust in the case of an institution populated by so many highly regarded artists and pedagogues.

Walter Gropius Walter Gropius ran the Bauhaus for nine years, from April 1919 until April 1928. His original manifesto for the Staatliches Bauhaus in Weimar proposed a unification of the arts under the primacy of architecture. The status granted to architecture carried over to the new program of 1923, in which he formulated his vision of the unity of art and technology. At that time, Gropius characterized architecture as "[walking] hand in hand with technology. It has developed a characteristic face that is considerably different from that of the old crafts-oriented building arts. Its typical traits are clear, well-proportioned features, adequate to all its necessary components like those of modern engineered machine products."[38]

The Weimar Bauhaus's curriculum had only vaguely addressed the students' demands for architectural studies, with the establishment of the Work Cooperative for Architecture (Arbeitsgemeinschaft für Architektur). The priorities of the school's 1919 manifesto were only met in Dessau in 1927, when an independent department of architecture was established. Meanwhile, the emphasis on the artistic aspects of the educational program and student work, already established in Weimar, had been dominant in the program. The same was true of the privileged position enjoyed by painters and interior designers. Professional awareness and ability in handicrafts were always part of the Bauhaus's educational program. Gropius considered these to be the essential underpinning of an architectural training. The experimental workshops were involved in the fabrication of objects and finishes for the Bauhaus buildings, including designs for the buildings' color schemes and the modest and sober prototypes for lamps, tubular steel furniture, and textiles. The architectural work was done by Gropius's office, which was associated with the Bauhaus; most of his employees were Bauhaus denizens. The office worked to establish standards and norms for the building elements and to cooperate with industry and trades.

After nine years of running the Bauhaus, Gropius decided to focus his ambition on other aspects of his work. In a letter dated 4 February 1928, he informed the city of Dessau of his resignation as Bauhaus director. He recommended as his successor the Swiss architect Hannes Meyer, who had arrived at the Bauhaus a year earlier at Gropius's invitation. László Moholy-Nagy, Marcel Breuer, and Herbert Bayer left the Bauhaus subsequent to Gropius's resignation.

In the United States, the Bauhaus, both as a work of modern architecture and as an institution, was linked to no other person in the same way as to its founder and first director.[39] Wherever the magazines, books, and exhibitions of the Bauhaus were mentioned, his name was almost always mentioned, too. This was true in reverse during the school's first years as well. The facts that Gropius was the author of the Bauhaus concept, the founder of the school modeled on that concept, and the architect of the building embodying his concepts were all well known in America. At the same time, the fact that other architects, in particular Carl Fieger and Ernst Neufert, had contributed significantly to the design and erection of the famous Bauhaus building remained virtually unknown.

The perception of Gropius changed over the years. Before 1928, the year of his first visit to America, he was often portrayed in American journals in conjunction with the Bauhaus's work. In this context, his theories and pedagogy were the focus of interest, not his architecture, a tendency rooted in the years of the school's founding. The article "Revolution Reflected in the 'New' Art of Germany" in *Current Opinion* and Milton Lowenstein's 1929 text "Germany's Bauhaus Experiment" in *Architecture* both reflected this focus. One exception was Herman George Scheffauer's article "The Work of Walter Gropius," which appeared in 1924 in *Architectural Review.* Scheffauer downplayed the Bauhaus, its basis, principles, and achievements, in favor of a monographic presentation of its founder's architectural work. Nonetheless, the Bauhaus remained the vehicle by which Gropius gained recognition on the American architectural scene. His personality and work were increasingly understood independently of the school after the realization of the Bauhaus Dessau buildings. Until 1926, only a few bits of information on him, scattered over several years, had reached America, so that the Bauhaus building secured his reputation as an architect in the States. The work was discussed and depicted in several different contexts in American periodicals and books; it would lose nothing of its fascination over the years to come.

After 1928, Gropius's fame grew in leaps, then remained constant in the years thereafter, only to grow yet again in the period from 1934 to 1936. In exhibitions and publications, his connection to the Bauhaus was often noted, but differently than had been the case in the early twenties. After 1928, the year of his resignation and of his first trip to

38 Walter Gropius, *Internationale Architektur,* 7ff.

39 For a comparison with the German reception, see Friedhelm Kröll, *Bauhaus 1919–1933,* 43.

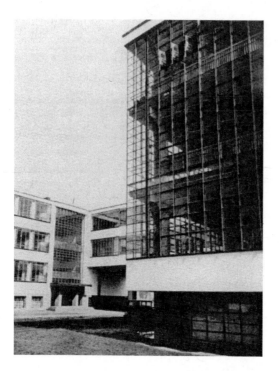

3.4 The Bauhaus building in Dessau, as featured in the *Architectural Record,* 1930. (Photo by Lucia Moholy from the *Architectural Record,* with kind permission of F. Karsten, London.)

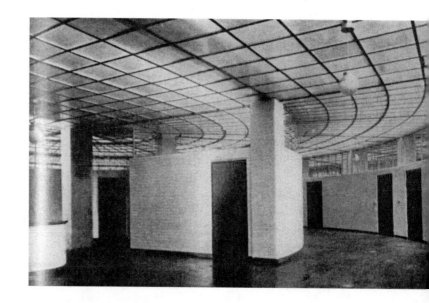

3.5 Employment office, Dessau, 1928–1929. Walter Gropius, architect. Featured in the *Architectural Record,* October 1930.

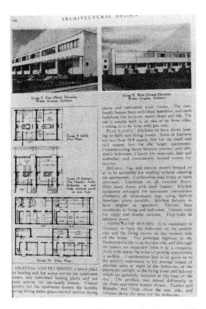

3.6 The Dammerstock housing development. Article by Ise Gropius, published in the *Architectural Forum*, August 1930.

America, the focus was no longer the concepts of the Bauhaus but rather the architect Walter Gropius. The Bauhaus became an attribute, often no more than a bibliographical note in articles and comments about his professional career. The fact that the Bauhaus could be mentioned without further explanation indicates that American architects had a certain degree of familiarity with the institution by that time. In the thirties, the architect Gropius was discussed primarily in relation to his architectural work and less in relation to his theories. Americans learned about the Totaltheater and the residential buildings in Dammerstock and Dessau-Törten in 1930 and about Siemensstadt in 1931. In the same year, these works were published within the context of the discourse on urbanism and skyscraper building, and discussed in terms of their intellectual grounding, principles, and technical and material innovations. Gropius's houses and housing complexes remained at the center of subsequent publications in which the buildings in Siemensstadt and his experiments in industrial production methods, prefabrication, and new materials received increasing attention.

By 1933, Gropius was so well known that the *Architectural Record* paid him a tribute, complete with portrait, on the occasion of his birthday. Information about his beliefs regarding social, political, and educational issues became more accessible in the context of the housing discussion after 1934. British journals at this time were especially interested in his English buildings and projects. American periodicals also devoted greater attention to his work after 1934. Shortly thereafter, his work as an industrial designer attracted notice, too.

In 1936, George Nelson published a comprehensive article entitled "Architects in Germany Today: Walter Gropius, Germany" in *Pencil Points*. It presented Gropius as the founder of the Bauhaus and an architect of the Neues Bauen. A personal interview in London had preceded the article. At this point, the Bauhaus had been closed for more than two years and National Socialism's cultural politics had affected the existences of people and institutions unmistakably. Josef and Anni Albers, two long-time and important Bauhaus professors, had fled to North Carolina; and they were not the only acquaintances of Gropius who had been forced to emigrate. It was logical that Nelson should mention the political developments in light of these facts and demand

that Gropius take a position on them. It is less understandable that Gropius avoided any criticism of the Third Reich and retreated to a position, lacking open solidarity with the regime's victims, that today is rightfully attacked as careerist. He went so far as to recommend to Nelson that the journalist avoid any political commentary on the dominant opinion on contemporary art in Germany. He explained his reasons in a letter to Nelson:

As I explained to you in London, I am concerned with insuring that no political comments of any kind will appear on the general German opinion against contemporary art, to whose protagonists I belong. Because all cultural matters in Germany are as yet entirely unsettled, any commentary from outside the country would be premature and would disadvantage my personal situation. I must demand that my photographs and the interview may only be published under this condition.[40]

Walter Gropius was accustomed to shaping the image that others fashioned of him. Since 1928, he had intervened in the American reception of his person and his work. His visit to America in that year, his contacts and correspondence with American professionals, his published work in the American media, and his book *The New Architecture and the Bauhaus,* which appeared in English in 1935 and described his attitude toward architecture and its relationship to the Bauhaus's philosophy, all served this purpose. The book was discussed extensively in the American architectural press. In the context of these events, the Bauhaus gained new prominence through the attention paid to Gropius between 1935 and 1936. This prominence was reinforced by the American debate on architectural education and on the possibility of applying the school's principles to the American system. It was in 1936, after all, that Gropius began his negotiations with Harvard University.

Gropius's name was to remain associated with the Bauhaus even after his official departure from Dessau, a fact that had little to do with historical events, but instead bespeaks a carefully maintained connection that is apparent in his words and action. Gropius was not only responsible for the selection and installation of his successors at the Bauhaus, but he also interfered with the founding of succeeding schools and controlled the posthumous reception of the Bauhaus to an amazing extent. On the other hand, "Mr. Gropius," as he was called in his old age, respected his responsibility to former students, colleagues, and supporters even after his emigration to England and later to the United States. He remained true to the Bauhaus's ideals and propagated them. As early as the spring of 1935, he secured positions for Moholy-Nagy and Breuer in England. After 1937, he sought work for Breuer and Herbert Bayer in the States. He recommended Moholy-Nagy for the directorship of the School of Industrial Design in Chicago and supported his friend's attempts to establish the New Bauhaus Institute. He tried continually to secure a teaching position at Harvard University for Josef Albers and gave regular guest lectures and seminars at Black Mountain College in North Carolina, where Albers and his wife, as well as his friend Xanti Schawinsky, taught and

Gropius's daughter Ati studied. He responded to calls for help from wartime and post-war Germany from Otti Berger, Adolf Sommerfeld, and others.[41] In 1946, Gropius organized a "Bauhaus Fund" to finance care packages for the former Bauhaus denizens who had remained in Germany by collecting contributions from those in the United States. Oskar Schlemmer, Joost Schmidt, Georg Muche, and Fritz Hesse all profited from this assistance.[42] Until the end of his life, Gropius cared for the Bauhaus, which he saw as his bequest, and worked to assure the proper understanding of his ideas. His active correspondence with former colleagues, officials, and museums on both sides of the Atlantic and his own written documentation, speeches, teaching, and contributions to symposia and exhibitions are proof of his commitment. His will of April 1933 asks that his death be celebrated in the tradition of the Bauhaus: "Wear no signs of mourning. It would be beautiful, if all my friends of the present and the past could get together for a fiesta a la Bauhaus—drinking, laughing, loving. Then I shall surely join in more than in life."[43]

It is not uncommon that the names of the founders and philosophic forces behind certain private educational institutions to remain identified with those schools, as in the case of Rudolf Steiner or Maria Montessori. The fact that a public institution, which the Bauhaus was during Gropius's tenure, remained identified with his name even after his departure is, on the contrary, unusual.

Hannes Meyer The Swiss architect Hannes Meyer succeeded Gropius as the director of the Bauhaus and held the position for some two years. In the summer of 1930, the city of Dessau terminated his contract on the grounds of an ideologizing of the Bauhaus.

At the end of his short tenure, Meyer could look back on considerable successes. His most extensive measure was to realize his predecessor's plans for an independent department of architecture at the Bauhaus by introducing a systematic course of study in the discipline. Based upon his own strict functionalist philosophy, he dismissed the establishment of aesthetic standards pursued under Gropius as formalism and thus reduced the status of artists and their work at the Bauhaus considerably. In accordance with his socialist *Weltanschauung*, he modified the curriculum to emphasize the value of practical work, raising the workshops' production and gearing it toward serving

40 Walter Gropius, letter to George Nelson dated 14 September 1935, quoted in Isaacs, *Walter Gropius*, 2:846.

41 Isaacs, *Walter Gropius*, 2:723, 782, 784, 803ff., 816, 826, 854f., 867, 869ff.

42 Letter from Walter Gropius to Mies, 30 October 1946 and 2 January 1947, both in the Mies van der Rohe Files, Library of Congress.

43 Robert Taylor, "Gropius Expressed 'America.'"

the needs of the people rather than luxury-oriented buyers. These curricular changes, which amounted to a restructuring of courses according to scientific methods, instituted a more general education, which Meyer reinforced by introducing new courses and guest lecturers. He defined the duty of architecture primarily in terms of organizing life. As he stated on assuming the directorship:

building is the deliberate organization of the processes of life.
building is a technical process and therefore only one part of the whole process. the
 functional diagram and the economic program are the determining principles of the
 building project.
building is no longer an individual task for the realization of architectural ambitions.
building is the communal effort of craftsmen and inventors. only he who, as a master
 in the working community of others, masters life itself . . . is a master builder.
building then, grows from being an individual affair of individuals (promoted by unem-
 ployment and the housing shortage) into a collective affair of the whole nation.
building is nothing but organization:
 social, technical, economical, psychological organization.[44]

The reception of Hannes Meyer in the United States contrasts in many respects from that of his predecessor. Before the end of the twenties, he was virtually unknown. At the beginning of the thirties, he was mentioned in architecture criticism concerned with the Bauhaus. His competition for the Palace of the League of Nations in Geneva[45] as well as other published works[46] and his function as director of the Bauhaus counteracted the anonymity of most Bauhaus denizens outside of Europe. This process was accelerated when he received foreign visitors, including Gropius's friend Robert Davison in 1929,[47] in his capacity as the school's director. Nonetheless, information and illustrations of his work were scarce in America: in the period at stake here, there was hardly any textual or visual material available that would have permitted a recipient to form even an initial judgment. For the most part, Meyer was the focus of criticism, almost all of it extraordinarily negative, as a person and not as an architect. One exception was an article in *Commercial Art and Industry* which stated that Meyer had been right to acknowledge the end of the period of artistic innovation and individuality at the Bauhaus. The article also affirmed that the time had come for more organization, precision, and systematic work.[48] Because the information on Meyer available in America was so limited, the commentary of a few authors became enormously influential.

One of the few bits of information generally known was his connection to the Bauhaus. As director, he obviously could not be ignored. It is clear, however, that almost all authors who mentioned Meyer made him responsible for the school's political difficulties. Neither Gropius nor any others who had been responsible for the institution were asked the reasons for Meyer's appointment nor to explain the extenuating political circumstances that characterized the period of his directorship. It is possible that Gropius's considerable involvement in the decision to appoint Meyer was

unknown. Nonetheless, those who were favorably disposed toward the Bauhaus perceived Meyer's appointment as a short-lived mistake. The fact that his tenure was bookended by that of Gropius and Mies, both of whom were increasingly seen in America as architectural giants and European pioneers, put Meyer at a further disadvantage with respect to his reception in America.

The critical attitude that either ignored or censured Hannes Meyer is ironic, considering the dominance of architecture in the reception of the Bauhaus at the end of the twenties. It was, after all, Meyer who institutionalized architecture at the Bauhaus by making it a central discipline in the course of study. He treated all of his architectural commissions as official Bauhaus commissions, quite unlike Walter Gropius. He was also successful in realizing his predecessor's wish to sell the workshops' models to industry as prototypes and thus to raise money for the institution.[49] But even his qualities as a businessman and financial planner did nothing to change the sparse and negative American reception. After an initial period of neutral observation, during which Henry-Russell Hitchcock praised Meyer and his partner Hans Wittwer and their entry in the 1928 Geneva Palace of Nations competition in two separate publications[50] and other authors merely described Meyer neutrally, an image was formed that led to his exclusion for many years from the circle of seriously received Bauhaus architects.[51]

One explanation for this phenomenon may be found in Barr's foreword to Hitchcock and Johnson's *The International Style.* The author dismisses Meyer as a "fanatical functionalist."[52] The wording of the text reveals the negative connotations of the functionalist label: "Some modern critics and groups of architects both in Europe and in America deny that the aesthetic element in architecture is important, or even that it exists. All aesthetic principles of style are to them meaningless and unreal. This new conception is science and not art, developed as an exaggeration of the idea of functionalism."[53] This passage clearly responds to Meyer's anti-artistic conception of architecture which was intended to limit architecture to a practical, functional formula:

44 Hannes Meyer, "Bauen: Building," quoted in Wingler, *The Bauhaus: Weimar, Dessau, Berlin, Chicago,* 154.

45 Bauhaus-Archiv Berlin, ed., *Hannes Meyer,* 110ff.

46 Frederick J. Woodbridge, "Ideas from European Schools," 726–729.

47 Isaacs, *Walter Gropius,* 2:532.

48 E. Suschitzky, "University of Commercial Art," 114.

49 Bauhaus-Archiv Berlin, ed., *Hannes Meyer,* 241.

50 Hitchcock, *Modern Architecture,* 190; Hitchcock, "*International Architecture,* by Walter Gropius," 191.

51 See Howard Dearstyne's critical evaluation of the Meyer era in *Inside the Bauhaus,* 205.

52 Alfred H. Barr, Jr., introduction to Hitchcock and Johnson, *The International Style.*

53 Hitchcock and Johnson, *The International Style,* 35.

building
all things in this world are a product of the formula: function times economy
all these things are, therefore, not works of art:
all art is composition, and hence is unsuited to achieve goals.
all life is function and therefore unartistic.[54]

The "aesthetization of nakedness"[55] that some critics now perceive in Meyer's architecture was seen by the authors of *The International Style* only as sober functionalism, and was incommensurate with the aesthetic values and desires of the American scene. In addition, the architectural history of the United States did not include the precedents that had prepared German architects for this moment. German architects had a reason to adopt a constructivist approach in seeking solutions to the elementary demands of daily use and habitation, and to legitimize the use of unclad industrial materials such as steel, concrete, and glass. A third reason for Meyer's rejection was the "collectivist tendency" prevalent at the Bauhaus under his direction.[56] When Barr called Meyer a "fanatical functionalist," he also meant "fanatical Marxist."[57] The implicit political and social aim of "improving the lot of the underprivileged classes"[58] met with little sympathy in the United States.

An article on the Bauhaus from *Art Digest* of 1931 gives an impression of the severity of the ideological dissent and of the misinterpretation of complex realities:

Under Meyer's *regime*, the *communist* student was favored and some students stayed on indefinitely at the expense of the bourgeois city of Dessau, which, nevertheless, continued its support of the Bauhaus. . . . He carried his *communism* so far that the city of Dessau wanted to stop the Bauhaus as an art school and turn its buildings into a hospital. The Bauhaus fell into disrepute. Germany ridiculed the *cliques of cantaquerous theorists* who did nothing but talk and issue manifestos to each other. Finally, the town of Dessau had enough of it and in September, 1930, dismissed Hannes Meyer as director.[59]

Four years later, the accusation of communism was echoed in George Nelson's influential article on Mies in *Pencil Points.* Nelson openly identified functionalism with communism: "Hannes Meyer [is] a functionalist and communist to boot. More interested in communism than architecture, apparently, Meyer changed the character of the school radically."[60] In the American reception of the Bauhaus, the decisive rejection of Meyer was to last for decades. It was based on the conviction that his political orientation had threatened the Bauhaus's existence. The fact that the Bauhaus was, in the meantime, received positively by large circles in the United States lent this belief the power of an accusation. Considering the political realities of Germany in 1930, this was an ironic inversion of the actual culpability.[61]

There are differences of opinion on whether Meyer was in fact a communist. Frank Whitford and others, including Gerhard Richter who studied with Meyer at

the Bauhaus in 1928–1929, implicitly affirm that he was when they speak of "Meyer's Marxism" or "the Marxist Meyer."[62] Howard Dearstyne and the Bauhaus-Archiv Berlin take a more moderate stance in their publications. Dearstyne, who knew the Bauhaus through his own experiences as a student, notes that many consider Meyer a communist because he went to the Soviet Union after his dismissal from the Bauhaus and worked there until 1936.[63] In its more recent publications, the Bauhaus-Archiv Berlin establishes that Meyer may have sympathized with the communist students at the Bauhaus beginning in 1929 and that these students may have contributed to the radicalization of his position. Meyer himself never took a clear position on the accusation of politicization among the students but rather emphasized that he was a cultural, but not a political, Marxist.[64]

According to later sources, Josef Albers and Mies van der Rohe, two prominent Bauhaus émigrés to the United States, contributed to Meyer's negative image there. In the case of Mies, this occurred within the period under examination. Albers, according to Mary E. Harris, the author of a well-respected book on Black Mountain College in North Carolina, felt repressed by Meyer's political ideology at the Bauhaus and feared the development of a political cell within the Bauhaus community.[65] Mies, according to the critic Sandra Honey in 1978, is said to have described the Bauhaus under Hannes Meyer as "a rather hectic place, with a wild group of students agitating for one thing or another, and turning out a large crop of illegitimate babies, much to the hor-

54 Hannes Meyer, "Bauen: Building," quoted in Wingler, *The Bauhaus: Weimar, Dessau, Berlin, Chicago*, 153.

55 Claude Schnaidt, "Ce qu'on sait, croit et ignore du Bauhaus," in Georges Tautel, ed., *L'influence du Bauhaus sur l'architecture contemporaine*, 22.

56 Hans M. Wingler, *Das Bauhaus, 1919–1933*, 148.

57 For comparison, see Peter Eisenman, introduction to Philip Johnson, *Writings*, 11–12.

58 Kröll, *Bauhaus 1919–1933*, 89.

59 "The Bauhaus" *(Art Digest)*, 28. Emphases are by the author of this article: note the journalist's polemical rhetoric.

60 Nelson, "Architects of Europe Today: Van der Rohe," 458.

61 On the question of culpability, see "The Bauhaus" *(Art Digest)*, 28, and Haskell, "The Closing of the Bauhaus," 374f.

62 Whitford, *Bauhaus*, 190. Gerhard Richter says of Meyer: "He was a communist to the core." In response to the question how he knew that, Richter answered that he placed the good of the community over that of the individual in all his activity and in everything he said, nor did he tolerate student work that ignored this credo. Author's interview with Gerhard Richter, 30 May 1991.

63 Dearstyne, *Inside the Bauhaus*. Compare Bauer, *Modern Housing*, 223.

64 Bauhaus-Archiv Berlin, ed., *Hannes Meyer*, 160, 162.

65 See Mary E. Harris, *The Arts at Black Mountain College*, 54.

ror of the staid citizens of Dessau."[66] The author is apparently referring to a part of Nelson's 1935 article on Mies, in which it is unclear whether this statement reflects Mies's opinion or Nelson's interpretation.[67] The image of the destructive communist Bauhaus functionary would seal the reception of Meyer as architect and Bauhaus teacher in the United States for a long time and prevent his historically accurate integration.[68]

Meyer's exclusion may seem a logical consequence of the American perception of Gropius and Mies as the embodiment of the Bauhaus. Meyer's own conscious attempt to distance himself from Gropius's conception of the Bauhaus reinforced this response. In protest of his dismissal as Bauhaus director, he wrote to the mayor of Dessau, Fritz Hesse: "Inbred theories [of the Gropius Bauhaus] closed every approach to a form for right living; . . . Art stifled life everywhere. Thus my tragic-comic situation arose: As Director of the Bauhaus I fought against the Bauhaus style."[69] At least from a formal perspective, Meyer's position against the integration of art in architecture at a school that was originally founded to pursue the idea of the *Gesamtkunstwerk* would have explained the negative perception of him and his almost complete exclusion from the reception of the Bauhaus in the United States. More than forty years later, Philip Johnson admitted:

Hannes Meyer was a communist and was a damned good architect and the more I see of Hannes Meyer, the greater man I think he was. But I don't like what he *said*. There has been much criticism even recently about his design for the League of Nations Building, for instance, an article in *Architectural Design* on how much better Corbusier's proposal was. I'm not so sure, but Meyer presented it in the worst way he could, an isometric, a totally meaningless design. You see, in those days I hated Hannes Meyer because I thought that the shit of the Neue Sachlichkeit Weltanschauung had something to do with architecture. The only mistake I made was to try to think that somehow the political opinion had something to do with the architecture. Not true at all! At that time, I was just anti-functionalist, you see. I was never anti-Marxian. Who cares who runs a country! I *still* believe that. I loved Stalin.[70]

Johnson's reevaluation of the architect Meyer within the modern movement and thus in the reception of Bauhaus architecture came too late. The destructive consequences of the negative judgment passed on him in one of the most influential texts on architecture of the time could not be revoked.

Ludwig Mies van der Rohe Ludwig Mies van der Rohe took control of the Bauhaus in August 1930, at a time in which the National Socialist movement was already strong. After the political confrontations surrounding Hannes Meyer, he tried to deideologize the institution radically. Under the pressure of

the necessary rationalization and consolidation of means and methods, he academicized the program and structure of the school. Thus, the Bauhaus moved closer to the usual form of a school of architecture at the level of higher education. This meant an almost complete end to the production of the workshops and the redefinition of the remaining courses to concentrate on interior design and all aspects of architecture. Lilly Reich and Ludwig Hilberseimer were hired, a move that reflected this change. Mies reduced the number of artists, but retained his high artistic demands on architecture. He distanced himself unambiguously from Hannes Meyer's social and functionalist conception of architecture and propagated his own understanding of architecture as a spiritual process bound to time and value:

The new age is a fact; it exists entirely independently of whether we say "yes" or "no"
 to it.

. . .

Let us accept as a fact the changed economic and social conditions.
All these things take their preordained and value-blind course.
What will be decisive is how we are going to retain our values within these given facts.
This is where the problems that challenge our intellects begin.
What matters is not "what" is being done, but simply and solely "how."

66 See Sandra Honey, "Mies at the Bauhaus," 52.

67 For comparison, see Nelson, "Architects of Europe Today: Van der Rohe," 458. Without quoting Mies or even referring to him, Nelson wrote about the Bauhaus under Meyer: "It must have been a rather hectic place, with a wild group of students agitating for one thing or another, and turning out a large crop of illegitimate babies, much to the horror of the staid citizens of Dessau." The lack of clarity about Mies's actual words prompts caution in evaluating Mies's involvement in the reception of Meyer in the United States.

68 It is notable that the integrated computer index of 1991 in the libraries of the three largest North Carolina universities, all of national reputation and incorporating a department of architecture or art history, have no listing under "subject: Meyer, Hannes." The treatment of Meyer varies in the U.S. encyclopedias of architecture. The AIA Encyclopedia of Architecture, 1989, 1:418ff, mentions Meyer's tenure as Bauhaus director but does not include an individual entry under his name. The Architecture Book, a paperback encyclopedia by Norval White, mentions Meyer neither under the Bauhaus nor individually. Adolf K. Placzek, ed., The Macmillan Encyclopedia of Architects, 3:162–164; James M. Richards, ed., Who Is Who in Architecture (1977), 211; and N. Silver in Morgan and Naylor, eds., Contemporary Architects, 187, 598, are more favorable toward Meyer. The Avery Index of 1958 lists only one article, from 1942 in Spanish, 4:6850. Of the 23 entries in the 1973 edition, only one by Kenneth Frampton is in English, 9:665. The mid-eighties saw the first objective evaluations of the Hannes Meyer era at the Bauhaus.

69 Hannes Meyer, "My Expulsion from the Bauhaus: An Open Letter to Lord Mayor Hesse of Dessau," published in Das Tagebuch, 1307, and quoted in Wingler, The Bauhaus: Weimar, Dessau, Berlin, Chicago, 163.

70 Philip C. Johnson in John W. Cook and Heinrich Klotz, Converstions with Architects, 38.

The fact that we are producing goods with these particular tools says nothing about our spiritual endeavors.

Whether we build tall buildings or low ones, whether we construct with steel or glass, says nothing about the merit of the building.

Whether centralization or decentralization is desirable in city planning is a practical question and not a question of values.

But what is decisive is just this question of values.

We have to set new values and to point to the highest intentions in order to obtain standards for judgment.

Purport and justification of any age, hence also of the new age, lie simply and solely in that it offers the spirit of prerequisites, the means of existence.[71]

Mies's view of architecture was deeply rooted in the spiritual concepts of Augustine and Thomas Aquinas and revealed his awareness of the classical European traditions. His directorship in Dessau and Berlin was an unusual step in the career of a man who had never taught and did not seem extremely interested in doing so. His role at the Bauhaus was followed attentively from the United States. The sharply observed political developments in Germany and the spectacular closure of the Dessau and Berlin Bauhaus associated with those developments were in part responsible. The Bauhaus's move from Dessau to Berlin was commented upon by *Architectural Forum* as follows: "The Bauhaus school, which was evicted from its quarters in Dessau, Germany, by the Government, has reopened in Berlin. The teaching staff remains the same, with Miss [sic] van der Rohe, who became director in 1930, continuing as head of the school."[72] The report bespeaks the author's interest and relative ignorance. There were de facto changes in the teaching staff following the move. The incorrect spelling of the name could be a misprint. However, the fact that such misspellings were often and varied in the American media of the early thirties indicates that Mies van der Rohe was, despite his eminent position in the European avant-garde of the twenties, much less well known at that time than Walter Gropius.[73]

Unlike Mies, the Bauhaus's founder had already realized a revolutionary building in the language of classical modernism, the Fagus factory in Alfeld an der Leine of 1911, before the First World War. His production and administration building for the German Werkbund Exposition of 1914 in Cologne represented another milestone in his career. Both buildings were published in America in the early twenties. Mies's assumption of the directorship in the Bauhaus's comparatively unspectacular late phase, plagued by political, financial, and organizational problems, and the short period of his tenure were less favorable to his finding fame as a protagonist of the Bauhaus. The position offered him no opportunity to realize a built work that would be representative of his time at the Bauhaus as his predecessor had done. His only building in Dessau was a small kiosk which he completed in 1932 as a municipal com-

mission and which went unnoticed in the States.[74] His reputation as a leading architect of the Neues Bauen was based in America on his 1927 directorship of the Weissenhof exposition in Stuttgart, where he also shone as the architect of an apartment building. The Siedlung, which included a group of row houses and apartment blocks, created a stir: it provided an overview of the various directions within the European avant-garde by providing an opportunity for leading German architects to build in collaboration with such European colleagues as Le Corbusier, J. J. P. Oud, and Mart Stam. Otherwise, Mies's architectural works were realized outside of a Bauhaus context: the Tugendhat house in Brno of 1930 and the Modellhaus at the Berlin Building Exposition of 1931. This does not mean that his affiliation with the Bauhaus escaped the notice of the architecture scene in the United States.[75] His assumption of the directorship marked the beginning of a phase in which not only was he associated with the Bauhaus, but in which that association became instrumental for his growing recognition in America. His pedagogic and administrative role at the institution was

71 Ludwig Mies van der Rohe, "Die neue Zeit," quoted in Wingler, *The Bauhaus: Weimar, Dessau, Berlin, Chicago,* 169.

72 "Bauhaus Reopened," 20.

73 Walter Gropius was amused by the various bastardizations of the name "Mies"; whenever he encountered one, he told Ludwig Mies van der Rohe of the anecdote. See, for example, Gropius's letter to Mies, 12 July 1966. Even after the early forties, Mies received letters, including some from architectural publications, in which his name was misspelled. See, for example, Subscription Service, *Architectural Forum,* letter to Mies, 14 May 1940; editor of *Architectural Forum,* letter to Mies, 17 February 1943, both in the Mies van der Rohe Files, Library of Congress. Mies always had his secretary respond with a letter correcting the spelling.

74 The only mention made of it in the literature was in 1986 as "Mies' unknown project" in Howard Dearstyne's book *Inside the Bauhaus,* 235ff., until Helmut Erfurth and Elisabeth Tharandt produced their monograph on the building, which no longer exists: *Ludwig Mies van der Rohe, die Trinkhalle. Sein einziger Bau in Dessau.*

75 Mies van der Rohe's Bauhaus affiliation is noted in "The Bauhaus" *(Art Digest),* 28, which emphasizes the political difficulties at the beginning of his tenure. Helen A. Read, "Exhibitions in Germany," 11, mentions Mies's position as Bauhaus director in the context of other, positively valued roles. Haskell, "The Closing of the Bauhaus," 374f., offers a rough insight into the most general curricular foci of the Bauhaus without going into detail about Mies's changes. Haskell at least defines Mies's position within the spectrum of architecture pedagogy at the Bauhaus. Nelson, "Architects of Europe Today: Van der Rohe," 458f., devotes only a brief section to Mies's activity at the Bauhaus. It thematizes only the initial political situation and ends with a conclusion that is in equal parts incorrect and disarmingly meaningless: "He [Mies] stayed only a year, however, doing some interesting work." Compare also the anonymous article "Education of the Architect," 214. A rare exception to the general lack of commentary on the particular pedagogic principles pursued by Mies is the short note in Hitchcock, Johnson, and Mumford, *Modern Architecture: International Exhibition,* 113: "Although his [Mies'] educational ideas are more concerned with art than those of his *sachlich* predecessor, Mies does not teach design. As in all architectural styles of the past, Mies feels that artistic ideas should be absorbed unconsciously while the student is learning to be a good builder."

3.7 *(this page)* Ludwig Mies van der Rohe and Lilly Reich: Living room with plate glass partitions, designed for the 1927 Weissenhof exposition, Stuttgart, as featured in the *Architectural Record,* October 1930. (Photos by Walter Lutkat, courtesy of the Mies van der Rohe Archive, The Museum of Modern Art, New York.)

3.8 *(this page)* Views of the
Weissenhof exposition, Stuttgart,
1927, published in *The New World
Architecture* by Sheldon Cheney.
(Courtesy of AMS Press, Inc.)

discussed in one standard reference work of Anglo-American architecture literature, Sheldon Cheney's *The New World Architecture.* The first Bauhaus exhibition in the United States, in Cambridge, New York, and Chicago in 1930–1931, portrayed the Dessau Bauhaus as it was under Mies van der Rohe. Lincoln Kirstein's text in the publication that accompanied the exhibition praises not only the architect Mies but also the ambitious educator and school director:

Mies wishes to make the best school in the world for those who are interested in architectural development based, not on historical Beaux Arts points of view but, regardless of tradition, on the principles of functionalism of materials that are necessary and indigenous to the present. He has stopped the communistic theorizing and has given his pupils actual tools and materials to work with. Instead of designing ten possible chairs, they build him one actual chair. . . . This experiment in education, however intermittent, must surely rank as the most original movements in the instruction of Fine Arts in the first part of the Twentieth Century.[76]

Kirstein misattributes a functionalism and pragmatism to Mies that was actually more true of the Bauhaus's previous epoch and thus blurs ideas, personalities, and time periods. Nonetheless, he fairly assesses the third director's influence on the Bauhaus.

An increase in the information on Mies van der Rohe's Bauhaus was apparent in 1931 and 1932. It coincided with an increase in American visitors to the institution, as noted in the Bauhaus diary of that year. The political difficulties that eventually led to the Bauhaus's closing, the move to Berlin, and the definitive end to the teaching activities in August 1933, also did much to keep Mies's name in the minds of interested Americans. Thus the "Modern Architecture" exhibition of 1932 in New York was not, as is often contended, largely responsible for first introducing Mies to America. Instead, it achieved what might be called a breakthrough in the American reception of Mies. It did so thanks to the institutional backing of the Museum of Modern Art and its influential organizers.

The exhibition was simultaneously also responsible for the fact that Mies's name was hardly ever mentioned in relation to the Bauhaus after the institution was finally closed. It portrayed Mies almost exclusively as an extraordinary avant-garde architect, just as Philip Johnson most admired him. Although Gropius was also presented as architect and not as theoretician and pedagogue, the fact that the Bauhaus building was at the center of his built work reinforced his affiliation in the consciousness of those who visited the exhibition.

The American reception of Mies in purely architectural terms overshadowed his significance as a school director. He transformed the character of the Bauhaus's programs in the years of his directorship and gained experience that would influence his fundamental reorganization of the architectural education at Armour Institute, the later Illinois Institute of Technology. In his speech on assuming office in Chicago, Mies

promised to reconceive entirely the existing curriculum at Armour Institute in accordance with the concepts he had implemented at the Bauhaus. Thus, it has yet to be established which of the two, Gropius or Mies, was more influential in reforming American architectural education on the basis of the Bauhaus's program.

The credit for introducing Mies's work to the American architecture scene at the beginning of the twenties may go to the article "Skyscrapers in Germany" by Walter Curt Behrendt. It appeared in the *AIA Journal* of 1923 and presented both daring skyscraper projects from the early twenties in text, illustrations, and floor plans. An image of the glass skyscraper with a polygonal floor plan was published three years later in Irving Pond's article "From Foreign Shores" in the same journal and in 1930 in Knud Lønberg-Holm's article "Glass: Technical News Research" in *Architectural Record*. Increasing attention was paid to Mies after he organized the Weissenhof exposition in Stuttgart in 1927, at which exemplary projects by European avant-garde architects were realized. He himself built a multifamily dwelling at the exposition. In 1929, Henry-Russell Hitchcock made reference to precisely this building in his book *Modern Architecture*, praising Mies as a highly promising pioneer of the Neues Bauen.

In 1929, the German Pavilion for the Barcelona world's fair was built. It might justifiably be expected that Mies van der Rohe's seminal work, published more often in Europe than any of his other buildings, would have ensured his breakthrough in America. It was, however, ignored in the United States. This is astonishing, in that media information on the world's fair was anything but paltry. One might explain the fact by contending that the American reporters were overwhelmed, or at least distracted, by the elegance of the old city and its historic buildings. Moreover, there may not have been anyone among them ready to acknowledge the first major international representation of German architecture since the First World War.

One exception was Helen Appleton Read's article "Germany at the Barcelona World's Fair" of 1929, which appeared in *The Arts*. She perceived the building's artistic quality, which, as she rightly recognized, completely removed Mies from the camp of the German functionalists. The contemplatively written text is accompanied by two photographs of the buildings. In a more than two-page article, marked by insightful observations, the author builds an argument for considering the work to be a masterpiece and a symbol of German postwar culture, characterized by clarity, objectivity, and integrity. Thus, the architecture of Mies van der Rohe is explicitly credited with expressing artistic and cultural-political value, as had previously been the case with the work of Walter Gropius as architect of the Weimar democracy or with the Bauhaus as institutional symbol of Germany's new democratic social order.[77] It was only in 1932,

76 Lincoln Kirstein, introduction to the Arts Club of Chicago's *Catalogue of an Exhibition from the Bauhaus, Dessau, Germany*, 3.

77 Helen A. Read, "Germany at the Barcelona World's Fair," 112f.

in Johnson and Hitchcock's exhibition "Modern Architecture: International Exhibition," that the building was acknowledged and duly respected by the architectural audience.[78]

Only after 1930, the year in which the Tugendhat house was completed in Brno, did the American reception of Mies gather speed. In contrast to the Barcelona Pavilion, this work was immediately acknowledged. Its flowing boundary between inside and outside was among the qualities noted; an article in *Architectural Review* stated: "[The Tugendhat House is] the consummate realization of the illusion of unclosed space: the envelope is so unobtrusive as almost to be unnoticeable."[79] Ignoring the controversies that the building had triggered in German architectural circles, Philip Johnson called it the "best looking house in the world."[80] Almost instantly, the Tugendhat house became the work by Mies most often published in the United States, as it remained during the following six years. In 1932, at the "Modern Architecture" exhibition in New York, a model of the house was displayed and much admired. A space designed especially for the house was illustrated in publications and received much attention, guaranteeing Mies's reputation by the beginning of the thirties as a designer of interiors and avant-garde furniture. This reputation sometimes developed its own dubious dynamic, as a letter from the editor of the journal *Modern Plastics* makes obvious. The "personal invitation" asks Mies "to submit as many entries as you possibly can" to a "Modern Plastics Competition," "in the interest of better design and application throughout the plastics industry."[81] Mies's reply is not known, nor are any efforts by him to design in plastics.

The organization of the German Building Exposition in Berlin in 1931 also circulated Mies's name in the American media. Helen Read's twelve-page article on the exhibition centered on Mies. She included illustrations of his work, wrote about his artistic relationship to Bruno Paul and Peter Behrens, compared him with other avant-gardists, and dealt with such concepts as "functionalism" and "Neue Sachlichkeit." Mies van der Rohe, the "celebrated architect and director of the Bauhaus in Dessau,"[82] as she reported, was in charge of the installation and direction of the renowned Berlin event. His own model house would be exhibited there.

Unlike Gropius, Mies did not intervene actively in the American perception of his person and work. But he was undoubtedly concerned that he not be identified with work and people who did not measure up to his standards. Thus, he warned Philip Johnson, who apparently was planning an exhibition on Mies and his students, not to be overly generous in defining the concept "student": "I thank you for your letter of November 2 of this year and understand that you would like to mount an exhibition of the work of my former students. It is somewhat unclear to me whom you are considering. But it is out of the question that anyone who spent only a short time at the Bauhaus or worked in my office can be considered my student."[83]

Mies himself maintained a certain distance from the Bauhaus in the twenties and, at least until the middle of the following decade, an ambivalent, if not critical,

attitude toward Walter Gropius. In a letter to Theo van Doesburg, for example, he criticized Gropius for the 1922–1923 curricular reorganization of the Bauhaus. He feared that the new constructivist position would favor a pseudo-artistic formalism.[84] Nonetheless, he accepted the invitation to participate in the Weimar Bauhaus exhibition from 1 August through 30 September 1923. When the first Bauhaus book was published in 1925, Gropius asked him to write an essay for one of the following volumes, although Mies declined.[85] On the other hand, Mies supported the Bauhaus during the preliminary negotiations between Gropius and the mayor of Dessau Fritz Hesse, when animosity in the city threatened to sway the decision of the city council. The mayor only agreed that the Bauhaus should move to Dessau after such prominent personalities as Peter Behrens and Mies van der Rohe as well as the Ring group had taken a stance in support of the plan.[86] In 1928, Gropius offered the directorship of the Bauhaus to Mies, who declined.[87] Only after Gropius, alarmed by the increasing political attacks to which the school was subject under Hannes Meyer, offered it to him a second time in 1930 did he accept. Mies had no experience with teaching at schools or universities, nor had he sought that experience.[88] The engagement with which he reconceived the Bauhaus, coached its students individually, and led the school proves his identification with the duties of the office. On the other hand, his interest in administration or in contact with the student body as a whole seems to have been minimal. His courses were only offered to a small number of advanced students, who were then able to enjoy privileged access to him. Under Mies, the Bauhaus's anti-academic character was lost. His understanding of learning and teaching at the Bauhaus was different in its professional and theoretical orientation from that of his predecessors.

After rejecting a position at Mills College in Oakland, California, that was of-

78 Elizabeth Mock, *Built in U.S.A., 1932–1944*, 22.

79 "House Plans, 1830–1930," 104.

80 Schulze, *Philip Johnson*, 68.

81 E. F. Longee, letter to Ludwig Mies van der Rohe, 5 May 1936, Mies van der Rohe Archive, Museum of Modern Art, New York, Correspondence.

82 Read, "Exhibitions in Germany," 11.

83 Ludwig Mies van der Rohe, letter to Philip C. Johnson dated 23 November 1934, Mies van der Rohe Archive, Museum of Modern Art, New York, Correspondence.

84 See Ludwig Mies van der Rohe, letter to van Doesburg, 27 August 1923, Mies van der Rohe Files, Library of Congress. For comparison, see Elaine Hochman, *Architects of Fortune*, 91, and Franz Schulze, *Mies van der Rohe: A Critical Biography*, 129.

85 Schulze, *Mies van der Rohe: A Critical Biography*, 129.

86 The "Ring," also called the Zehnerring (Ring of Ten), was a union of young architects founded by Mies van der Rohe. It was to prepare the basis for a new architecture appropriate to its time.

87 According to Whitford, *Bauhaus*, 185.

88 Author's interview with Dirk Lohan, 30 May 1990.

fered to him in 1935,[89] and after losing the competition for a chair at Harvard University to Gropius, Mies finally accepted the deanship at the Amour Institute in Chicago in 1938. His previous correspondence with the school proves that he saw himself primarily as an architect and not as a pedagogue. In the letters, he ascribes much more weight to his position on the qualities of an epochal architecture than to his education vision; he speaks only indirectly of the Bauhaus. There is speculation that Mies assumed the directorship of the Bauhaus in 1930 for primarily selfish reasons, at a time when his architectural practice was extremely slow. In fact, he did not get to build as much during those years as other prominent architects. In any case, the history of the Bauhaus proves that the school needed him to reestablish its reputation, perhaps more than he needed the school. His decisive defense of the Bauhaus against political attacks proves that he identified with the school. In the spring of 1933, when the Nazis confronted him with unacceptable conditions if he were to keep the Berlin school open, he denied them their chance to close the Bauhaus permanently by initiating a vote of the masters' council for a preemptive closing. For the American Bauhaus students who were partially responsible for disseminating his work in America and for his move to Chicago and who had known him as a teacher and architect, the name of Mies van der Rohe unequivocally stood for the school.

He was also the legal heir to the Bauhaus name. His contract with the city of Dessau stipulated that, in the case of a dissolution of the Bauhaus, the rights to its name would become the possession of the last director.[90] Mies was by no means indifferent to this privilege, as evident in his disapprobation of László Moholy-Nagy's use of the name for the New Bauhaus in Chicago.[91] He only relinquished the right toward the end of his life, in a letter to Gropius:

Dear Gropius,
I would like today to restore to you, founder of the Bauhaus and author of its name, the exclusive right to the name Bauhaus, which was granted to me after the Bauhaus's dissolution by virtue of my contract with the city of Dessau.
Regards,
Mies van der Rohe.[92]

Later American reception only rarely identified Mies with the Bauhaus. One such example was Harold Bush-Brown, who saw the Bauhaus's ideal of a unity of art and architecture realized in Mies's work: "In his own work, Van der Rohe [sic] was the personification of the Bauhaus, dedicated to bringing together art and industry in the common course of reform and expansion made possible by the effective use of science and technology."[93] For others, the association of the Bauhaus with its third director had only negative connotations. A statement made in the early fifties by Frank Lloyd Wright, who clearly considered Mies a Bauhaus architect, clearly expresses this: "These Bauhaus architects . . . ran from political totalitarianism in Germany to what is now made by specious promotion to seem their own totalitarianism in art here in

America. . . . Why do I distrust and defy such 'internationalism' as I do communism? Because both must by their nature do this very leveling in the name of civilization."[94]

Unlike Gropius, Mies van der Rohe did not present himself in America as the keeper of the Bauhaus faith. A man of few words, he tolerated questions about the Bauhaus and otherwise let his work and teaching speak for his position. Nonetheless, he always owned up to his role at the Bauhaus. His critical observations on the way its heritage was treated did nothing to change this, even after he refused on those grounds to contribute to the large 1938 Bauhaus exhibition at the Museum of Modern Art curated by Herbert Bayer, Walter Gropius, and his wife Ise. He contributed to Gropius's Bauhaus fund, wrote replacement diplomas for students whose documents had been lost in the war, stated his position on the Bauhaus in interviews and conversations, and remained in continuous correspondence with Gropius on the Bauhaus.[95] He cooperated whenever a common statement on an issue related to the school was required. Regardless of his confident evaluation of his own role in the Bauhaus's history, he did not lose his sense of proportion and acknowledged Gropius's right to administer the school's estate. When the British Broadcasting Corporation asked him for a comprehensive radio interview on his involvement with the Bauhaus, he responded: "I feel strongly that the person who should be interviewed is Walter Gropius. He can talk about the original idea of the Bauhaus which is, in my opinion, more pertinent, of more interest today and more important than the accidental political events that influenced its last years and loss." He had spoken enough about his contribution to the history of the Bauhaus, he added. There was nothing left to say.[96]

THE FACULTY

Josef and Anni Albers In the person of Josef Albers, America acquired an artist who had experienced the Bauhaus in all its phases and had been among the school's most gifted pedagogues. When he arrived as a student in Weimar in 1920, he became involved in the foundation course and was given partial responsi-

89 Franz Schulze, "The Bauhaus Architects," 234.

90 Copy of the contract, § 3, Mies van der Rohe Files, Library of Congress.

91 Schulze, *Mies van der Rohe: A Critical Biography*, 235.

92 Ludwig Mies van der Rohe, letter to Gropius, 18 August 1967, Mies van der Rohe Files, Library of Congress.

93 Harold Bush-Brown, *Beaux Arts to Bauhaus and Beyond*, 101.

94 Schulze, *Mies van der Rohe: A Critical Biography*, 259.

95 Mies van der Rohe Files, Library of Congress.

96 Ludwig Mies van der Rohe, letter to L. Cohn dated 7 May 1968, Mies van der Rohe Files, Library of Congress.

bility for the glass workshop. In 1925 in Dessau, he was named a "young master" (*Jungmeister*). After Moholy-Nagy's departure in 1928, he assumed full responsibility for the entire foundation course and directed it into a new trajectory that would later greatly influence art schools and other educational institutions in America. In this course, a prerequisite for all Bauhaus students, Albers had the students perform fundamental experiments with the most diverse of materials. The aim was to determine the materials' characteristics and behavior, and to understand the relationship between form and material. Tactile and other perceptual exercises that complemented the program were intended to sharpen the senses and to awaken a sensibility for solutions appropriate to the material used. Josef Albers followed the Bauhaus to Berlin, where he served at times as acting director. He remained until it was closed in 1933. Anni Albers, nee Fleischmann, had matriculated at the Staatliches Bauhaus in Weimar in 1922, where she pursued her interest in experimental textile design. She married Josef Albers in 1925 and went with him to Dessau, where she earned her diploma in 1930 and subsequently taught in the Bauhaus's weaving workshop.[97]

In the wake of the closing of the then-municipal school in 1932, Josef Albers like his colleagues received a threatening letter from the Dessau city council that canceled his employment contract on the grounds that they had turned the Bauhaus into a "cell of communism," with its director and teachers engaged in "political activities."[98] Josef Albers continued teaching in Berlin. After the dissolution of the school there in 1933, he was the first Bauhaus master to acquire a position at an American educational institution, Black Mountain College in North Carolina. His wife Anni, who was Jewish, joined him. The cost of the journey and their first wages were paid with assistance from the trustees of the Museum of Modern Art. Edward M. M. Warburg and Philip Johnson personally guaranteed financial support to help secure their visas.[99] Johnson had made his initial contact with the Albers through Theodore Dreier, cofounder of the college and the nephew of Katherine Dreier,[100] who had visited the Weimar Bauhaus in the early twenties and bought some of Josef Albers's work. Although she had not met him and his wife personally on that occasion, she discouraged her nephew from bringing Albers to the school when he consulted her on the matter. He ignored her advice. Later, Katherine Dreier would come to know the advantages of a professional collaboration with Josef Albers.[101]

Newspapers in New York and in certain cities in North Carolina reported the Albers' arrival.[102] Initially, more attention was paid to Anni Albers than to her husband. The *New York Sun* introduced her to American readers in 1933 as "Frau Anni Albers, one of the foremost designers of textiles in Europe and a leader in the movement started by the famous Bauhaus in Dessau, Germany, to revive the art of textile weaving."[103] Hardly any notice was given to Josef Albers despite his prominent position at the Bauhaus. Sigrid Weltge Wortmann explains this with the fact that Anni spoke English and Josef did not. This reception inverted the realities of the situation: in Germany, Anni Albers was much less famous than her husband, who was one of the

Bauhaus's masters as she was not. There were already, however, some American ob-
servers who forecast Josef Albers's success. Thus, Edward M. M. Warburg prophesied,
"Professor Albers may exert an influence in this country that will fundamentally
change present methods of approach to art education."[104]

Another exception was an article by Hitchcock that spoke of Albers in connec-
tion with the Berlin Building Exposition of 1931. It presented him, in accordance
with the circumstances, not as a painter or pedagogue but as a designer of interiors and
wood furniture. The article makes no mention of Albers's connection to the Bauhaus.
Hitchcock and Johnson were to cite the same domestic interiors one year later in *The
International Style,* this time accompanied by a photograph and descriptive text.[105]
Viewed retrospectively in the 1990s, Josef Albers's educational theories seem as valid
as they were in the 1920s and 1930s. In fact, he may be regarded as one of the most
influential Bauhaus artists.

Black Mountain College was located in a remote area of the Appalachians in
North Carolina. With its superregional student body and faculty, it remained an en-
clave during its first years. Albers's English was not fluent enough to allow him to
publicize himself. He first emerged in 1936, when he began to teach a course at Har-
vard University as adjunct faculty quite similar to the Bauhaus foundation course. This
contact led to his first American solo exhibition in a major American city. The New
Art Circle gallery of J. B. Neumann in New York, among others, showed his oil paint-
ings. Albers began to intervene in the reception of his work as painter and pedagogue
by means of his own publications,[106] although the Bauhaus remained in the back-
ground during these events. The same was true of Anni Albers and Xanti (Alexander)
Schawinsky, another Bauhaus artist who came to Black Mountain College in 1936.
Thanks to the fundamental research completed by Mary Emma Harris, we know today

97 Information from Stiftung Bauhaus Dessau, Archiv Sammlung.

98 Sheri Bernstein, "Josef Albers at Black Mountain College," 254.

99 Schulze, *Philip Johnson,* 105.

100 See the section "Points of Contact," chapter 2, above.

101 Sigrid Weltge Wortmann, *Bauhaus Textiles,* 163.

102 "Art Professor Fleeing Nazis, Here to Teach," *Brooklyn Daily Eagle,* 26 November 1933;
 "L. H. O., a Teacher from Bauhaus," *New York Times,* 29 November 1933; "Germans on Faculty
 at Black Mountain School," *Asheville* (N.C.) *Citizen,* 5 December 1933.

103 Weltge Wortmann, *Bauhaus Textiles,* 163, quotes the article in the *New York Sun,* 4 December
 1933.

104 "Germans on Faculty at Black Mountain School," 12.

105 See Henry-Russell Hitchcock's reference to Josef Albers's "livingroom with furniture, all in wood"
 in "Architecture Chronicle," 96; Hitchcock and Johnson, *The International Style.*

106 Josef Albers, "Why I Favor Abstract Art."

that the private Black Mountain College was "a spiritual heir and center for the transmission of Bauhaus ideas," although it was a liberal arts, and not an art, school.[107]

Lászlo Moholy-Nagy The Hungarian László Moholy-Nagy was unquestionably one of the most influential teachers and artists at the Bauhaus. He had been called to Weimar by Walter Gropius after the departure of Johannes Itten in 1923 to assume responsibility for the foundation course and the metals workshop. Moholy-Nagy's arrival effected a decisive change in the orientation of the school's program. The introduction of constructivist-related painting, the production of the Bauhaus books, and the development of the photogram and of kinetic sculpture are all tied to his name. He left the Bauhaus after Gropius's resignation. After living in Berlin, he emigrated to Amsterdam, London, and Chicago, where he became the director of the New Bauhaus in 1937.

Moholy-Nagy was introduced in America as a visual artist in the context of various exhibitions of modern European art. The "International Exhibition" mounted by the Société Anonyme at the Brooklyn Museum in 1926, included Moholy-Nagy in the constructivist camp. A review in the *Nation* did not mention the Bauhaus directly, but at least cited the artist's attempt to relate his work to the new industrial civilization, an approach he shared with the Bauhaus:

The constructivists—Lissitzky, Moholy-Nagy, Pannagi—took over from the cubist's geometrization of form and texture-contrasts and eliminated the last vestiges of reality. They sought to relate their work to the present industrial order and scientific progress by using the materials of the one—iron, concrete, glass—and emulating the logical precision of the other.[108]

Moholy-Nagy began to play a noteworthy role in the American reception of Bauhaus architecture toward the end of the period under discussion. He began to receive the attention of critics and authors affiliated with the English publications that had already devoted considerable space to Gropius.[109] Moholy-Nagy's association with his friend, who was already known in America, certainly translated into a considerable marketing asset. With his well-received 1935 book *The New Vision,* Moholy-Nagy reinforced his own growing renown in the United States. Previously Moholy-Nagy had been viewed more narrowly as a photographer;[110] this book, which described the idea and pedagogic concept of the Bauhaus, earned him a broader reception and helped make possible his emigration to the United States a few years later. The New Bauhaus represented Moholy-Nagy's attempt to create a continuity with the Dessau years,[111] but the financial and organizational difficulties involved, and his illness and early death, prevented his successor institution from taking root.

Marcel Breuer Few other members of the Bauhaus were the subject of attention in
 the architecture-dominated Bauhaus reception prior to 1935–1936.
The Hungarian Marcel Breuer was one of these exceptions. Breuer matriculated as a
student in Weimar in 1920 and immediately received notice for his innovative table
and chair designs. Among these were designs used in the "Experimental House" for the
Weimar Bauhaus exhibition of 1923. At the same time, he developed his own concepts
of graphics and architecture. Named a *Jungmeister* at the Dessau Bauhaus in 1925, he
assumed responsibility for the furniture workshop, where he made the famous tubular
steel chair he called the "Wassily chair." He pursued his interest in architecture as an
autodidact. After Gropius's resignation, he, too, left the Bauhaus in 1928 for Berlin,
where he worked in Gropius's office. From London, he finally emigrated to the United
States in 1937, where he became a professor at Harvard University.

Only a few American critics and authors took notice of Breuer between 1919 and
1936, and most of them knew him through their direct contact with the Dessau
Bauhaus. He was first accorded due respect at the end of the twenties, initially on the
basis of his reputation as an interior designer. Herman George Scheffauer reported in
1927 on one of Breuer's designs for a nickel-plated steel tubular chair, which Schef-
fauer considered a paradigmatic example of the Bauhaus production guided by func-
tion and purpose.[112] In certain exceptional cases, Breuer's talent as an architect
attracted the notice of those who saw in his work the beginnings of a brilliant career. In
1929, Horner and Fischer wrote about the tubular steel furniture designed by "Marcel
Breuer of Dessau" without noting his connection to the Bauhaus.[113] Hitchcock intro-
duced him in the same year as an interior architect and emphasized his Bauhaus con-
nection: "The chief activity of the Bauhaus at this time [ca. 1922–1923] was in

107 Harris, *The Arts at Black Mountain College*, 163.

108 Louis Lozowick, "Modern Art," 672.

109 P. Morton Shand is one of the authors who mentioned Moholy-Nagy in relation to Gropius:
 "[Moholy-Nagy] has been the close friend of perhaps the greatest of all modern architects,
 Walter Gropius, since 1923." "New Eyes for Old," 12.

110 Moholy-Nagy, "How Photography Revolutionizes Vision"; Shand, "New Eyes for Old." Shand,
 who considered Moholy-Nagy a "leading architectural photographer," was more fair to him than
 others by adding to that description that he was "not only a photographer." Also see "Photogra-
 phy in a Flash"; "Light Architecture"; Herbert A. Read, "A New Humanism."

111 The *Avery Index* of 1973 (9:773ff.) listed 24 articles by or about Moholy-Nagy, of which 21 had
 appeared in English or American journals. None of them, however, is dated before 1936. Eight
 appeared within the period 1936–1939, 12 in 1939–50, and one after 1950.

112 Herman George Scheffauer, "The Bauhaus Program," 12 May 1927.

113 Horner and Fischer, "Modern Architecture in Germany," 41.

connection with the organization of the contemporary interior. In this, Gropius and his associates, of whom Breuer was the most important, had a considerable success."[114]

Breuer's status as "designer" was echoed in Hitchcock's next book, coauthored with Philip Johnson, *The International Style*.[115] Coinciding with a shift of attention toward his architectural work, including the Doldertal Apartments in Zurich (1935–1936), the interest in Breuer increased just prior to his emigration to America in 1937, when he was the subject of a number of reports in *Architectural Record*[116] and published his own three-page article in the London magazine *Architectural Review*. In his article, he pointed out from his point of view the decisive impulses behind the new architecture. Although he described Gropius's concept of the unity of art and technology as close to his own convictions, he made only this implicit reference to the Bauhaus.[117] Breuer used the term "New Architecture," as did Gropius in the title of his book published in that same year, but whereas Gropius added the words "and the Bauhaus" to his book's title, Breuer avoided any mention of the school. The absence of the Bauhaus in Breuer's description of his position is painfully obvious and seems to imply a distanced relationship to the school at this time. This interpretation is supported by an anecdote related by the architect Harwell Hamilton Harris about his first meeting with Breuer at a CIAM conference in 1943 in New York: "Breuer was there. He got up and said, 'At one time the Bauhaus served a very useful purpose, but that time has passed. The Bauhaus is dead, and I think we should let CIAM die.' He was interested in design in its very general form."[118]

Breuer's refusal to position himself in a living, present-tense relationship to the Bauhaus may be understandable, considering the strong identification of the Bauhaus with its founder. This explanation is made more plausible by the events around the New York Bauhaus exhibition of 1938 at the Museum of Modern Art: Breuer was left with only a secondary role. He may have found it necessary to declare the Bauhaus part of the past in order to move out of Gropius's shadow.

Ludwig Hilberseimer The architect, urban planner, and theoretician Ludwig Hilberseimer was brought to the Dessau Bauhaus by Hannes Meyer in 1929 to head the Department of Architecture. He remained at the Bauhaus under Ludwig Mies van der Rohe and offered his practically oriented architecture course until the school closed in 1933.[119] His theories on the planning of housing, city, and region were intended to bring order to the uncontrolled growth of the modern metropolis.[120] His models for the stark city of parallel high-rise tracts, his "city of tomorrow," were based on empirically drawn conclusions about the relationship between density and open space, in which a conceptual affinity with Le Corbusier is apparent. In 1938, Hilberseimer emigrated to America with his friend Mies and resumed his teaching career at the Illinois Institute of Technology.

Hilberseimer had enjoyed little publicity in America before 1936. His contribution to the famous Weissenhof exposition of 1927 had done little to change that.

Wherever his work appeared, it was viewed with little comprehension. On the basis of his designs' extreme rigor, Hilberseimer was denounced as a follower of an "entirely conventional Neue Sachlichkeit."[121] His architectural and city planning projects were perceived as ahistoric and counter to the collective historical memory of the young nation. One exception to this tendency was Catherine Bauer, who in her book *Modern Housing* offered an objective description of the principle of the *Zeilenbau* (rows of midrise slabs) in Germany. Hilberseimer's 1927 book *Internationale neue Baukunst* remained almost entirely unknown in the United States at that time. His political and ideological associations with Hannes Meyer prior to 1936, the period before his emigration, might have led to an equally negative perception of his work.[122]

Lyonel Feininger, Wassily Kandinsky, Paul Klee Among the painters, the Russian Wassily Kandinsky, the Swiss Paul Klee, and the American Lyonel Feininger had attracted attention in the United States by the mid-thirties, largely with the support of Emmy (Galka) Scheyer. Scheyer's initiatives were reinforced by émigré German art dealers, among them Karl Nierendorf, Curt Valentin, Alfred Flechtheim, and J. B. Neumann. In 1934, after founding the New Art Circle and a new gallery in New York, Neumann acted as Klee's representative in the States and lectured about his work.[123] By the mid-1930s, a number of private collectors, such as Arthur J. Eddy from the law offices of Eddy, Wetten and Pegler in Chicago and Albert Bloch from the School of Fine Arts at the University of Kansas in Lawrence, had established their own contacts with one or several of the artists. Even so, of these painters only Klee became popular, and that only in relative terms.

114 Hitchcock, *Modern Architecture,* 188.

115 Hitchcock and Johnson, *The International Style,* plate 107. Hitchcock mentions Breuer's architectural achievements in two other publications, *"Internationale Architektur,* by Walter Gropius," 191, and in "Architecture Chronicle," 96.

116 "Haus in Wiesbaden"; "Apartment House Lobby"; "The Apartment Interior"; "Doldertal Apartments, Zürich." Also see Isaacs, *Walter Gropius,* 2:750.

117 Marcel Breuer, "Where Do We Stand?," 133ff. Also see Peter Blake, *Marcel Breuer,* 199ff.

118 Author's interview with Harwell Hamilton Harris, 26 February 1990.

119 Christian Wolsdorff, "Die Architektur am Bauhaus," 311f., and Wingler, *The Bauhaus: Weimar, Dessau, Berlin, Chicago.*

120 In Ludwig Hilberseimer, *Grossstadtarchitektur.*

121 Hitchcock, *Modern Architecture,* 195.

122 Dearstyne, *Inside the Bauhaus,* 215. The *Avery Index* of 1958 (7:267f.) does not list a single article on Hilberseimer prior to 1936.

123 J. B. Neumann, "Confessions of an Art Dealer."

Although the Bauhaus painters, in particular Klee and Kandinsky, exerted a fundamental influence on the fields of theory, writing, and artistic work and education at the Bauhaus, they were widely perceived as individual artists rather than members of the school. They gained their influence at least in part by arriving at the Bauhaus earlier and remaining longer than most other faculty. Feininger stayed from 1919 to 1932, Klee from 1920 to 1931; Kandinsky came in 1922 and remained at the school until the very end.

Klee, Kandinsky, and Feininger were already internationally recognized artists before they arrived at the Weimar Bauhaus; works by all three had been exhibited and sold in the United States even before the Bauhaus was founded.[124] Their hiring by Gropius changed little in the American perception of them as individual artists or members of particular circles of European painters. Their reception developed almost separately from the reception of the Bauhaus, although their main promoters, such as Katherine Dreier, J. B. Neumann, Galka Scheyer, and Wilhelm Valentiner, were acquainted with some of the people who supported their architectural and design colleagues. An article in the *Nation* published on the occasion of the "International Exhibition" of the Société Anonyme in the Brooklyn Museum referred to Klee and Kandinsky merely as expressionists. The article states:

Kandinsky, one of the leading exponents of the school, paints color harmonies which, depending on their degree of abstraction, he calls impressions, improvisations, compositions. Like Bergson, he uses many an intellectual argument to disprove the validity of reason. He conceives of art as born of "an inner contemplation which is inscrutable." . . . The ethereal color harmonies and naive grotesqueries of Paul Klee make him the most introspective of all expressionists. His "Diesseitig bin ich gar nicht fassbar" is perhaps the limit to which metaphysical aesthetics can go.[125]

And not a word of their teaching at the Bauhaus. The exceptions here were two articles by Scheffauer that mentioned Kandinsky and Klee in one breath with Johannes Itten, Lyonel Feininger, Adolf Meyer, and Walter Gropius; and texts by Hitchcock that credited Feininger, Klee, and Kandinsky as being important members of the Bauhaus. Otherwise, these painters attracted little notice in America in those years for their roles at the Bauhaus and for the influence of that institutional context on their work.[126] In light of the increasingly architecture-centered reception of the school, this fact is not surprising. On closer inspection, however, it reveals an essential distortion of information that was typical even of the architecture-related reception of the Bauhaus in the United States: it overlooked the elementary and inseparable role played by art in the architectural training as first formulated by Gropius and operative until Hannes Meyer's assumption of the directorship.

Other Faculty In contrast to his more famous colleagues Klee, Kandinsky, and Fein-
inger, the name of the painter Johannes Itten was mentioned only
sporadically. Itten had been one of the Bauhaus's most influential pedagogues, artists,
and theoreticians until his departure in 1923. It was he who introduced the famous
foundation course as well as the *Weltanschauung*-oriented lifestyle and work structure.
In 1924, after his departure, he was mentioned as a peripheral figure in an article on
Gropius by Herman George Scheffauer, who called him one of the "most distinguished
European designers and proponents of the new."[127] It may be that Itten received such
little notice because his tenure fell within the school's initial phase, when it was still
little known abroad. Its more widespread international recognition began with the
Weimar Bauhaus exhibition of 1923, the year in which Itten left the school.

Many other Bauhaus artists, designers, and architects were more or less over-
looked in the American reception of those years. This occurred even when they had
played an essential role in the theory, pedagogy, or productive artistic work of the
school, or when they were destined to emigrate to the States at a later point. This is
true of Walter Peterhans, for example, who had directed the photography workshop in
Dessau and Berlin between 1929 and 1933 and later became a professor at the Illinois
Institute of Technology. His receipt of the professorship in 1938 was in fact directly
related to Mies van der Rohe's arrival at the school. Peterhans was an exceptional pro-
fessional who defined photography as "painting with light," thus elevating the
medium beyond a mere method of exact visual reproduction.[128] Most of the visual
artists remained virtually unknown in America during that period. This was true for
the sculptor Gerhard Marcks, one of the first appointees at the Bauhaus who was in
charge of the pottery workshop until its discontinuation in 1925, and for the formida-
ble artist Oskar Schlemmer, who between 1920 and 1929 developed the sculpture
workshop and, in Dessau, the Bauhaus stage production program. Georg Muche's
model house was mentioned on the occasion of the Bauhaus exhibition in 1923, but as
a painter and leader of the Weimar and Dessau textile workshops he was included in
American discussions. Not much was known about the innovative products of the
metal workshops[129] and their leading designers such as Marianne Brandt and Wilhelm

124 E. Washburn Freund, "Modern Art in Germany," 45; and Helen A. Read, "The Exhibition Idea in
 Germany," 201. Also refer to the sections "Exhibitions" and "Points of Contact," chapter 2,
 above.

125 Lozowick, "Modern Art," 672.

126 Scheffauer, "The Work of Walter Gropius," 50; Hitchcock, *Modern Architecture*, 187.

127 Scheffauer, "The Work of Walter Gropius," 50.

128 Quoted in Wingler, *The Bauhaus: Weimar, Dessau, Berlin, Chicago*, 498.

129 Bernstein, "Josef Albers at Black Mountain College," 254.

Wagenfeld, who, more than most of their colleagues, achieved the programmatic unity of art and technology in the designs of their lamps and other utilitarian goods. Equally little attention was given to the first generation of Bauhaus students, some of whom became extraordinary artists and, following the Bauhaus's move to Dessau, were appointed as *Jungmeister* and teachers. They proved the success of the educational concepts of the Weimar Bauhaus and made the Dessau Bauhaus the era of the student generation. Besides Josef Albers, this group included Herbert Bayer, who was in charge of the printing workshop until 1928; his successor Joost Schmidt, a multitalented visual artist and admired teacher; Hinnerk Scheper, who was responsible for the mural-painting workshop; and Gunta Stölzl, the only woman master at the Bauhaus, who directed the textile workshop after Muche's departure and who had significant influence on industrial and artistic weaving.

Numerous Bauhaus associates whose accomplishments were worthy of mention remained almost entirely unknown even if they were architects or interior designers. This group included Alfred Arndt, Anton Brenner, Gunter Conrad, Howard Dearstyne, Friedl Dicker, Wils Ebert, Fred Forbat, Edvard Heiberg, Wilhelm Jakob Hess, Herbert Hirche, Hubert Hoffmann, Waldemar Hüsing, Eduard Ludwig, Adolf Meyer, Farkas Molnár, Georg Muche, Rudolf Ortner, Pius Pahl, Lilly Reich, Selman Selmanagic, Franz Singer, Mart Stam, Hans Volger, Gerhard Weber, and Hans Wittwer.[130] In addition to Adolf Meyer, Gropius's partner until 1925, between 1921 and 1928 Werner Düttmann, Carl Fieger, Franz Möller, Ernst Neufert, Richard Paulick, and Bunzo Yamaguchi worked for Gropius's private office, which was not only located at the Bauhaus building but also produced most of those works that would later be received as Gropius's "Bauhaus architecture." Some of the architects mentioned above appear in the articles studied here, but only seldom and always in conjunction with the architects who were the primary focus of reception. Thus, Adolf Meyer is mentioned with Gropius, Lilly Reich with Mies van der Rohe, and Hans Wittwer with Hannes Meyer. They remain faceless, their artistic individuality undefined and overshadowed by their partners.

Of all these examples, the failure to recognize Adolf Meyer is most noticeable. As Gropius's partner and closest associate, he was not only equally responsible for the Fagus shoe factory of 1911 but also for the architectural work completed during the Weimar Bauhaus period. Lilly Reich, who worked in similarly symbiotic cooperation with Mies, was also ignored. She was an exceptional talent and much more than a mere assistant in her work with Mies. No one acted as her advocate in America to rescue her work from relative anonymity. In Germany, too, her achievements were undervalued, both within her own oeuvre and in her significance for Mies's intellectual and artistic evolution. The fact that Reich was a female member of the Bauhaus caught in the male-dominated reception of those years may have been a factor here, as well as in the case of Stölzl.

INSTITUTIONAL
CHARACTER

The Bauhaus was the result of the 1919 merger of two Weimar schools, the Art Academy (Grossherzogliche Sächsische Kunsthochschule) and the School of Arts and Crafts (Grossherzogliche Sächsische Kunstgewerbeschule). Henry van de Velde had been the director of the latter until he decided to return to Belgium in 1915, after xenophobia in Germany and the outbreak of the First World War had resulted in his vilification as a "foreigner." He recommended Walter Gropius as his successor. After long negotiations, Gropius was named the director of the newly founded Staatliches Bauhaus zu Weimar. The same reactionary forces that had persecuted van de Velde and thus contributed to the creation of the Bauhaus were responsible for the school's expulsion from the city six years later.

Gropius's program for the founding of the school incorporated a series of historical and contemporary paradigms. Nonetheless, the new school was more than the sum of its influences: it was conceived as the reconciliation between art and life, as the way to form a new social environment and to educate a new kind of human being. Its aim was to sublate the schism between architecture and the visual arts that had occurred at the end of the baroque period. Gropius therefore dissolved the boundaries between the traditionally defined disciplines in favor of a synthetic educational program. As a rule, the teachers were versed in more than one area of design. The Bauhaus was neither an art school in a traditional sense nor a school for industrial design nor an architecture academy. It was several types of schools at once, a hybrid. The combination of the disciplines in a single entity was revolutionary, making the Bauhaus a school without precedent.

The foundation course, the complementary studies in forms and materials, and the workshop training were mandatory for all students and provided the basics for their future occupation as craftsmen, painters, sculptors, designers, or architects. The foundation course was meant to revive the students' natural creativity and to sharpen their senses. Thus, the range of studies included color, graphics, composition, materials, tools, and construction, as well as the investigation of nature. Training in the clay, stone, wood, metal, painting, weaving, or glass workshops meant experimentation with the individual materials and learning about the relation of their specific character to form. It also was meant to provide the young people with sound practical skills so that those without true artistic potential could at least make their living as craftsmen and -women. On completing these basic courses, students who had shown a particular aptitude were chosen to study building arts and set design. No explicitly architectural

130 **Wolsdorff, "Die Architektur am Bauhaus,"** and Wingler, *The Bauhaus: Weimar, Dessau, Berlin, Chicago.*

courses were offered in Weimar or, at least initially, in Dessau. The founding manifesto stated:

To embellish buildings was once the noblest function of the fine arts; they were the indispensable components of great architecture. Today, the arts exist in isolation, from which they can be rescued only through the conscious, cooperative effort of all craftsmen. Architects, painters, and sculptors must recognize anew and learn to grasp the composite character of a building both as an entity and in its separate parts. Only then will their work be imbued with the architectural spirit which it had lost as a "salon art." The old schools of art were unable to produce this unity; how could they, since art cannot be taught.[131]

In 1923, Gropius rewrote the Bauhaus's program, postulating the unity of art and technology. Fascination with the machine replaced Mazdaznan, a mystical philosophy followed under Johannes Itten. Moholy-Nagy, Itten's successor, reoriented the courses in design and the workshops' production toward modern, engineer-driven industrial construction. The privileged position of the painter and designer remained unscathed.

With the move to Dessau, the foundation course and most workshops were continued; until 1928, the program was aimed at the design and production of simultaneously aesthetic and functional objects. The dual teaching system of *Werkstattmeister* (workshop master) and *Formmeister* (form master) was abandoned: a generation of *Jungmeister* had been trained by 1925, well able to unite the necessary crafts skills and artistic qualities in one and the same teacher. Efforts to cooperate with industry and the trades were redoubled with the intention of standardizing and creating norms for building elements. The emphasis on the artistic aspects of education and on handicrafts was maintained, as indicated by the Bauhaus books and journals. The school remained a public, in fact a municipal, institution. It became increasingly academicized, and the teachers were given the title of "professor."

With the inception of Hannes Meyer's directorship, a strictly functionalist position was pursued. Gropius's aim of establishing aesthetic standards was dismissed as formalism and the status of the artist was reduced. In accordance with his socialist principles, the new director emphasized the value of practical work, increased the workshops' production, modified the curriculum to accommodate a more scientific methodology and to offer a general education more amenable to "real life," and introduced the corresponding ancillary courses and guest lectures.

Mies van der Rohe assumed control of the Bauhaus under pressure to rationalize and consolidate means and methods. The school was deideologized, further academicized, and made to resemble even more an architecture school. This move meant an almost complete end to the workshops' activities and a redefinition of their purpose as subservient to the department of interior design and architecture. The proportion of

guest lecturers and artists was reduced without compromising the third director's artistic aspirations. After the Bauhaus was forced to move to Berlin in 1932, it was run as a private institution.

Gropius's postulate of architecture's primacy was only an ideal statement of purpose during the Bauhaus's first eight years. In 1924, Marcel Breuer, Farkas Molnár, and Georg Muche submitted a written proposal to found a separate department of architecture. The department was to offer practically oriented courses and to complete fundamental research, including the development of norms and typologies.[132] Nonetheless, architecture at the Bauhaus remained synonymous with the work done by Gropius's private office, located as it was in the Dessau Bauhaus building. According to Gropius, the long procrastination in establishing the architecture department, which had already been proposed in 1919, was due to the need to offer fundamental training to future architecture students. It may also be that he saw his office as an extension of the Bauhaus. Marcel Franciscono cites other motives:

There are a number of obvious reasons why the projected visionary architectural works were never undertaken at the Bauhaus [Weimar] . . . : the very quick realization that they—and the ideal of the organic society they symbolized—could have little practical issue in the present work, the incompatibility of the *Einheitskunstwerk* with the stylistic direction of modern architecture on a whole, and not least, the sheer lack of means and of pupil and faculty interest in or sufficient capability for the work in the beginning when such an idea was still viable enough to be undertaken.[133]

It was not until 1927 that architecture was introduced as a standard course. It was institutionalized as a department in 1928 and became the focus of the education as of 1930. As is evident from his 1960 comment, the last director regarded the Bauhaus as an architecture academy and called it "for many years one of the most important architecture schools in Europe."[134]

There was no equivalent to the Bauhaus in the United States, a fact that made it difficult to classify and describe the school here. Its polyvalence within a unified structure has allowed various interest groups to recognize "their" Bauhaus in some fragment of the program. As the Bauhaus's fame grew and as increasingly diverse groups took an interest in the school, its unified image began to disintegrate. The tendency to appro-

131 Walter Gropius, "Program of the Staatliche Bauhaus in Weimar, April 1919," quoted in Wingler, *The Bauhaus: Weimar, Dessau, Berlin, Chicago,* 31.

132 According to C. Schädlich, "Die Beziehungen des Bauhaus zu den USA," 61.

133 Marcel Franciscono, *Walter Gropius and the Creation of the Bauhaus in Weimar,* 137, n. 26.

134 Ludwig Mies van der Rohe, letter of recommendation for Nelly A. Peissschowitz dated 14 October 1960, Mies van der Rohe Files, Library of Congress.

priate the Bauhaus for a specific purpose is apparent not only in architecture journals but also in professional organizations. Art journals preferred to present the school as an academy of art.[135] Exceptions to this tendency included *Art News,* in Flora Turkel-Deri's "Berlin Letter";[136] and the London periodical *Apollo,* in which Oscar Bie's series "Letter from Berlin" appeared, reporting on contemporary happenings in art and architecture in the German capitol. Bie spoke of the Bauhaus as an "abstract school of pure form, located between art and architecture."[137] By the early thirties, the various art journals concerned themselves almost exclusively with artistic and art-pedagogic matters while journals of design reported mostly on the productive and economically relevant developments.[138] Periodicals of a cultural-intellectual or social-political orientation drew a more accurate picture of the Bauhaus. These included *Current Opinion*'s article "Revolution Reflected in the New Art of Germany" (1919), the *Nation*'s "The Closing of the Bauhaus" (1932), and the *Christian Science Monitor*'s three illustrated articles by Herman George Scheffauer in 1927 under the title "Dessau: Special Correspondence." The third of Scheffauer's articles is devoted to theater but the first two discuss the new, unconventional formal language employed by the furniture workshop and by the Bauhaus architecture realized in Dessau. The Bauhaus building and the masters' houses exemplified the purity and simplicity of the new forms and the importance of function, materials, and machine production.[139]

The greatest change in perception was the increasing concentration on architecture. The corollary to this development, and to the increasing fame of Gropius and Mies as leading figures, was the reception of the Bauhaus in the United States as a school of architecture only. Other departments and their changing balances between continuity and change were increasingly overlooked.

The Image of the Architecture School One of the very earliest articles on the Bauhaus, "Revolution Reflected in the 'New' Art of Germany," published in 1919 in *Current Opinion,* reflects the school's innovative character fairly accurately. It describes the most recent developments that had led to the school's establishment. Thus, it cites the initiatives of the German Werkbund, the mutuality of influence between revolution and art following the November Revolution which led to the founding of the Workers' Council on Art (Arbeitsrat für Kunst), and the adoption of the concepts formulated by the council's Berlin section as the artistic basis for the Bauhaus institution. The article describes Gropius's belief that all the arts should be united under one roof as well as his aims for educational and social reform.[140]

As early as 1923, the focus of most interest began to shift to the work and personality of Gropius, although his work remained associated with the Bauhaus. His architecture appeared in this context not as dogmatically consistent but rather as typologically varied. Thus, the Sommerfeld house was seen as the paradigm of the single-

family house with regard to the use of traditional methods, materials, and ornament. The Werkbund exposition buildings in Cologne and the Fagus factory in Alfeld were exemplary as purely functional buildings in their innovative deployment of materials and their horizontality, airiness, and simplicity. Principles derived from the factory and the administration building were perceived as typical of the Neues Bauen. The prognosis was that this was the "architecture of the future."[141] That same year, Scheffauer published a two-page article entitled "Building the Master Builder: The Staatliche Bauhaus in Weimar" in the New York magazine *Freeman*, which claimed to serve an audience of "intellectuals of all classes."[142] The article is one of the most accurate characterizations of the Bauhaus from an American perspective. Although the names of many Bauhaus artists were still omitted or misspelled, the article was able to communicate to its readers an authentic image of the synthetic concept underpinning life at the Bauhaus. Scheffauer did not commit himself to any particular conceptual definition of the Bauhaus's institutional character when he wrote:

A new world is revealed to us here; a new conception of work and methods of work, and the teaching of these methods. A synthesis between the mediaeval conception of the trade-guild, the modern polytechnicum and intensified future methods of production and manufacture, has been striven for and to a great extent realized. The fundamental thought of the Bauhaus school, the inspiration that guides its masters, journeymen and apprentices, is a new harmony between the social, industrial and aesthetic needs of modern man. It is the idea of a new unity, the aggregation of the many "arts," "tendencies," and "phenomena" into an indivisible whole, into that entity which is established in human nature itself and which attains significance only through the function of life. Architecture is once more to be raised to the regal dignity of the art inclusive of arts, to become the epitome, the visible expression of the spiritual and material capacities of the time. The living spirit of building, the essential soul of an active architecture, embraces

135 See, for example, "The Bauhaus" *(Art Digest)*. It presented the Bauhaus as "the art school at Dessau, Germany...which in Europe ranked as the most progressive in the fine and applied arts," 27.

136 Flora Turkel-Deri, "Berlin Letter," 1.

137 Oscar Bie, "Letter from Berlin," 229.

138 Compare, for example, *Art Digest* 5 (14 January 1931), and *Commercial Art and Industry,* 10 March 1931.

139 Scheffauer, "The Bauhaus Stage" and "The Bauhaus Program."

140 "Revolution Reflected in the 'New' Art of Germany," 256. The collaboration between craftsmen, artists, and architects pursued at the Bauhaus is made clear in Scheffauer's earlier article on Gropius, "The Work of Walter Gropius."

141 Scheffauer, "The Work of Walter Gropius," 51ff.

142 "Freeman Advertisement."

all the activities, all the art and technique of a people, a period or a world. Architecture today has been degraded to a mere study; as a mirror of civilization it reflects the disintegration and chaos of the modern soul.[143]

The article also discusses the curriculum, the Weimar Musterhaus am Horn, and the Bauhaus's public events.

In 1924, another article by Scheffauer entitled "The Work of Walter Gropius" followed in the *Architectural Review,* one of a four-part series on "the most important German architects." Only the introduction mentioned the Staatliches Bauhaus in Weimar as a "well-organized, fruitful and heretical institution [that] has been established upon ancient and venerable foundations . . . and upon many new and dynamic theories in the arts and the teaching of them." The Bauhaus was praised as a "great institution" because of its faculty, including Kandinsky, Feininger, Itten, and Adolf Meyer; its curriculum, which combined the virtues of crafts with the media, methods, and demands of the industrial age; and its intention to educate creative and productive artists and architects.[144] By and large, the author accurately portrayed the situation, except for the fact that Itten had already left the school and Meyer did not belong to the permanent faculty. The article clearly demonstrates how attention was drawn away from the institution and toward the person of Walter Gropius.

When the school moved to the building in Dessau, this perception was solidified. The building was discussed less frequently as the built form of the school's program or as an expression of its democratic structure than as a notable work by the architect Gropius. It was not long before the Bauhaus was perceived as the epitome *sine qua non* of the new architecture. Reports of its dedication ceremony immediately found their way into the American press.[145] Sheldon Cheney's description in *The New World Architecture* can be considered representative of the general tone of admiration:

No one can stand looking at the fine mass of the Glass Box, with its long horizontal bands of concrete contrasted with the immense areas of glass grill, without feeling that a new reach has been made toward a strictly rational twentieth century beauty-in-building. When one thinks back to the nineteenth century factories and workshops, the lightness-with-strength here, and the cleanliness, become doubly notable. . . . It would be miraculous if Walter Gropius, fulfilling a new vision, even one rather theoretically developed on a creed of economy and practicality, found no adjustments necessary when his building first stood there in concrete and metal and glass. What is truly important is that he contrived out of those materials, using each in characteristic ways, a structure that somehow expresses the power and cleanliness of the new industrialism, the massiveness and the precision of the machine, . . . —and at the same time a building that affords a constant pleasurable "feel" to its workers. No one else has quite so convincingly advanced the doctrine of naked functional architecture. And if the Bauhaus people prefer to talk about something called "a rightness" in their designing, in place of

aesthetic values, we may know that the truth and the decorativeness of their work will flow into the stream that is modern architecture.[146]

Architectural Forum captured the tenor of that time when it wrote, "in Dessau, we find . . . the *Bauhaus* by Walter Gropius. The Bauhaus is a school of architecture."[147] The topics of the articles changed accordingly: function, purpose, machine production processes, experiments with new materials, reduction of the formal language were now at the center of interest. The principles that were linked to the architecture of the Bauhaus at the end of the twenties were:

- The application of architectural studies and designs to mass production.
- The economy of building and the integration of prefabricated and standardized components.
- The integration of important aspects of daily life in design.
- The orientation of spaces to light and other climatic factors.
- The attempt to create an impression of spatial expanse using the appropriate color scheme on the walls.
- Harmony of part and whole.[148]

The one-sided perception of the Bauhaus was not inevitable. It was the product of a lobby that represented architecture, as opposed to other disciplines at the Bauhaus. Participants in the school contributed to this lobby, the most vocal among them being Gropius himself. The publication of his book *The New Architecture and the Bauhaus* reinforced and legitimized the architectocentric description of the Bauhaus. Gropius's agenda was explicitly reflected in the subsequent descriptions of the school as a "school of design-education" and "training center" for aficionados of modern architecture,[149] and was implicit in other articles that did not attempt to classify the school.[150]

The terminology used in America to classify the Bauhaus varied greatly in its conceptual precision, bespeaking a degree of uncertainty in describing an institution with no analogy on the American educational landscape. The literalness of Milton

143 Scheffauer, "Building the Master Builder," 304.

144 Scheffauer, "The Work of Walter Gropius," 50–54. Bruno Taut, Erich Mendelsohn, and Hans Poelzig are the other architects in the series.

145 *Berliner Tageblatt*, Monthly Edition (for American readers), December 1926.

146 Cheney, *The New World Architecture*, 306–307.

147 Horner and Fischer, "Modern Architecture in Germany," 41. Also see Bie, "Letter from Berlin," 229.

148 Lowenstein, "Germany's Bauhaus Experiment."

149 James M. Richards, "Walter Gropius," 45.

150 For example, see George Nelson, "Architects of Europe Today: Gropius," 425.

Lowenstein's translated moniker "building school"[151] indicates his desire to find an authentic name. Other authors, apparently equally literally, called the Bauhaus a "school of architecture," an "architect's factory," or "a leading architecture school."[152] Even texts that opt for an entirely neutral description such as "center for education" believed that the Bauhaus's curriculum was purely architectural.[153] The school's name certainly contributed to this misconception. *Bau* means "building" and is also the root of the verb "to build"; *Haus* means "house," "home," or "shelter." Thus, the name Bauhaus encompasses the process of erecting a building and the state of inhabitation or being-at-home. With its assonance and its neatly balanced syllables, Gropius's felicitous compound is catchy and easily recalled. In English as well as German, it creates a poetic and playful tonal balance. The fact that the German pronunciation of the diphthong *au* closely resembles the English *ou,* and the orthographic similarity between the words *haus* and *house,* facilitated the phonological and semantic decoding of the word "Bauhaus" for Anglo-Saxons. Because of these favorable linguistic conditions, the catchword potential of Gropius's invention could unfold in the English-speaking world. Mies van der Rohe understood the advantages of the name when he said, "the best thing that Gropius ever did was to invent that name. I wouldn't change it for anything."[154] This attitude is certainly understandable from an architect's point of view.

The American reception of the Bauhaus as simply a school of architecture would perhaps have been corrected, had comparison been made to the avant-garde movements in Holland, France, and the Soviet Union. Such a strategy would have distilled each movement's essential characteristics, including the roles assigned to painting, sculpture, product design, and didactic methodology, and their intertwining with architecture. The Bauhaus's vision, that its work would usher in a new form of life and societal change, would have become clear. The 1927 Weissenhof exposition in Stuttgart, in which several tendencies of the contemporary avant-garde were presented, did offer the opportunity for concrete comparisons. In fact, it merely served to reconfirm a homogenizing point of view.

The equation of Gropius's work and Bauhaus architecture continued even after Meyer and Mies succeeded to the directorship, despite the latter's prominent position in the school's reception. This treatment was implicit in Philip Johnson's juxtaposition between the "Bauhaus style" and "Mies van der Rohe's Modernism."[155] Johnson equated Bauhaus architecture with functionalism and, in this context, infused the concept of functionalism with considerable negative connotations. The following quotation from Hitchcock and Johnson's *The International Style* is a good example:

While the functionalists continue to deny that the aesthetic element in architecture is important, more and more buildings are produced in which these principles are wisely and effectively followed without sacrifice of functional virtues. . . . Some modern critics

and groups of architects both in Europe and in America deny that the aesthetic element in architecture is important, or even that it exists. All aesthetic principles of style are to them meaningless and unreal. This new conception that building is science and not art, developed as an exaggeration of the idea of functionalism.[156]

The same antagonism had already been incited by Hitchcock some two years earlier when he juxtaposed the "functional" architecture of Gropius to the "post-functional" of Mies van der Rohe.[157] This line of thought later led to the unwarranted equation of Bauhaus architecture with functionalism in the strictest sense and, when employed as part of a purely pragmatic and "non-ideological" approach, was used to legitimize such polemic labels as "factory style" and "hospital style." As simplistic as it may seem, the fact that Gropius had been a student of Peter Behrens was evidence enough that he had been influenced by the "steel, concrete and glass Turbinenhalle at the A.E.G. works in Berlin (1909), the prototype of all modern factory buildings."[158] In fact, under Mies the Bauhaus distanced itself completely from all functionalist principles; moreover, Gropius himself had never subscribed to strict functionalism but rather propounded an "explicitly aesthetic philosophy" based upon psychological studies.[159] He used the words "art and technology" in his theory as a protest against the oversimplified formulas that equated form and function. If, indeed, functional concerns are central to his creative production, he by no means disdained aesthetic form; he simply maintained that it should result from the dictates of function. The cliché that emerged from the Bauhaus's functionalist period under Hannes Meyer, an era almost entirely disregarded or denigrated in the United States, was used to disqualify Bauhaus architecture in general.[160]

151 Lowenstein, "Germany's Bauhaus Experiment," 1.

152 Horner and Fischer, "Modern Architecture in Germany," 41; Haskell, "The Closing of the Bauhaus," 374f.

153 Bauer, *Modern Housing*, 221.

154 Mies in conversation with Alfred Rosenberg, quoted in Hochman, *Architects of Fortune*, 122. The author refers to the unedited text in Wingler, *Das Bauhaus, 1919–1933*, 187.

155 See Philip Johnson, "Architecture in the Third Reich," 137f. The article makes no mention of Mies's connection to the Bauhaus.

156 Hitchcock and Johnson, *The International Style*, 35, 39.

157 Hitchcock, "Architecture Chronicle," 95f. The article, which describes Mies and Lilly Reich's contribution to the German Building Exposition of 1931, does not mention Mies's association with the Bauhaus although he was its director at that time.

158 "Bauhaus, at Dessau, designed by Walter Gropius," 236.

159 Peter Gay, *Weimar Culture*, 98. Also see Ludwig Grote, "The Bauhaus and Functionalism," 216, and Hartmut Probst and Christian Schädlich, *Walter Gropius*, 1:29ff.

160 Johnson, "Architecture in the Third Reich," and William H. Jordy, *American Buildings and Their Architects*, 5:131.

Other contemporary observers included a broader spectrum in their definition of Bauhaus architecture. Some interpreters, such as Douglas Haskell, did not take the divisive characteristics of Bauhaus architecture as their criteria but rather the common principles: a scientific or rational starting point, a belief in democracy, the rejection of "gee-gaws" and ornament, the abstraction of form, and the use of modern materials and construction methods. (The fact that these commonalties actually outweighed the divisive issues had no influence on the rejection of Bauhaus architecture by the petty bourgeoisie of the Third Reich.)

The association of Bauhaus architecture with social housing, as reflected in projects such as Gropius's *Siedlungen,* row houses, and smaller house projects on the one hand with Mies van der Rohe's Weissenhof apartment building on the other, translates into another cliché, that of "social housing" or "workers' housing."[161] It is possible to imagine how the misconception could arise, considering that mass housing was an issue central to the Neues Bauen in Germany. In Gropius's case, it was an area in which he was extraordinarily engaged, prolific, and successful. The negative connotations of the concept in America derive from a misunderstanding that equated mass housing with an ideologically motivated attempt to negate individual human needs. This image was firmly planted in the heads of the Bauhaus's critics as the embodiment of naked functionalism.[162]

The International Style and the Bauhaus In the exhibition "Modern Architecture: International Exhibition" at the Museum of Modern Art and the accompanying publications, only Le Corbusier and J. J. P. Oud were represented as extensively as Gropius and Mies. The prominent position granted to the Europeans led to accusations that Hitchcock and Johnson had intended to force a foreign style of building onto the United States. The following table summarizes the buildings and designs of the two Bauhaus architects included in the exhibition.[163]

161 Lowenstein, "Germany's Bauhaus Experiment," 2ff.; "Thirteen Housing Developments," 276, 280; Ise Gropius, "Dammerstock Housing Development," 187ff.; Bauer, *Modern Housing,* 220f.; Nelson, "Architects of Europe Today: Gropius," 426. Walter Gropius's own early American publication "The Small House of Today" emphasizes the social motivation of his architecture, as expressed by the statement of intention "to give renewed and thorough consideration to the great problem of house construction from a social, technical and economic point of view," 266.

162 Tom Wolfe's bestseller *From Bauhaus to Our House* proves the longevity of the "workers' housing" cliché (35, 40).

163 Based on "Looking Back at 'Modern Architecture,'" 20–21.

WALTER GROPIUS

Exhibition	Catalogue	Book
Fagus factory Alfeld, Germany 1910–1914	As in exhibition	—
Director's House Dessau, Germany 1925–1926	—	—
Store and apartment house Törten Siedlung Dessau, Germany 1926–1928	Experimental houses Törten Siedlung Dessau, Germany 1926–1928	As in catalogue
The Bauhaus Dessau, Germany 1925–1926	As in exhibition	As in exhibition
Municipal employment office Dessau, Germany 1928	As in exhibition	As in exhibition
—	**Houses for workers** Pomerania, Germany 1906	—
—	**Lewin house** Berlin-Zehlendorf, Germany 1928	—

MIES VAN DER ROHE

Exhibition	Catalogue	Book
German Pavilion Barcelona world's fair 1929	As in exhibition	As in exhibition
Tugendhat house Brno, Czechoslovakia 1930	As in exhibition	As in exhibition
Lange house Krefeld, Germany 1928	As in exhibition	—

Apartment house Weissenhof Siedlung Stuttgart, Germany 1927	As in exhibition	As in exhibition
—	Project for the Kröller-Müller house Wassenar, The Netherlands 1912	—
—	Project for a country house in brick 1922	—
—	—	Apartment study New York City 1930

This event was to determine for many years the course of the reception of these two German architects and, synonymously, of Bauhaus architecture. The exhibition fostered an image of a homogeneous architecture at the Bauhaus and an understanding of classical modernism as a unified movement. The elimination of the different characteristics of each individual avant-garde tendency facilitated the postulation of their equality within the modern movement, as Peter Eisenman has convincingly argued.[164] Especially on the east coast, which, unlike California, had not developed its own genuine American version of modernism, the Bauhaus soon became synonymous with the International Style simply on the strength of the "Modern Architecture" exhibition and the book *The International Style*.[165] This parity is not tenable, even when applied to aesthetic qualities. The Bauhaus architects certainly absorbed achievements made by other avant-garde movements,[166] just as their impact on the rest of the international movement known as the Neues Bauen is indisputable. Nonetheless, the Bauhaus was only one of the pillars of European modernism. Its institutionalization, efficiently productive workshops, highly visible faculty, efficient self-promotion machinery,[167] and iconic building in Dessau[168] helped to propel the Bauhaus particularly far in comparison to De Stijl and L'Esprit Nouveau.

If the effect was not immediate, this was only because the reception of the "Modern Architecture" show was initially cautious and, at least among architecture critics, descriptive and detail-oriented. These kinds of reviews may not have been intended by the curators or even by the authors, but they were implicit in the strategy and purpose of the show. Hitchcock and Johnson had analyzed the individual and national manifestations of the modern movement not on the basis of their specificity but primarily with an eye to the commonalties in their formal language, use of materials, and construction methods. The intention was to prove that modernism was a universal phenomenon.[169] Accordingly, Alfred Barr, Jr., wrote in the foreword to *The International Style*: "I believe

that there exists today a modern style as original, as consistent, as logical and as widely distributed as any in the past. The authors have called it the International Style. . . . [This new style] exists throughout the world, is unified and inclusive, not fragmentary and contradictory."[170] It was on this basis that they formulated a "unified architectural language . . . an index of formal and architectural usages"[171] consisting of three primary characteristics: emphasis on volume rather than mass, regularity instead of axial symmetry, and the use of distinguished materials and surfaces, technical perfection, and proper proportions instead of applied ornament.[172] These were to become the principles of a new "post-functionalist" style that Barr, Hitchcock, and Johnson dubbed "the International Style."[173] Nonetheless, Hitchcock had already used the term in *Modern Architecture* based upon Gropius's first Bauhaus book, *Internationale Architektur*. The growing international and transcultural thinking among avant-garde architects at the end of the twenties resounded in other 1927 books and exhibitions, notably in Ludwig Hilberseimer book *Internationale Neue Baukunst* and in the "International Plan and Model Exhibition" organized in connection with the Weissenhof-Siedlung exposition.

164 Eisenman, introduction to Johnson, *Writings*, 11–12.

165 The architect Harwell Hamilton Harris noticed subsequent to his move from California to North Carolina that the name "Bauhaus" was used interchangeably with "modern architecture" on the east coast: "Bauhaus was in the East synonymous to modern architecture. Modern was what we would call the Bauhaus, not the mixture we had in California." Interview with Harwell Hamilton Harris, 26 February 1990. See Edgar Kaufmann, Jr., *Introduction to Modern Design*, 15. In the fifties, this indiscriminate perception began to influence the popular reception, as is evident in the weekly architecture column of the *New York Times*. See Wolfe, *From Bauhaus to Our House*, 71; Eric Stange, "MIT has Designs on Bauhaus."

166 Kaufmann, *Introduction to Modern Design*, 15ff.

167 Walter Dexel et al. use the word "propaganda" in *Der "Bauhausstil"—ein Mythos*, 17. See also Julius Posener, *From Schinkel to the Bauhaus*, 48.

168 William H. Jordy called the building "a demonstration of the full range of visual possibilities" and "a compendium of the architectural elements" of the Style. Jordy, *American Buildings and Their Architects*, 4:134.

169 Christoph Hackelsberger, *Die aufgeschobene Moderne*, 14. William H. Jordy concludes that the concept of "modernism" as defined by Hitchcock and Johnson was appropriated by historians but that the architects and critics who at the time were concerned with the "Style" did not use the term. Jordy, *American Buildings and Their Architects*, 5:118. Vincent Scully notes that most protagonists of the new architecture would have found the designation "tasteless." Scully, "Henry-Russell Hitchcock and the New Tradition," 10.

170 Barr, introduction to Hitchcock and Johnson, *The International Style*, 11, 19.

171 José A. Dols, *Moderne Architektur*, 62.

172 Hitchcock and Johnson, *The International Style*, 13. The exhibition catalogue mentioned a fourth principle: flexibility.

173 Hitchcock and Johnson credit Alfred Barr with coining the phrase "the International Style." See Jordy, *American Buildings and Their Architects*, 5:434, and Peter Eisenman, introduction to Johnson, *Writings*, note 10.

The semantics of the adjective "international" were also politically loaded in the twenties, due to its adoption by the Bolshevik and socialist movements.

Hitchcock, Barr, and Johnson credited their brainchild with being the only true style of the twentieth century, comparable to the great styles of the past. The authors' position bespeaks their rejection of historicism and eclecticism, a stance that was characteristic for the Neues Bauen in the twenties and for the Bauhaus. Instead, "the foundation provided by the nineteenth century's development of forces of production, new materials, construction techniques, and technologies, expressed in iron and glass or reinforced concrete building, was to underpin the future development of architecture."[174]

"Modern Architecture: International Exhibition" exposed the schism between the American reception and Europe's reception of its avant-gardes. The Bauhaus architects saw their work as timelessly valid, as the long-sought and finally discovered formal vocabulary that marked the last phase of architecture. The formulation of an "International Style" thus ran counter to the Bauhaus's perception of itself. The school's architects in particular had always resisted any commitment to stylistic criteria. In their eyes, the new forms did not represent any absolute values but were instead the architectural expression of social aims; these forms represented no more than suggestions of ways in which collective life could be organized.[175] Gropius did not understand the Bauhaus's architecture as a mere system of forms, materials, and construction methods but as a result of long-lived principles and accomplishments. He countered the idea of a "Bauhaus style" as follows:

Only too often have our true intentions been misunderstood, as they still are today. The Bauhaus movement has been seen as an attempt to create a "style"; and so every building and object that is unornamented and unindebted to any historical style is perceived as an example of this imaginary "Bauhaus style." This approach is diametrically opposed to what we strive toward. The aim of the Bauhaus does not comprise the propagation of some style or other, some system or dogma, but rather the hope that a vital influence can be brought to bear on design. A "Bauhaus style" would mean regression to an uncreative, stagnated academicism, to that which the founding of the Bauhaus was meant to resist. Our efforts aim to find a new approach that allows the development of a creative consciousness and thus, finally, a new attitude toward life. As far as I know, the Bauhaus was the first institution in the world that risked introducing this principle into a concrete pedagogic program. The concept of this program derived from an analysis of the relationships within our industrial age and its fundamental currents.[176]

Mies van der Rohe also resisted the determinacy of a formal stylistic categorization. In a 1927 letter to Dr. Riezler, then editor of the German Werkbund magazine *Die Form*, he wrote: "Is form really an aim? Is it not instead a product of the design process? Is it not the process which is essential? Does not a small shift in the process's conditions

produce an entirely different result? Another form? I would therefore wish that we march on without a flag."[177] Nonetheless, the Bauhaus itself was only a temporal manifestation, a style, according to Gottfried Semper's definition: "Style is the revelation of the fundamental idea raised to the level of artistic significance; it includes all the internal and external coefficients which act to modify that idea in its manifestation as a work of art."[178] The usual American definition of style deviates from Semper's to mean in general the sum of a building's essential formal characteristics. As defined in a standard reference work published by the Historic American Buildings Survey Organization, style is "a definite type of architecture, distinguished by special characteristics of structure and ornament."[179] According to this criterion, which corresponds to Hitchcock and Johnson's, style is an essentially phenotypic quality. The fact that the reception of the International Style degenerated into a one-dimensional image of abstract, cubic volumes made of steel, concrete, and planes of glass with smooth white walls and a flat roof, horizontal strip windows, and large terraces cannot be pinned on Hitchcock and Johnson. In fact, that image shares just as much with such descriptions as Walter Gropius's criteria in *The New Architecture and the Bauhaus*.[180]

The Bauhaus ironically proved more amenable than other movements to formulating the International Style. This is clear even in the movement's name, which seems to have been inspired by the first Bauhaus book, Walter Gropius's *Internationale Architektur*. The works by Gropius shown in the exhibition date exclusively from the Dessau period. By securing a privileged place among the architects presented for Mies van der Rohe, the curators and authors paid homage to the Bauhaus director then in office. The influence of the two architects goes beyond what is superficially apparent. Hitchcock, Barr, and Johnson's definition of the Style relies considerably on the views developed by Gustav Adolf Platz five years earlier in his standard reference work *Die Baukunst der neuesten Zeit*, in which he described the characteristics of Gropius's and Mies van der Rohe's avant-garde works. This book, which was in such great demand that a second edition was already issued by Propyläen Press in 1930, suggested the

174 Behr, "Das Bauhausgebäude in seiner Bedeutung für die Entwicklung der neueren Architektur," 464.

175 Manfredo Tafuri, *Architecture and Utopia*, 77.

176 Walter Gropius, *Architektur. Wege zu einer optischen Kultur*, 16f. These thoughts are reflected earlier in *The New Architecture and the Bauhaus*, 61f.

177 Ludwig Mies van der Rohe, letter to Dr. Riezler, undated, Mies van der Rohe Archive, private files of Dirk Lohan, Chicago.

178 Gottfried Semper, quoted in Wingler, *Das Bauhaus, 1919–1933*, 24. Note the reference made to Semper's concept of style in contemporary definitions, for example *dtv-Atlas zur Baukunst*, 1:71.

179 John C. Poppeliers, S. Allen Chambers, and Nancy B. Schwartz, *What Style Is It?*, 10.

180 Gropius, *The New Architecture and the Bauhaus*, 20ff.

internationalism of the new architecture most convincingly, although Platz did not use the term "international architecture." The idea was further promoted in a book by Frederick Kiesler titled *Contemporary Art Applied to the Store and Its Display.* Including a number of illustrations of works of contemporary art, architecture, and design, the text entertained the idea of the internationality of the new modern architecture in Europe, two years before Hitchcock and Johnson formulated their definition of the "International Style."[181]

The conflation of individual works of the avant-garde within the context of a common movement was not a new idea, either. Five years before *The International Style,* Platz had built a similar argument. Philip Johnson knew *Die Baukunst der neuesten Zeit,* perhaps through *Architectural Record.* In a 1928 issue of that magazine, Pauline Fullerton, then the head librarian in the Department of Art and Architecture at the New York Public Library, had included the book in her recommended reading list: "A discussion of the new movement in architecture, followed by more than four hundred illustrations of various types of buildings, predominantly German. There is a brief dictionary of architects and their works, and . . . an index of text and plates."[182] Johnson, who could read the book in the original German and was thus not limited to its extensive photographic documentation, cited it favorably in a 1931 review, published in the *New Republic,* of Cheney's book *New World Architecture:* "Judged merely as a picture book, 'The New World Architecture' falls short of the standard set by the second edition of Platz's 'Baukunst der Neuesten Zeit.'"[183] While he used the book as a source of information and an architectural travel guide when he visited Europe in 1930,[184] it probably served as an eye-opener for the avant-garde's works as well. Thus, an architectural criticism of the Bauhaus was incorporated directly into the formulation, presentation, and reception of the International Style via *Die Baukunst der neuesten Zeit.* A glance at Platz's bibliography reveals his sources, including:

> Walter Gropius and Karl Nierendorf, eds., *Bauhaus, Staatliches, in Weimar, 1919–1923;* Walter Gropius, *Internationale Architektur* and *Neue Arbeiten der Bauhaus-Werkstätten;* Mies van der Rohe, "Industrielles Bauen"; and Publications by the "Ring" group in the journal *Bauwelt.*[185]

A comparison of the table of contents in *The International Style* with that of Platz's book reveals a series of common criteria for describing the new style. Some of the topics covered by the authors of *The International Style* were:

- The influence of early American modernism on the Neues Bauen;[186]
- The growth of the new aesthetic from the bond between art and technology, excluding rigid functionalism;[187]
- Horizontality, dissolution of the building's massing, and rejection of ornament as fundamental principles, and the attribution of aesthetic power to composition and materials;[188]

- Paradigmatic character of the Dessau Bauhaus building with regard to these principles;[189]
- The pioneering position of Mies van der Rohe, Gropius, and Oud in the movement.[190]

Platz and others had already envisioned the new buildings' rise to the status of a style.[191] In *Baukunst der neuesten Zeit,* he had written: "A new architecture is arising. . . . We are at the beginning of a development process . . . that will precipitate a new style." Even the equivalence implied between the "new style" and historic styles, such as Gothic, and the belief that this new style would lead away from the "chaos" of historicism, already appear in Platz's work. In addition to its explicit references to Gropius and Mies, Platz's book refers indirectly to the philosophical positions and mode of production of both these architects. Listing the common characteristics of the "new architecture," the author cites the conception of architecture as "an expression of the

181 Dieter Bogner, "Architecture as Biotechnique," 147.

182 Pauline Fullerton, "List of New Books on Architecture and the Allied Arts," 85. In the thirties and forties, bibliographies of the most important books on modern architecture included Platz's work.

183 Philip Johnson, "Modernism in Architecture," 134.

184 According to Schulze, *Mies van der Rohe: A Critical Biography.* Also see Terence Riley, *The International Style,* 202.

185 Platz does not include footnotes. Thus, the reader has to recover his use of the literature mentioned in the bibliography.

186 Platz on Frank Lloyd Wright: "It is not surprising that this great artist had a strong influence on German architects....Many currents tying us to America eminate from Wright's rural houses and sober industrial buildings but most of all from his skyscrapers" (*Die Baukunst der neuesten Zeit,* 67). Compare to Hitchcock and Johnson: "But it was in America that the promise of a new style appeared first and, up to the war, advanced most rapidly [particularly with Wright's continuation of the Chicago school]" (*The International Style,* 25).

187 Platz, quoting Peter Behrens's maxim in his text: "We do not want a technology that follows its own course in isolation but rather a technology that is sensitive to the *Kunstwollen* of the era." Behrens also warns of the "dangers of functional architecture" (*Die Baukunst der neuesten Zeit,* 66). Compare Hitchcock and Johnson: "The new conception that building is science and not art, developed as an exaggeration of the idea of functionalism" (*The International Style,* 35).

188 Platz, *Die Baukunst der neuesten Zeit,* 65, 75. Compare Hitchcock and Johnson, *The International Style,* 13.

189 Platz calls the building "a convincing symptom of the pendulum swing" toward the new architecture. Hitchcock and Johnson: "The Bauhaus is something more than a mere development from the technical triumph of the Alfeld factory," in reference to a previous description of the Fagus factory as the prototype of the style.

190 Platz does not mention Le Corbusier because his book is limited to German and Dutch architecture; *Die Baukunst der neuesten Zeit,* 64ff. Compare Hitchcock and Johnson, *The International Style,* 28, 31, 33.

191 Also see the writing of Walter Curt Behrendt from the twenties.

era" and "the era's will," both ideas that Mies propounded at that time. He also cites
the consideration of economically disempowered portions of the population in the new
planning and "the metaphysical roots [of the new architecture] . . . in a new recogni-
tion of the dignity of man as the only true basis of nobility."[192] In the latter two pas-
sages, the social motivation and democratic conviction that in part motivated the
founding of the Bauhaus are revealed. It is mainly in this regard that *The International
Style* clearly distanced itself from *Baukunst der neuesten Zeit*.

192 Platz, *Die Baukunst der neuesten Zeit*, 17–20, 76–78, 90. The bibliography includes Ludwig
Mies van der Rohe (91).

4

Controversies
Surrounding
Bauhaus
Architecture

T he American reception of the Bauhaus, by the mid-thirties, had grown far beyond the initial, more rarefied circles. The Bauhaus and its architecture became known as an alternative to traditional building. The school's closing and the subsequent marginalization or emigration of its most important protagonists became an opportunity for the United States to appropriate its concepts and vital forces by conferring various professorial positions upon former Bauhaus masters. Ludwig Mies van der Rohe's increasing professional isolation after the establishment of a National Socialist regime and Walter Gropius's emigration to England were both common knowledge in America in 1936.[1] When the prospect of a professorship was offered to these architects, both signaled their interest unambiguously.

To insure the success of such appointments, the acquiescence of more than an elite circle of connoisseurs of the European scene would be necessary. Thus, a basis had to be prepared in universities and in cultural and professional organizations for the acceptance of the unfamiliar intellectual heritage of the Bauhaus. This was a considerable undertaking, although "arriving so late in the decade, they, the Bauhaus masters, found a receptive climate for their points of view," and "increasing understanding and, among liberal-minded students, increasing impatience as well for the kind of instruction that Gropius, Mies and Breuer eventually offered."[2] Modernism, and with it the ideas of the Bauhaus, had long since established itself in the United States. Nonetheless, there was also considerable resistance, not only from opposing professional and academic camps but also on political grounds. The Bauhaus was, after all, a repository of German intellectual culture, a fact that could have entirely discredited the International Style in the American consciousness. The school was subject to the reservations many Americans harbored against Germany at that time.[3]

1 "Architecture of the Nazis," 122f.
2 William H. Jordy, "The Aftermath of the Bauhaus in America," 502.
3 Refer to Gordon A. Craig, *Wahrnehmung und Einschätzung*, 8, 13ff.

AESTHETIC
OBJECTIONS

One of the basic principles taught by Josef Albers was that there is always more than one solution to an aesthetic problem. The variety of responses to the various exercises proves the success with which this principle was pursued at the Bauhaus. This insight was forgotten, however, as the reception of the Bauhaus in America focused increasingly on architecture and on the Dessau school under Walter Gropius. The result was the limited set of criteria that later established itself as the "Bauhaus idiom" in the minds of Americans. Among American critics, the need to deal with an architecture and aesthetics conceived on the one hand as an alternative to architectural conventions and on the other as incommensurate with the usual standards, fostered insecurity. It resulted in a strangely polarized reaction: either fascinated amenability or unrelenting rejection. This schism was apparent even in the early twenties.

Certain reservations were the product of limited or stilted contact with the Bauhaus; later, these same objections against modernism and the International Style would be voiced during the postmodernist era. They included the loss of communicative power, inadequate symbolic capacity, dogmatism, and lack of respect for regional, historical, and typological tradition. The most pronounced critique came from the Beaux-Arts camp, which found itself competing with a new philosophy and, in the latter part of the thirties, with its unwanted proponents. It must not be forgotten that the classical tradition of the federal style and Greek revival was tied to the nation's founding and to its pioneer era. Thus, avant-garde architecture contradicted a seemingly constant and valid sign of national identity. Even in terms of the more recent past, America was hardly an architectural historical vacuum into which the European avant-gardists could enter. The architects of the Chicago school and Frank Lloyd Wright were still intellectual presences, even if it did not seem so for a time. More than a few would have been happy had American architecture returned to this tradition to rejuvenate itself. There was more at stake in this discussion than factual arguments: it was a matter of taste and conflicting cultural concepts. The works of the contemporary European avant-garde were received within a different milieu in the United States than the one in which they had been produced. Thus they met with different aesthetic preconditions, expectations, and standards.

Many American critics had difficulty accepting the unaccustomed and foreign qualities of the abstract formal language. The biting review by Egerton Swartwout, who wrote a series of criticisms of contemporaneous foreign architecture journals for *American Architect* in 1923, epitomizes this reaction:

I have received this month a copy of a German publication *Moderne Bauformen*, together with the statement that I will receive it monthly hereafter. Not understanding German I am unable to read the text, but the illustrations are modern enough, God

knows, and to judge from them I can't say I appreciate the promise of its monthly receipt. . . . This modern rot seems very much in evidence now in Germany and by the same token all over the continent. . . . Whether it was caused by the war or whether it caused the war I don't know, but it seems universal. Here it seems confined to Greenwich Village and to some horrible examples of that degenerate school of Matisse and Cezanne et al. with which the pages of our so-called art magazines are defiled and which are apparently made by a feeble-minded but utterly depraved child of eleven.[4]

If Swartwout here attacked the object of his criticism with a sharp tongue but conceptual vagueness, an article that appeared five months later leaves absolutely no doubt that the attack was aimed at the avant-garde of the twenties, not at prewar modernism.[5] The discrediting rhetoric in which he couched his position was to be echoed ten years later in the art and architecture criticism of fascist Germany.

In the following years, as German-American contact increased, the denunciation of the Neues Bauen's stark, abstract forms was no rarity. Nonetheless, a more sober tone and balanced critique prevailed in the more reputable journals, resulting sometimes in ambivalence or uncertainty. Sigurd Fischer and Edwin Horner, who traveled to Holland and Germany for *Architectural Record* in 1929, recognized the qualities of the new buildings, such as their logic and simplicity. At the same time, they criticized the Dessau Bauhaus building for representing an unacceptably extreme position for the avant-gardes of both countries:

The extremists of this group go so far as to contend that nothing that is not absolutely essential to the function of a building should be included in its design; that there should be no ornament whatsoever. The idea is consistent with the theory behind the modernist movement that, in order to produce a new architecture which will be appropriate to our time, we must begin with the barest necessities and evolve a new style.[6]

They were so sure of their judgment of the Bauhaus as to predict that the architecture produced in this academic context would have no future. On the other hand, even at the time of their research, the Neues Bauen had already received so much attention and recognition in the States that its success could not be entirely precluded. Horner and Fischer resolved their quandary by reducing the text in their thirty-page article to a

4 Egerton Swartwout, "Review of Recent Architectural Magazines" (20 June 1923), 577.

5 Five months after receiving the first issue of *Moderne Bauformen*, Swartwout attacked the editors of *Architectural Review* for publishing modern Dutch architecture with such phrases as "cubic film production" and "modern stage sets." "Review of Recent Architectural Magazines" (21 November 1923), 462.

6 Edwin A. Horner and Sigurd Fischer, "Modern Architecture in Holland," 203, and "Modern Architecture in Germany," 41.

4.1 Old Masters moving into modern houses. (Drawing by Carl Rose, 1935. Reprinted by permission of The New Yorker Magazine, Inc.)

minimum and publishing instead numerous large-format photographs of the new buildings, including a full-page photograph of the Dessau Bauhaus and a half-page photograph of the master's house in which Gropius lived.[7]

In that same year, other architecture critics accused the European concrete, steel, and glass architecture of extremism.[8] Reports on the Barcelona world's fair of 1929 used the city's historical architecture as a positive counterimage, concentrating on the picturesque piazzas, splendid boulevards, and urban palaces while ignoring Mies van der Rohe's German Pavilion or discounting it in general terms: "Italy, Belgium, France, Germany, Denmark, Hungary, Norway, Romania, Sweden and Yugoslavia have buildings of sorts, but only Italy, Belgium and France have erected distinctive and consequential pavilions."[9] Articles on the 1931 German Building Exposition in Berlin in the *Journal of Home Economics* and *The American City* gave other reasons for their rejection of the modern European aesthetic: the reduction of ornament to a point of absurdity, the "degeneration of the calming effect of the simple line to dullness," the strident color combinations and the standardization to a point of excess of the houses' interior decoration.[10] The traditionalist Ralph T. Walker accused the European avant-garde of neotheological dogmatism:

Europe has exalted the plumber, and the T-Square and Triangle are rampant. The right angle is the cross of the new European theology of architecture. The European architect is so engrossed with the two dimensions of Euclidean geometry and a theory of structure, that he has ceased to produce architecture for human beings. Not the engineer of imagination, but one who has replaced the old builder's rule of thumb methods by a rule of textbooks.[11]

Even in skyscraper design, the new architecture did not satisfy expectations. It offered neither the static massiveness and monumentality of neo-Gothic skyscrapers nor the elegant and sensual grandeur of art deco. Furthermore, it lacked any form of symbolism or traditional expressive values. Even the machine aesthetic, incorporated into art deco on the heels of the 1925 Exposition Internationale des Arts Décoratifs et Industriels Modernes in Paris,[12] could not maintain its primacy into the late thirties without recourse to handicrafts and ornament.

Next to the factually based reasons for rejecting the functionalist and rationalist aesthetic, other arguments urged the need for continuity with existing aesthetic, ethical, and social norms and the increased esteem for technical perfection. Judgments were passed despite inadequate information, scant opportunity for comparison, or simple misunderstanding. Deeper reasons for the rejection were fear of the unknown or the threat posed to valued cultural standards, well-loved traditions,[13] and political symbols. The disinclination to form an informed opinion went so far that the "simple-minded Nazis" were credited with patriotically protecting their "picturesque cities and villages" against the architectural "havoc" with which the Bauhaus threatened them.[14] Within this context, the association of avant-gardists with the radical left, anarchism, socialism, and Bolshevism was only too welcome. The American rejection of the conformity and bare aesthetics of the new architecture differed only in intensity from that of many Germans—a fact the Nazis relied on in their attacks against the Bauhaus architects.

The exclusion of George Howe and William Lescaze from the Architectural League of New York's annual exhibition demonstrates that even toward the end of the decade, most Americans had little tolerance for modernism. Eliel Saarinen's Tribune Building could be considered a touchstone: many believed that its formal language showed respect for indigenous tradition while its construction technique was "appro-

7 Horner and Fischer, "Modern Architecture in Germany," 45, 42.

8 Ralph T. Walker, "The Relation of Skyscrapers to Our Life," 694.

9 W. F. Paris, "The Barcelona Exposition," 496. The same tendency may be found in C. Reginald Grundy, "Barcelona To-day," 3ff.; and C. J. Stahl, "The Colored Lightening of the Barcelona Exposition," 131ff. The lack of contemporaneous articles on Mies's Barcelona Pavilion in the United States is evident in the *Art Index*, 1929–1932.

10 Mathilde C. Hader, "The Berlin Housing Exhibit," 1135. Also see "Berlin's Housing and Planning Exhibition," 90f.

11 Ralph T. Walker in George Howe et al., "Modernist and Traditionalist," 50.

12 Norbert Messler, *The Art Deco Skyscraper in New York*, 179.

13 Suggestions of these motivations can be found in "Obsolescence vs. Modernism," 11; Wells Bennet, "Modernism Is Still in the Making," 87f.; Dwight J. Baum, "This Modernism," 599.

14 B. C. Flournoy, "The Closing of the Bauhaus."

priate" to the times.[15] The power of such arguments would be proven a short time later, when the appointment of a former Bauhaus director to a professorship at Harvard University resulted in a direct confrontation between conservative circles and those who championed innovation and open-mindedness. In 1936, when Joseph Hudnut, then dean of the School of Architecture, began negotiations with the university board and with his own faculty on the appointment of Gropius or Mies, the dissent of the conservative faction created significant problems. Hudnut described the difficulties in a letter to Mies in September of that year: "It would be foolish to pretend that there will not be opposition to the appointment of a modern architect as Professor of Design. In Berlin, I tried to make clear to you the cause of this opposition—which is based in part on ignorance and in part on a difference in principles—and since my visit in Berlin, I have received letters which promise an opposition even more serious than I expected."[16]

If negative criticism is often the result of deviation from the dominant aesthetic taste, it must not be forgotten that a large portion of the architecture produced by the Bauhaus was also tied to social aims. To overcome such fundamental obstacles in the United States was not easy, especially since European modernism was seen by certain conservative groups as a degenerate culture's destructive attack on America.

POLITICALLY
MOTIVATED
BARRIERS

In processes of reception, not only the subject of the reception but also the timing and the historical background in its entirety must be considered. This was especially true for the United States. The year 1930 marked a significant change in the way the United States viewed itself: the country no longer conceived of itself as a country of immigrants. Immigration quotas were introduced on the grounds of high unemployment, a measure that was intended to prevent any further strain on the job market. Its consequence was, however, a changed way of thinking. Newcomers were considered "aliens," and a more stringent hierarchy among immigrants on the basis of nationality evolved. The United States, like other countries, had never been equally receptive to different cultures. In the case of Germany, the issues were complicated: on the one hand, Americans still admired the cultural legacy of classical music, science, and traditional art; on the other hand, Germany was seen as the initiator of World War I. After a brief thaw, these sentiments congealed into a new hard line, especially after the National Socialists took power. On the eve of the Second World War, politically motivated barriers appeared that would make it more difficult for the friends and supporters of the new architecture to prevail.[17]

Protection of National Interests The political recriminations were fed by a strong
sense of nationalism that had developed over the
course of the twenties. Alfred Barr, Jr., had been aware of this problem when, at the
onset of the International Style debate, he anticipated that any foreign influence would
be rejected on the basis of nationalism, a potential hurdle for the Style's success.[18] His
fears were confirmed when the Museum of Modern Art's board of directors agreed to
approve the exhibition only if it maintained a quantitative balance between American
and foreign architects.[19] On another occasion, when Barr suggested to the board that
Mies van der Rohe be commissioned to build the new museum facility, he found strong
disapprobation for the idea that a foreigner be entrusted with the commission for this
important American institution.

Thomas Mabry, the museum's business director at that time, wrote to Barr in
June 1936 that the architect expected to receive the project, Philip Goodwin, would
not accept a foreigner even in a peripheral capacity: "Goodwin talked to me over the
phone the other day and at last came out definitely against getting any foreign archi-
tect as collaborator. Indeed, he said he would withdraw from it if they were precipi-
tated upon him. . . . The building committee has decided to go ahead with Philip
Goodwin and, incidentally, his assistant Stone, and to dismiss the idea of inviting Oud
or Mies."[20] Barr accurately predicted the position of the museum's directorship and
tried to win its members over by proving the ambivalence in his opponents' position:
"I know that some of our trustees are strongly nationalistic in feeling but I think they
do not hesitate to buy their English clothes or French hats (if not French pictures)—
nor do they seriously object to the Museum's owning foreign paintings. Why then
should we be prejudiced against a foreign architect?"[21] He received no answer. Barr was
unable to prevail over the bulwark of resentment; the nationalistic forces in the leader-
ship maintained the upper hand.

It would be illusory to believe that artists and architects from abroad are received
only on the basis of their work or as representatives of specific institutions or profes-
sional groups. They are always also inseparable from a particular period in the culture

15 Charles Crombie, "Correspondence: The Decline of Architecture," 141.

16 Joseph Hudnut, letter to Mies, 3 September 1936, Mies van der Rohe Archive, private files of
Dirk Lohan, Chicago.

17 On the connection between national character and aesthetic preferences, see H. Coleman
Baskerville, "Contemporary Styles," 251.

18 Alfred H. Barr, introduction to Hitchcock and Johnson, *The International Style*, 15.

19 Elizabeth Mock, *Built in U.S.A.*, 12.

20 Thomas D. Mabry, Jr., letter to Alfred H. Barr, 18 June 1936, Museum of Modern Art, New York.

21 Alfred H. Barr, Jr., letter to Philip Goodwin, 6 July 1936. Also see Alfred H. Barr, letter to Mrs.
John D. Rockefeller, Jr., 2 July 1936. Both in Museum of Modern Art, New York.

of their nation. "No more foreigners" was thus one of the objections to the overtures made by Dean Joseph Hudnut of Harvard University to Mies and Gropius. Michael van Beuren, a former Berlin Bauhaus student, described the nationalistically motivated resistance on the part of the architecture faculty in a letter to Mies in the fall of 1936: ". . . and then the crackpots who have somehow caught wind of this [negotiation with two Germans] and scream 'no more foreigners.'" He warned Mies that the influence of this "reactionary clique" could make his life at Harvard difficult.[22]

The academic resistance to the importation of foreign culture was not based on a deep-seated principle. In certain cases, it was instead rooted in a feeling of national superiority. This was echoed in the architectural press, for example, in this 1931 letter to the editor of *Pencil Points:* "Let the American architectural schools teach real architecture, fitting American conditions with American methods, not European school architecture."[23]

Foreigners also encountered difficulties with state-controlled professional organizations. The Architectural Registration Board, responsible for licensing architects, proceeded more or less restrictively by the mid-thirties in most states. New York would confer "upon a foreigner under no conditions the license to practice architecture,"[24] not even as a consultant to an American colleague. Massachusetts offered temporary licenses to foreigners. Illinois, on the other hand, granted registration and the right to practice to foreign architects. It was traditionally a state favored by German immigrants; a German architect, Dankmar Adler, had already achieved renown in Chicago.

It is clear from the licensing statutes of New York and Massachusetts that the barriers within professional organizations were not motivated by vocational but rather by nationalistic reasons. Both states allowed a foreigner to practice the profession for ten years if he stated in a court of law his intention to become an American citizen. In compliance with this rule, Gropius submitted an application for registration in the state of Massachusetts.[25] Mies was spared this problem in Chicago. Both became American citizens in 1944.

The infiltration of nationalistic thinking into the profession proves that architecture, more than any other visual art, touches the core of a nation's identity. At a time when architecture's social and economic-political function was thought to be great, any attempt to ensconce the representatives of a universal style in institutions of national prestige was bound to cause resistance and tension.[26]

Anti-German Tendencies In 1934, the gallery owner Galka Scheyer wrote to Paul Klee from California: "I would appreciate if, in the future, you quote your prices in Swiss francs. It is easier to discuss Swiss prices with people here than German ones because Germany is on the black list."[27]

While the issue of foreign culture in the United States was generally a delicate one in the first decades of this century, it was especially difficult with regard to Germany. The two countries, which had traditionally prided themselves on a solid political and cultural relationship, began to drift apart at the end of the nineteenth century. The open explosion of animosity in the First World War drastically curtailed cultural exchanges. German opera was banned from music halls, German art from museums, and the German language from the course offerings at many schools. Germany's image as the country of classical music, literature, and romanticism was slowly replaced by the dangerous and aggressive Germany depicted in American propaganda to justify the nation's entry into the war. Motivated by reports of German war crimes in Belgium, George Bellows created his famous twelve-lithograph series of "the Huns." Negative feelings were tenacious: in 1923, a petition was circulated in San Francisco and signed by two thousand students and teachers for the reintroduction of German as a high school language course. The petition was refused by the school board. Emotions ran so deep that politicians who were perceived as too liberal on the German issue risked their reelection.[28] There were exceptions, such as the Quakers who distributed lunches to German schools and maintained a consistently humanitarian position toward the people in postwar Germany. Sympathetic to the country's problems of unemployment, poverty, and hunger, they continued their aid regardless of radical confrontations between left and right, political assassinations and coups, and reparations.

A 1920 article in *The Freeman* on expressionist painting stated plainly that political prejudices against Germany had caused American museums and journals to overlook important artists and movements simply on the basis of their national affiliations.[29] In conservative circles, among which Harvard University must be reckoned at the time, these resentments were particularly difficult to dispel. A critical comment

22 Michael van Beuren, letters to Mies, 21 October and 6 November 1936, Mies van der Rohe Archive, private files of Dirk Lohan, Chicago.

23 Louis Leonard, "A Letter from Louis Leonard," 386.

24 Joseph Hudnut, letter to Mies, 26 October 1936, Mies van der Rohe Archive, private files of Dirk Lohan, Chicago.

25 Reginald R. Isaacs, *Walter Gropius*, 2:858.

26 The detachment of style from national tradition was still used decades later as an argument against it, as in the early Reagan years, when a strengthened sense of nationality also led to an intensified exploration of an American architectural heritage. This phenomenon is reflected in the tone and content of publications such as Lisa Germany, *Harwell Hamilton Harris*, and Tom Wolfe, *From Bauhaus to Our House*.

27 Galka Scheyer, letter to Paul Klee, 1934, Paul Klee Nachlassverwaltung, Bern.

28 "Current Comment: German Language Ban Lifting," 435, and "California Refuses Permit," 567.

29 "The Expressionist Movement," 63–64.

in the *Nation* of 1930 describing the postwar atmosphere at the university makes this obvious: "As a sign that even in Cambridge the war is over, the Harvard Contemporary Society opened in Mid-April for a month a considerable exhibition of modern German art."[30]

Considering that the first exclusively Bauhaus exhibition in the United States took place at that university, in fact in that same year, the extent to which the political atmosphere of the twenties restricted the reception of the Bauhaus is clear. German culture in America had still not recovered from the harm done to it by the First World War. Walter Gropius underestimated the situation when he believed in 1923 that enough time had passed since the war to raise funds in America for needy Bauhaus students.[31] There had always been exceptions to the rejection of German culture in the twenties, among them the Société Anonyme's exhibitions in New York and the Blue Four exhibitions on the West Coast, both of which included the works of Bauhaus painters. Events such as these nonetheless were limited to private initiatives and small galleries; and after 1933, the German works became hard to sell, as J. B. Neumann wrote to Paul Klee: "There is no perspective here for German painters—all my efforts—ten years of difficult work—are for nothing. Luckily you are Swiss and not a 'Hitlerianer.'"[32] The climate began to relax later in the decade, as evidenced by the 1929 centennial celebration for Carl Schurz, a respected American who had made no secret of his German heritage. Although the militarism of the German spirit and German culture had been criticized up to 1925,[33] writers now began to speak of the "new Germany." Films such as *The Cabinet of Dr. Caligari* and *Metropolis* were well reviewed, and there was marked interest in Ernst Toller's article on the new German theater or Helen Appleton Read's reports on the Bauhaus, exhibitions, and other cultural events. Altogether, the image of Germany remained ambivalent for the duration of the Weimar Republic.

The situation was complicated by the common equation of Germany with socialism, a word that inspired hostility among most Americans. They associated socialism with the 1917 revolution in Russia and thus with violence.[34] After 1919, national patriotism grew into an anti-communist hysteria, fed by war and the Russian Revolution. Known as the Red Scare, it left a trace of fear among the populace and politicians even after it had ebbed. Labor laws, for example, reflected the suspicion of "socialist" measures for years to come. Thus, it was legal until 1932 for an employer to enforce a contract in a court of law that prohibited employees from joining a union. The minimal control exercised on the most wealthy reflected the conviction that wealth and investment were indivisible guarantees of national economic health. Political isolationism, economic power, and "self-made men" were all favored.[35] The minimal power of the country's left-wing intellectuals and politicians left no reason to expect any change in these conditions.

In his influential 1966 book *The Arrogance of Power,* Senator J. William Fulbright described the relationship that had prevailed since that time between the United States

to socialism or communism: "Despite our genuine sympathy for those who cry out against poverty and social injustice, . . . our sympathy dissolves into hostility when reform becomes revolution; and when communism is involved, as it often is, our hostility takes the form of unseemly panic."[36] Some of the Bauhaus's faculty hoped to contribute actively to the establishment of socialism in Germany and thus understood "architecture as a medium . . . in which to make politics explicit."[37] In this context, they saw the Bauhaus as a "gathering place for those who wished to build the cathedral of socialism, dedicated to the future and rising toward the heavens."[38] After the Bauhaus moved to Dessau, the municipally subsidized projects realized there, such as the school building, the municipal employment office, and the Törten Siedlung, and the practical cooperation between school and city, became known as paradigms of social democracy. In the United States, the Dessau Bauhaus and the Weissenhof Siedlung were associated with social democratic politics.[39] It seems paradoxical that Gropius's and Mies's favorable reputations in America were based on the Bauhaus building and the Weissenhof Siedlung—if only after some ideological purging.

Beginning in the mid-twenties, the political climate between Americans and Germans became more relaxed. New economic and cultural ties were forged. Thus, in 1930 in Cologne, the cornerstone of the German Ford factory was laid in Henry Ford's presence. American correspondents wrote more amiable reports on German cultural and intellectual life. Nonetheless, anti-German sentiments were fueled anew by the National Socialists' seizure of power. Even universities saw confrontations sparked by tense German-American relations. At Harvard University, for example, feelings ran high when the German visitor Ernst Hanfstängl, at times a close acquaintance of the Führer, offered the school a scholarship for the study of "Hitler's Germany." The university declined.[40] But a moral ambivalence was also at work on campus. When Erich

30 F. W. Coburn, "Boston Happenings" (February 1931), 141–142.

31 See the section "Points of Contact," chapter 2, above.

32 J. B. Neumann, letter to Paul Klee, 27 February 1934, Felix Klee-Nachlass, Klee Nachlassverwaltung, Bern.

33 See Raymond Wyer, "Germany and Art," 16.

34 Rhodri Jeffreys-Jones, "Soziale Folgen der Industrialisierung und der Erste Weltkrieg, 1890–1920," 265.

35 Dudley E. Baines, "Die Vereinigten Staaten zwischen den Weltkriegen," 288f., 304f.

36 J. William Fulbright, *The Arrogance of Power*, 76.

37 Johannes Werner, "Die Kathedrale des Sozialismus," 265.

38 Oskar Schlemmer, "Das Staatliche Bauhaus in Weimar," 181.

39 Paul Philippe Cret, for example, in 1933 described the relationship between the direction in architecture supported by Gropius and Mies and the political left in "Ten Years of Modernism," 92. Also see Hitchcock and Johnson, *The International Style*, 141–147, 181, and Franz Schulze, *Mies van der Rohe: A Critical Biography*, 143.

40 Lincoln Kirstein, "Harvard and Hanfstängl," 648–649, and "Harvard University Rejects Fellowship," 423.

Cohn, a potential sponsor, asked the director of the Germanic Museum not to include politically controversial art in a show planned for 1935, Charles L. Kuhn instantly dropped the anti-Nazi works of George Grosz from the exhibition list.[41]

Mies, Gropius, and other Bauhaus immigrants were not spared the suspicion with which Americans regarded Germany. Some were accused of espionage by the Federal Bureau of Investigation not long after their immigration, Mies in September 1939, Gropius in July 1940, and Moholy-Nagy in 1943. Thereafter, extensive files were kept on all of them.[42] Other Bauhaus people such as Josef and Anni Albers, Herbert Bayer, Lilly Reich, Walter Peterhans, and Xanti Schawinsky who did not become subjects of individual FBI investigations are named and identified in the main files of their friends and affiliates. The dates fall outside of the period of reception under study here, but the attitudes that initially led to the suspicion had been building over the course of the previous years and remained influential. Thus, the FBI activity reflects the tense atmosphere that formed the background in particular for Mies's and Gropius's efforts to receive commissions or positions in the United States.

Both were accused by people whom they knew only barely or not at all. In both cases, the accusation arose from banal evidence, misinterpreted by poor observation or the imagination. In the hysterical atmosphere of that time, the architects' German nationality was sufficient to make them suspicious.

Mies was brought to the attention of the FBI's Chicago office on September 6, 1939, by a Commissioner Walker who had received a written accusation a short time earlier from a "business woman" living in Glencoe, Illinois. After examining the information, the commissioner decided to consider the witness "reliable" and to forward her letter to the central office in Washington. The accusation reads:

I have just returned from Pike Lake Lodge, Wis., and while there was very suspicious of four Germans who were staying there. The leader was supposed to be a marvelous architect from N.Y. He had two younger men there and a woman Sec'y, who had just come over from Germany. They spoke nothing but German and spent their time over "drawings_____" I may be wrong, but they impressed me as spies, perhaps drawing plans of our country for the woman to take back to Germany. If you are interested, I can tell you more about it. My phone number is _____ (during day).
Most sincerely yours
_____(Signed).[43]

The woman thought it unlikely that a famous architect would spend so long a time in an out-of-the-way, tiny and little-known vacation spot like Pike Lake Lodge in Wisconsin. She was disquieted by the way the strangers kept to themselves, remaining apart from other vacationers and speaking German. As Walker later explained, she had just seen the film *Confessions of a Nazi Spy.* The actor's "confessions" had obviously influenced her to conclude that she had stumbled on a group of spies.

In reality, the suspicious drawings were for the Illinois Institute of Technology,[44] according to George Danforth who was with the party at Pike Lake Lodge. The modular design system developed by Mies may have looked to the informant like the geometric grid used by the U.S. land survey, a grid eminently apparent in the agricultural district in which she lived.[45] But even if allowances are made for this confusion, only an inflammable political situation can explain how Mies van der Rohe, Lilly Reich, Ludwig Hilberseimer, George Danforth, and Bill Priestly's vacation, which later filled volumes of FBI research, could lead to this denunciation.[46] The consequences for Mies were not only subsequent FBI research into his personal history, but also the creation of a secret file on him that includes entries made over the course of twenty years.

The FBI files on Walter Gropius cover a similarly long time but are more extensive. They were begun in June 1940, after a special agent of the local FBI office received a call from a woman who claimed that Walter Gropius harbored "pro-Hitler" and "anti-Semitic" feelings. He decided not to pursue the matter further and only noted it in a memo.

In July came the second report to the FBI's Boston office in the form of an anonymous letter:

Have you ever had occasion to look up Mr. and Mrs. Walter Gropius, Baker Bridge Road, Lincoln, Mass.? He serves on the faculty of the Harvard School of Architecture. She is one of the smartest and cleverest women I have ever met. Both are native Germans, and leaders in a set of doubtful sympathies. They may be all right, but I don't trust them around the corner. I would be glad to give you all the help I can on this, but please do not use my name.[47]

41 Stephanie Barron, ed., *Exiles and Emigrés.*

42 The following information on FBI activity relating to Mies van der Rohe and Walter Gropius is excerpted from their files. See the appendix, above in this volume, for more extensive excerpts. Not all pages of the Moholy-Nagy files were released by the FBI under the Freedom of Information Act; 1943 is the earliest filing date that could be identified by the author.

43 FBI file on Mies van der Rohe. The omissions in the text indicate the portions that have been blackened out in the publicly available FBI documents.

44 Information communicated by George Danforth to Dirk Lohan, late November 1991. Forwarded to the author by Lohan Associates Inc., Chicago, 21 November 1991.

45 The Land Ordinance of 1785 stipulated that the territories northwest of the Ohio be laid out on a grid system with a basic unit of 6 by 6 miles. Each unit was then subdivided into 36 sections of one square mile each.

46 The identification of the people involved was made with the help of Dirk Lohan, Mies's grandson and his successor in his Chicago office. Author's telephone conversations with Dirk Lohan on 21 November 1991. Following Lohan's confirmation of his identifications with George Danforth, the possibility was considered that the person whom Lohan had taken to be Hilberseimer could have been John Barney Rogers. The FBI files offer no answers to these questions: all names have been blackened out.

47 FBI files, Walter Gropius.

Approximately three months later, a man, again anonymously, called the same FBI office and stated that he had received information on an "ultra-modern house" in Lincoln, near Mrs. James Storrow. Munitions, machine guns, and bombs were apparently being stored in the house's cellar. The house in question, as confirmed by later police investigation, belonged to Ise and Walter Gropius.

The agent on duty considered the caller "more or less crazy" and recommended in his report to the FBI headquarters in Washington that the matter be left alone. The FBI director J. Edgar Hoover, however, had already received an anonymous letter accusing Gropius of spying for the Third Reich while enjoying refugee status. Hoover delegated the case to the Massachusetts State Police for further investigation. He advised his Boston office to inform him, should the accusations against Gropius prove true. The Gropius case was no longer classified as a matter of espionage but of "internal security." In January 1941, Boston responded to Washington with a four-page report that recommended closing the case on the basis of its findings. Walter Gropius, as the report stated, was not amicably disposed toward the Axis; he and his wife were law-abiding citizens. The fact that many American-born neighbors looked on them with suspicion was probably explained by the fact that they had little to do with other people, did not participate in the town's social life, and were responsible for the building of four modern houses in an old town that clung to tradition and a simpler life. Finally, their nationality made any suspicion natural.[48]

These FBI reports reveal new prejudices against "aliens." One implication is that their "otherness" was not only embodied in their person, their language, and their nationality, but also in the architecture of their house. Gropius's simple, anti-symbolic modern house in Lincoln was ironically enough seen as representing the same National Socialist regime which a short time before had condemned modern architecture as un-Germanic. Measured against the indigenous American tradition, the house stood for cultural inferiority in the eyes of its neighbors. Their disapprobation led them to equate nationality and architectural expression, and thus to reject the person and thing as one.

Once begun, both FBI files remained open, as did that of Moholy-Nagy. From the mid-forties on, however, the Bauhaus immigrants were no longer placed in the Nazi camp but, by a strange twist of political perceptions, came under surveillance because of supposed communist tendencies.[49] They were thought, especially Gropius, to engage in "un-American activities." Thus, in a bizarre repetition of the Third Reich's arbitrary accusations of "Bolshevism" against the Bauhaus leaders, both Mies and Gropius again became targets of extreme political forces.

If the United States was to be opened to more than a marginal Bauhaus influence, then the contradiction between the respect due to the intellectual leadership of this politically leftist movement in Germany and the anti-German atmosphere that prevailed in the United States had to be reconciled. The discrepancy between Bauhaus architecture and the American tradition had to be bridged. It was an ongoing

process, beginning in 1919 with the reception of the Bauhaus in American architectural criticism.

ACCEPTANCE
AND SUPPORT

Despite increased transatlantic communication, comparatively few among the American architectural public were conversant with European avant-garde architecture by the end of the twenties.[50] The circle of those who were well-disposed to the new movement and credited it with importance for the future was even smaller.[51] The primary supporters of the Bauhaus in the United States were recruited from its ranks. Most of them were either academics, including professors and university administrators; professionals such as architects, including former Bauhaus students, the authors and editors of architecture journals and books, art historians, collectors and dealers, and curators of museums; or patrons of modern art and architecture, including groups of highly educated nonarchitects from the world of finance and the cultural milieu as well as board members of museums and other organizations. The reception processes within these various groups cannot be considered separately, because there were too many commonalities and cross-currents in the participants' contacts, activities, and functions.

Behind almost every case of international cultural reception is one person who "beats the drum," who takes on the work of an artist and makes it famous.[52] None of the Bauhaus émigrés of the 1930s would have made it onto center stage without an influential lobby in the United States. In their case, and especially in that of Mies and Gropius, a single person would have been overwhelmed by this task. The reception of an entire movement and not only of a single artist was at stake, although this was less decisive than the fact that the medium concerned was mainly architecture and archi-

48 Ibid.

49 The entire files on Mies made in the mid-forties no longer concern National Socialist sympathies but rather communist. In 1946, a pamphlet entitled "We Need You" was distributed by the Midwest Division of Independent Citizens Committee of the Arts, Sciences, Professions, Inc. The group, on whose board Mies served, had been blacklisted by the House Un-American Activities Committee as a "communist front."

50 Donald Albrecht argues in *Designing Dreams*, 13, that most of these people relied on specialized journals for their information. This is only partially true.

51 Tom Wolfe casts a dubious light on these people in his book *From Bauhaus to Our House*, published in the eighties, a time of popular national feeling in America. He characterizes the egocentric followers of the European avant-garde as "businessmen and their wives" who tried to surround themselves at home with the flair of the avant-garde they had experienced in Europe and thus decided to import and institutionalize it as if it were a consumer good (41ff.).

52 Jürgen Born, "Kafka in America."

tectural education. Because of the way in which it impinges physically on the real world, architecture implies a much greater degree of expression and threat than painting, music, or literature. Architecture possesses a public presence; it cannot be avoided. It is loaded with functions and meanings and is relatively permanent. With the closure of the Bauhaus and the potential conferral on Bauhaus architects of professorships at important American universities, this "threat" assumed concrete form. To alleviate these fears, there were the facts that by 1936 support for the International Style and for both Mies and Gropius had increased, and that the call for educational reform was increasingly adamant. Until the early thirties, only a handful of authors and gallery owners had disseminated knowledge on the Bauhaus and its architecture. Thereafter, their ranks included a few influential individuals and smaller groups of people who were to some extent in contact with one another. Their mutual acquaintance did not always mean concerted action; their agendas were too diverse for that. In the later phase, these priorities meant that Philip Johnson, Alfred Barr, Jr., and various former Bauhaus students were the supporters of the Albers' emigrations and the pillars of the Mies reception, whereas Joseph Hudnut, Lawrence Kocher, Robert Davison, and Walter Gropius himself were the most important supporters of the Bauhaus's founder.[53] Together, and with the support of others, these people were able to direct the trajectory taken within their professions by the reception of Bauhaus architecture until the mid-thirties. They did so by means of activities, publications, connections, and influence. Their efforts were thus bound to fall on fertile ground, in particular as Josef Albers, Mies, and Gropius, once established in their positions, cleared the way for some of their Bauhaus associates to follow. All the time, the Bauhaus remained the point of connection, the common denominator.[54]

Philip Johnson While Philip Cortelyou Johnson was pursuing his studies in classical philology at Harvard University in 1927, he met Henry-Russell Hitchcock, who graduated the same year, and the 25-year-old Alfred Barr, Jr. Johnson became interested in the classical modernism of European architecture; during several trips to Germany in the late twenties and early thirties, he familiarized himself in person with the built works of the avant-garde. Barr's and Johnson's appreciation of each other was mutual and led to one of the most influential collaborations in the history of modern architecture. When Barr established the Department of Architecture at the Museum of Modern Art in 1932, Johnson served as an unremunerated director.[55]

Hoping to make Europe's avant-garde movements known in the United States and to bring certain of their protagonists into the country, Johnson intervened significantly and instrumentally in the development of American architecture after 1930. In 1929, on the occasion of one of his visits to the Dessau Bauhaus with Barr, he sat in on Josef Albers's foundation course. It was apparently difficult for Johnson to describe the nature and purpose of the experimental activities, but he was impressed nonetheless, as

a later letter expresses: "[The foundation course] is a course in creative handwork, difficult to explain, but one of the most valuable courses at the Bauhaus."[56]

He also came to appreciate the woven works of Anni Albers. When the Berlin Bauhaus was closed and Josef and Anni Albers lost their positions and were threatened by the political developments of Nazi Germany, Johnson assisted them in finding positions at Black Mountain College in North Carolina, where both could build new careers.[57] At the Bauhaus, Paul Klee, "the greatest man there" as Johnson wrote in a letter, attracted his attention enough to buy some of his paintings. He also came to appreciate Marcel Breuer's work, while Wassily Kandinsky was not among his favorites at all. Hannes Meyer, then the director, does not figure anywhere among Johnson's discoveries in Dessau. Instead, he paid Walter Gropius a visit in Berlin.[58]

Johnson is considerably better known for his important role in the American reception of Mies. He wrote to Mies for the first time on the occasion of the Berlin Building Exhibition of 1931. The open-plan model house displayed there led him to describe Mies as synonymous with the exhibition. In another article of 1933, Johnson described him as the most important representative of the new, apolitical architecture associated with modern art. This architecture stood against functionalism and was affirmed in the prize-winning design for the Reichsbank building.[59] In such works as Mies's Barcelona Pavilion, Barr's interest in modern art was as well satisfied as Johnson's in modern architecture. Mies was the prototype of an artist-architect who conformed to the founding philosophy of the Museum of Modern Art.

Johnson and Barr laid a cornerstone for the exceptional second career enjoyed by this architect in America when they presented his work in the 1932 "Modern Architecture: International Exhibition." Despite his inclusion in many publications, Mies was still not a common name in architecture circles by 1932. That changed with the MoMA exhibition and its accompanying publications. George E. Danforth, then a student at Armour Institute, later recalled:

53 The divergent receptions of Mies and Gropius are depicted in Reginald R. Isaacs's extraordinarily extensive Gropius biography. With regard to their respective supporters, Isaacs's 27-page index includes the names of Barr with seven references and Johnson with three. In comparison, the number for Davison is 28, for Kocher 23, and for Hudnut 73.

54 It should also be recalled that Mies and Gropius were part of the same reception process for most American authors and critics.

55 Alfred H. Barr, Jr., letter to A. C. Goodyear, 8 January 1935, Alfred H. Barr, Jr., Papers, Archives of American Art, New York.

56 Philip C. Johnson, letter to David Yerkes, dated 10 January 1933, Philip Johnson Files, Museum of Modern Art Archive.

57 See the discussion of the Albers in the section "The Faculty," chapter 3, above.

58 Franz Schulze, *Philip Johnson*, 55.

59 Philip Johnson, *Writings*, 49–54.

When Armour Institute appointed Ludwig Mies van der Rohe as its Director in the department of architecture in the fall of 1938, not much was know to us students about him, or about the two colleagues Mies brought with him: Walter Peterhans and Ludwig Hilberseimer. Earlier in the year, we had been excited by rumors that Mies was being considered as director of the department. Through such books as Hitchcock and Johnson's 1932 catalogue *The International Style: Architecture Since 1922*, we were aware of Mies' work, especially the Barcelona Pavilion, the Tugendhat House and some of his theoretical projects and the exhibitions he had been included in. And we certainly knew the Weissenhof Siedlung in Stuttgart, built under Mies' direction and containing a dazzling array of housing by many of Europe's leading architects, including a house by Ludwig Hilberseimer. Yet, Hilberseimer was an unknown person.[60]

The fact that Hitchcock, Johnson, and Barr's efforts around 1932 did not reach nearly all the players on the architecture scene is reflected by the position taken by Henry T. Heald, then dean of Armour Institute, who in 1936 was engaged in persuading Mies to come to the school. He invited him to Chicago, as he later stated, on the recommendation of John Holabird, one of the city's leading architects. Holabird himself knew little about Mies; he described Mies to Heald in the following terms after he had shown some images of his work: "I don't know Mies van der Rohe, but the Barcelona Pavilion and one or two other things that he has done are outstanding. And . . . after all, even if we don't know too much about the fellow, he's so much better than any of the people you could get to head a school of architecture, why not take a chance? So we invited Mies."[61]

According to Philip Johnson, Mies was entirely unknown in the United States prior to the "Modern Architecture" exhibition. Johnson maintained in the nineties just as he had in the thirties that he had "discovered" Mies. Up to that point, meaning during the twenties, Mies had supposedly not been mentioned by any magazine or book on architecture.[62] The fact that this is incorrect is proven by a glance at any serious Mies bibliography, such as that by David Spaeth, which cites a 1923 article in the *Journal of the American Institute of Architects* on the early skyscraper projects.[63] The large American art and architecture bibliography, the *Avery Index to Architecture Periodicals,* indicates that the Bauhaus and several of the individual architects associated with it had received notice before 1930. It would be astonishing were this not the case. After the end of the First World War, the American press followed every political move in vanquished Germany with alertness and distrust. It is clear that the Bauhaus, which began to make waves in the German press as early as 1923, could not have been overlooked. Thereafter, in fact, numerous reports on the Bauhaus found their way to the United States.[64]

Looking back on his "discovery" of Mies, Johnson later also claimed that, before 1932, no one in the United States had taken notice of the novel activities in Dessau

and Berlin.[65] According to his account, the American newspapers were entirely reactionary and not prepared to publish anything about the European avant-garde. He responded to the objection that both he and Barr nonetheless succeeded in publishing by pointing to his friendship with Lincoln Kirstein, who had facilitated their journalistic careers, and by citing the influence of the Rockefellers, which had reinforced Barr's position. In fact, not only had Henry-Russell Hitchcock and Sheldon Cheney known enough about the movement to devote considerable space in their respective books *Modern Architecture* (1929) and *The New World Architecture* (1930) to them; but some twenty articles, most including illustrations of one or more projects, had appeared in the *AIA Journal, Architectural Forum, Architects' Journal, Pencil Points, Hound and Horn, Arts, Apollo,* the *Nation,* and, above all, *Architectural Record* before Johnson had published his first text on Mies. With few exceptions, these articles were all written by different authors, a fact that by itself implies a certain degree of recognition. Particular mention should be made here of the articles by Helen Appleton Read from 1929 and 1931, one on Mies's Barcelona Pavilion and the other on his work for the German Building Exposition in Berlin. The author worked in close contact with the Museum of Modern Art and was a friend of Philip Johnson. According to Johnson, they spent time together in Berlin in the early thirties and exchanged ideas.[66]

Johnson must by all means be credited with recognizing Mies's exceptional talent and historical significance early and accurately.[67] He trusted his judgment at a time when it met with little sympathy, and persisted in publicizing his opinion. And although he might have felt reassured by Gustav Adolf Platz's assessment of Mies, he may still be said to prove Josef Albers's axiom on human vision: among one hundred people with a sense of sight, there will be one who really sees, and among one hundred

60 George E. Danforth, "Hilberseimer Remembered," 8.

61 Henry T. Heald, "Mies van der Rohe at I.I.T.," 105. The fact that Heald had taken a risk became clear soon after Mies's arrival: Mies did not speak a word of English, so for some time, IIT became the only American architecture school with courses taught mainly in German (106).

62 Author's interview with Philip Johnson, 16 October 1990. In addition, see Philip C. Johnson, "A Personal Testament."

63 David A. Spaeth, *Ludwig Mies van der Rohe: An Annotated Bibliography and Chronology.*

64 These reports were not collated systematically, however, and bibliographic marginal comments in the catalogue of known sources meant that the writing of this book involved a thorough search for material in Anglo-American periodicals and books. The result significantly expands previous bibliographies covering the period between 1919 and 1936.

65 Johnson, "A Personal Testament," 109.

66 Author's interview with Philip C. Johnson, 21 September 1992.

67 Hitchcock had categorized Mies as a promising talent; *Modern Architecture,* 190, 192.

4.2 Philip Johnson (center) with Alfred Barr, Jr., and his wife Margaret, Cortona, Italy, 1932. (Photo: The Museum of Modern Art, New York.)

who really see, one who also thinks.[68] On the occasion of the "Modern Architecture" exhibition, Johnson gave Mies preferential treatment: he invited him to design the installation[69] and guaranteed him a prominent position among the architects included. Both offers reflect Johnson's conviction that Mies was the most important of the "new pioneers": "Mies . . . I felt more than all the others was worthy of being called the greatest architect in the world."[70] To a considerable degree, Johnson's judgment was based on his personal acquaintance with Mies, whom he had visited on his European tour in the summer of 1930.[71] Mies was the director of the Bauhaus at that time but also regularly in his office in Berlin. Johnson's visit was not a one-time event.[72]

Johnson's enthusiasm went so far that he offered Mies a private commission to design his apartment in New York. He attempted to win other commissions for him and published his work in periodicals. In 1949, he would write the first American biography of Mies and build his famous glass house in New Canaan, Connecticut, evidence of his intensive study of Mies's architecture.[73] "I am the first Miesian," he explained later, looking back on those years.[74] In 1930, he acknowledged his sympathies openly: in the context of an initiative sponsored by the New York art dealer

J. B. Neumann, he assumed the role of U.S. representative of the Werkbund magazine *Die Form*.[75]

In the early thirties, Johnson did his best to promote not only Mies as an individual architect but also the Bauhaus as a whole. When the New York gallery owner John Becker set about collecting objects for the first Bauhaus exhibition in the States, Johnson helped him gain access to models and drawings.[76] An article published by Johnson one year later in *Arts* also witnesses his affirmative attitude toward the Bauhaus at that time.[77] He explained that it was typical of the Bauhaus's architecture to paint interior walls various colors and that "this successful use of color" represented "a contribution to a better architecture." With the assent of the Bauhaus's director at that time, Johnson offered to be the first official representative of the Bauhaus in America. A brief notice on the reopening of the Bauhaus in Berlin in a 1933 issue of *Architectural Forum* ended with the information, "Anyone wishing information about the Bauhaus apply to Philip Johnson, the American Representative, at the Museum of Modern Art, 11 West 53 Street, New York."[78]

By that time, Johnson's initial enthusiasm for Walter Gropius and the Bauhaus, which had even led him to write in the lower-case alphabet, had already faded. It may be surprising to find Johnson in the role of its "American Representative" despite his ambivalence toward the Bauhaus. He later made absolutely clear that he considered the Bauhaus and Mies van der Rohe to be antagonists, separated by their differing views on

68 Josef Albers (quoting William Morris), paraphrased from a video on his work, on view at the Josef Albers Museum in Bottrop, Germany, March 1992.

69 The author is not aware of the invitation's precise preconditions.

70 Johnson, "A Personal Testament," 109.

71 Schulze, *Mies van der Rohe: A Critical Biography*, 178f.

72 Mies told Dirk Lohan: "Later, he [Philip Johnson] came to Berlin every year. It was then that he became interested in architecture, collected photographs and all those things." Transcript of Dirk Lohan's interview with Mies, Chicago, summer 1968, 1ff, in Mies van der Rohe Archive, private files of Dirk Lohan, Chicago.

73 Dirk Lohan asked Mies in 1968 why Johnson hadn't studied with him at IIT but instead with Gropius at Harvard. Mies veiled his answer in sophisticated irony: "Yes, Harvard is a special school, you know, that is where the better people go. He [Johnson] had been at Harvard earlier, as a poor student. And Gropius was not so bad that Johnson would have had to forsake his alma mater." Transcript of Dirk Lohan's interview with Mies, ibid., 4.

74 Philip C. Johnson, quoted in Heinrich Klotz and John W. Cook, *Architektur im Widerspruch*, 29.

75 According to Terence Riley, *The International Style*, 203. The address of the J. B. Neumann gallery in Manhattan was 9 East 57th Street.

76 Johnson recalled offering "craft objects." Author's interview with Philip C. Johnson, 21 September 1992.

77 Philip C. Johnson, "The Architecture of the New School," 398.

78 "Bauhaus Reopened," 20.

art and history. The Neue Sachlichkeit, which he related to functionalism and saw concretized in Hannes Meyer's work, led him to speak deprecatingly about "the Bauhaus crowd." In the end, Mies was not a Bauhaus architect in Johnson's mind but rather an exception there, a master of the building arts at the Bauhaus, "out of the mainstream." If Johnson's attitude toward the Bauhaus seems contradictory at different times, it probably reflected more than ambivalence or a change of opinion. In *Writings,* he states that the American reception of the Bauhaus around 1930 was above all a struggle against the establishment, which was led by Harvard University and the New York Architectural League.[79] In these circles, Johnson was considered an ambitious social climber, as his fellow student Wilhelm Vigo von Moltke would later contend.[80] Whether or not these activities at the beginning of his career were predominantly self-serving, it is certain that Philip Johnson represented the Bauhaus with intensive engagement in the early thirties.

More than a year after the closing of the Bauhaus, Johnson summarized the results of his promotion of the last director: "I am not sure to what extent you realize how well-known you have become in the United States and in what great honor all modern architects hold you and your work, nor do I believe I am immodest in saying this is in a great measure due to my efforts on your behalf, through exhibitions, articles, and lectures."[81]

The relationship between Mies and Johnson lasted longer than the latter's flirtation with the Bauhaus. It remained a felicitous symbiosis until Johnson distanced himself from Mies with the design for his glass house in the fifties and thus opened a new chapter in the discourse of modernism.

Alfred Barr, Jr. Johnson's esteem for Mies was shared by Alfred Barr, Jr., the first director of the Museum of Modern Art. Barr believed in contemporary art and saw to it that European modernist painting and sculpture were included in the museum's collection on its opening in 1929.[82] In 1932, with the establishment of the Department of Architecture headed by Johnson, he also made the institution into a bastion of modern European architecture.[83]

When Barr first met Johnson, he had already a proven record as a disseminator of ideas on modern art. A series of five lectures on modernism that he had given at Wellesley College included a discussion of the Bauhaus. He had also made his mark as an author and critic with articles in *Hound and Horn.* In 1929, when he became director of the Museum of Modern Art, he organized a group of potent patrons. He stood in the center of a circle of intellectuals around the museum, including his friends Margaret Scolari-Fitzmaurice and Jere Abbott, the art dealer J. B. Neumann, the art historian James Johnson Sweeney, and his Harvard acquaintances Lincoln Kirstein and Edward M. M. Warburg. With regard to the Bauhaus reception, Barr's role in the various initiatives to bring Gropius and especially Mies to the United States was instrumental.

He was able to use his prominent position and influential connections to the worlds of American publishing, finance, and architecture, especially to the Rockefellers, in furthering these goals.

Barr met Mies for the first time in Berlin at the beginning of the thirties. He sought him out again in 1936 when he had been entrusted with a delicate mission by Harvard University, which was then seeking to fill a professorship in architecture for the following year. Joseph Hudnut, then dean of the graduate school, had set his hopes on conferring the position on Oud, Gropius, or Mies. He asked Barr to ascertain whether Mies would be interested. In May 1936, Hudnut wrote to Barr:

I shall be able to appoint a Professor of Design in this School during the coming year and I am most interested in securing the services of one of the really important leaders in modern architecture. . . . It occurred to me . . . that you might be willing, during your visit abroad, to discuss informally with Mr. Gropius or Mr. Van der Rohe (or perhaps with both) the possibility of their coming to Harvard.[84]

The discussions resulted in a clear refusal from Oud, a perhaps from Gropius, and a yes from Mies. Barr recommended to Hudnut that he choose Mies, who was ostensibly "the best architect in the world."[85] He hoped that Harvard would approve Mies for the position and that this decision would positively influence a second matter that he had mentioned to Mies: the Museum of Modern Art was looking for an architect to design its new building and Barr, a member of the building committee, wanted Mies to receive the commission.[86] It was Barr's ambition to build a collection of modern art and architecture for the museum that would be as good as possible, and he wanted this collection housed in a building whose architecture answered to the same

79 Johnson, *Writings*, 207f.

80 United States Army Intelligence and Security Command, statement of Vigo von Moltke, copy of the transcript, 3.

81 Philip Johnson, letter to Ludwig Mies van der Rohe, 2 November 1934, Mies van der Rohe Archive, Museum of Modern Art, New York, Correspondence.

82 Wolfe, *From Bauhaus to Our House*, 41.

83 Alfred H. Barr, *Masters of Modern Art*, 232. In March 1933, *Pencil Points* reported on the opening of a permanent architecture exhibit in the museum, designed and built to be a paradigm of modern interior design. It was intended as a space for architecture, furniture, and industrial and typographic design and to be complemented by a broad assortment of books, periodicals, and photographs. See "The Museum of Modern Art Architecture Room," 139.

84 Joseph Hudnut, letter to Alfred H. Barr, Jr., 18 May 1936, Alfred H. Barr, Jr., Papers, Archives of American Art, New York.

85 Alfred H. Barr, letter to Philip Goodwin, 6 July 1936. Also see Joseph Hudnut, letter to Alfred H. Barr, 18 May 1936; and Alfred H. Barr, letter to Mrs. D. Rockefeller, Jr., 12 July 1936. In Rona Roob, "1936: The Museum Selects an Architect," 23ff.

86 The museum had been located since 1932 in a rented building on the north side of West 53rd Street.

standards: "The Museum as a patron of modern architecture, cannot afford to run the risk of mediocrity in the design of its new building. It must have the superlatively best." He believed that Mies van der Rohe would be the ideal architect. He called him "a man whom many of us believe is the greatest architect of our generation. . . . He is charming, affable and used to working with others; . . . he directed the great Stuttgart Weissenhof Siedlung in 1926 and organized the Bauausstellung in Berlin in 1932. He has made special studies in installation problems, is a master in flexible space composition, and, he says, has made studies of modern museum problems."[87]

When Barr asked Mies on 20 June 1936 whether he would be interested in taking the commission, he received a definitively affirmative answer.[88] The museum's plans, as Mies wrote in his response, would be of "great interest" to him; "it would be a rare and fine commission."[89] Barr argued vehemently in favor of Mies and left no means untried that even remotely promised success in his pursuit of this matter. He did not prevail. Even as he was still negotiating in Europe, the building committee gave the commission to Philip Goodwin, a member of the museum's board.

Barr's third attempt to bring Mies to the States would finally meet with success. Mies took his first trip to America in August 1937 in order to complete a commission that Barr had gotten for him: he was to design a house in Jackson Hole, Wyoming, for the Resors, patrons of the museum.[90] Barr indirectly initiated another set of negotiations, this time between Mies and the Armour Institute in Chicago. The result would be Mies's emigration to America.[91]

The Armour Institute and Former Bauhaus Students

The Armour Institute, known today as the Illinois Institute of Technology, began its preparations to advertise for a new dean for its architecture school in 1935. John Holabird, partner in the architectural firm of Holabird and Root in Chicago, was entrusted with the search. In February 1936, on the request of Armour's president, William E. Hotchkiss, the exiting dean, Henry T. Heald, and the head of the search committee, James D. Cunningham, he wrote to a number of architects asking that they suggest candidates. Many responses urged him to find a younger, energetic man; he compiled a list of candidates accordingly. One of the architects whose advice was requested was Richard Neutra. He recommended Walter Gropius, among others. Some lists received by Holabird included Mies van der Rohe. Unlike in New York and at Harvard, Mies was little known in Chicago. No one on the search committee knew about him, but one of Holabird's colleagues, David Adler, enthusiastically provided them with information. Adler took Holabird and Jerome Loebl, another member of the committee, to the Burnham Library and showed them photographs of the Barcelona Pavilion. Both were impressed and allowed themselves to be convinced that Mies could be entrusted with the position. Holabird wrote to Mies

immediately, inquiring whether he would be interested in it. Armour harbored the ambition of becoming the best architectural school in the country and was thus eager to hire the best possible dean.[92] The letter's text read as follows:

Dear Sir:
We have in Chicago an Architectural School forming a part of the Armour Institute of Technology. The School is housed by itself in the Art Institute of Chicago, has 100 to 120 students and is, by reason of its location, more or less independent of Armour Institute. The Trustees and President of Armour Institute are very anxious to secure the best available head for the Architectural School with the idea of making it the finest school in the country. . . .

. . . In talking the matter over with the Advisory Committee, I thought that as we were considering the possibility of a European heading this school that I would like to ask if you would, under any conditions, consider such an appointment. I am, of course, a great admirer of your work and if we are to consider the best I would naturally turn to you first.

The School itself can be made anything that the proper man might wish; he would have a free hand with the authorities of the Institution. He could organize the School in such a manner that he could establish his private practice. . . .

. . . Please pardon me if I seem presumptuous in even suggesting such a position to you. It may be that you could recommend someone who might consider coming to this country.
Yours truly,
(Signed) John A. Holabird.[93]

87 Barr, letter to Goodwin, 6 July 1936, in Roob, "1936: The Museum Selects an Architect," 27. Mies's connection to the Bauhaus is not mentioned by Barr. He also slightly confuses his dates: the Weissenhof Siedlung took place in 1927 and the Berlin Bauausstellung in 1931.

88 He had also asked Oud and Gropius about this matter; they responded to this offer just as they had responded to Harvard's tentative offer.

89 Mies van der Rohe, letter to Alfred H. Barr, Jr., 14 July 1936, Alfred H. Barr, Jr., Papers, Archives of American Art, New York.

90 According to Schulze, Mies van der Rohe: A Critical Biography, 206, 209.

91 Barr's contact with Mies was not limited to the issues mentioned here. He also introduced Mies to other American architects. See Alfred H. Barr, letter to Mies van der Rohe, 19 July 1936, Mies van der Rohe Archive, private files of Dirk Lohan, Chicago. Also see John W. Cook and Heinrich Klotz, Conversations with Architects, 123.

92 J. A. Holabird, letter to Mies, 20 March 1936, Mies van der Rohe Files, Library of Congress. Holabird had attempted to establish the extent of Gropius's interest via Richard Neutra, but Gropius refused, saying that he preferred practice to teaching at that point in his life. Walter Gropius, letter to J. A. Holabird, 31 March 1936.

93 J. A. Holabird, letter to Mies, 20 March 1936, from Elaine Hochman, Architects of Fortune, 255. Unabridged original in Mies van der Rohe Files, Library of Congress.

After he had affirmed his interest by telegraph,[94] Mies wrote a longer letter that exposed his ambivalence. On the basis of his experience, he had "specific preconceptions about the structure of an educational institution for the teaching of architecture."[95] He wondered whether his ideas could be realized at Armour. In the course of his further correspondence with Armour, Mies arrived at the conclusion in June that he should decline the offer. He refused the position in a letter to Holabird:

It is with regret that I am compelled to tell you that, after careful consideration, I will decline the position at the Armour Institute. I do so because I could not believe that the framework provided by the school would allow for as comprehensive an architectural education as seems to me necessary at this time. The changes in the school's curriculum would have to be so fundamental that they would go far beyond the boundaries of the current architecture department.[96]

His contact with Armour continued nonetheless. In September, Mies wrote to William E. Hotchkiss to say that he had "in the meantime received an offer from another American university" which he intended to accept. He offered his advice for the continuing search.[97] The Harvard position, to which Mies probably was referring here, went to Walter Gropius. Mies was also under consideration for the open dean's position at Columbia University in New York, but his lack of English-language skills was judged an insurmountable obstacle.

Mies's later acceptance of Armour Institute's offer was in part to the credit of his former American Bauhaus students, including Michael van Beuren, Bertrand Goldberg, William J. Priestley, and John Barney Rogers.[98] On learning that Mies would be passing through Chicago on his trip to Wyoming in fall 1937, they set about arranging a meeting between him and Armour's administration. Priestley was responsible for the fact that Armour Institute even learned that Mies would be in the States and was successful in establishing contact with him. The meeting took place, and in December 1937 an agreement was reached after extensive correspondence on the position. At the beginning of April, Armour Institute officially circulated news of the appointment. In the late summer of 1938, Ludwig Mies van der Rohe assumed the office of dean, assured that he would be allowed to realize his ideas with complete freedom.

His former students Priestley and Rogers remained important figures for Mies. He worked on the Resor project in their New York office, they assisted him in developing a curriculum for Armour, and Rogers served him regularly at the school as translator.[99] Mies could also count on the help of the others. For example, Goldberg was the translator at his first meeting with Frank Lloyd Wright.[100]

Joseph Hudnut Joseph Hudnut was one of the first traditionally trained architects in the United States to recognize the meaning of the Neues Bauen

and to attempt to employ its principles in architectural education. As the dean of the Harvard University school of architecture, he cleared the way for modern architectural education in America by successfully advocating Walter Gropius's professorship in 1936.[101] Among his predecessors was the art historian George Edgell, who had in his day called for a "modern" architecture. In 1929, Edgell had introduced the discipline of urban planning to Harvard, the first school in America to offer the subject. He did not, however, reform the architecture program. The two subjects remained divided between an engineer-oriented and an art historical trajectory. As a consequence, many architects were able to ignore all but aesthetic considerations. On Hudnut's arrival, he was able to use the dissatisfaction that came from the stagnation in teaching and practice and to take advantage of the school's opportunities, including the subsidies offered under the New Deal. Reginald R. Isaacs argues that Hudnut's belief in social responsibility influenced him to call upon Gropius, an architect who had proven his ability to translate this responsibility into teaching and practice.[102]

Hudnut's role in the reception of Bauhaus architecture in the United States differs from Barr's or Johnson's in one essential respect: he was in search of a collaborator who, as department head, would help him to realize his ambitious plans. When Hudnut asked Barr to visit Gropius and Mies during his imminent European trip and to inquire after their potential interest in coming to Harvard, he wrote: "What I have in mind is something in the nature of a general discussion of the idea. If it should appear that either of these great teachers would like to come here or would be interested in coming here, I could then—at a later date—take up a discussion of the details of *my* program."[103] As dean, Hudnut was in a position to initiate and to prevail in the appointment of the professor of his choice. With Barr's assistance, an initial meeting with Gropius was arranged in Rotterdam in 1936; basic conditions for Gropius's acceptance were clarified in that meeting. Hudnut was interested in Gropius the pedagogue;

94 Mies, telegram to J. A. Holabird, 20 April 1936, Mies van der Rohe Files, Library of Congress.

95 Mies, letter to J. A. Holabird, 4 May 1936, Mies van der Rohe Files, Library of Congress.

96 Mies, letter to J. A. Holabird, 22 June 1936, Mies van der Rohe Files, Library of Congress.

97 Mies, letter to W. E. Hotchkiss, 2 September 1936, Mies van der Rohe Files, Library of Congress.

98 On van Beuren's Bauhaus affiliation, see Schulze, *Mies van der Rohe: A Critical Biography*, 207. Schulze does not note the dates of this student's matriculation at the Bauhaus, but he mentions Mies as his "mentor." On the other students, see Hans M. Wingler, *Das Bauhaus, 1919–1933*, list of matriculated Bauhaus students, 534–536.

99 According to Schulze, *Mies van der Rohe: A Critical Biography*, 205ff.

100 According to Cook and Klotz, *Conversations with Architects*, 123.

101 Lewis Mumford, *Roots of Contemporary American Architecture*, 426.

102 Isaacs, *Walter Gropius*, 2:839ff.

103 Joseph Hudnut, letter to Alfred H. Barr, 18 May 1936, Alfred H. Barr, Jr., Papers, Archives of American Art, New York. Italics added.

Gropius himself was concerned with his career as an architect. One of his fundamental preconditions was therefore that he not only teach in America, but also be able to continue to practice architecture freely. The meeting ended without a concrete agreement, but Gropius had certainly expressed his interest clearly enough. Another meeting was scheduled two months later in London, with James Bryant Conant, Harvard's president; there, too, no agreement was finalized.

In mid-November, Hudnut wrote to Gropius that he could expect to be offered an appointment at Harvard effective in February 1937. His letter conveys an impression of the high expectations that he and the university had for Gropius: "Your presence at Harvard University will not only be of the greatest possible value to this institution, but I furthermore believe that the service that you may do for the architecture of this country is of inestimable value." At the beginning of December, Hudnut advised Gropius via telegram of the appointment's approval. In a letter of the same day, he explained to Gropius his vision of the newly configured architectural education at Harvard and the role he would like Gropius to play: "No one in the world . . . could help me more in this undertaking than you," he wrote.[104] The way in which he formulated his thoughts leaves no doubt that Hudnut saw himself in the role of reformer and Gropius as the ally he would need to realize his ambitions. It was clear, as he had explained to Barr earlier, that anyone who came to Harvard as professor of design would have to make concessions to the university's tradition. In that same year, he sent the Museum of Modern Art a confidential transcript of the job advertisement indicating that he had already conceived a detailed curriculum.[105] Judging from these sources, it would seem that Hudnut wanted a professor who would support his position as dean, not a competitor who would want to impose his own agenda.

Thus, the situation at Harvard on Gropius's arrival was considerably different from the situation at the founding of the Bauhaus, where Gropius had determined independently the conceptual and pragmatic framework of the school's activities. Thus, it was to be expected that the Bauhaus's founder and long-time director might encounter conflicts in his new position. At the inception of his American career, he was in an entirely different situation than was Mies, who on the basis of his position and contract enjoyed much greater freedom at Armour Institute.

Hudnut's intentions in restructuring the Harvard program were pragmatic. This meant that Gropius's philosophical position could not be the basis of his teaching, as it had been in Dessau and Weimar. One of the most distinguished characteristics of his earlier teaching was thus lost. For this reason alone, it would be wrong to speak of a "transplantation" of the Bauhaus to America, as has often been done. After the appropriate committee had approved the appointment in January 1937, Gropius accepted the position; in March of that year, he and his wife Ise arrived in the States.[106]

Mies had also initially been a candidate for the professorship at Harvard. Hudnut met him in August 1936 in Berlin after Barr had conveyed to him the architect's interest.[107] After an apparently favorable meeting, a correspondence between the two grew.

Hudnut gave the impression that, by the end of November 1936, Mies would receive the university's approval, although Hudnut did mention the fact that Harvard's faculty could make the appointment of a modern architect difficult[108] and that, in accordance with the usual protocol, at least one other candidate would be considered, in this case Gropius. In November, however, Mies received a letter of rejection from Hudnut that offered no adequate explanation for this decision. It stated, "I have not been successful in my plans, I think it will be impractible [sic] to invite you at the present time to accept a chair at Harvard."[109]

There has, of course, been speculation on what might have influenced Hudnut to favor Gropius. He might, as has been suggested, have been disturbed by Lilly Reich's energetic participation in discussions, or have been unhappy with Mies's "bachelor existence," with the fact that he "kept an extremely unorthodox household."[110] Perhaps he simply liked Gropius and "hunger[ed] for his many ideas," or, as he admitted privately, was "not much of a fighter" and had given in to the impressive reputation of "Gropius's Bauhaus."[111]

It is plausible that the Bauhaus was only counted in Gropius's favor. After the publication of his book *The New Architecture and the Bauhaus* in 1935, there was a renewed tendency to consider him and the Bauhaus as synonymous. It is possible that

104 Joseph Hudnut, letter to Walter Gropius, 13 November 1936, quoted in Isaacs, *Walter Gropius*, 2:815.

105 Hudnut, letter to Barr, 18 May 1936; also "Memorandum: Proposed appointment of a Professor of Design in the Graduate School of Design, Harvard University," undated; both documents in the Alfred H. Barr, Jr., Papers, Archives of American Art, New York.

106 On learning of Gropius's appointment to Harvard, MoMA planned a large Bauhaus exhibition in his honor. Prepared by Gropius, his wife, and Herbert Bayer, the show, entitled "Bauhaus 1919–1928," ran from December 1938 to January 1939. It illustrated the school's founding, growth, work, and principles during the Gropius years. The omission of the Meyer era and Mies's refusal of the invitation to participate determined the effect of this exhibition at the onset of the second significant phase of American reception of Bauhaus architecture, strengthening the identification of Gropius with the Bauhaus. On Mies's reasons for declining to participate in the exhibition, see Walter Gropius, letter to Mies, 29 June 1938, and Mies, letter to Walter Gropius, 2 August 1938; Mies van der Rohe Archive, private files of Dirk Lohan, Chicago.

107 Joseph Hudnut, letter to Mies, 21 July 1936, Mies van der Rohe Archive, private files of Dirk Lohan, Chicago.

108 Joseph Hudnut, letter to Mies, 3 September 1936, Mies van der Rohe Archive, private files of Dirk Lohan, Chicago.

109 Joseph Hudnut, letter to Mies, 16 November 1936, Mies van der Rohe Archive, private files of Dirk Lohan, Chicago.

110 Isaacs, *Walter Gropius*, 2:811. This argument, which might seem far-fetched from a European point of view, may in fact have influenced the decision. Isaacs understands the personnel practices of American universities and knows that social status plays a significant role.

111 Michael van Beuren mentioned these last three points in a letter to Mies, 6 November 1936, written immediately following a personal conversation with Hudnut; Mies van der Rohe Archive, private files of Dirk Lohan, Chicago.

Hudnut felt threatened by Mies and his own ambitious convictions about the structure of a "modern institute of architecture."[112] Hudnut did not leave the impression in any of his letters that he expected to share the responsibility and recognition for the proposed curricular reform with the new head.

It is impossible to exclude the possibility that several of the factors mentioned, or even entirely different ones, played a role in the decision. Harvard was a three-hundred-year-old institution, very much conscious of its tradition and prestige. When Mies later noted with a fine irony, "Yes, Harvard is a special school, you know, that is where the better people go,"[113] he was referring to the fact that faculty and student body at this expensive private university epitomized the combination of family background and education within their class. He did not have similar credentials, although he had seen enough of similar upper-middle-class circles in his younger years. Finally, there is another fact to be considered which has often received inadequate attention: Gropius had maintained a relationship with Hudnut since 1928, an advantage with which Mies could not compete.

According to Gropius's biographer Reginald Isaacs, Hudnut was "already fully determined to bring Walter Gropius to Harvard" in May 1936.[114] If this premise is true, then he had merely led Mies on for months. He did not lay his cards on the table until he had received the committee's approval for the other candidate and Gropius's acceptance thereafter. Whether he intentionally misled Mies or, unaware of irreversible conditions or incorrect in his assessment of the faculty's mood, merely shared with him his own false expectations, remains unclear.

Lawrence Kocher and Robert Davison In the course of their correspondence and periodic visits to Germany, the relationships between Gropius and Lawrence Kocher and Robert Davison developed into friendships. Davison, of the Institute for Housing Research at Columbia University, was one of the first American architects to judge the new developments in German housing and *Siedlung* building with his own eyes. Following his first meeting with Gropius in New York in 1928, he traveled to Berlin for the first time in 1929. He saw the drawings for Siemensstadt and visited the Bauhaus and the Törten Siedlung in Dessau and the Siedlung am Lindenbaum, then under construction, in Frankfurt. When Davison returned from his trips in summer 1929 and fall 1933, during which he had visited Gropius, he expressed to his friends his admiration for the German architect who had already begun to do in Europe what Davison only hoped to do in the United States.[115] Kocher, editor of *Architectural Record*, shared Davison's admiration. Already during Gropius's trip to America, Kocher had met him and had asked him to write an article for his well-respected journal.[116] In 1934, at Davison's initiative, Kocher asked Gropius casually whether he would like to work in the United States.[117] Gropius responded favor-

ably: "Your idea that I come to the U.S.A. by no means disagrees with me. It could in fact provide the opportunities to realize more of my ideas about the artistic education, theoretical and practical work of the Neues Bauen movement than is possible here." Gropius also pointed out that a teaching position would be necessary to facilitate his integration into the new cultural circle.[118] This thought inspired Kocher and Davison to action, and even Gropius took pains to maintain his connection to the two. He informed both of his plans for the immediate future and reaffirmed his interest in coming to the States. When Kocher extended an invitation to him in October of that year to introduce him to the architect and businessman Antonin Raymond,[119] Gropius had already committed himself to Maxwell Fry. Kocher also attempted to gain a professorship at Columbia University in New York for Gropius. He discussed the plan with Joseph Hudnut, who was then the dean of the architecture school there and was apparently favorably disposed. Kocher immediately informed Gropius that Hudnut "would consider . . . the situation."[120] At a later date, he added that Hudnut wanted to bring Gropius to Harvard and would even welcome him with an exhibition of his work.[121] Davison, meanwhile, asked Gropius in the summer of 1936 whether he would consider a one-year position as consultant to the John B. Pierce Foundation in the area of housing research, but Gropius was already settled in London.[122]

Just how strong Gropius's interest in America was at that point is obvious in the long letters he wrote in response to Kocher and to Pierre Jay.[123] His letter to the latter reflected his uneasiness at his possible failure to attain an appointment to a school in the United States. He asked Jay whether Kocher's suggestion that he pursue an ap-

112 Mies, letter to Barr, 14 July 1936, Alfred H. Barr, Jr., Papers, Archives of American Art, New York.

113 Transcript of Dirk Lohan's interview with Mies, Chicago, summer 1968, 4, Mies van der Rohe Archive, private files of Dirk Lohan, Chicago.

114 Isaacs makes this contention in *Walter Gropius*, 2:846, based on a conversation with Hudnut in May 1936 in Cambridge, Massachusetts.

115 Isaacs, *Walter Gropius*, 2:652.

116 Isaacs, *Walter Gropius*, 2:511ff.

117 Lawrence A. Kocher, letter to Walter Gropius, 12 March 1934, in Isaacs, *Walter Gropius*, 2:652.

118 Walter Gropius, letter to Lawrence A. Kocher, Berlin, 25 March 1934, in Isaacs, *Walter Gropius*, 2:652f.

119 Antonin Raymond, who was born in Prague and had come to the United States at the age of fifteen, accompanied Frank Lloyd Wright to Tokyo, remained in the Far East, and became a spokesman for modern architecture there.

120 Lawrence A. Kocher, letter to Walter Gropius, 29 May 1934, in Isaacs, *Walter Gropius*, 2:654.

121 Isaacs, *Walter Gropius*, 2:701.

122 Isaacs, *Walter Gropius*, 2:782f.

123 Walter Gropius, letter to Lawrence A. Kocher, 7 July 1934, in Isaacs, *Walter Gropius*, 2:654f. Walter Gropius, letter to Pierre Jay, 20 June 1934, in ibid., 2:655.

pointment to Columbia University was to be taken seriously. Jay subsequently received Kocher's assurance that this was the case, which put Gropius's mind "at ease."[124] The contact Kocher established to Hudnut would not, in the end, lead to an appointment at Columbia, but it opened the doors to Harvard.

By December 1934 Kocher had contacted at least twelve American universities on Gropius's behalf, among them Harvard, Cornell, Yale, Princeton, the University of Minnesota, and the Massachusetts Institute of Technology. He promised Gropius that he would do everything to secure for him a position in the United States.[125] The fact that Davison's efforts were not entirely unsuccessful is evidenced by an offer from Everett Meeks, dean of the school of architecture at Yale University, who invited Gropius to lecture in early 1935. Gropius refused, but left himself the possibility of accepting at a later date.[126]

As editor of *Architectural Record,* Kocher could at least ensure that Gropius's name became known among the journal's readership. Between 1928 and 1936, more than ten articles referring to Gropius appeared in *Architectural Record,* many of which discussed his work directly or included excellent illustrations of it.[127] Kocher's recommendation and persistence may be credited with Hudnut's appointment of Gropius at Harvard. Even if no other contacts established by the Bauhaus's founder had led to immediate results, Lawrence Kocher, who had also taught at Black Mountain College for a time, was able to establish good relations with the various universities and to create opportunities for the dissemination of Bauhaus architecture.

No one working on behalf of the Bauhaus and its architects would have succeeded against the professional and ideological hindrances of that time, had there not also been broad-based support in architectural circles. Harvard and Armour Institute were private institutions. They could afford to take people onto their faculties, but only if these people were attractive enough to the student body to maintain matriculation. This was especially true of Harvard in the thirties, a relatively conservative and traditional institution. The negotiations surrounding the appointment of Gropius and Mies must be seen in this light if one is to appreciate the extraordinary nature of the decisions to appoint them. Thus, these events required a resolution of the contradictions that surrounded the Bauhaus and its protagonists.

124 According to Isaacs, *Walter Gropius,* 2:655.

125 Lawrence A. Kocher, letter to Walter Gropius, New York, 6 June 1935, in Isaacs, *Walter Gropius,* 2:746.

126 Isaacs, *Walter Gropius,* 2:746.

127 For example, Gropius's birthday was noted in text and in an image that pictured him in front of a poster of his Chicago Tribune project. "Professor Walter Gropius, Well-Known German Architect," 145.

Against
the
Odds:
The
Resolution
of
Contradictions

The contradictions that became evident in the early reception of the Bauhaus cannot be dismissed by asserting that an elite clique had, thanks to its influence, succeeded in absorbing prominent European avant-gardists into its social ambiance for selfish reasons.[1] The opposition was too strong, many of the positions at stake too politicized, the number of former Bauhaus habitués in the United States too great, and their professional difficulties for the most part too considerable for that to have been the case.[2] Wolfgang Pehnt rightly notes that "against the comparatively comfortable careers of the few prominent individuals who were able to continue their work in the USA . . . stand the career changes and poverty of many acknowledged members, and even more so in the case of less famous architects." He maintains that "in light of the atmosphere of that time and the individual preconditions of the Bauhaus architects, it is astonishing that the 'few' good careers even were possible at all."[3]

Political barriers seem to have presented the least problem for Ludwig Mies van der Rohe. His directorship of the Bauhaus had been marked by the struggle to keep the school out of political turmoil. In 1926, he met the writer Eduard Fuchs, a Jewish member of the German Communist Party and of the Society of Friends of the New Russia (Gesellschaft der Freunde des neuen Russlands). Fuchs encouraged him to join the Society, a step that would produce difficulties for Mies in Nazi Germany and again in the early fifties in America, during the hysterical wave of persecution in the McCarthy era. At the time, however, it led to a commission from Fuchs to design a monument for Rosa Luxemburg and Karl Liebknecht. By 1933, Mies was prepared to collaborate with the opposing faction. He submitted a design for the new Reichsbank and signed a 1934 "Artists' Statement" (Aufruf der Kulturschaffenden) in support of the Führer. Mies wanted only to build. He still managed to realize the Lemke house in Berlin-Hohenschönhausen in 1933; thereafter, he lived from the royalties from his furniture designs, was expelled from the Akademie der Künste and otherwise humiliated.[4] Philip Johnson had already made clear in the United States in 1933 that Mies was not a political person: in an article, he wrote that Mies had also kept his distance from politics and even distanced himself from the functionalists because of their association with leftist tendencies.[5] His appointment at Armour Institute was aided by the fact that this school was open-minded in issues of nationality[6] and that the people responsible for judging his application did so, as far as can be ascertained in retrospect, on an appropriate basis. In other cases involving the employment of Bauhaus denizens or ideas, the situation was different. Nonetheless, certain mechanisms and strategies were in place to eliminate difficulties.

1 This is Tom Wolfe's polemical argument in *From Bauhaus to Our House*, 51ff.

SUPPRESSION OF THE
WELTANSCHAUUNG AND
SOCIAL UTOPIAN ASPECTS
OF THE BAUHAUS

The very aspect of its program that the American cultural critic Peter Gay has called "the revolutionary implications of the Bauhaus experiments"[7] was largely ignored at the beginning of the Bauhaus's reception in the United States. In the first half of the thirties, the period during which the university appointments were under consideration, most published texts concentrated on issues of style. Only a few American architecture critics such as George Howe or the housing experts Carol Aronovici, Catherine Bauer, Lewis Mumford, and Clarence Stein were interested in the social agenda of the modern movement and its implications for the United States. Above all, stylistic and pedagogical aspects were the focus of attention. An article by George Nelson that described the Bauhaus's stated allegiance to a particular *Weltanschauung* was published at a time when Gropius's Harvard appointment had most likely already been decided. Gropius himself went to America in part because he hoped that his "new architecture" could be realized there in all its dimensions. In a 1936 letter to Lawrence Kocher, he wrote: "The conditions for the new architecture here [in Germany] are really not very favorable, and since I have known everything about the movement behind the Neues Bauen for the past twenty years, I would be inclined to come over."[8] He would soon find that the "cathedral of socialism" and other of his architectural concepts, bound as they were to the Europe of the twenties, could not be transplanted to America. It is difficult enough to explain to most Americans what a Gothic cathedral is about, not to mention the purpose of socialism.

In the formulation of the International Style, including the work of Gropius and Mies, and in its definition as one step in architecture's historical evolution, it seems to have been effective to ignore the Bauhaus's inextricability from the general European reform movement and from the pedagogic intent to create "the new human being." Alfred Barr's foreword to *The International Style* proves that this strategy was premeditated. Barr justified it with the entirely aesthetic orientation of the book's authors: "The aesthetic qualities of the style are the principal concern of the authors of the book. . . . He [Hitchcock] and Mr. Johnson have also made little attempt to present here the technical or sociological aspects of the style except in so far as they are related to the problem of design."[9] The inclusion of Catherine Bauer, Lewis Mumford, Clarence Stein, and Henry Wright in the curatorship of "Modern Architecture" exhibition, and the decision to devote a third section to housing, proved that the head curators also understood the social implications of the new style. Nonetheless, works related to social issues were given only peripheral status.

Even Mies, considered apolitical by most, had recognized architecture as an instrument of social change in his 1927 comment on the new housing in Germany:

he stated that these efforts represented only a part of a larger struggle for a new social order.[10] The social aspect was much more pronounced in the work of Walter Gropius and Hannes Meyer. As founder and director of the Bauhaus, Gropius had understood architecture as part of a wider agenda.[11] His works and actions leave no doubt about his commitment to social and humanistic goals: no level of society was to be excluded from economic benefit or dignified housing. *Siedlungen* such as Dessau-Törten attempted to realize this goal. In his 1919 founding manifesto, Gropius had articulated his vision of the Bauhaus as a better means to design the future: "Let us then create a new guild of craftsmen without the class distinctions that raise an arrogant barrier between craftsman and artist. Together let us desire, conceive, and create the new structure of the future, which will embrace architecture and sculpture and painting in one unity and which will one day rise toward heaven from the hands of a million workers like the crystal symbol of a new faith."[12] His contemporary Bruno Taut had already described the "new faith" in *Die Stadtkrone*:

There is a word that both rich and poor follow, that echoes everywhere as it promises Christianity in a new form: social consciousness. The feeling that it is necessary to contribute to mankind's well-being, somehow, for oneself and for others, to achieve spiritual peace and to be at one, in solidarity with all men—this feeling lives, at least it slumbers, in everyone. Socialism in a nonpolitical, suprapolitical sense, remote from any form of domination, understood as the simple, unadorned relationship of human beings among themselves—socialism bridges the schism between factions and nations subjected to

2 One list compiled by Gropius in 1946 includes twenty-six former members of the Bauhaus then living in the States. See list "Bauhaus Members in this Country," Mies van der Rohe Files, Library of Congress.

3 Wolfgang Pehnt, *Das Ende der Zuversicht*, 65.

4 Elaine Hochman, *Architects of Fortune*.

5 Philip C. Johnson, "Architecture in the Third Reich," 137–139.

6 Michael van Beuren, letter to Mies, 21 October and 3 November 1936, Mies van der Rohe Archive, private files of Dirk Lohan, Chicago.

7 Peter Gay, *Weimar Culture*, 100.

8 Walter Gropius, letter to Lawrence A. Kocher, 25 March 1936, in Reginald R. Isaacs, *Walter Gropius*, 2:652.

9 Foreword to Henry-Russell Hitchcock and Philip Johnson, *The International Style*, 13.

10 "The struggle for the new dwelling is but part of the larger struggle for a new social order." Mies van der Rohe, quoted in Vittorio M. Lampugnani, *Encyclopedia of 20th Century Architecture*, 160.

11 Walter Gropius, *Architektur*, 43.

12 Walter Gropius, "Gründungsmanifest und –programm des Staatlichen Bauhauses Weimar, April 1919," in Hans M. Wingler, *The Bauhaus: Weimar, Dessau, Berlin, Chicago*, 31.

their own self-discipline and bonds human to human. If anything can crown the city today, then it is the expression of this thought.[13]

The significance for the new architecture of this mood of imminent change in postwar Germany Gropius explained to his students as follows: "We are in the midst of a momentous catastrophe of world history, of a transformation of all aspects of life and of the entire human being. . . . The distress of Germany will spiritualize and deepen us. With the falling away of material opportunities, the spiritual opportunities have now risen enormously."[14]

The elimination of the commitment to a world view as the precondition to the formulation of the International Style fundamentally redefined the formal machinery, theory, and function of the art of the Bauhaus. What motivated Barr, Hitchcock, and Johnson to do so? One reason may have been that the United States had no experience with the evolution of a style in the comprehensive, classic sense of, for example, the Gothic. The country had established a tradition of expressing its values in borrowed "styles" without necessarily assuming their spiritual connotations. The United States had also never spawned a supraregional movement comparable to the Werkbund or the Workers' Council on Art from which a school like the Bauhaus could draw strength and ideas. The achievements of the Chicago school had hardly been developed further. The political, economic, and social preconditions for a program based in a world view, such as had developed at the Bauhaus, had never, or only fragmentarily, existed in the United States. Moreover, these issues were extremely difficult to accept, given the different cultural concepts characteristic of the two countries. Thus, the new architecture was not seen in American society as it had been in German, as the anticipatory manifestation of a new social order.[15] If Gropius's social and political hopes were viewed even in Germany as utopian visions, then any attempt to integrate an ideological program into the International Style would have made it incomprehensible in the United States. Karl-Heinz Hüter notes that the programmatic formulations of Gropius's architectural vision in *Der Baugeist der neuen Volksgemeinde* should be seen as aiming at a conceptual and experiential "overcoming of the ego."[16] In the United States, such thoughts were quickly equated with an infringement of the rights of citizens, which was tantamount to sacrilege. Privileging the good of the community over that of the individual was seen as an affront because it was related to Marxist doctrine. Those architects who emphasized the functional and thus rejected anything excessive, including the signature of the individual artist, were suspected of extending the ideological attack on the individual into the area of culture. This did not mean that there was absolutely no audience in the United States for social issues. On the contrary: the depression and its prospective antidote, the New Deal, forced a confrontation with many social problems. A similar sensibility was expressed in the literature and the visual arts of those years, which dealt with such topics as unemployment, strikes, street

life, and hunger. But the economic situation and its consequences were, in the last analysis, not part of the way the nation wanted to see itself. Instead, they were seen as weak points to be repaired as quickly as possible.

The determinants of the Bauhaus architecture, as seen from the American point of view, would in the future be those identified by Kenneth Stowell in his commentary on the exhibition: "From this bare beginning may grow in the fertile imagination of youthful designers, an architecture that will be truly functionally efficient, economically sound and aesthetically satisfactory."[17] This definition corresponds to some fundamental intentions of the early Bauhaus program, which was geared to the education of a type of architect whose work would respond to the economic, functional, and aesthetic demands of the time. But it does not speak of the hope that the Bauhaus teachers also harbored, that the new architecture would be "a catalyst in the transformation of society."[18] What had begun as a comprehensive design for a new form of life, the project of an aesthetically minded cultural reform, had to a large extent been reduced to a "style" comprising a certain repertoire of formal design strategies, of motifs. Released from their integrity to the original idea, they could from now on be used freely for various design needs. Under the premise of this extroverted understanding of architecture, the floodgates were opened to formalism and cheap plagiarism. The year 1932 marked the point when the previously divergent conceptions of the architecture produced at the Bauhaus were subsumed in a unified image. In place of the eternally valid issues with which the Bauhaus architects hoped to come to terms, the most obvious typological characteristics and commonalties of their temporally bracketed answers were displayed.

The loss of the *Weltanschauung* element proved to be a two-sided coin, for it also represented an opportunity for the Bauhaus's architects: not only did their work become more digestible for a contemporary American audience, but its formal elements

13 Bruno Taut, *Die Stadtkrone*, 59ff.

14 Walter Gropius, "Rede während einer internen Bauhaus-Ausstellung von Studentenarbeiten," June 1919, in Howard Dearstyne, *Inside the Bauhaus*, 52ff. Gropius did not want his general convictions or *Weltanschauung* to be understood as partisan political ideology. His reaction to Oskar Schlemmer's manifesto, written as an advertisement for a Bauhaus exhibition in 1923, makes this clear. Schlemmer had described the Bauhaus as the "gathering point of those who want to build the cathedral of socialism, dedicated to the future and reaching toward the heavens." Oskar Schlemmer, "Das Staatliche Bauhaus in Weimar," 181ff. Gropius had the text expunged. According to Isaacs, *Walter Gropius*, 1:298.

15 Walter Curt Behrendt, *Modern Building*, 219. Trachtenberg and Hyman note that in Europe, Bauhaus architecture had represented the zeitgeist; in America, it did not: *Architecture*, 524.

16 Karl-Heinz Hüter, *Architektur in Berlin*, 91.

17 Kenneth K. Stowell, "The International Style," 253.

18 Lampugnani, *Encyclopedia of 20th Century Architecture*, 160.

also became accessible to generations of architects, who could play with them unburdened by the utopian aspirations behind the original concepts. By condensing the new architecture to its abstract and thus elementary formal-aesthetic vocabulary, Barr, Hitchcock, and Johnson revealed one of the great achievements of the Bauhaus, namely to have provided for the first time in architectural history a basic language of forms that, free of cultural and geographical bounds, could be universally understood and applied—to some extent even adjusted to regional traditions. The universality of its formal language, derived from the repercussions of primitive art in cubism and expressionism, both influencing the Bauhaus, is a main reason for the Bauhaus products' lasting appeal. Thus the deideologizing of Bauhaus architecture proved to be not just a conceptual loss but, at the same time, the regaining of its aesthetic and artistic autonomy.

IDENTIFICATION
WITH ANTI-FASCISM

On the orders of the Dessau state attorney, Berlin police and storm troopers entered the Bauhaus's facilities in Berlin-Steglitz on 11 April 1933, searched the building for subversive material, and temporarily arrested a group of students. They were later released, but the school's director found himself compelled to dissolve the institution on 19 July.

In the search for answers to the contradictions embedded in the controversies surrounding the Bauhaus, it should also not be forgotten that the former Bauhaus artists and architects had come to America from Germany in the wave of anti-fascist immigration. They had generally been admitted as victims of the National Socialist regime. For Jewish émigrés such as Anni Albers, Marcel Breuer, and Xanti Schawinsky, this asylum was particularly important. The treatment that might have awaited them as artists might be surmised from the notice received by the Stuttgart sculptor Margarethe Garthe in 1936 from the President of the Reichskammer of the Visual Arts:

Notice!

Based upon my examination of the qualities of your personal characteristics, you are not in possession of the necessary proclivity and reliability to participate in the advancement of German culture in a manner responsible to people and state. You thus do not fulfill the requirements for a membership in the Reichskammer of the Visual Arts.

On the basis of § 10 of the first code on the execution of the Reichskulturkammer's bylaws of 1.11.1933 (RGBI. I, p. 797), I reject your application for acceptance into the Reichskammer of the Visual Arts and forbid you to practice the profession of sculptor.

Your activities within the opportunities offered by the State Union of Jewish Cultural Organizations, Berlin SW. 19, Stallschreiberstr. 44, are not affected by this decree. (Signed) Mai.[19]

The loss of professional licenses and positions was only the first step toward the worst scenario. Some of the Jewish Bauhaus associates who were not lucky enough to flee Nazi Germany lost their life in concentration camps. The textile artist Otti Berger was one of them.

The closing of the Bauhaus and the subsequent increase in the political and racist defamation and persecution of artists and architects made it possible to interpret their work as the expression of a Western way of life, democracy, and freedom. Thereafter, the fact that the National Socialists had condemned the school's art and architecture as incapable of embodying traditional German values proved, ironically, advantageous to the Bauhaus's acceptance elsewhere. Officials in their native country had unambiguously stated that Gropius and Mies produced buildings that were "un-Germanic" and cosmopolitan. Thus, to discredit these buildings as subversive examples of German cultural influence was simply untenable. Anyone who had accepted the original definition of the International Style would also have no problem in seeing the Bauhaus and its associated architecture as untainted by specific German events of the late nineteenth and early twentieth century, both in art historical and general historical terms. Defined in this way, the Bauhaus's formal vocabulary could not only be integrated in the United States, but could also form part of a Western-oriented international culture in America's victorious postwar march through the "free world."

The humanist position implicit in the United States's acceptance of cultural refugees soon proved ambivalent. Secondary motives became apparent, such as national interest and a certain sense of guilt at the country's silence during the rise of the National Socialists in Germany. The Bauhaus's demise had elicited only scattered protests. Thus, when the Weimar Bauhaus was struggling for its existence, Herman George Scheffauer wrote a letter of protest against the imminent closure,[20] but there was no large-scale resistance from the United States. Douglas Haskell noted this in an accusatory tone in a brief 1933 article on the final closing of the Berlin Bauhaus. He reprimanded his countrymen for their passivity in the face of constant appeals from German architects such as Walter Gropius, Ernst May, and Bruno Taut to help free Germany from National Socialist oppression: "It is not possible for anyone who knew these men to lay the blame entirely on the Nazis. Every American, among other for-

19 President of the Reichskammer der bildenden Künste, registered notice to Margarethe Garther, 19 June 1936, Alfred H. Barr, Jr., Papers, Archives of American Art, New York.

20 Christian Schädlich, "Die Beziehungen des Bauhauses zu den USA," 62ff.

eign visitors, was begged by these German leaders to urge his countrymen, in the name
of survival of civilization, to ease the burden under which Germany was struggling.
We were ineffective. The defeat is ours; the suffering theirs."[21] By opening America's
doors to certain Bauhaus architects and other leading figures in German culture and
scholarship, a form of reparation was made that simultaneously promised to be a prof-
itable investment in the nation's future. The acceptance of immigrants for humanitar-
ian reasons does not necessarily represent a contradiction in the generally anti-German
climate surrounding cultural issues. It is the respect shown, or not shown, to these
émigrés that raises questions.

The identification of cultural émigrés with anti-fascism could itself be problem-
atic. If fascism was the opposite of communism, as it was perceived in the United
States, then "anti-fascists" were also suspected of being "red" or at least sympathizers.
In public, those who had turned their backs on the National Socialist regime were
celebrated. But in the subtle undercurrents of the American consciousness, they were
suspected of being potentially subversive.[22] During the paranoid pre-McCarthy era,
both Gropius and Mies were investigated by the Federal Bureau of Investigation
and became the subjects of files that contain detailed information on their contacts,
affiliations with groups, and petitions they had signed which were classified as "un-
American" and "pro-Communist."[23]

POTENTIAL FOR
AMERICANIZATION

**America needs no European art and no European artists . . . America must be left to its
own devices, for better or worse. . . . Either become an American in America or stay a
European in Europe. You can't do any favors for America as a European.[24]**

As described by the Bauhaus painter Georg Muche in 1924 at the end of his stay
in New York, this state of affairs seemed at first sight to bode poorly for the Bauhaus's
successful assimilation in the United States. In fact, Muche's assessment of the Ameri-
can attitude toward foreign cultural influences was not entirely wrong. Except in the
metropolises, the country tended to measure foreign culture on the basis of its capacity
for conformity and integration. This was evident at a national level in the debate in-
spired by the Chicago Tribune competition on whether a foreigner could offer America
what it then sought, the architectural expression of the way it saw itself. The fact that
the second prize had gone to the Finn Eliel Saarinen was explained by critics as owing
to his empathy with the American mentality.[25] The Bauhaus's relations to an Amer-
ican context were even tighter, however. Its extraordinary potential for Americaniza-
tion derived from what might be called the Bauhaus's "American elements." Besides
the increasingly strong ties between the school and the American scene, various struc-

tures, interests, and aims at the school displayed commonalties with parallel developments in America. In the work and theories of several protagonists, the influence of American precedents was evident. This was especially true for architecture at the Bauhaus, which does much to explain the degree of its success in its American reception.

One concrete step toward Americanization was the "Modern Architecture" exhibition in 1932. By excluding the regional and emphasizing the universal and cosmopolitan, the exhibition largely divorced the Bauhaus and its architecture from its national identity and made it common cultural property. It could be applied arbitrarily for any number of functions: residential buildings, industrial buildings, buildings for offices and for transportation.

Even in the years prior to the institution's founding, both Gropius and Mies displayed an interest in America that went beyond the general magnetism which the United States exerted on German artists, architects, writers, filmmakers, and musicians. In 1911, when Gropius compiled a photo album of works of modern architecture for the German art historian Karl-Ernst Osthaus, he included a number of American examples, including the grain silos of the Midwest. Gropius saw the aesthetic quality in their entirely functionally determined and industrial form, devoid of any traditional elements, as the embodiment of the American zeitgeist determined by machines, the masses, and mass transit. In the fourteen examples he included in his 1913 essay for the German Werkbund, he tried to show "spiritual affinities" between the North American industrial buildings of that time and his own works. In his own architecture, however, Gropius did attempt to ennoble the purely functional by means of art and monumentalization.[26]

American influence also appeared in other ways in the works of Gropius and Mies. Both came to know and draw inspiration from the work of Frank Lloyd Wright through the edition of Wright's oeuvre by Ernst Wasmuth in 1911, the first compre-

21 Douglas Haskell, "The German Architects," 449.

22 Hans Vaget, "Edgar Hoover's Thomas Mann."

23 Lee Gray, "Mies van der Rohe and Walter Gropius in the FBI Files," 146. In later years, the discussion of certain Bauhaus architects would be extended to accusations of National Socialist sympathizing.

24 G. Muche, *Das künstlerische Werk*, quoted in Schädlich, "Die Beziehungen des Bauhauses zu den USA."

25 Irving K. Pond, "High Buildings and Beauty," 182. On the occasion of the competition, Louis Sullivan also spoke of the conviction "that a foreigner should possess the insight required to penetrate to the depths of the sound, strong, kindly and aspiring idealism which lies at the core of the American people: one day to make them truly great sons of the Earth." Sullivan, "The Chicago Tribune Competition," 156.

26 Winfried Nerdinger, *Walter Gropius*, 9ff.

hensive publication about the eminent American architect.[27] The Berlin publisher had a stand at the St. Louis world's fair in 1904 and had established his contact with Wright on that occasion. The 1923 Sommerfeld house by Gropius and Adolf Meyer is hard to imagine without Wright's precedents; the same is true for the open plans and flowing spaces of the two country houses in concrete and brick by Mies, designed in 1923 and 1924. In terms of their building typology and ambitions, the two utopian glass skyscrapers of 1921 and 1922 continued in the American tradition. The horizontality displayed in other important works by both architects, and which was absorbed in the definition of the International Style, may be found as a formal element in American architecture, for example, in the long rows of closely spaced windows of many warehouses and in the facades of the Chicago school. In Gropius's case, the influence was also explicit in his housing concepts. A lecture entitled "The House in Eight Days," which he gave in Berlin in March 1926, indicates that his own thoughts on serial production were based on American precedents both typologically and in their primary aim.[28]

Certain building technologies from the United States also were integrated into the work of the German architects, such as the use of steel frame construction as developed in the Chicago school. Another commonality was the interest in the theories of Frederick Winslow Taylor on scientific management and the analyses of Frank B. Gilbreth on the efficient organization of the work process. The move toward rationalization, mechanization, and scientific experimentation in the technology and construction methods used in skyscraper building was also of mutual concern. The affirmation of technology implicit in Fordism hardly surpassed that of the Bauhaus after 1923. Around the same time as Albert Kahn's sober, functionalist River Rouge factory in Dearborn was erected and Charles Sheeler was painting his unpeopled and precise images celebrating the aesthetic of the machine, the Weimar Bauhaus was undergoing its transformation into a pioneering institute, cross-fertilizing art and technology in an experimental design laboratory. The anonymization and secularization evident in the spirit of industrially and economically aspiring postwar America was equally present in Germany. In Ludwig Mies van der Rohe's opinion:

The whole trend of our time . . . is toward the secular. The endeavors of the mystics will be remembered as mere episodes. Despite our greater understanding of life, we shall build no cathedrals. Nor do the brave gestures of the romantics anything to us [sic], for behind them we detect the empty form. . . . The individual is losing significance; his destiny is no longer what interests us. The decisive achievements in all fields are impersonal, and their authors are for the most part obscure. They are part of the trend of our times toward anonymity.[29]

Its experimental and practically oriented curriculum brought the Bauhaus closer to American pragmatism. Learning by doing, as emphasized in the foundation course,

and the education of the individual for the sake of the community, the school's goal, recalled John Dewey's beliefs. The Dessau Bauhaus buildings, which comprised an integrated community for study, work, and living, had pronounced similarities to the American campus model. Several artists who taught at the Bauhaus had established contacts with the American scene even before 1919. American teachers and lecturers, students and visitors were no rarity at the Bauhaus by the end of the twenties. In America, the Bauhaus sought and sometimes found resonance, support, official representation, and commissions. Some Americans protested against the school's closing. In the end, Mies attempted to anchor the Bauhaus in the United States by means of a branch of the school in that country.

The international character of the Bauhaus, and in particular its American contacts and affinities, had not escaped the attention of the National Socialists. In 1933, they explicitly rebuked Mies for supposedly contributing to the Americanization of German culture.[30] There is no question that the Bauhaus absorbed important influences from the United States and underwent developments that had their parallels overseas. It is also clear that the American reception over the entire course of the Bauhaus's existence was by no means a one-way event, as it is often represented. In fact, it becomes evident that the acceptance of the Bauhaus's ideas in America was often motivated by sober self-interest. America recognized itself in the Bauhaus and its architecture. The subsequent adaptation of the Bauhaus was thus in part an unconscious acceptance of the country's own heritage, which, it was hoped, would thus become strengthened. The departure to the United States of several Bauhaus protagonists after the school's dissolution was a natural development, and the international character that in 1933 had counted against the school now played into the hands of those who wanted to continue their careers in the United States. Among them were those teachers whose work at the Bauhaus had had the most pronounced relationship to American developments: Josef Albers, László Moholy-Nagy, Walter Gropius, and Ludwig Mies van der Rohe. Thus, they gave back what they had received as well as what they had made of it.

It should not be overlooked that the transfer of ideas and concepts was not simply a transplantation, but in each case rather a gradual and individual process of transformation and cultural assimilation. This process was set in motion largely with regard

27 Ernst Wasmuth, ed., *Frank Lloyd Wright. Ausgeführte Bauten und Entwürfe.*

28 Gropius believed that, as in America, houses could also be chosen from a catalogue, ordered, and delivered in eight days in Germany. These American-type houses were to be produced on the basis of prototypes using methods, materials, and a stylistic vocabulary adapted to Germany. According to Isaacs, *Walter Gropius*, 1:370ff.

29 Ludwig Mies van der Rohe, quoted in Wayne Andrews, *Architecture in America*, 15.

30 Ludwig Mies van der Rohe, letter to Ministerpräsident Freyberg, Staatsministerium Dessau, 13 July 1933, Stiftung Bauhaus Dessau, Archiv Sammlung.

to activities and ideas that Americans considered attractive. Many aspects of the school's program were barely known before 1936, or not known at all. This was the case with the productions of the Bauhaus stage and the pottery and textile workshops. Other work, such as the expressionist paintings and sculptures of the early Weimar period, did not appeal to the American taste. Some of the interior design products of the metal and carpentry workshops did show up occasionally in publications, exhibitions, and film, but were not met with much interest. At times, a difference of cultural concepts might have stood in the way. The American middle and upper classes preferred traditional furniture. The bent tubular steel and steel band chairs that Marcel Breuer and Mies introduced or the plain, geometric cubes that Breuer combined for cabinets found an even lesser clientele than in Europe. Also, the mobility in the American way of life, particularly of the younger generation, did not allow paying too much attention to expensive furniture and home accessories. People who move every few years, the Austrian architect and designer Josef Frank argued, prefer items that can be left behind, on the street curb or with the Salvation Army.[31]

All contradictions considered, there is no doubt that a strong affinity between the school and American culture developed early on. Being aware of it, two of the directors, Gropius and Mies, made an effort to cultivate the Bauhaus's affair with America.

EXPECTATIONS OF AN AMERICAN RENAISSANCE

Immediately after the National Socialist acts of repression against undesirable intellectuals and artists began, critical American periodicals began to report on the measures. The news of who had been fired or forced to resign from his or her position spread relatively quickly. The heirs to the true democratic spirit and cultural life of Germany, many of the persecuted, were welcomed in the States. A century earlier, during the immigration of 1848, the country had experienced how refugees from Germany and Austria-Hungary could revitalize its democracy and strengthen its institutions. In light of the new wave of immigrants, hope was raised of a second cultural and intellectual renaissance.

After the First World War, America took its leave from the classical, rational tendencies of the nineteenth century with an intellectual *risorgimento*. The lawyer and philosopher of human rights Oliver Wendell Holmes attacked formal law and ordered the adaptation of the judicial system to social changes. The philosopher and pedagogue John Dewey rejected formal logic and pleaded for the development of logical thought through an education which emphasized individual responsibility and integration into

The New
REPUBLIC
Published Weekly
Wednesday March 18, 1931

JOHN DEWEY
on The Need for a New Party
I: Crisis in the Economic-Political System

Four Sonnets, by *Edna St. Vincent Millay*
Program Making *vs.* Power Politics
*In Dispraise of Life, Experience and
Reality*, by Morris R. Cohen

FIFTEEN CENTS A COPY
FIVE DOLLARS A YEAR
VOL. LXVI. NO. 850

5.1 The *New Republic,* featuring an article by
John Dewey, 18 March 1931.

communal life. The sociologist and econo-mist Thorstein Veblen questioned classical economics; he offered a socially critical analysis of the upper class and made no secret of his expectation that the new in-dustrial technologies would transform social relations. In the area of art, similarly disruptive intellectual forces were palpable as they toppled traditional values such as harmony, decoration, and naturalism.[32] Arthur Dove, Morgan Russell, and other artists turned to abstract painting. In New Orleans, jazz was born. The First World War accelerated this creative reversal even more. In the twenties, however, it slowed, and the hope of a complete rebirth of the arts paled. A nihilism prevailed in the arts that still makes it difficult to understand the enormous productive artistic power of that decade. Only with the appearance of new intellectual and artistic influences in the thirties did hope of the rejuvenation and revitalization of American culture resurface. This time, the hope was bound to a readiness to accept inspiration from abroad. Among modernistically inclined architects, the Bauhaus now entered immediately into the discourse, as these words from Joseph Hudnut's introduction to *The New Ar-chitecture and the Bauhaus* make clear:

The construction of these [Bauhaus] buildings assured, I believe, the triumph of modern architecture. We have now to develop, enrich and amplify the principle that is starkly given here; but the principle remains. New inventions, new mechanizations and new standards will of course transform our new expression, as will also the changing fabric of industrial organization. The factory, I think, will become a more important tool in the production of buildings. The new control of light, of sound and of atmosphere, the new syncretization of services and of research, and the new themes of design arising from collective change must all be taken into account; and we shall discover, no doubt, a greater imaginative resourcefulness. We have learned at the Bauhaus how our process of education may be addressed to this coming Renaissance.[33]

31 Josef Frank in a 1946 interview, quoted in Kristina Wängberg-Eriksson, "Josef Frank im Exil auf Manhattan."

32 William E. Leuchtenberg quotes the poet Ezra Pound in *The Perils of Prosperity,* 141. Also see Emil Lengyel, "German Culture in Exile," 607–609; and "The Arts under Hitlerism," 268–269.

33 Joseph Hudnut, foreword to Gropius, *The New Architecture and the Bauhaus,* 10.

The weight of such expectations was reflected in the investment made in teaching and research. New institutions for immigrants of various disciplinary backgrounds were founded, such as the University of Exiles at the New School for Social Research.[34] Germany's catastrophic creative bloodletting meant a chance for the still-young American power to extend its strong position in military and economic areas to culture and scholarship.

SUPPLY
AND
DEMAND

America's first contacts with the Bauhaus in the 1920s and early 1930s tell as much about the country's cultural situation and ambitions as about the Bauhaus. A "new conception of the world,"[35] as Gropius formulated it, had also come to the fore in inter-war America. Here, however, it was not only a matter of changes in the political and social system, but a realization of the country's strengthened position and a new orientation in domestic and external politics that resulted from it. The impulses emanating from this change led to an awakening among critics and intellectuals, who saw a discrepancy between the problems created by these developments and the available solutions. This context explains why, by the mid-thirties, the American interest in the original interdisciplinary complex of a school that embraced the visual arts, product design, stage production, and architecture had shifted almost entirely to architecture and architectural education.

Many of the architectural issues that had arisen in the United States after the First World War were still under discussion in the mid-thirties: the structure of town planning and zoning laws, modern skyscraper construction, the development of technologies equal to the new building materials and methods, the formulation of an "American" aesthetic vocabulary. Other urgent matters had joined these: the need for mass housing, for efficient and economic buildings, for modern schools and universities, and for the reform of architectural education. A comparison with Europe convinced many American architecture critics that the solutions being proposed on the other side of the Atlantic might be worth considering seriously as an alternative to indigenous developments. Europe was believed to be ahead in craftsmanship and building technologies.[36] Walter Curt Behrendt, Catherine Bauer, and others introduced America to the results of German apartment house and *Siedlung* construction.[37] In *Modern Housing,* Bauer placed Germany at the center of housing innovations, with the period between the First World War and 1931 in Germany as the most fruitful epoch of modern residential and *Siedlung* building.[38]

In January 1936, an article in the *Nation* brought together various elements of the reception of the previous years. The author, Albert Mayer, expressed his dis-

appointment at the state of American architecture, pointed to German architecture, especially that of the Bauhaus, as a model for the future, and prophesied the triumph of an international style in the United States. The style he foresaw was more diverse, certainly, than the style defined by Hitchcock and Johnson:

It can be seen that we are unlikely to achieve great architecture in this country in the near future. The conditions are not here, and the architects are not here. Our job in these changing times is to struggle toward establishing the conditions that can produce great architecture, to educate new architects worthy of these conditions, and as far as we can, to create challenging examples which can be the forerunners of something great. The nearest approach to great architecture in modern times, certainly the most challenging mass movement, was the German housing and city rebuilding in the fifteen years after the war. Here, the architects became leaders in the demand for a richer life, and simultaneously in the creation of its architectural frame. Of course, all this is changed and the individuals responsible for it have been dismissed or banished by the Nazis. But what a splendid testimonial to them remains! . . . There will be an international style of our day, not necessarily the "international style" so-called. . . . It will differ as between architects and from place to place and from country to country, but there will be some uniformity of underlying idiom as there always is in all great architecture. It may have the severe beauty of Gropius's Bauhaus, the magnificent scale and open flows of the schools and housing of Romerstadt, the Romanticism of Dudok's City Hall in Hilversum, the rocky beauty of some of Frank Lloyd Wright's work or the fluent transparency of Brinkman and Van der Vlught's Van Nelle factory. . . . They are the challenging forerunners.[39]

The most important motivation for American institutions to overlook political and cultural prejudices, to accept the Bauhaus's ideas, and finally to open their doors to Bauhaus architects came from their contact with the European avant-gardes: the work and education pursued at the Bauhaus could offer answers to the questions and problems that had been under discussion in the States since the war. They conceded that the European pioneers would provide the United States access to the greatest achievements of that time and that these Europeans would, finally, bring with them an urbane flair

34 "Hail, Exiled Scholars," 398.

35 Walter Gropius quoted in Karl-Heinz Hüter, *Architektur in Berlin*, 84.

36 James M. Hewlett, "Modernism and the Architect," 342; Stephan I. Richebourg, "Some Thoughts on Modern Architecture," 143; John F. Harbeson, "Some Things in Which We May Learn from Europe," 106; William W. Watkin, "The Advent of the New Manner in America," 523, 528.

37 Behrendt, *Modern Building*, 206.

38 Catherine K. Bauer, *Modern Housing*, 220f.

39 Albert Mayer, "The Architect and the World," 45.

5.2 *(right)* Walter and Ise Gropius leaving for the United States, 12 March 1937. (Photographer unknown; Bauhaus-Archiv, Berlin.)

5.3 Walter Gropius teaching at the Graduate School of Design, Harvard University, 1944. (Photo by PIX Inc., New York; Bauhaus-Archiv, Berlin.)

5.4 Model of the Illinois Institute of Technology campus, Chicago. From left to right: James C. Peebles, Ludwig Mies van der Rohe, Henry T. Heald. (Photo: The Illinois Institute of Technology Press.)

5.5 Ludwig Mies van der Rohe in his Chicago office, 1963. Next to him is Antones Tritis. (Photo by Howard Dearstyne; courtesy of George Danforth.)

with which the powerful elite of finance and capital, especially on the east coast, hoped to represent themselves. Bound to these motives was the expectation that European experience could be transferred to the United States and that the country would continue the development of the Neues Bauen in leaps and bounds. The "American features" in the works and biographies of Walter Gropius and Ludwig Mies van der Rohe inspired the hope that these architects would be sensitive to American needs. In the work and theories of these two men, the Neues Bauen could be seen from an American perspective. They were considered the pioneers of the new architecture, the true leaders of modern architectural education,[40] capable of communicating their wisdom to the next generation.[41] Both had proven their flexibility by pursuing new solutions in commercial, industrial, and institutional building as well as in *Siedlung,* housing, and private house building. Both had successfully developed new technologies using modern materials and methods, and derived a consistent, appropriate formal language whose rejection of pure functionalism was amenable to the American mentality. Mies van der Rohe had proven his visionary ideas in skyscraper building and in urban planning. The work of both bespoke concepts that formulated the challenges of the industrial era and the ways in which those challenges could be met.[42] The United States was cognizant of this ability and of the reputations that Mies and Gropius had achieved in Europe by virtue of their earlier associations with a figure already well known and significant in America, Peter Behrens.[43] Their own work, their roles in the Werkbund, their activities as the curators and planners of important exhibitions, and finally their tenures as director of the Bauhaus contributed to their acknowledgment.

The stylistic simplicity of Gropius's exemplary works seemed amenable to economical building. Iconic works such as the Dessau Bauhaus and visionary designs such as the glass skyscrapers and the concrete office building fulfilled simultaneously the aesthetic, functional, and representative demands that the economy placed on the new architecture. They were innovative and gave the impression of being exclusive. The rationality and clarity of the geometric forms appealed to finance's desire for control and power. This was the seed of what would later be manifested in countless buildings as the affinity between finance and the international style, and would lead to the description "corporate style."

The experience that Gropius and Mies brought with them impressed Americans as the source of new solutions. This apparent correspondence between supply and demand (to use the terminology of economics) made the two architects extraordinarily attractive to the United States. It made it easy for many skeptics to overlook ideological, nationalistic, cultural, or aesthetical prejudices. In late 1936, when the immigration of both architects seemed probable, there was a considerable expectation that they would be able to give the country what they had lent their own cultural milieu. The fact that America greatly overestimated the influence and currency of the new architecture in Germany would first become obvious later.

Architectural education at that time was struggling to structure an educational program equal to the demands of the present and the future. There were American experiments, for example at the Carnegie Institute of Technology. In the early twenties, in the hope of reconceiving the standard of American design and architectural education, America had looked to Europe for ideas. In 1920, a correspondent for the American *Magazine of Art* visited art and crafts schools and came to the conclusion that the European schools were superior to the American in their selection of students and the quality of their teaching. German schools were in a position to realize the potential offered by the standardized production of visually and functionally sophisticated industrial products. Apparently, strategic economic motives played a role in this evaluation: the author added that the United States had imported expensive products long enough; it was time to import ideas and talent instead and to conquer the world market itself.[44]

In 1930, Henry-Russell Hitchcock recommended taking a closer look at the Bauhaus's concepts. He portrayed the Bauhaus in his article "Architectural Education Again" as one of two European precedents for an architectural education appropriate to the times:

The young man or woman who has decided to become not simply an architect, can receive a complete course of instruction into which the hypothesis of imitation of the past never once enters. City planning and the functional study of industrial architecture receive special emphasis, and design is based absolutely on contemporary means of production. At the same time . . . the students are brought definitely into connection, by subsidiary or volitional courses, with contemporary painting, sculpture, theatre arts, publicity, music, and literature. They are also in direct association . . . with students in the other arts, and thus achieve some of that centrality of position, which architects have many times needed in the past.[45]

40 Henry L. Kamphoefner, "A Few Personal Obervations on the Rise and Decline of the Modern Movement in Architecture," 18.

41 Joseph Hudnut stated in December 1936 that he and Gropius were of the same opinion in matters related to the profession and the teaching of architecture. Joseph Hudnut et al., "Not of One Mind," 27.

42 See Ludwig Mies van der Rohe, "Baukunst und Zeitwille," 31f., and "Die neue Zeit," 406; Walter Gropius, "Bilanz des neuen Bauens," 153ff.

43 Behrens had been introduced in the States via extensive articles, such as Edwin A. Horner and Sigurd Fischer, "Modern Architecture in Germany," 1929; Shepard Vogelsang, "Peter Behrens, Architect and Teacher," 1930; William W. Watkin, "The New Manner in France and Northern Europe," 1931; and Behrens's own article, "The Work of Josef Hoffmann," 1924.

44 "Art and Industry," 80–82. Economic motivations and reform in architecture had long been intertwined in Europe, for example in the Werkbund program.

45 Hitchcock, "Architectural Education Again," 446. The second school was the Institut Supérieure des Art Décoratifs in Brussels under the directorship of Henry van de Velde.

Taking a stand against cultural isolationist tendencies, Hitchcock pointed to prece-
dents of Europeans who had successfully taught at American architecture schools:
Alfred Neumann in Oakland, Richard Neutra in Los Angeles, Knud Lønberg-Holm
in Michigan, J. J. P. Oud in Princeton. He met with both resistance and support, the
latter among progressive circles in the American architectural scene and among Euro-
pean immigrant authors. Among these was Sigfried Giedion, at the time general secre-
tary of the Congrès Internationaux d'Architecture Moderne (CIAM). Already in 1934
he had recommended Gropius to various American architecture schools. "Wouldn't an
experienced pedagogue and creative spirit like Walter Gropius be a great aid in re-
forming the architecture schools of America?" he asked in his article "What Should
Be Done to Improve Architectural Education?" Giedion thus instigated consideration
of the Bauhaus's founder for a teaching position.[46]

Even the opinions voiced by the Bauhaus's students were drawn into the discus-
sion of the Bauhaus education's international validity. In an article on the closing of the
Dessau school and its reopening in Berlin, Flora Turkel-Deri wrote:

**The Bauhaus is the most important of the Arts and Crafts institutions. . . . A new type of
builder and craftsman will undoubtedly emerge from this school, and will perpetuate the
lessons learned therein with resultant benefits to the community. An international band
of workers are trained on these lines. Since . . . Americans are among them, I thought
it interesting to find out whether they appreciate the method, or whether they think it
typically "German." I asked a young girl from Chicago who has been with the [Dessau]
Bauhaus for the last year to escort me around the building. During the course of this
tour, she made the following enlightened comment: "Through the teaching of the rudi-
ments of all the crafts, a wonderful command over the methods of technical procedures
is acquired. We thus become acquainted with the nature of materials and their special
treatment. Analysis of the problems of form, light, color, space, line, surface and so
forth, provide the theoretical basis for practical work, while the sociological side of the
architect's and decorator's task is thoroughly covered through many projects concerning
planning, housing and general agreement."**

The opinion of the author was that the Bauhaus unquestionably provided an education
that was not culturally limited and could also be of use to Americans. It put the stu-
dents in the position of answering to the future demands of the professional world.[47]
Thereafter, articles appearing in the larger architecture journals discussed the possibili-
ties of reforming American architecture and architectural education. The model of the
Dessau Bauhaus had inspired consideration of the harmony between educational pro-
gram and place of study.[48]

In the first half of the thirties, the critical discussion of the topic increased
markedly. After 1936, at least one periodical, *Architectural Record,* was full of articles
on architectural education.[49] In the critical concluding commentary to an article that
enumerated new criteria for a progressive architecture education, the Bauhaus was

emphatically recommended as a paradigm. The school's success was credited to the "experienced teaching" of the school's leaders.[50] In the *Magazine of Art,* an article entitled "Wanted: An American Bauhaus" demanded that American education be modeled on the Dessau precedent.[51] The concern for the educational situation developed increasingly into a willingness to accept the ideas of the Bauhaus avant-gardists, and an expectation that this would fertilize indigenous cultural circles. The Bauhaus's international student body and faculty and its intensive artistic exchange with other European groups was a model of openness to the world. The give and take of intellectual impetus appeared to know no national or ethnic boundaries. The existing American alternatives—Eliel Saarinen at Cranbrook, Frank Lloyd Wright at Taliesin—were neglected amid the general euphoria. To a considerable degree, the American fascination with the Bauhaus moderns was caused by a misunderstanding of the comparatively small quantitative representation of their work within the spectrum of European modernism and of the limited impact of the new architecture on contemporary European architecture in general. It was hardly known that the "heroic age" of classical modernism had passed by the time the opportunity arose to bring Bauhaus artists and architects to America. Many of the Bauhaus images that were generated in the process of the American reception were tele-pictures, pictures gained from a far distance.

The possibility of acquiring people from the Bauhaus arose with the establishment of the National Socialist regime and the dissolution of the institution in 1933. The subsequent exclusion of certain avant-garde artists and architects from the public construction sector meant inadequate commissions and employment for most.[52] During the later years of the Bauhaus, approximately 20 percent of the students and a large portion of the faculty were foreigners. Most of them left when the Germans empowered Hitler to lead the country. In addition, many German members of the school, in particular those who had been in leadership positions, emigrated. More than 100 Bauhaus denizens settled in different European countries, Israel, South Africa, Aus-

46 Sigfried Giedion, "What Should Be Done to Improve Architectural Education?," 374.

47 Flora Turkel-Deri, "Berlin Letter," 8.

48 Giedion, "What Should Be Done to Improve Architectural Education?" Also see Earl F. Sykes, "Modern Bibliography of School Design," 487; Frederick J. Woodbridge, "Ideas from European Schools." Among earlier publications, N. L. Engelhardt, "The Planning of High School Buildings for Better Utilization."

49 "Education of the Architect," an overview of the curricula and aims of progressive American architecture schools and vocational schools offering architectural training. It includes, among others, Harvard, at the time under Hudnut's direction, and Black Mountain College in North Carolina, on the grounds of Josef Albers's "powerful influence" and the relevance of his educational concepts, developed at the Bauhaus and practiced at the college (212). IIT is not included.

50 Ibid., 214.

51 E. M. Benson, "Wanted: An American Bauhaus."

52 Sigfried Giedion, *Space, Time and Architecture,* 500.

tralia, and South and North America. Acting in a dual capacity as practicing artists or architects and educators, some of them spearheaded the dissemination of Bauhaus concepts and established a broad base of influence. The decision of Black Mountain College, Harvard University, and Armour Institute to make the best of this situation and to hire one of the Bauhaus's most influential artists and its two leading architects not only transformed the schools involved, and accelerated the Americanization of the Bauhaus, but also changed the structure of American art pedagogy and the function of the university in architecture. Until then, important new movements had come from practice, most recently from the architectural offices of the Chicago school and of Frank Lloyd Wright; hereafter, and for a long time to come, the decisive impulses would come from academia.

OPEN-MINDEDNESS
AND ACCEPTANCE

The appointments of Gropius and Mies to American universities had enormous implications: they would become landmarks in American architectural history. It was not the first time that the United States had opened itself to new ideas stemming from European architecture. Italian, French, and Spanish-Mexican influences had already affected building styles and construction methods considerably. Above all, however, English precedents and cultural heritage, appropriated through the literature, had been significant for the United States, which had drawn a large proportion of its social, political, and cultural background from Britain. The Federal style is one such example: it was seen as an expression of the American identity won in the Revolutionary War but was in fact a borrowed style. Many of its formal elements derive from the ideas and designs of the brothers Robert and James Adam in London, known in the States through copy books and periodicals. The Greek revival style, which reflected the identification of the young American nation with the Greek wars of independence against the Turks, was also inspired by a literary source, the book by James Stuart and Nicholas Revett entitled *The Antiquities of Athens.* The Gothic revival style, expression of cultural fidelity to the Christian tradition, was at least partially inspired by and disseminated through Sir Walter Scott's popular novels and the teachings of John Ruskin.[53]

The intensive reception of the Bauhaus between 1919 and 1936, and the subsequent appointment of the two German architects and former Bauhaus directors, was the first time that the country welcomed any significant architectural influence from Germany. Still, this influence could only spread out due to the recontextualization of the transferred material, formal, and aesthetic European traditions within the American cultural context. In this process, the social and utopian ideas that underlay modernism in Germany were largely lost. Most of the Bauhaus émigrés accepted this, even

5.6 The ultimate integration: German Bauhaus architects become Americans.

Walter Gropius. These developments have falsely led some historians to the conclusion that in the American environment, the Bauhaus ideas were reduced to merely formal concepts of design. This is particularly incorrect in the case of the basic concepts of the Bauhaus pedagogy, which were adopted by numerous American institutions without losing their authenticity.

The many exhibitions and symposia dealing with the Bauhaus and its influence, and the countless publications that have appeared on the Bauhaus up to the present, all reflect it. Hundreds of books and articles on Gropius and Mies alone appeared in the relatively brief period between their immigration and their formal professional recognition by the American Institute of Architects at the end of the fifties. Visual evidence is presented by the numerous office buildings, school, hospitals, hotels, and housing complexes that bear the stamp of the architecture taught and produced at the Bauhaus. Institutions such as Black Mountain College, the Graduate School of Design at Harvard University, Illinois Institute of Technology, or the New Bauhaus, which incorporated the ideas of the historical Bauhaus into their curricula, strongly influenced design education in the United States.

Today, the architectural licensing examination requires that candidates answer detailed questions on the Bauhaus. Furthermore, the fact that the Bauhaus is considered a desirable element of general German cultural knowledge is evident in the "cultural background" section of the state-administered examination for German language teachers.[54] The titles of successful popular literature in the eighties play on the Bauhaus name, for example Tom Wolfe's bestseller *From Bauhaus to Our House* or Bette Hammel's *From Bauhaus to Bowties.*[55] At the end of 1990, *Life* magazine included Ludwig Mies van der Rohe in its selection of the one hundred most important Americans of the century in honor of the skyscraper architecture that has molded the skylines of the American metropolises. And meanwhile, certain idioms originating in the historical Bauhaus have been absorbed into mainstream American culture to the point that their genealogy is no longer considered, as evidence by completely banal things. For example, the four images in the stamp series American Architects from 1982 depict

53 G. E. Kidder Smith, *The Architecture of the United States*, 2:19–21.

54 *National Teachers Examination, Specialty Area Test: German*, part 5: Cultural Background (Princeton, N.J., 1990).

55 Bette J. Hammel, *From Bauhaus to Bowties*.

5.7 Fulfillment of expectations: the Seagram Building, New York, 1954–1958. Ludwig Mies van der Rohe, architect. (Photo by Ezra Stoller, reproduced with kind permission of Esto Photographic Services.)

5.8 The banal commercialization of the Bauhaus name in the 1980s: furniture advertisement. (Illustration in the *Ann Arbor News*, 18 June 1984.)

Frank Lloyd Wright's Fallingwater and Eero Saarinen's Dulles Airport, but also Ludwig Mies van der Rohe's Crown Hall in Chicago and Walter Gropius's house in Lincoln, Massachusetts.[56] Many household products and objects that bear the signature of Bauhaus designers belong to the everyday world of certain American home and business milieus. They are, moreover, placed there to assert a particular image. Only infrequently does their presence seem surprising, as in a television advertisement broadcast in the early nineties by the Hanes Corporation: coming at us in our living rooms was Michael Jordan, stretched out in a Barcelona chair and wearing nothing more than standard cotton underwear. Presented by *the* sports superstar seated in *the* classical modern chair, even the most banal product could only be of the finest quality.[57] The advertising efficacy of such images assumes a solid acquaintance with the objects shown, an acquaintance that only develops over the course of many years. From the perspective of the late twentieth century, one has to admire the prescience of Walter Gropius who, in a 1953 letter to Fritz Hesse, the former Dessau mayor and faithful supporter of the Bauhaus, wrote:

In retrospect, you can hardly believe that in spite of difficulties the Bauhaus has made such an impression. When you live in Germany, you can hardly imagine how world-famous the Bauhaus has become, especially in the United States and England. In both countries, the curriculums of the schools of art and architecture have followed the teachings of the Bauhaus, and the official state examination for architects contains the obligatory question, "What is the Bauhaus?" Therefore it was all worthwhile, though neither you nor I knew beforehand the great and almost insurmountable difficulties we were going to have.[58]

The Bauhaus's popularity in America, however, was always countered by skepticism and harsh criticism. Some critics have argued that modernism did not grow from the social and historical context of the United States but was instead imported and imposed.[59] This assertion is only true if the criteria applied to the matter are completely generalized. If solutions that had been developed in Europe were seen in

56 *Postal Guide to US Stamps*, 16th ed. (Washington, D.C., 1989), 219.

57 Hanes TV commercial, NBC Broadcasting, 10 August 1991.

58 Walter Gropius, quoted by Gillian Naylor in *The Bauhaus Reassessed*, 179.

59 Wolfe, *From Bauhaus to Our House*, 41f.

5.9 The urban image in 1983: *Chicago Architecture,* wall painting by Richard Haas, for Lohan Associates, Chicago. Oil on linen, 7'10" by 18'1". (Photo courtesty of Dirk Lohan.)

America as attractive and transplantable, that does not mean that a comparable, genuine modernism would not have developed there, too. The combination of industrialization, energy, and wealth that had been the preconditions to the developments in Europe were also present in the United States. The basis for comparable development existed on various levels, in the housing discussion, in urban skyscraper building, and in the reform of the educational system. Carl Condit, for example, in his work on Chicago's architecture, presents concrete examples of the way in which American architects continued the tradition of the Chicago school, especially in house design and housing. There is no question that an incipient modernism had developed in America from the realities of a life fundamentally changed by industrialization. Its first fruits were the observations and experiments of Louis Sullivan and the rest of the Chicago school, and finally the work of Frank Lloyd Wright. Even if these developments were rooted in fundamentally different cultural concepts and in the specific American atmosphere of the 1920s, not pursued in the twenties as extensively as they were in Europe, the sentiment remained, nurtured by the political and economic transformations of those years, that the era demanded its own architecture. Like the Europeans, the Americans were interested in the industrialization of the construction process, if for more commercially or economically motivated reasons. The results of their active search for new solutions included the collaborative research departments of universities and business organizations; Buckminster Fuller's 1928 call for the industrialized production of the single-family house (the 4D Manifesto); his 1927 Dymaxion house; and the experimental work of other architects such as Howe and Lescaze, Frey and Kocher, Alfred Kastner and Oscar Stonorov, the Bowman brothers, and the protagonists of California modernism. These developments, which paralleled the Neues Bauen in Europe, were dampened by the absence of another vital precondition that contributed to modernism's rise in Europe: the cosmopolitan diversity that supported a mutually

fruitful exchange of ideas. The American scene was suddenly confronted with the considerably broader, more explosive European avant-gardes, their lobby, their conceptual and, in the Bauhaus's case, institutional infrastructure.

The initial successes of the protagonists could not be maintained. Nonetheless, even in the seventies, during the massive and continual attacks on modernism, the power of the movement and its standards was reflected in the fury of its opposition, as articulated in Stanley Tigerman's collage of Mies's Crown Hall as a sinking ship. The reproaches made against the Bauhaus, such as its inhumane dogmatism, excessive abstraction, arrogant blindness to historical and local conditions, and its stereotypical glass boxes, were nonetheless unable to halt discussion of it. Not even postmodernism succeeded in doing that.

Today, at the end of the nineties, the rekindling of interest in modernism and in the Bauhaus is unmistakable. This tendency began with the events celebrating the hundredth birthdays of Walter Gropius and Ludwig Mies van der Rohe, in 1983 and 1986 respectively. There were other signs that a reevaluation of modernism was under way, such as Peter Blake's ironic comment that the long-awaited appearance of postmodernism on New York's Park Avenue and in East Berlin could be taken as a certain sign of that style's imminent demise.[60] In the United States, a number of important publications appeared almost simultaneously, among them the English-language, unabridged MIT edition of Hans Maria Wingler's reference work, *Das Bauhaus;* Frank Whitford's *Bauhaus* book; John Zukowsky's *The Unknown Mies van der Rohe and His Disciples of Modernism;* Werner Blaser's *Mies van der Rohe—Less Is More;* Reginald Isaacs's two-volume Gropius biography; and the Mies van der Rohe biography by Franz Schulze.[61] Arthur Drexler's four-volume publication of drawings from the Museum of Modern Art archive[62] may well be one of the most important contributions to future research.[63] Prominent exhibitions in the United States in recent years, including the Mies van der Rohe exhibition at the Museum of Modern Art, have highlighted the work of the two Bauhaus directors. In spring 1992, the School of Architecture at Columbia University in New York honored the sixtieth anniversary of the influential exhibition "Modern Architecture" with a complete reconstruction.[64] The 1999 architecture exhibition "The Un-Private House" mirrors a revised focus on Mies and his influence on con-

60 Peter Blake, "The Case against Postmodernism," 324f.

61 Isaacs, *Walter Gropius;* Franz Schulze, *Mies van der Rohe: A Critical Biography.*

62 Arthur Drexler, ed., *Mies van der Rohe Archive.*

63 Winfried Nerdinger, "Nachlese zum 100. Geburtstag," 419ff.

64 "The International Style: Exhibition 15 and the Museum of Modern Art," Arthur Ross Architectural Gallery, Columbia University, 9 March–2 May 1992. Direction: Terence Riley, Keenen-Riley Architects, New York.

temporary architecture, in particular with regard to the issues of transparency and sensuousness of materials.[65] For its August issue in 1991, the magazine *Architectural Digest* asked one hundred architects known for their work in housing to cite their most important precedents. The 67 American architects in the group who cited twentieth-century architects named only Frank Lloyd Wright and Louis Kahn more often than Ludwig Mies van der Rohe. While this survey should not be misunderstood as representative,[66] it does show that certain criticisms are less current today. Thus, the statement made in 1988 by Winfried Nerdinger that "today, Mies is perhaps only known as the representative and originator of an anonymous concrete or steel architecture which is forced to serve as an oft-cited scapegoat for all the problems of industrialization and technology"[67] seems overly pessimistic. Instead, in their use of the early European avant-garde's formal vocabulary, contemporary architects quote their Bauhaus colleagues.[68] Their interest has less to do with the myth of the historical Bauhaus, its utopian models, or its heroic ambition to be the paradigm of the industrial era that would arise once the rejuvenating power of technology had reversed the incredible destruction wrought by the First World War. Instead, what remain relevant are the design potential and universality of its formal vocabulary, its artistic and productive achievements, the didactic and methodical conception of its transdisciplinary pedagogy, and its readiness to ask the difficult question of what the era demanded of education. It is this final question that is again in the minds of university educators today, especially in light of the coming century and the increasing pace at which needs change.[69] Such developments seem to prove the Bauhaus's founder correct in constantly emphasizing the principles that would carry the Bauhaus's idea beyond the bounds of temporality. As Mies summarized:

The Bauhaus was not an institution with a clear program—it was an idea, and Gropius formulated this idea with great precision. . . . The fact that it was an idea, I think, is the cause of this enormous influence the Bauhaus had on every progressive school around

65 Organized by Terence Riley, the exhibition runs at the Museum of Modern Art in New York from 1 July to 5 October 1999. See Susan Doubilet, "A Preview of MoMA's Splashy Summer Show."

66 *Architectural Digest* is a California-based magazine that discreetly offers the "lifestyles of the rich and famous" to a well-heeled, mixed audience of professionals and laypeople. The publication, founded in 1920, had a 1989 circulation of 600,758.

67 Nerdinger, "Nachlese zum 100. Geburtstag," 419.

68 Ralph Johnson, principal in the firm Perkins and Will, plays off the formal elements of Gropius and Mayer's Fagus factory facade in his Vernal G. Riffe, Jr., Building on the Ohio State University campus.

69 *North Carolina State University School of Design News*, "Dean's Message," Fall/Winter 1995–96, 4–7.

70 Ludwig Mies van der Rohe, "The Bauhaus was an Idea...," quoted in Hans M. Wingler, *The Bauhaus: Weimar, Dessau, Berlin, Chicago*, vii.

the globe. You cannot do that with organization, you cannot do that with propaganda. Only an idea spreads so far.[70]

What is unrepeatable in the early Bauhaus reception in the United States is not, finally, its inextricability from the history of the two countries between the two wars, or from the Third Reich. It is the intensity of the interest with which the Bauhaus was followed in America as a cultural development in the Germany of the twentieth century. Its result is the integration of many of the school's ideas into indigenous American culture.

Appendix: Documents

THE ARTS CLUB OF CHICAGO

CATALOGUE OF AN EXHIBITION

FROM THE

BAUHAUS, DESSAU, GERMANY

Loaned by
JOHN BECKER
New York

MARCH 13 TO MARCH 28
1931

The Arts Club of Chicago, catalogue of the first Bauhaus exhibition in the United States, March 1931. (With kind permission of the Arts Club of Chicago.)

EXHIBITION

PAINTINGS AND WATERCOLORS:

Erich Borchert
Lyonel Feininger
Wassily Kandinsky
Paul Klee

WOODCUTS, LITHOGRAPHS AND PRINTS:

Paul Klee
Lyonel Feininger

ARCHITECTURAL MODEL:

Charkow Opera House. Designed by Alfred Claus.

BAUHAUS FOLIOS OF LITHOGRAPHS AND WOODCUTS:

1. (out of print) Lyonel Feininger, Johannes Itten, Paul Klee, Gerhard Marcks, Georg Muche, Oskar Schlemmer and Lothar Schreyer.

3. (out of print) Rudolf Bauer, Willi Baumeister, Heinrich Campendonk, Walter Dexel, Oskar Fischer, van Heemskerck, Bernard Hoetger, Franz Marc, Kurt Schwitters, Fritz Stuckenberg, Arnold Topp and William Waver.

4. Alexander Archipenko, Umberto Boccioni, Carlo Cara, Marc Chagall, Giorgi di Chirico, Mme. N. Gontcharowa, Alexei von Jawlensky, Wassily Kandinsky, M. Larinow, Gino Severini and Enrico Prampolini.

5. (out of print) Max Beckmann, Max Burchartz, Otto Gleichmann, George Grosz, Erich Heckel, E. L. Kirchwer, Oskar Kokoschka, Alfred Kubin, Karl Mense, Max Pechstein, Christian Rohlfs, Edwin Scharff and Karl Schmidt-Rottluff.

BAUHAUSBÜCHER:

1. Walter Gropius. Internationale Architektur
2. Paul Klee. Pädagogisches Skizzenbuch
8. L. Moholy-Nagy. Malerei, Fotografie, Film
9. Kandinsky. Punkt und Linie zur Fläche
10. J. J. P. Oud. Holländische Architektur
11. Kasimir Malewitsch. Die Gegenstandslose Welt
12. Walter Gropius. Bauhausneubauten in Dessau
13. Albert Gleizes. Kubismus
14. L. Moholy-Nagy. Von Material zur Architektur

PHOTOGRAPHS:

The Bauhaus building at Dessau
The German Pavilion at Barcelona, 1929, by Miés van der Rohe

BAUHAUS: Introductory Note

The Staatliches Bauhaus was founded in the city of Weimar in 1919, directly after the war, by the architect Walter Gropius, in collaboration with the Thuringian Republican government, as an experiment in democracy in relation to furthering the applied arts. Gropius, at the time, was well known in Germany for his pioneering in the new architecture, having built his great Fagus factory as well as the glass factory in Cologne before the war. The Bauhaus was to inhabit a building designed by Van de Velde, the great Belgian architect and theorist. Van de Velde is a figure of considerable importance. He started the style of the Art Nouveau in Paris in 1901, perhaps the most permanent examples of which are the entrances to the Metro stations. In 1914 he was made the director of an architectural school at Weimar (which later, with the advent of Gropius, became known as the Bauhaus) but, after the intervention of the war, he refused to go back to Germany. He has always insisted that the ideas of the Bauhaus were his ideas, although his name is rarely mentioned in connection with them. Gropius had ideas of craft work and of an intimate community and socialized guild spirit. This was related to the return of the mediaeval sponsored in England by William Morris, and later more directly by the Viennese organizations such as the Weiner Werkstaette.

Johannes Itten, a Swiss pedagogue trained in Vienna, came to the Bauhaus in 1919 to teach the basic principles of expressionism. Itten did not want his pupils to go wild in their personal idioms, but rather to develop their creative powers along the lines of the greatest possible invention and in real feeling for the material at hand. The ages of Itten's students ranged from fourteen to thirty. They came from all classes, from the rich Berlin bourgeois and from the peasantry. Politically speaking, they embraced all the febrile beliefs and dogmas currently popular. There were anarchists, spartacists, communists, all of them more or less unsettled and rebellious against existing and pre-existing conditions in art and life. There were many foreigners, and the Bauhaus was coeducational from the start. The social experiments ranged from a system of rigid dieting to an unsanctioned but nevertheless tolerated system of companionate marriage.

Itten left the Bauhaus in 1921, and by 1923, when the Bauhaus moved to Dessau, the students had passed through the excitement of apprenticeship and were turning out work of real achievement: Albers in glass painting, Breuer with his pipe chairs, Gropius with his theater at Jena. Oskar Schlemmer made experiments in the dance: he visualized the stage as a three dimensional canvas and moved abstract figures in harmony across the scene. He invented the Triadische Ballet, a dance form in rhythms of three with the movements pre-indicated on the floor in triads. Moholy-Nagy invented photomontage and developed various kinds of trick photography of surprising attitudes, impending figures placed on lines of long perspectives, or in conjunction with abstract composition.

The Bauhaus left Weimar in 1923. The director of the Museum of Fine Arts at Dessau, a town of some ninety thousand inhabitants, about sixty-five miles from Berlin, persuaded the Burgomeister of the town, Herr Hesse, to ask Gropius to move the Bauhaus to Dessau to increase the prestige of the town. It is a fact of significance, when one considers that in the entire United States no such undertaking has ever been desired or attempted, that this town of less than one hundred thousand has continued to support the Bauhaus throughout the unsettled economic and social period of German reconstruction. Perhaps this is in some part due to the extraordinary effect Gropius had on everyone with whom he came in contact. A brilliant publicist and theorist, he had the astounding faculty of making men of small parts outdo themselves when working for him. His influence was everywhere, in everything, in the painting, in the typography, and of course in the architecture. Gropius, however, had the fundamental fault of being obsessed by the problems of technique. Primarily an artist, he has the romantic fallacy of feeling that he must talk like an engineer and not like a designer. Influenced somewhat by Theo Van Doesburg and the Dutch group of de Stijl, Gropius taught the use of primary, essential colors on large flat areas in interesting linear and angular relations. As Gropius emphasized functionalism more and more, the teaching of the art of painting, which has nothing to do with functionalism in interior work, naturally became less and less important. As a result, Klee, Feininger and Kandinsky stopped their courses in painting but, made independent of the necessity of teaching by pensions from the town of Dessau, continued to live at the Bauhaus.

Gropius left the Bauhaus as director in 1927 because he wished to devote more of his time to private architectural practice and less to education. He called Hannes Meyer, a Swiss communist, to be the new director. Meyer was obsessed with the idea of Sachlichkeit, that is, the idea of extreme practicability, the minimum of construction and the maximum of functional potentiality. Meyer eliminated color from architecture entirely, since he said it was decoration applied, and no integral part of the fabric of the building. He carried functionalism to such a degree of fantastic thoroughness that diagrams were made to show the proper circulation for one or two or three persons together in a room. Dots were drawn on the perspective plans to show where one should best sit in a chair. Under Meyer's regime the communist student was favored and some students stayed on indefinitely at the expense of the bourgeois city of Dessau, which, nevertheless, continued its support of the Bauhaus. Meyer's arbitrary ideas lost Schlemmer, the experimenter in the dance, and Klee, one of the original theorists. In fact Meyer carried his communism so far that the city of Dessau wanted to stop the Bauhaus as an art school and to turn its building into a hospital. The Bauhaus fell into disrepute. Germany ridiculed the cliques of cantankerous theorists who did nothing but talk and issue manifestoes to each other. Finally the town of Dessau had enough of it and in September, 1930, they dismissed Hannes Meyer as director.

Gropius, although he was no longer officially connected with the Bauhaus, nevertheless watched over it and, as far as he could, saw that

its policies were furthered in the press. It was he who, in conjunction with his former pupils, Breuer and Hassenflug, arranged the large Bauhaus show in Paris last summer. After the dismissal of Meyer, Gropius was to a great degree instrumental in asking Miës van der Rohe to become the director in October, 1930. Miës was the president of the Deutcher Werkbund, the powerful society of artists and industrials for the promotion of German goods. Perhaps his greatest monument is the superb pavilion of the 1929 exhibition at Barcelona. Next summer he is directing the Berlin architectural show on the extraordinary principle of single authority as to what shall be and what shall not be included.

The first thing Miës did at the Bauhaus was to throw out the communists, or at least those who had been living there only because they were communists. He shut the school for a month and reopened it only to those who were interested in the development of pure architecture. Miës wishes to make the best school in the world for those who are interested in architectural development based, not on historical Beaux Arts points of view but, regardless of tradition, on the principles of functionalism, of materials that are necessary and indigenous to the present. He has stopped the communistic theorizing and has given his pupils actual tools and materials to work with. Instead of designing ten possible chairs, they build him one actual chair.

Besides its role of official architect for the town of Dessau, the Bauhaus has published the Bauhausbücher, a series of books dealing with theories of design and construction of architecture, painting and photography, and it has edited other publications which contain works of outstanding men in all fields of art on the continent. This experiment in education, however intermittent, must surely rank as the most important original movement in the instruction of Fine Arts in the first part of the Twentieth Century.

This exhibition from the Bauhaus is loaned to the Arts Club by the John Becker Gallery of New York. Mr. Becker procured through Mr. Philip Johnson the model of the Charkow Opera House by Mr. Alfred Claus, a pupil of Miës van der Rohe. The model was made for the current international United States of Soviet Russia competition.

The introduction in this catalogue is by Mr. Lincoln Kirstein and is reprinted through his courtesy from the recent catalogue of the Harvard Society for Contemporary Art.

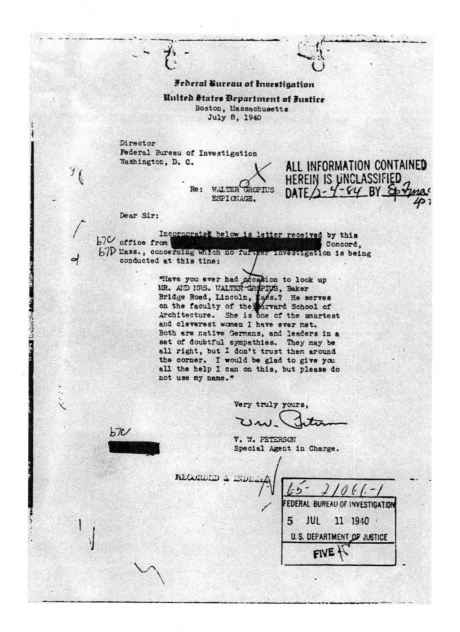

United States Federal Bureau of Investigation, Walter Gropius File (excerpts).

Federal Bureau of Investigation

United States Department of Justice

Boston, Massachusetts
October 31, 1940

Director
Federal Bureau of Investigation
Washington, D. C.

ALL INFORMATION CONTAINED
HEREIN IS UNCLASSIFIED
DATE *12-4-80* BY *Sp Jngs*

Re: UNKNOWN SUBJECT;
LINCOLN, MASSACHUSETTS.
INTERNAL SECURITY.

Dear Sir:

On the night of October 28, 1940, an individual telephoned this office, refusing to speak to anyone, except the writer, at which time the writer was out to dinner. He left a telephone number, but refused to give his name. The telephone number which I called upon my return was ███████████ which is listed to ███████████ Newton, Mass.

In this connection, the attention of the Bureau is directed to Bureau File ██████████ entitled "UNKNOWN SUBJECTS; ████████", which is undoubtedly the same complainant, and who is considered to be something of a "nut".

██

The informant, who undoubtedly was ████████ stated that he has received information concerning a house which contains, in the cellar, ammunition, machine guns, and bombs. He stated that a certain party, whose name he refused to divulge, visited this house and finally, through a pretext, was permitted in the cellar and there saw the above mentioned ammunition. It is stated that the house was an ultra-modern one located near the home of Mrs. James J. Storrow, widow of the late President of Lee Higginson & Co., and former Mayor of Boston. It is stated that in order to find this house, you go over the back road from Lincoln to Concord, Mass., and this house sets back in a field. I have directed a communication to the Massachusetts State Police, furnishing them with the above information. However, in view of the nature of the informant in this case, it is not believed it is worthy of further attention by this office.

RECORDED & INDEXED

Very truly yours,

V. W. Peterson

V. W. PETERSON
Special Agent in Charge.

65-21066-2
FEDERAL BUREAU OF INVESTIGATION
3 NOV 2 1940
U S DEPARTMENT OF JUSTICE

2 of 3

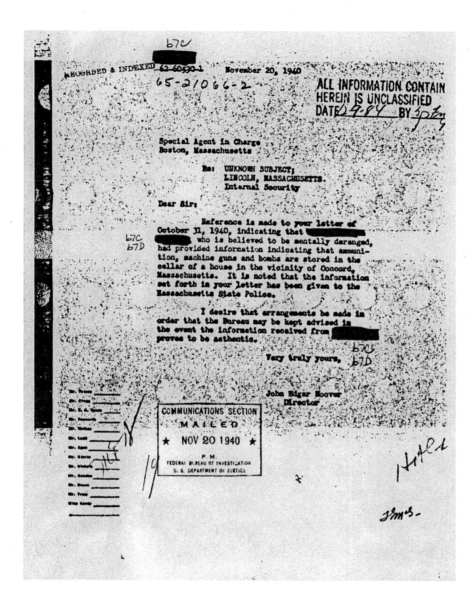

RECORDED & INDEXED 62-60530-1 November 20, 1940

65-21066-2

ALL INFORMATION CONTAIN
HEREIN IS UNCLASSIFIED
DATE 2-9-84 BY sp Em

Special Agent in Charge
Boston, Massachusetts

Re: UNKNOWN SUBJECT;
 LINCOLN, MASSACHUSETTS.
 Internal Security

Dear Sir:

 Reference is made to your letter of
October 31, 1940, indicating that ███████████
███████, who is believed to be mentally deranged,
had provided information indicating that ammuni-
tion, machine guns and bombs are stored in the
cellar of a house in the vicinity of Concord,
Massachusetts. It is noted that the information
set forth in your letter has been given to the
Massachusetts State Police.

 I desire that arrangements be made in
order that the Bureau may be kept advised in
the event the information received from ████████
proves to be authentic.

 Very truly yours,

 John Edgar Hoover
 Director

COMMUNICATIONS SECTION
M A I L E D
★ NOV 20 1940 ★
P M.
FEDERAL BUREAU OF INVESTIGATION
U. S. DEPARTMENT OF JUSTICE

FEDERAL BUREAU OF INVESTIGATION

Form No. 1
THIS CASE ORIGINATED AT CHICAGO, ILLINOIS CHICAGO FILE NO. 65-152

REPORT MADE AT	DATE WHEN MADE	PERIOD FOR WHICH MADE	REPORT MADE BY
CHICAGO, ILLINOIS	9/15/39	9/13/39	

TITLE	CHARACTER OF CASE
UNKNOWN SUBJECTS (4) Informant	ESPIONAGE

SYNOPSIS OF FACTS: Informant reports four Germans, three men
and one woman, who rented a cabin at Pike
Lake Lodge, Wisconsin, recently, conversed
entirely in German and appeared to be en-
gaged in the perusal of various maps and
plats. Names of subjects unknown to in-
formant, but informant advised ▓▓▓▓
has ▓▓▓▓ and detailed infor-
mation relative to their background.
Female suspect allegedly a German school
teacher in United States on leave, and No.
1 male suspect allegedly a well known
architect, New York City.

P.

DETAILS:

On September 6, 1939, this field division received a letter
from United States Commissioner EDWIN K. WALKER, Chicago, Illinois, written
on the letterhead of ▓▓▓▓▓▓▓▓, this letter being quoted as follows:

"Commissioner Walker
Chicago, Ill.

**ALL INFORMATION CONTAINED
HEREIN IS UNCLASSIFIED
DATE 11-30-84 BY ▓▓▓**

Dear Sir:

I have just returned from Pike Lake Lodge, Wis. and

APPROVED AND FORWARDED	SPECIAL AGENT IN CHARGE	DO NOT WRITE IN THESE SPACES	
		65+4656+1	SEP 20 1939
5-Bureau	COPIES OF THIS REPORT		
1-Commander Conf.)	Pers. &	SEP 18 A.M.	
1-Captain & Conf.)	G-2 (Pers.)		
2-Milwaukee			
2-Chicago			

United States Federal Bureau of Investigation, Ludwig Mies van der Rohe File (excerpts).

while there was very suspicious of four Germans who were stay-
ing there. The leader was supposed to be a marvelous archi-
tect from N. Y. He had two younger men there and a woman Secy.
who had just come over from Germany. They spoke nothing but
German and spent their time over "drawings ――". I may be
wrong but they impressed me as spies, perhaps drawing plans
of our country for the woman to take back to Germany. If you
are interested I can tell you more about it. My phone number
is ███████████████████████ (during day).

b7C

 Most sincerely yours

 (Signed) ████████████ L7C b7P

 Sept. 3"

b7C b7D AT GLENCOE, ILLINOIS ████████

██████████████████████████ advised that ████████
 █████ was considered
reliable in every respect and a woman of some ██████████

L7C b7D ███████████████████ was interviewed at her place of business,
 ████████, Glencoe, Illinois, and advised the writer that about
three weeks prior to the time she had addressed the letter to Commis-
sioner WALKER she and her daughter had been camping at the Pike Lake
Lodge which is located approximately four miles from Park Falls, Wiscon-
sin, and about eight miles from Fifield. She advised this lodge is opera-
b7C ted by ██████████████ and is not a well known summer resort. She ad-
vised that while there she observed four persons who spoke entirely in
German, three of them being males and one being a female; that due to
the fact that she had just seen the movie "Confessions of a Nazi Spy",
she immediately became suspicious of these persons; that due to the fact
that these individuals conversed entirely in German and kept entirely
b7C to themselves and did not mingle with other patrons of the camp, she
made inquiry concerning them of ██████████ who advised that the
three male members of the party first appeared at the lodge together
and were later joined by the female member and that she had later learned
that this lady was a German school teacher presently on leave in the
United States from the old country. She advised she also learned that
the No. 1 suspect was a very prominent German architect in New York
City; that he spent the entire time studying maps and drawing same, but
that she had never observed what these maps were of or what any of the
drawings consisted of. She advised that the No. 1 suspect, the alleged

architect, appeared to be the leader of the party and the others seemed
to be entirely dominated by his commands and wishes. She further advised
that the members of her party had gathered from the actions of this Ger-
man party that the German school teacher was memorizing the maps in
order to take the information back to Germany with her. She advised
that all four of the persons comprising the German party were intelli-
gent, well dressed and that she had learned that none of them were re-
lated by either blood or marriage.

b7C She advised that [] requires a register to
be kept; that their stay there cost them approximately $35.00 a piece
which was paid by the alleged architect. She advised that she and the
members of her party further thought it strange that anyone allegedly
so prominent as the architect would pick out such an out of the way
place as Pike Lake Lodge for an outing; that they are firmly convinced
that this was a meeting of German espionage agents and that the alleged
school teacher was to return to Germany with the information. She ad-
b7C vised that [] has retained his register and no doubt further
information concerning them could be obtained from him. She advised
that she did not know whether these persons appeared at the camp in
an automobile; that she had never observed any car about the premises,
and never knew of these persons having any visitors from Milwaukee or
any of the surrounding cities, these individuals keeping entirely to
themselves all during her stay there.

 Following are descriptions of these four individuals
b7C b7D obtained from []

No. 1 (Alleged German architect from New York City)

Age	About 45
Height	6'
Build	Stout
Hair	Blonde
Appearance	Quoted as being typical German; neat appearing; spoke English but conversed with other parties in fluent German

No. 2 (Male)

Age	About 24 - 25
Height	5' 11"
Appearance	Thin, sickly appearing; may have been secretary to No. 1

- 3 -

No. 3 (Male)

No description recalled

No. 4 (Female)

Age	Approximately 40
Hair	Black
Appearance	Typically German; neat appearing; school teacher type and wore clothing consisting of skirt and blouse. Not known to speak English.

UNDEVELOPED LEADS:

THE MILWAUKEE FIELD DIVISION, at Pike Lake Lodge, near Fifield, Wisconsin: Will contact ████████████████ of this camp, to secure all information from the register and other sources of information relative to the identities of the above described individuals in order that complete information may be had relative to their alleged activities as agents of the German Government.

PENDING

- 4 -

Bibliography

Archives Alfred H. Barr, Jr. Papers, Archives of American Art, New York. Bauhaus-
 Archiv Berlin.
Stiftung Bauhaus Dessau, Archiv Sammlung.
Gropius Papers, Houghton Library, Harvard University.
Philip Johnson Files, Museum of Modern Art Archive, Architecture and Design
 Department, New York.
Klee Nachlassverwaltung, Bern.
Mies van der Rohe Archive, private files of Dirk Lohan, Chicago.
Mies van der Rohe Archive, Museum of Modern Art, Architecture and Design Depart-
 ment, New York.
Mies van der Rohe Files, United States Library of Congress, Manuscript Division,
 Washington, D.C.
László Moholy-Nagy Archive, private files of Hattula Moholy-Nagy, Ann Arbor,
 Michigan.

Bibliographical Sources *Architectural Index.* U.S. bibliography, annual. Complete
 index of *American Architect, Architectural Forum, Architectural
 Record, House and Home, Interiors, Progressive Architecture.* Selective index of *American
 Institute of Architects Journal.*
Art Index. U.S. bibliography, quarterly. Majority of journals are American, some inter-
 national.
Avery Index to Architectural Periodicals. Avery Memorial Architectural Library Catolog.
 Columbia University, New York, 1958 and 1973. (Original edition 1895.) Works
 of well-known architects completely included. Complete index of the most impor-
 tant American journals (*American Architect, Architectural Forum, Architectural Record,
 Progressive Architecture*) going back to their founding (1876, 1892, 1891, 1920).
 The 1973 edition compiled by A. K. Placzek.
Doumato, Lamia. *Hugh Ferriss: A Bibliography.* Vance Bibliographies, Monticello, Ill.,
 1979.
Harmon, Robert B. *The Bauhaus—Art and Architecture in Harmony: A Selected Bibliogra-
 phy.* Vance Bibliographies, Monticello, Ill., 1980.
Harmon, Robert B. *Ludwig Mies van der Rohe: Master Architect: A Selected Bibliography.*
 Vance Bibliographies, Monticello, Ill., 1979.
Harmon, Robert B. *Modern Architectural Vision in the Works of Walter Gropius: A Selected
 Bibliography.* Vance Bibliographies, Monticello, Ill., 1979.
Index to Art Periodicals. Compiled by the Art Institute of Chicago, Ryerson Library.
 Boston, 1962.
Library of Congress, Washington, D.C. "Bauhaus/Walter Gropius/Mies van der Rohe."
 Computer index, version of January 1991.

Lyons Library, North Carolina State University, School of Design. *Bauhaus: Selected Bibliography.* Raleigh, N.C., 1973.

Spaeth, David A. *Ludwig Mies van der Rohe: An Annotated Bibliography and Chronology.* New York, 1979.

Stoika-Stanka, Wanda. *Bauhaus Art and Architecture: Influence.* Vance Bibliographies, Monticello, Ill., 1987.

Ulrich's International Periodicals Dictionary, vol. 3: Indexes. The Bowker International Database, 27th ed. New York, 1988–1989.

Books and Articles Adams, George. "Memories of a Bauhaus Student." *Architectural Review* 144 (September 1968): 192–194.

Adams, Rayne. "Thoughts on Modern, and Other, Ornament." *Pencil Points* 10 (January 1929): 3–16.

Adams, Willi P., ed. *Die Vereinigten Staaten von Amerika.* Frankfurt am Main, 1978.

Albers, Josef. "Why I Favor Abstract Art." In *Four Painters: Albers, Dreier, Drewes, Kelpe.* Publication associated with the exhibition "Abstracting," Museum of Modern Art, New York, 1936–1937.

Albrecht, Donald. *Designing Dreams: Modern Architecture in the Movies.* New York, 1968.

Anderson, Margaret. "My Thirty Years' War." Editorial. *Little Review,* May 1929, 2–4.

Andrews, Wayne. *Architecture in America: A Photographic History from the Colonial Period to the Present.* Rev. ed. New York, 1977.

"Apartment House Lobby." *Architectural Record* 80 (October 1936): 252.

"The Apartment Interior." *Architectural Record* 80 (October 1936): 306.

Archilles, Rolf, et al., eds. *Mies van der Rohe: Architect as Educator.* Ex. cat., Illinois Institute of Technology, Chicago, 6 June–12 July 1986.

"The Architect in New Fields." *Architectural Record* 80 (September 1936): 198.

"Architects' Show Bars Two Moderns. Howe and Lescaze Quit League to 'Fight Alone' Rather Than Compromise with 'Crowd.'" *New York Times,* 28 February 1932, 1:4.

"Architectural Morphology." *Architectural Record* 68 (August 1930): 166–174.

"Architecture of the Nazis." *Architectural Review* 74 (October 1933): 122–124.

Argan, Giulio Carlo. *Walter Gropius e la Bauhaus.* Turin, 1951.

"Art and Industry—An Industrial Art Survey." *Magazine of Art* 14 (February 1923): 80–83.

"Art Professor Fleeing Nazis, Here to Teach." *Brooklyn Daily Eagle,* 26 November 1933.

Arts Club of Chicago. *Catalogue of an Exhibition from the Bauhaus, Dessau, Germany.* March 1931.

"The Arts under Hitlerism." *New Republic* 74 (19 April 1933): 268–269.

Baines, Dudley E. "Die Vereinigten Staaten zwischen den Weltkriegen, 1919–1941." In Adams, ed., *Die Vereinigten Staaten von Amerika,* 283–353.

Bangs, Jean M. "Greene and Greene." *Architectural Forum* 89 (October 1948): 81–88.

Banham, Reyner. "On Trial: Mies van der Rohe. Almost Nothing Is Too Much." *Architectural Review* 132 (August 1962): 125–128.

Banham, Reyner. *Theory and Design in the First Machine Age.* New York, 1960.

Barnett, Vivian Endicott. "Die Gründung der Blaue Vier und ihre Präsentation in New York 1924–1925." In *Die Blaue Vier. Feininger, Jawlensky, Kandinsky, Klee in der Neuen Welt.* Ex. cat., Kunstmuseum Bern, 5 December 1997–March 1998; KunstSammlung Nordrhein-Westfalen, Düsseldorf, 28 March–28 June 1998.

Barr, Alfred H. "Art in the Third Reich—Preview, 1933." *Magazine of Art* 38 (October 1945): 211–222.

Barr, Alfred H. "Dutch Letter." *The Arts* 13 (January 1928): 48–49.

Barr, Alfred H. "Editorial Memorandum, Concerning Art in the Third Reich." *Magazine of Art* 38 (October 1945): 211.

Barr, Alfred H. *Masters of Modern Art.* New York, 1954.

Barr, Alfred H. "Modern Architecture. Review of Henry-Russell Hitchcock's *Modern Architecture,* 1929." *Hound and Horn* 3 (April-June 1930): 431–435.

Barr, Alfred H. "Notes on Russian Architecture." *The Arts* 15 (February 1929): 103–106.

Barron, Stephanie, ed. *"Entartete Kunst": Das Schicksal der Avantgarde im Nazi-Deutschland.* Ex. cat., Altes Museum, Berlin, 4 March–31 May 1992. Titled "Degenerate Art," the exhibition had been developed for the Los Angeles County Museum of Art, shown 17 February–12 May 1991.

Barron, Stephanie, ed. *Exiles and Emigrés: The Flight of European Artists from Hitler.* Ex. cat., Los Angeles Contemporary Museum of Art, 1997.

Barry, Iris. "The Cinema: Metropolis." Film review. *Spectator* 138 (London, 26 March 1927): 540.

Baskerville, H. Coleman. "Contemporary Styles: A Brief Discussion of World Architecture of the Present Day." *Pencil Points* 12 (April 1931): 249–256.

Bauer, Catherine K. "Are Good Houses Un-American?" *New Republic* 70 (2 March 1932): 74.

Bauer, Catherine K. "Exhibition of Modern Architecture at the Museum of Modern Art." *Creative Art,* March 1932, 201–206.

Bauer, Catherine K. *Modern Housing.* Boston and New York, 1934.

Bauer, Catherine K. "'Slum Clearance' or 'Housing'?" *The Nation* 137 (27 December 1933): 730–731.

"The Bauhaus." *Art Digest* 5 (15 January 1931): 27–28.

"Bauhaus." *Museum of Modern Art Bulletin* (New York) 1 (June 1933): 4.

Bauhaus-Archiv Berlin, ed. *Experiment Bauhaus. Das Bauhaus-Archiv (West) zu Gast im Bauhaus Dessau.* Berlin, 1989.

Bauhaus-Archiv Berlin, ed. *50 Jahre New Bauhaus. Bauhausnachfolge in Chicago.* Berlin, 1987.

Bauhaus-Archiv Berlin, ed. *Hannes Meyer. Architekt, Urbanist, Lehrer, 1889–1954.* Ex. cat., Bauhaus-Archiv Berlin and Deutsches Architekturmuseum, Frankfurt am Main; Berlin, 19 September–20 November 1989; Frankfurt, 8 December 1989–25 February 1990; Zurich, 21 March–20 May 1990. Berlin and Frankfurt, 1989.

"Bauhaus, at Dessau, Designed by Walter Gropius." *Architectural Review* 72 (November 1932): 236.

"Bauhaus Closed." *Architectural Forum* 57 (October 1932): 16.

"Bauhaus-Glosse." *Deutsche Bauhütte* 13 (24 June 1931).

"Bauhaus Reopened." *Architectural Forum* 58 (January 1933): 20.

Baum, Dwight J. "This Modernism." *Pencil Points* 13 (September 1932): 597–600.

Bayer, Herbert, Ise Gropius, and Walter Gropius, eds. *Bauhaus 1919–1928.* Ex. cat., Museum of Modern Art, New York, 8 December 1938–30 January 1939.

Behr, Adalbert. "Das Bauhausgebäude in seiner Bedeutung für die Entwicklung der neueren Architektur." Scholarly colloquium held in Weimar, 27–29 October 1976. *Wissenschaftliche Zeitschrift der Hochschule für Architektur und Bauwesen Weimar* 23, no. 5/6 (1976): 464.

Behrendt, Walter Curt. "The Architect in These Times." *Magazine of Art* 28 (March 1935): 141–147.

Behrendt, Walter Curt. *Modern Building: Its Nature, Problems and Forms.* New York, 1937.

Behrendt, Walter Curt. "Skyscrapers in Germany." *American Institute of Architects Journal* 11 (September 1923): 365–370.

Behrens, Peter. "The Work of Josef Hoffmann." *American Institute of Architects Journal* 12 (October 1924): 421–426.

Benevolo, Leonardo. *Geschichte der Literatur des 19. und 20. Jahrhunderts.* Vol. 2. Munich, 1964.

Benevolo, Leonardo. *History of Modern Architecture.* 2 vols. Cambridge, Mass., 1971.

Bennet, Wells. "Modernism Is Still in the Making." *Pencil Points* 12 (February 1931): 87–88.

Benson, E. M. "Wanted: An American Bauhaus." *Magazine of Art* 27 (June 1934): 307–311.

"Berlin's Housing and Planning Exhibition." *The American City* 45 (August 1931): 90–91.

Bernstein, Sheri. "Josef Albers at Black Mountain College." In Barron, ed., *Exiles and Emigrés.*

Bie, Oscar. "Letter from Berlin." *Apollo* 10 (July 1929): 46–47; (October 1929): 228–229.

Blake, Peter. "The Case against Postmodernism. Part I." *Interior Design,* October 1987, 324–325.

Blake, Peter. *Marcel Breuer: Architect and Designer.* New York, 1949.

Blake, Peter. *The Master Builders.* New York, 1976.

Blake, Peter. "Mies van der Rohe: Some Notes on the Architect and His Work." *Architectural Forum* 131 (October 1969): 35–39.

Blaser, Werner. *Mies van der Rohe.* Zurich, 1972.

Blaser, Werner. *Mies van der Rohe: Teaching and Principles.* New York, 1977.

Bletter, Rosemarie H., and Cervin Robinson. *Skyscraper Style: Art Deco, New York.* New York, 1975.

Blundell Jones, Peter. "Image of Essence? Houses and Modernism." *Architectural Review* 187 (April 1990): 35.

Boeckl, Matthias, ed. *Visionäre und Vertriebene. Österreichische Spuren in der modernen amerikanischen Architektur.* Berlin, 1995.

Bogdanovich, Peter. *Fritz Lang in America.* New York, 1969.

Bogner, Dieter. "Architecture as Biotechnique. Friedrich Kiesler und das Space House von 1933." In Boeckl, ed., *Visionäre und Vertriebene.*

Borch, Herbert von. *Amerika—Dekadenz und Grösse.* Munich, 1981.

Born, Jürgen. "Kafka in America." Lecture delivered at the symposium "The Fame of German Writers in America," University of South Carolina, Columbia, 5–7 April 1990.

Breuer, Marcel. "Where Do We Stand?" *Architectural Review* 77, no. 461 (April 1935): 133–136.

Bright, John I. "An 'International Architecture.'" *Magazine of Art* 25 (August 1932): 107–112.

Brock, H. I. "Architecture Styled International." *New York Times Magazine,* 7 February 1932, 2:22.

Brolin, Brent. *The Failure of Modern Architecture.* New York, 1976.

Brown, Milton W. *American Painting: From the Armory Show to the Depression.* 1955; rev. ed., Princeton, 1972.

Burchell, Robert E. *Die Einwanderung nach Amerika im 19. und 20. Jahrhundert.* In Adams, ed., *Die Vereinigten Staaten von Amerika,* 184–234.

Burckhardt, Lucius, ed. *Der Werkbund in Deutschland, Österreich und der Schweiz.* Stuttgart, 1978.

Burkhardt, Berthold. "The Conservation of Modern Monuments." In Kentgens-Craig/ Stiftung Bauhaus Dessau, eds., *The Dessau Bauhaus Building, 1926–1999.*

Bush-Brown, Harold. *Beaux Arts to Bauhaus and Beyond.* New York, 1976.

Butler, Charles, and the Committee on Housing Exhibition. "The Planned Community." *Architectural Forum* 58 (April 1933): 253–254.

"Calendars: Another Glasshouse." *Progressive Architecture,* July 1991, 34.

"California Refuses Permit." *The Nation* 115 (29 November 1922): 567.

Calkins, Ernesto E. "Beauty, the New Business Tool." *Atlantic Monthly* 140 (1927): 145–156.

"The Capitol of the World, and the Greatest Design Opportunity of a Generation." *Interiors* 105 (March 1946): 76–77, 102.

Carter, Peter. "Mies. Peter Carter, Interview with Mies van der Rohe." *20th Century,* Spring 1964, 138–143.

Cash, Wilburn J. *The Mind of the South.* New York, 1941.

Casteels, Maurice. *The New Style.* London, 1931.

Cheney, Martha and Sheldon. *Art and the Machine.* New York, 1936.

Cheney, Sheldon. *The New World Architecture.* London, 1930.

Churchill, Henry S. "The New Architecture." *The Nation* 117 (14 November 1923): 552–553.

Churchill, Henry C. Review of *The International Style: Architecture since 1922* by Henry-Russell Hitchcock, Jr., and Philip Johnson. *Creative Art,* June 1932, 489–490.

Claussen, Horst. *Walter Gropius. Grundzüge seines Denkens.* Hildesheim, 1986.

"Closing of the Bauhaus at Dessau." *Art Digest* 8 (October 15, 1933): 7.

"Closing of the Bauhaus at Dessau." *Studio* 4 (London, November 1932): 295.

Coburn, F. W. "Boston Happenings." *Magazine of Art* 21 (June 1930): 350–351.

Coburn, F. W. "Boston Happenings." *Magazine of Art* 22 (February 1931): 141–142.

Colton, Arthur W. *"Dutch Architecture of the Twentieth Century,* by J. P. Mieras and F. R. Yerbury." *Architectural Record* 60 (July 1926): 91–94.

Columbia University, New York. *Four Great Makers of Modern Architecture: Gropius, Le Corbusier, Mies van der Rohe, Wright.* Transcript of a symposium, March-May 1961. New York, 1963.

Condit, Carl W. *The Chicago School of Architecture: A History of Commercial and Public Building in the Chicago Area, 1875–1925.* Chicago and London, 1964.

Conrads, Ulrich, M. Droste, W. Nerdinger, and H. Strohl, eds. *Die Bauhaus Debatte 1953. Dokumente einer verdrängten Kontroverse.* Braunschweig, 1994.

Conrads, Ulrich, and Hans Sperlich. *The Architecture of Fantasy: Utopian Building and Planning in Modern Times.* New York, 1962.

Conrads, Ulrich, and Hans Sperlich. *Fantastic Architecture.* London, 1963.

Cook, John W., and Heinrich Klotz. *Conversations with Architects.* New York, 1973.

Craig, Gordon A. *Wahrnehmung und Einschätzung. Amerikaner und Deutsche aus der Sicht eines angloamerikanischen Historikers.* Stuttgart, 1987.

Creighton, Thomas H. "Kiesler's Pursuit of an Idea." *Progressive Architecture* 42 (July 1961): 104–123.

Cret, Paul Philippe. "Ten Years of Modernism." *Architectural Forum* 59 (August 1933): 91–94.

Croly, Herbert. "A Modern Problem in Architectural Education: Notes and Comments." *Architectural Record* 63 (May 1928): 469–470.

Crombie, Charles. "Correspondence: The Decline of Architecture." *Hound and Horn* 1 (December 1927): 140–143.

"Cry Stop to Havoc, or Preservation by Development. A Scheme for a Block of Flats at Windsor. Walter Gropius and Maxwell Fry, Architects." *Architectural Review* 77 (May 1935): 188–192.

Cunningham, Mary. "The Barcelona Exposition." *Landscape Architecture* 21–22 (January 1931): 101–102.

"Current Comment: German Language Ban Lifting." *The Freeman* 2 (19 January 1921): 435.

Danforth, George E. "Hilberseimer Remembered." In Richard Pommer, David Spaeth, and Kevin Harrington, eds., *In the Shadow of Mies: Ludwig Hilberseimer, Architect, Educator, and Urban Planner.* Chicago, 1988.

Davison, Robert L. "New Construction Methods." *Architectural Record* 66 (October 1929): 361–385.

Davison, Robert L. "A Pioneer: The All-Metal Apartment House." *Architectural Record* 68 (July 1930): 3–9.

Dearstyne, Howard. *Inside the Bauhaus.* New York, 1986.

"The Decade 1929–1939." Modern Architecture Symposium, Columbia University, New York, 8–10 May 1964. *Journal of the Society of Architectural Historians* 24 (March 1965): 24–93.

"Dessau, the Glass-Walled 'Bauhaus.'" *Architects' Journal* 73 (17 June 1931): 873–874.

Dexel, Walter. *Der "Bauhausstil"—ein Mythos. Texte 1921–1965.* Starnberg, 1976.

Dietzsch, Folke. "Die Studierenden am Bauhaus. Eine analytische Betrachtung zur strukturellen Zusammensetzung der Studierenden, zu ihrem Studium und Leben am Bauhaus sowie zu ihrem späteren Wirken." Vol. 2: Documents, Supplements. Ph.D. thesis, Weimar, 1991.

Doesburg, Theo van. "Evolution of Modern Architecture in Holland." *Little Review,* Spring 1925, 47–51.

"Doldertal Apartments, Zürich." *Architectural Record* 80 (October 1936): 287.

Dols, José A. *Moderne Architektur. Fundamente, Funktionen, Formen.* Hamburg, 1978.

Doubilet, Susan. "A Critical Survey of the Architectural Record, 1891–1938, and the American Architectural Periodicals It Absorbed, 1876–1938." M.S. thesis in Historic Preservation, Graduate School of Architecture and Planning, Columbia University, New York, May 1981.

Doubilet, Susan. "A Preview of MoMA's Splashy Summer Show." *Architectural Record,* April 1999, 43–44.

Drexler, Arthur, ed. *Mies van der Rohe Archive: An Illustrated Catalogue of the Mies van der Rohe Drawings in the Museum of Modern Art.* New York, 1986.

Drexler, Arthur, and Thomas Hines. *The Architecture of Richard Neutra: From International Style to California Modern.* New York, 1982.

dtv-Atlas zur Baukunst. Vol. 2: *Baugeschichte von der Romantik bis zur Gegenwart.* Munich, 1981.

E.A.M. "Toward Internationalism in Art." *The Freeman* 2 (22 September 1920): 43.

Edgell, George H. *The American Architecture of To-day.* New York, 1928.

"Education of the Architect." *Architectural Record* 80 (September 1936): 201–214.

Egbert, Donald Drew. "*Modern Architecture,* by Henry-Russell Hitchcock." Book review. *Art Bulletin* 12 (March 1930): 89–99.

Egbert, Donald Drew. *Social Radicalism and the Arts.* New York, 1970.

Eichhoff, Jürgen. "Die deutsche Sprache in Amerika." In Trommler, *Amerika und die Deutschen,* 235–252.

Eisenman, Peter. "The Big Little Magazine: *Perspecta* 12 and the Future of the Architectural Past." Review. *Architectural Forum* 131 (October 1969): 74–75, 104.

Eisenman, Peter. Introduction to Johnson, *Writings,* 11–12.

Eisler, Colin T. "Kunstgeschichte American Style." In Fleming and Baylin, *The Intellectual Migration,* 544–629.

Eisner, Lotte. *Fritz Lang.* London, 1976.

Engelbrecht, Lloyd C. "Chicago—eine Stadt auf der Suche nach einem Bauhaus?" In Bauhaus-Archiv Berlin, ed., *50 Jahre New Bauhaus.*

Engelhardt, N. L. "The Planning of High School Buildings for Better Utilization: Technical News and Research." *Architectural Record* 66 (September 1929): 275–284.

Erfurth, Helmut, and Elisabeth Tharandt. *Ludwig Mies van der Rohe, die Trinkhalle. Sein einziger Bau in Dessau.* Bauhausminiaturen 1. Dessau, 1995.

"Exhibition Buildings." *Architectural Record* 80 (December 1936): 423–432.

"The Expressionist Movement." *The Freeman* 2, no. 29 (September 1920): 63–64.

"Feelings against Nazi-Germany." *The Nation* 141, no. 7 (August 1935): 141.

Ferriss, Hugh. "Architectural Rendering." In *Encyclopedia Britannica* (Chicago, 1969), 2:310–311. First appeared in 1929 ed.

Ferriss, Hugh. *The Metropolis of Tomorrow.* New York, 1929.

Ferriss, Hugh. "Power of America." *Pencil Points* 13 (June 1942): 61–62.

Fisher, Howard T. "New Elements in House Design." *Architectural Record* 66 (November 1929): 397–403.

Fitch, James Marston. *American Building: The Historical Forces That Shaped It.* Cambridge, 1966. German trans. *Vier Jahrhunderte Bauen in USA.* Berlin and Frankfurt am Main, 1968.

Fitch, James Marston. *Walter Gropius.* New York, 1960.

Fleming, Donald, and Bernard Baylin, eds. *The Intellectual Migration: Europe and America, 1930–1960.* Cambridge, Mass., 1969.

Flint, Ralph. "Present Trends in Architecture in Fine Exhibit." *Art News* 30 (13 February 1932): 5.

Flournoy, B. C. "The Closing of the Bauhaus." Letter to the editor in reply to Douglas Haskell's article of the same name. *The Nation* 135 (1932): 533.

Frampton, Kenneth. *Modern Architecture: A Critical History.* 2d ed. London, 1985.

Frampton, Kenneth, and Yukio Futagawa. *Modern Architecture, 1851–1945.* New York, 1982.

Franciscono, Marcel. *Walter Gropius and the Creation of the Bauhaus in Weimar: The Ideas and Artistic Theories of Its Founding Years.* Chicago, 1971.

Frank, Josef. "International Housing Exposition, Vienna, Austria." *Architectural Forum* 57 (October 1932): 325–338.

Frank, Werner. *Die vergeudete Moderne.* Stuttgart, 1981.

"Freeman Advertisement." *Freeman* 8, no. 28 (November 1923): 288.

Freund, E. Washburn. "The Lessons of German Applied Art." *International Studio* 75 (July 1922): 328–334.

Freund, E. Washburn. "Modern Art in Germany." *International Studio* 78 (1923): 41–46.

Friedlander, Leo. "The New Architecture and the Master Sculptor." *Architectural Forum* 46 (January 1927): 1, 4–5, 8.

Fry, Maxwell. "The Small House of Today. Review of *The Modern House* by F. R. S. Yorke." *Architectural Review* 76 (July 1934): 20.

Fuchs, Karl-Albert. "Die Stellung des Bauhauses in der Geschichte und die Bedeutung seines Erbes für die entwickelte sozialistische Gesellschaft." Scholarly colloquium held in Weimar, 27–29 October 1976. *Wissenschaftliche Zeitschrift der Hochschule für Architektur und Bauwesen Weimar* 23, no. 5/6 (1976): 439–440.

Fulbright, J. William. *The Arrogance of Power.* New York, 1966.

Fullerton, Pauline. "List of New Books on Architecture and the Allied Arts." *Architectural Record* 64 (July 1928): 85–86.

Gay, Peter. *Weimar Culture.* London, 1968.

Geddes, Norman Bel. *Horizons.* Boston, 1932.

"Germans on Faculty at Black Mountain School." *Asheville* [N.C.] *Citizen,* 5 December 1933, 12.

Germany, Lisa. *Harwell Hamilton Harris.* Austin, Texas, 1985.

"Germany Adopting the Skyscraper." *Scientific American* 127 (August 1922): 111. In 1922 also published in *Literary Digest.*

"Germany. Municipal and Cooperative Housing. Berlin, Siemensstadt." *Architectural Forum* 58 (April 1933): 259.

Gibbs, Kenneth T. *Business Architectural Imagery in America, 1870–1930.* Ann Arbor, Mich., 1984.

Gibbs, Philip. "America's New Place in the World." *Harper's Monthly Magazine* 140 (December 1919): 89–97.

Giedion, Sigfried. *A Decade of Contemporary Architecture.* New York, 1954.

Giedion, Sigfried. *Space, Time and Architecture: The Growth of a New Tradition.* 1941; 5th ed., Cambridge, Mass. 1967.

Giedion, Sigfried. "The Status of Comtemporary Architecture." *Architectural Record* 75 (May 1934): 378–379.

Giedion, Sigfried. *Walter Gropius: Work and Teamwork.* New York, 1954.

Giedion, Sigfried. "What Should Be Done to Improve Architectural Education?" *Architectural Record* 75 (May 1934): 373–375.

Gill, Brendan. *Many Masks: A Life of Frank Lloyd Wright.* New York, 1987.

Glaser, Wolfgang, ed. *Americans and Germans.* Munich, 1985.

Goble, Emerson. "Architectural Record through 75 Years." *Architectural Record* 140 (July 1966): 207–214.

Goldberger, Paul. *The Skyscraper.* New York, 1981.

Goodrich, Lloyd. "*The New Vision in the German Arts,* by Herman George Scheffauer." *The Arts* 6 (July 1924): 60.

Gray, Lee. "Mies van der Rohe and Walter Gropius in the FBI Files." In Schulze, ed., *Mies van der Rohe: Critical Essays,* 146.

"Greenhouses and Conversatories." *Architectural Record* 70 (November 1931): 387–390.

Gropius, Ise. "Dammerstock Housing Development: The House for Practical Use." *Architectural Forum* 53 (August 1930): 187–192.

Gropius, Ise. "Modern Dwellings for Modern People." *House Beautiful* 69 (May 1931): 508, 532, 534.

Gropius, Walter. *Apollo in the Democracy.* New York, 1968.

Gropius, Walter. *Architektur. Wege zu einer optischen Kultur.* Frankfurt am Main and Hamburg, 1956. German translation of Gropius, *Scope of Total Architecture.*

Gropius, Walter. "Art Education and State." *Yearbook of Education* (London, 1936), 238–242.

Gropius, Walter. *Bauhausbauten Dessau.* Neue Bauhausbücher. Mainz, 1974. 1st ed. 1930, Bauhausbücher 12.

Gropius, Walter. "Bilanz des neuen Bauens." Lecture given on 5 February 1934 in Budapest. In Probst and Schädlich, *Walter Gropius,* 3:152–165.

Gropius, Walter. "Formal and Technical Problems of Modern Architecture and Planning." *R.I.B.A. Journal* 41 (1934): 679ff.

Gropius, Walter. *Internationale Architektur.* Neue Bauhausbücher. Mainz, 1981. 1st ed. 1925, Bauhausbücher 1.

Gropius, Walter. "Modern Buildings: Defense of Mass Production." *The Scotsman*, 5 December 1934.

Gropius, Walter. *The New Architecture and the Bauhaus.* London, 1935.

Gropius, Walter. "Rede während einer internen Bauhaus-Ausstellung von Studentenarbeiten." Weimar, June 1919. In Dearstyne, *Inside the Bauhaus*, 52f.

Gropius, Walter. "Rehousing in Big Cities: Outwards or Upwards?" *The Listener* 11 (1934): 814–816.

Gropius, Walter. "The Role of Reinforced Concrete in the Development of Modern Construction." *The Concrete Way* 7 (November/December 1934): 119–133.

Gropius, Walter. *Scope of Total Architecture.* 1943; 4th ed., New York, 1970.

Gropius, Walter. "The Small House of Today." *Architectural Forum* 54 (March 1931): 266–278.

Grote, Ludwig. "The Bauhaus and Functionalism." In Neumann, ed., *Bauhaus and Bauhaus People,* 215–217.

Grundy, C. Reginald. "Barcelona To-day." *Connoisseur* 85 (January 1930): 3–7.

Hackelsberger, Christoph. *Die aufgeschobene Moderne. Ein Versuch zur Einordnung der Architektur der 50ger Jahre.* Munich and Berlin, 1985.

Hader, Mathilde C. "The Berlin Housing Exhibit." *Journal of Home Economics* 23 (December 1931): 1134–1135.

Hahn, Peter. *Bauhaus Berlin.* Berlin, 1985.

"Hail, Exiled Scholars!" *The Nation* 137 (11 October 1933): 398.

Halasz, André. "Obsolence vs. Modernism: Response to 'Respectability vs. Architecture.'" Editorial. *Architectural Forum* 63 (September 1935): 11–12.

Hammel, Bette J. *From Bauhaus to Bowties: H.G.A. Celebrates 25 Years.* Minneapolis, 1989.

Harbeson, John F. "Some Things in Which We May Learn from Europe." Design in Modern Architecture, Part 10. *Pencil Points* 12 (February 1931): 101–106.

Harrington, Kevin. "Bauhaus Symposium: Interview with Bertrand Goldberg." *Design Issues* 5, no. 1 (Fall 1988).

Harris, Harwell Hamilton. "Why I Became an Architect." Lecture for the AIA student chapter, North Carolina State University, School of Design, 2 October 1977. Harwell Hamilton Harris, personal files.

Harris, Mary E. *The Arts at Black Mountain College.* Cambridge, Mass., 1987.

"Harvard University Rejects Fellowship." *The Nation* 139 (17 October 1934): 423.

Haskell, Douglas. "The Bright Lights." *The Nation* 132 (14 January 1931): 55–56.

Haskell, Douglas. "The Closing of the Bauhaus." *The Nation* 135 (19 October 1932): 374–375.

Haskell, Douglas. "Decorative Modernism." *The Nation* 128 (20 March 1929): 354.

Haskell, Douglas. "The German Architects: Letter to the Editor of The Nation." *The Nation* 136 (19 April 1933): 449.

Haskell, Douglas. "Grain Elevators and Houses." *The Nation* 135 (16 November 1932): 485–486.

Haskell, Douglas. "What the Man about Town Will Build." *The Nation* 134 (13 April 1932): 441–443.

Hasler, Thomas. "Die Kirche Sankt Anna in Düren von Rudolf Schwarz." *Archithese,* May 1996, 20–27.

"Haus in Wiesbaden, Germany. Marcel Breuer, Architect." *Architectural Record* 75 (May 1934): 428–429.

Heald, Henry T. "Mies van der Rohe at I.I.T." In Columbia University, ed., *Four Makers of Modern Architecture,* 105–108. New York, 1961.

Heap, Jane. "Lost: A Renaissance." *The Little Review,* May 1929, 5–6.

Heap, Jane. "Machine Age Exposition." Exhibition announcement. *The Little Review,* Spring 1925, 22–24.

Herdeg, Klaus. *The Decorated Diagram: Harvard Architecture and the Failure of the Bauhaus Legacy.* Cambridge, Mass., 1983.

Herzogenrath, Wulf. "Zur Rezeption des Bauhauses." In Schadendorf, *Beiträge zur Rezeption der Kunst des 19. und 20. Jahrhunderts,* 129–139.

Hewlett, James M. "Modernism and the Architect." *American Institute of Architects Journal* 16 (September 1928): 340–342.

Heyer, Paul. *Architects on Architecture: New Directions in America.* 2d ed. New York, 1978.

Hilberseimer, Ludwig. *Grossstadtarchitektur.* 1927; 2d ed., Stuttgart, 1978.

Hildebrand, Grant. *Designing for Industry: The Architecture of Albert Kahn.* Cambridge, Mass., 1974.

Hines, Thomas S. *Richard Neutra and the Search for Modern Architecture: A Biography and History.* New York and Oxford, 1982.

Hitchcock, Henry-Russell. "Architectural Education Again." *Architectural Record* 67 (May 1930): 445–446.

Hitchcock, Henry-Russell. "The Architectural Work of J. J. P. Oud." *The Arts* 13 (February 1928): 97–103.

Hitchcock, Henry-Russell. "Architecture Chronicle: Berlin, Paris, 1931." *Hound and Horn* 5 (October-December 1931): 94–97.

Hitchcock, Henry-Russell. "The Decade 1929–1939." *Journal of the Society of Architectural Historians* 24 (March 1965): 5.

Hitchcock, Henry-Russell. "The Decline of Architecture." *Hound and Horn* 1 (September 1927): 28–35.

Hitchcock, Henry-Russell. "Foreign Periodicals." *Architectural Record* 63 (May 1928): 494–496; 64 (July 1928): 87–88.

Hitchcock, Henry-Russell. "Four Harvard Architects." *Hound and Horn* 2 (September 1928): 41–47.

Hitchcock, Henry-Russell. "*How America Builds. Wie baut Amerika?* By Richard J. Neutra." Review. *Architectural Record* 63 (June 1928): 594–595.

Hitchcock, Henry-Russell. "*Internationale Architektur,* by Walter Gropius." Review. *Architectural Record* 66 (August 1929): 191.

Hitchcock, Henry-Russell. *Modern Architecture: Romanticism and Reintegration.* New York, 1929.

Hitchcock, Henry-Russell. "The New Pioneers. Modern Architecture II." *Architectural Record* 63 (May 1928): 452–460.

Hitchcock, Henry-Russell. "*Towards a New Architecture,* by Le Corbusier." Review. *Architectural Record* 63 (January 1928): 90–91.

Hitchcock, Henry-Russell, and Philip Johnson. Foreword by Alfred Barr. *The International Style: Architecture since 1922.* New York, 1932.

Hitchcock, Henry-Russell, Philip Johnson, and Lewis Mumford. *Modern Architecture: International Exhibition.* Ex. cat., Museum of Modern Art, New York, 10 February–23 March 1932. 1932; rpt. New York, 1969.

Hochman, Elaine. *Architects of Fortune: Mies van der Rohe and the Third Reich.* New York, 1989.

Honey, Sandra. "Mies at the Bauhaus." *Architectural Association Quarterly* 10, no. 1 (1978): 52–59.

Hooper, Parker M. "Twentieth Century European Architecture." *Architectural Forum* 50 (February 1929): 209.

"Horizontal Planes Chart the Course of Europe's Modernism." *House and Garden* 61 (April 1932): 56–57.

Horner, Edwin A., and Sigurd Fischer. "Modern Architecture in Germany." *Architectural Forum* 51 (July 1929): 41–71.

Horner, Edwin A., and Sigurd Fischer. "Modern Architecture in Holland." *Architectural Forum* 50 (February 1929): 203–239.

"House in Church Street, Chelsea, 1936; Walter Gropius and Maxwell Fry." *Architectural Review* 80 (December 1936): 249–253.

"House Plans, 1830–1930." *Architectural Review* 77 (March 1935): 104.

"Housing's White Knight." *Architectural Forum* 84 (March 1946): 116–119.

Houstian, Christina. "Minister, Kindermädchen, Little Friend: Galka Scheyer und die Blaue Vier." In *Die Blaue Vier. Feininger, Jawlensky, Kandinsky, Klee in der Neuen Welt.* Ex. cat. Kunstmuseum Bern, 5 December 1997–1 March 1998; Kunstsammlung Nordrhein-Westfalen, Düsseldorf, 28 March–28 June 1998.

Howe, George. "Functional Aesthetics and the Social Ideal." *Pencil Points* 13 (April 1932): 215–218.

Howe, George, et al. "Modernist and Traditionalist: Being a Few Pertinent Points from the Addresses of George Howe, C. Howard Walker, Ralph T. Walker, at the

63rd Convention of the A.I.A., Washington." *Architectural Forum* 53 (July 1930): 49–50.

Hudnut, Joseph. Foreword to Walter Gropius, *The New Architecture and the Bauhaus.* Cambridge, 1936.

Hudnut, Joseph et al. "Not of One Mind." *American Architect* 149 (December 1936): 27.

Huse, Norbert. *"Neues Bauen" 1918–1933. Moderne Architektur in der Weimarer Republik.* Munich, 1975.

Hüter, Karl-Heinz. *Architektur in Berlin. 1919–1933.* Dresden, 1987.

Hüter, Karl-Heinz. *Das Bauhaus in Weimar.* East Berlin, 1976.

Huxtable, Ada L. *Kicked a Building Lately?* New York, 1976.

Isaacs, Reginald R. *Walter Gropius. Der Mensch und sein Werk.* 2 vols. Berlin, 1983, 1984.

Jackson, Kenneth T. *Crabgrass Frontier: The Suburbanization of the United States.* New York, 1985.

Jeffreys-Jones, Rhodri. "Soziale Folgen der Industrialisierung und der Erste Weltkrieg, 1890–1920." In Adams, ed., *Die Vereinigten Staaten von Amerika,* 235–282.

Jencks, Charles. *Modern Movements in Architecture.* New York, 1973.

Jensen, Paul M. *The Cinema of Fritz Lang.* New York, 1969.

Johnson, Alvin. "A Building for Adult Education: The New School for Social Research, New York City." *T-Square Club Journal,* October 1931, 16–19.

Johnson, Philip C. "Architecture in the Third Reich." *Hound and Horn* 7 (October–December 1933): 137–139.

Johnson, Philip C. "The Architecture of the New School," *The Arts* 17 (March 1931): 393–398. Rpt. in Johnson, *Writings.*

Johnson, Philip C. "The Berlin Building Exposition of 1931." *Shelter* 2, no. 1 (January 1932): 17–19, 36–37.

Johnson, Philip C. *Mies van der Rohe.* New York, 1947.

Johnson, Philip C. "Modernism in Architecture." *The New Republic* 66 (18 March 1931): 134.

Johnson, Philip C. "A Personal Testament." In Columbia University, *Four Great Makers of Modern Architecture,* 109–112.

Johnson, Philip C. "Where Do We Stand?" In Johnson, *Writings.*

Johnson, Philip C. *Writings.* New York, 1979.

Jordy, William H. "The Aftermath of the Bauhaus in America: Gropius, Mies, and Breuer." In Fleming and Baylin, eds., *The Intellectual Migration,* 485–526.

Jordy, William H. *American Buildings and Their Architects.* Vol. 5, *The Impact of European Modernism in the Mid-Twentieth Century.* New York, 1972.

Jordy, William H. "The International Style in the 1930s." *Journal of the Society of Architectural Historians* 24 (March 1965): 10–14.

Junghans, Kurt. *Der Deutsche Werkbund.* East Berlin, 1982.

Kamphoefner, Henry L. "A Few Personal Observations on the Rise and Decline of the Modern Movement in Architecture." *North Carolina Architect* 36 (March-April 1988): 18–21.

Katz, Bill, and Linda S. Katz. *Magazines for Libraries.* 6th ed. New York, 1989.

Kaufmann, Edgar, Jr. *Introduction to Modern Design.* 3d ed. New York, 1969.

Keally, Francis. "Sketches of Three Buildings in Germany." *Architectural Record* 65 (February 1929): 175–176.

Kemp, Wolfgang, ed. *Der Betrachter ist im Bild. Kunstwissenschaft und Rezeptionsästhetik.* Cologne, 1985.

Kempcke, Günter, et al. *Handwörterbuch der deutschen Gegenwartssprache.* 2 vols. East Berlin, 1984.

Kent, H. H. "The Chicago Tribune Competition."

Kentgens-Craig, Margret/Stiftung Bauhaus Dessau, eds. *The Dessau Bauhaus Building, 1926–1999.* Basel, Berlin, and Boston, 1998.

Keyes, Catherine Ann. *Bibliography: Certain Aspects of Modern Architecture, as Exemplified in the Theories and Architectural Works of Erich Mendelsohn, Jacobus Johannes Pieter Oud, André Lurçat, Walter Gropius and Ludwig Mies van der Rohe.* New York, 1932.

Killam, Charles W. "Modern Design as Influenced by Modern Materials." *Architectural Forum* 53 (July 1930): 39–42.

Killick, John R. "Die industrielle Revolution in den Vereinigten Staaten." In Adams, ed., *Die Vereinigten Staaten von Amerika,* 125–183.

Kimball, Roger. "Philip Johnson's Revenge." *Architectural Record* 176 (August 1988): 53–55.

Kirstein, Lincoln. "Harvard and Hanfstängl." *The Nation* 139 (5 December 1934): 648–649.

Kirstein, Lincoln. Introduction to Arts Club of Chicago, *Catalogue of an Exhibition from the Bauhaus, Dessau, Germany.* March 1931.

Klotz, Heinrich. *Vision der Moderne. Das Prinzip Konstruktion.* Munich, 1986.

Klotz, Heinrich, and John W. Cook. *Architektur im Widerspruch.* Zurich, 1974.

Kocher, Lawrence A. "Interchange of Architectural Ideas. Notes and Comments." *Architectural Record* 53 (May 1923): 474–475.

Kocher, Lawrence A. "Keeping the Architect Educated." *Architectural Record* 67 (January 1930): 45–46.

Kocher, Lawrence A. "The Library of the Architect." *Architectural Record* 56 (1924): 218–224, 317–318; 57 (1925), 29–32, 125–128, 221–224.

Kreis, Wilhelm. "The New City of Tomorrow." *Architectural Forum* 55 (August 1931): 197–200.

Kröll, Friedhelm. *Bauhaus 1919–1933. Künstler zwischen Isolation und kollektiver Praxis.* Düsseldorf, 1974.

Kuh, Katherine. "Mies van der Rohe: Modern Classicist. Interview with Ludwig Mies van der Rohe." *Saturday Review,* 23 January 1965, 22, 23, 61.

Kunstsammlung Nordrhein-Westfalen. "The Blue Four." Ex. leaflet. Düsseldorf, 1998.

Lampugnani, Vittorio Magnago, ed. *Encyclopedia of 20th-Century Architecture.* New York, 1986.

Lane, Barbara Miller. *Architecture and Politics in Germany, 1918–1945.* Cambridge, Mass., 1968.

Langa, Helen. "Modernism and Modernity during the New Deal Era: New York Printmakers, Social Themes, and Stilistic Innovations." *Southeastern College Art Conference Review* 12, no. 4 (1994): 273–283.

Le Corbusier. *Towards a New Architecture.* 1927; New York, 1976.

Leich, Jean F., and Paul Goldberger. *Architectural Visions: The Drawings of Hugh Ferriss.* New York, 1980.

Lengyel, Emil. "German Culture in Exile." *The Nation* 136 (31 May 1933): 607–609.

Leonard, Louis. "A Letter from Louis Leonard, A.I.A., of Cleveland, Ohio." *Pencil Points* 12 (May 1931): 386.

Leuchtenburg, William E. *The Perils of Prosperity.* Chicago and London, 1958.

Levinson, M. E. "This Modern Architecture: A Summary of the April Meeting of the T-Square Club." *T-Square Club Journal,* April 1931, 22.

"L.H.O., a Teacher from Bauhaus." *New York Times,* 29 November 1933.

"Light Architecture." *Industrial Arts* 1 (Spring 1936): 15–17.

Lippmann, Herbert. "The Machine-Age Exposition." *The Arts* 11 (June 1927): 324–326.

Lippmann, Herbert. "*Towards a New Architecture,* by Le Corbusier." *The Arts* 13 (June 1928): 395–396.

Lønberg-Holm, Knud. "Glass: Technical News and Research." *Architectural Record* 68 (October 1930): 327–358.

Lønberg-Holm, Knud. "New Theatre Architecture in Europe: The 'Totaltheater,' Proposed by Walter Gropius, Architect, 1927." *Architectural Record* 67 (May 1930): 490–495.

Lønberg-Holm, Knud. "Planning the Retail Store: Cooperative Store, Dessau-Törten." *Architectural Record* 69 (June 1931): 498.

Lønberg-Holm, Knud. "Trends in Lightening." *Architectural Record* 70 (October 1931): 279–302.

"Looking Back at 'Modern Architecture.'" *Skyline* (February 1982): 18–27.

Lowenstein, Milton D. "Germany's Bauhaus Experiment." *Architecture* 60 (July 1929): 1–6.

Lozowick, Louis. "Modern Art: Genesis or Exodus?" *The Nation* 123 (22 December 1926): 672.

Luce, Henry Robinson. *The American Century.* 2d ed. New York, 1941.

"Machine-Art Exposition." Ex. cat., New York, organized by Jane Heap, 16–27 May 1927. *Little Review* 11–12 (1927): suppl. 1–37.

"The Machine as Slave and Master." *The Freeman* 1 (12 May 1920): 208–210.

Malcolmson, Reginald. "Architecture in Steel." *Architecture d'aujourd'hui* 29 (September 1958): 98–99.

Mayer, Albert. "The Architect and the World." *The Nation* 142 (8 January 1936): 43–45.

Mayer, Albert. "Housing: A Call to Action." *The Nation* 138 (18 April 1934): 435–436.

Mayer, Albert. "Why the Housing Program Failed." *The Nation* 138 (11 April 1934): 408–409.

McCommons, Richard B. "Architectural Education in America." In *Guide to Architectural Schools in North America,* viii–ix. Washington, D.C., 1982.

McCoy, Esther. *Richard Neutra.* New York, 1960.

McCoy, Esther. *Vienna to Los Angeles: Two Journeys.* Santa Monica, Calif., 1979.

McCoy, Esther, and Barbara Goldstein. *Guide to U.S. Architecture: 1940–1980.* Santa Monica, Calif., 1982.

McCullough, Fiske J. "The House of the Bauhaus Reconsidered." *Progressive Architecture,* December 1966, 160–166.

McGrath, Raymond. "Looking into Glass." *Architectural Review* 71 (January 1932): 28–34.

McGrath, Raymond. "Modern Synthetic Facing Materials." *Architects' Journal* 74, no. 4 (1931): 595–598.

Mendelsohn, Erich. *Amerika. Bilderbuch eines Architekten.* 6th ed. Berlin, 1928.

Messler, Norbert. *The Art Deco Skyscraper in New York.* 2d ed. New York, 1986.

"*The Metropolis of Tomorrow,* by Hugh Ferriss." Review. *American Architect* 137 (March 1930): 66.

Meyer, Hannes. "Bauen: Building." *Bauhaus* 2, no. 4 (Dessau, 1928). Rpt. in Wingler, *The Bauhaus: Weimar, Dessau, Berlin, Chicago,* 153–154.

Meyer, Hannes. "Curriculum Vitae." Quoted in Wolsdorff, "Die Architektur am Bauhaus."

Meyer, Hannes. "Mein Hinauswurf aus dem Bauhaus [My Expulsion from the Bauhaus]." Open letter to Fritz Hesse, Lord Mayor of the City of Dessau. *Das Tagebuch* (Berlin) 11, no. 33 (16 August 1930): 1307f. Rpt. in Wingler, *The Bauhaus: Weimar, Dessau, Berlin, Chicago,* 163–165.

Mies van der Rohe, Ludwig. "Bauen." *G,* no. 2 (September 1923): 1. Trans. as "Building" in Neumeyer, *The Artless Word,* 242.

Mies van der Rohe, Ludwig. "Baukunst und Zeitwille." *Der Querschnitt* 4, no. 1 (1924): 31–32. Trans. as "Building Art and the Will of the Epoch" in Neumeyer, *The Artless Word,* 245–247.

Mies van der Rohe, Ludwig. "Hochhausprojekt für Bahnhof Friedrichstrasse in Berlin." *Frühlicht* 1 (Summer 1922): 122–124. Trans. as "Skyscrapers" in Neumeyer, *The Artless Word,* 240.

Mies van der Rohe, Ludwig. "Industrielles Bauen." *G,* no. 3 (June 1924): 8–13. Trans. as "Industrial Building" in Neumeyer, *The Artless Word,* 248.

Mies van der Rohe, Ludwig. Lecture for the Immermann-Bund, 14 March 1927, Düsseldorf. Transcript, Dirk Lohan Archives, Chicago. English trans. in Neumeyer, *The Artless Word,* 262.

Mies van der Rohe, Ludwig. "Mies Speaks." Translated transcript. *Architectural Review* 144 (December 1968): 451–452.

Mies van der Rohe, Ludwig. "Die neue Zeit." *Die Form* 5, no. 15 (1 August 1930): 406. Trans. as "The New Time" in Neumeyer, *The Artless Word,* 309.

Mies van der Rohe, Ludwig. Summary of a lecture at the meeting of the Deutscher Werkbund, Summer 1930, Vienna. Transcript, Dirk Lohan Archives, Chicago.

Mies van der Rohe, Ludwig. "Die Voraussetzungen baukünstlerischen Schaffens." Manuscript, 1928. Library of Congress, Manuscript Division, Washington, D.C. Trans. as "The Preconditions of Architectural Work" in Neumeyer, *The Artless Word,* 299–301.

"Mies van der Rohe im Gespräch mit Dirk Lohan." Chicago, Summer 1968. Typed records of an interview, Dirk Lohan Archives, Chicago.

Mikkelsen, Michael A. "Expansion of the Architectural Record for 1930." Editorial. *Architectural Record* 66 (November 1929): 501–502.

Mikkelsen, Michael A. "A Word about a New Format." *Architectural Record* 63 (January 1928): 1–2.

Miles, Harold. "Architecture in Motion Pictures." *Pencil Points* 8 (September 1927): 535–544.

Miller, Paul D. "How Does the City Look from the Air?" *The American City* 43 (November 1930): 125–127.

Mock, Elizabeth. *Built in U.S.A.* New York, 1944.

"Modern Architecture Comes to Front in Three Simultaneous Exhibits." *Art Digest,* 15 February 1932, 7.

"Modern Architecture: Frank Lloyd Wright and Hugh Ferriss Discuss Modern Architecture." *Architectural Forum* 53 (November 1930): 535–538.

Moholy-Nagy, László. "How Photography Revolutionizes Vision." *The Listener,* 8 November 1933.

Moholy-Nagy, László. *The New Vision.* 4th ed. New York, 1947. 1st German ed., 1928; 1st English ed., 1935.

Moholy-Nagy, Sibyl. Contribution to a discussion, Sunday Session, Modern Architecture Symposium. *Journal of the Society of Architectural Historians* 24 (March 1965): 80–86.

Moholy-Nagy, Sibyl. "The Diaspora." *Journal of the Society of Architectural Historians* 24 (March 1965): 24–26.

Monyhan, Jeanne Patricia. "The Influence of the Bauhaus on Art Education in the U.S." Ph.D. diss., Northwestern University, Evanston, Illinois, 1980.

Morgan, Ann Lee, and Colin Naylor, eds. *Contemporary Architects.* 2d ed. Chicago and London, 1987.

Morrow, Irving F. "The Bright Lights. Letter to the Editor." *The Nation* 132 (11 March 1931): 274.

Morse, Richard A. "Where Are These Modern Buildings? Examples to Be Found in Holland and Germany." *Pencil Points* 12 (May 1931): 373–378.

"Motion Pix Producers Recognize Efforts of Architects in the Productions." *American Architect* 117 (4 February 1920): 157.

Müller, Michael. *Architektur und Avantgarde.* Frankfurt am Main, 1984.

Mumford, Lewis. *Roots of Contemporary American Architecture.* 3d ed. New York, 1972.

Mumford, Lewis. *Sticks and Stones: A Study of American Architecture and Civilization.* New York, 1924.

Muschenheim, William. "The Apartment Interior: Its Planning and Furnishing." *Architectural Record* 80 (October 1936): 306–321.

Museum of Modern Art, New York. *Machine Art.* Ex. cat., Museum of Modern Art, 6 March–30 April 1934. New York, 1934.

"The Museum of Modern Art Architecture Room." *Pencil Points* 14 (March 1933): 139.

Naylor, Gillian. *The Bauhaus Reassessed.* New York, 1985.

Nelson, George. "Architects of Europe Today: Van der Rohe, Germany." *Pencil Points* 16 (September 1935): 453–460.

Nelson, George. "Architects of Europe Today: Walter Gropius, Germany." *Pencil Points* 17 (August 1936): 422–432.

Nerdinger, Winfried. "Nachlese zum 100. Geburtstag. Neue Literatur zu Mies van der Rohe." *Kunstchronik* 41 (August 1988): 419–429.

Nerdinger, Winfried. *Walter Gropius: Der Architekt. Zeichnungen, Photos, Pläne aus dem Busch-Reisinger Museum, Cambridge, Mass. und dem Bauhaus-Archiv Berlin, mit einem kritischen Werkverzeichnis.* Berlin, 1985.

Neumann, Dietrich, ed. *Filmarchitektur. Von Metropolis bis Blade Runner.* Munich, 1996.

Neumann, Dietrich. *Die Wolkenkratzer kommen. Deutsche Hochhäuser der Zwanziger Jahre. Debatten, Projekte, Bauten.* Braunschweig and Wiesbaden, 1995.

Neumann, Eckhardt. *Bauhaus and Bauhaus People.* New York, 1970.

Neumann, J. B. "Confessions of an Art Dealer." Unpublished manuscript, 1958. Felix Klee-Nachlass, Klee Nachlassverwaltung, Bern.

Neumeyer, Fritz. *Mies van der Rohe. Das kunstlose Wort. Gedanken zur Baukunst.* Berlin, 1986. English trans. as *The Artless Word: Mies van der Rohe on the Building Art.* Cambridge, Mass., 1991.

Neutra, Richard J. *Buildings and Projects.* Zurich, 1951.

Neutra, Richard J. *Wie baut Amerika?* Stuttgart, 1927.

"The New Architecture and the Bauhaus, by Walter Gropius. Review." *R.I.B.A. Journal* 42 (10 August 1935): 1052.

"New Housing Designs and Construction Systems." *Architectural Record* 75 (January 1934): 27.

"News of the Month: New Partnership." *Architectural Record* 80 (October 1936): 251.

"The New World Architecture by Sheldon Cheney." *The Arts* 17 (January 1931): 271, 279.

Nimmons, George C. "Interview at the AIA Convention, 1927." *American Architect* 131 (1927): 701.

Nimmons, George C. "Skyscrapers in America." *American Institute of Architects Journal* 11 (September 1923): 370–372.

Norberg-Schulz, Christian. "Talks with Mies van der Rohe." *Architecture d'aujourd'hui* 29 (September 1958): 100.

"Obsolescence vs. Modernism." *Architectural Forum* 63 (September 1935): 11.

"Opening of the Gropius Exhibition." *R.I.B.A. Journal* 41 (19 May 1934): 704.

Panofsky, Erwin. "The History of Art as a Humanistic Discipline." In *The Meaning of the Humanities,* ed. Theodore M. Green. Princeton, 1940.

Papi, Lorenzo. *Ludwig Mies van der Rohe—Gestalter unserer Zeit.* Florence, 1974.

Paris, William F. "The Barcelona Exposition, a Splendid but Costly Effort of the Catalan People." *Architectural Forum* 51 (November 1929): 481–496.

Paris, William F. "The International Exposition of Modern Industrial and Decorative Art in Paris." *Architectural Record* 58 (October 1925): 365–385.

Park, Edwin Avery. *New Backgrounds for a New Age.* New York, 1927.

Parker, William S. "Skyscraper Anywhere." *American Institute of Architects Journal* 11 (September 1923): 372.

Paul, Bruno. "Modern Art: Interior Architecture." *Architectural Forum* 50 (January 1929): 98–104.

Pazitnov, L. *Das schöpferische Erbe des Bauhauses, 1919–1933.* Berlin, 1963.

Pehnt, Wolfgang. *Das Ende der Zuversicht. Architektur in diesem Jahrhundert; Ideen— Bauten—Dokumente.* Berlin, 1983.

Peisch, Mark. "Modern Architecture and Architectural Criticism in the U.S.A., 1929–1939." *Journal of the Society of Architectural Historians* 24 (March 1965): 78.

Persitz, Alexandre. "L'oeuvre de Mies van der Rohe." *Architecture d'aujourd'hui* 29 (September 1958): 2–5.

Pevsner, Nikolaus. *Pioneers of Modern Design: From William Morris to Walter Gropius.* 2d ed. New York, 1949.

Philip, Hans J. Letter to the editor. *American Institute of Architects Journal* 12 (July 1924): 340.

"Photograph of Head of Turtoise Shell Cat, by Moholy-Nagy." *Vanity Fair* 35 (September 1930): 58–59.

"Photography in a Flash." *Industrial Arts* 1 (Winter 1936): 294–303.

Placzek, Adolf K. "A Brief Review of the Decade's Architectural Literature." *Journal of the Society of Architectural Historians* 24 (March 1965): 31–35.

Placzek, Adolf K., ed. *Macmillan Encyclopedia of Architects.* New York and London, 1982.

Platz, Gustav Adolf. *Die Baukunst der neuesten Zeit.* Berlin, 1927.

Pond, Irving K. "From Foreign Shores." *American Institute of Architects Journal* 12 (May 1924): 235–239; 13 (May 1925): 157–161; 13 (November 1925): 402–405.

Pond, Irving K. "High Buildings and Beauty." *Architectural Forum* 38 (February 1923): 41–44; (April 1923): 179–182.

Poppeliers, John C., S. Allen Chambers, and Nancy B. Schwartz. *What Style Is It? A Guide to American Architecture.* Washington, D.C., 1983.

Posener, Julius. *From Schinkel to the Bauhaus: Five Lectures on the Growth of Modern German Architecture.* Architectural Association Paper no. 5. London, 1972.

Probst, Hartmut, and Christian Schädlich. *Walter Gropius.* Vol. 1, *Der Architekt und Theoretiker;* vol. 3, *Ausgewählte Schriften.* East Berlin, 1986, 1988.

"Professor Kocher Joins the Architectural Record Staff. Notes and Comments." *Architectural Record* 62 (August 1927): 167.

"Professor Walter Gropius, Well-Known German Architect, Who Recently Celebrated His Fiftieth Birthday." *Architectural Record* 74 (August 1933): 145.

Read, Helen A. "The Exhibition Idea in Germany." *The Arts* 10 (October 1926): 201–213.

Read, Helen A. "Exhibitions in Germany: The Berlin Architectural Show." *The Arts* 18 (October 1931): 5–17.

Read, Helen A. "Germany at the Barcelona World's Fair." *The Arts* 16 (October 1929): 112–113.

Read, Herbert A. "A New Humanism: Review of *The New Vision,* by László Moholy-Nagy." *Architectural Review* 78 (July 1935): 150–151.

"Reducing Dead Load, Saving Time, and Increasing Control: Recent Technical Developments." *Architectural Record* 68 (December 1930): 473–490.

"Respectability vs. Architecture." *Architectural Forum* 63 (July 1935): 1–5.

"Revolution Reflected in the 'New' Art of Germany: Art as a Weapon for the Destruction of the Old Order." *Current Opinion* 67 (October 1919): 254–256.

Rice, Norman N. "The Small House: A Problem to Be Solved." *Architectural Forum* 55 (July 1931): 2–6.

Richards, James M. "Towards a Rational Aesthetic." *Architectural Review* 78 (December 1935): 211–218.

Richards, James M. "Walter Gropius." *Architectural Review* 78 (August 1935): 45–46.

Richards, James M., ed. *Who Is Who in Architecture.* New York, 1977.

Richebourg, Stephan I. "Some Thoughts on Modern Architecture." *American Institute of Architects Journal* 10 (May 1922): 140–143.

Riley, Terence. *The International Style: Exhibition 15 and the Museum of Modern Art.* New York, 1992.

Robertson, Paul. "The Skyscraper Office Building." *Architectural Forum* 52 (June 1930): 879–880.

Roob, Rona. "1936: The Museum Selects an Architect. Excerpts from the Barr Papers of the Museum of Modern Art." *Archives of American Art Journal* 23, no. 1 (1983): 22–30.

Rose, Barbara. *American Art since 1900: A Critical History.* New York, 1967.

Ross, Marvin. "Shorter Notices: *The American Architecture of To-day,* by G. H. Edgell. Review." *Hound and Horn* 1 (June 1928): 374–376.

Rowland, Anna. *The Bauhaus Course Book.* New York, 1990.

Russel, Frank. *Mies van der Rohe: European Works.* London and New York, 1986.

Sammons, Jeffrey L. "Heinrich Heine in America." Lecture at the symposium "The Fame of German Writers in America," University of South Carolina, Columbia, 5–7 April 1990.

Schadendorf, Wulf. *Beiträge zur Rezeption der Kunst des 19. und 20. Jahrhunderts.* Munich, 1975.

Schädlich, Christian. "Die Beziehungen des Bauhauses zu den USA." *Wissenschaftliche Zeitschrift der Hochschule für Architektur und Bauwesen Weimar,* no. 35, A:2, pp. 59–72.

Scheffauer, Herman George. "The Bauhaus Program." *Christian Science Monitor,* 12 May and 19 May 1927.

Scheffauer, Herman George. "The Bauhaus Stage." *Christian Science Monitor,* 16 June 1927.

Scheffauer, Herman George. "Building the Master Builder: The Staatliches Bauhaus of Weimar." *The Freeman* 8 (5 December 1923): 304–305.

Scheffauer, Herman George. "Dynamic Architecture: New Forms of the Future." *Dial* 70 (21 March 1921): 323–328.

Scheffauer, Herman George. "The Work of Walter Gropius." *Architectural Review* 56 (July 1924): 50–54.

Schlemmer, Oskar. "Das Staatliche Bauhaus in Weimar." In Schneede, *Die Zwanziger Jahre,* 181ff.

Schnaidt, Claude. "Ce qu'on sait, croix, savoir et ignore du Bauhaus." In Tautel, *L'influence du Bauhaus sur l'architecture contemporaine,* 17–38.

Schneede, Uwe M. *Die Zwanziger Jahre. Manifeste und Dokumente deutscher Künstler.* Cologne, 1979.

Schreyer, Lothar. *Erinnerungen an Paul Klee.* Munich, 1959.

Schulz, Eberhard. *Das kurze Leben der modernen Architektur. Betrachtungen über die Spätzeit des Bauhauses.* Stuttgart, 1977.

Schulze, Franz. "The Bauhaus Architects." In Barron, ed., *Exiles and Emigrés.*

Schulze, Franz. "Mies in America: Interview with James Ingo Freed." In Schulze, ed., *Mies van der Rohe: Critical Essays,* 172–199.

Schulze, Franz. *Mies van der Rohe: A Critical Biography.* Chicago, 1985.

Schulze, Franz, ed. *Mies van der Rohe: Critical Essays.* New York, 1989.

Schulze, Franz. *Philip Johnson: Life and Work.* Chicago, 1994.

Schwartz, J. "Exhibition of Machine Art Now on View at Modern Museum." *Art News* 32 (10 March 1934): 32.

Scott Brown, Denise. "Little Magazines in Architecture and Urbanism." *American Institute of Planners Journal* 34 (July 1968): 223–233.

Scully, Vincent. *American Architecture and Urbanism.* New York and Washington, 1969.

Scully, Vincent. "Doldrums in the Suburbs." *Journal of the Society of Architectural Historians* 24 (March 1965): 36–47.

Scully, Vincent Joseph, Jr. "Henry-Russell Hitchcock and the New Tradition." In Searing, ed., *In Search of Modern Architecture,* 10–13.

Searing, Helen, ed. *In Search of Modern Architecture: A Tribute to Henry-Russell Hitchcock.* New York, 1982.

Semper, Gottfried. *Wissenschaft, Industrie und Kunst.* Braunschweig, 1852. Rpt. in Wingler, *The Bauhaus: Weimar, Dessau, Berlin, Chicago,* 18.

Sexton, Randolph W. *American Commercial Buildings of Today.* New York, 1928.

Shand, P. Morton. "New Eyes for Old." *Architectural Review* 75 (January 1934): 11–12.

Shand, P. Morton. "Scenario for a Human Drama. II: Immediate Background." *Architectural Review* 76 (August 1934): 39–42.

Shirer, William. *Berlin Diary.* New York, 1941.

"'Siemens-Stadt' Industrial Suburb, the Mächentig Strasse." *Architects' Journal* 74 (7 October 1931): 475.

"The Skyline. Mr. Wright's City: Downtown Dignity." *The New Yorker* 11 (27 April 1935): 63–66.

Smith, G. E. Kidder. *The Architecture of the United States.* 3 vols. Garden City, N.Y., 1981.

Stahl, C. J. "The Colored Lightening of the Barcelona Exposition." *Pencil Points* 11 (February 1930): 131–138.

Stange, Eric. "MIT Has Designs on Bauhaus." *Boston Herald,* 10 October 1986.

Stein, Clarence S. "Community Housing Procedure." *Architectural Forum* 56 (March 1932): 221–228.

Stephens, Suzanne. "Fifty Years of Change. Architectural Journalism Analyzed: Reflections on a Half Century." *Progressive Architecture* 51 (June 1970): 130–139.

Stern, Robert. "Relevance of the Decade." *Journal of the Society of Architectural Historians* 24 (March 1965): 6–10.

Sterne, Margaret. *The Passionate Eye: The Life of William R. Valentiner.* Detroit, 1980.

Sterner, Harold. "International Architectural Style: Architecture Chronicle." *Hound and Horn* 5 (April-June 1932): 452–460.

Stiftung Bauhaus Dessau, Lutz Schöbe, and Wolfgang Thöner, eds. *Die Sammlung.* Dessau, 1995.

Stonorov, Oscar G. "*Modern Architecture: Romanticism and Reintegration,* by Henry-Russell Hitchcock." Review. *Architectural Record* 67 (June 1930): 586.

Stowell, Kenneth K. "Housing and the Emergency." *Architectural Forum* 56 (March 1932): 253.

Stowell, Kenneth K. "The International Style." Review. *Architectural Forum* 56 (March 1932): 253.

Stowell, Kenneth K. "Leadership and Education. Editorial Policy and Opinion." *Architectural Forum* 54 (April 1931): 439.

Sullivan, Louis H. "The Chicago Tribune Competition." *Architectural Record* 53 (February 1923): 156–157.

Suschitzky, E. "University of Commercial Art." *Commercial Art and Industry* 10 (31 March 1931): 113–114.

Swartwout, Egerton. "Review of Recent Architectural Magazines." *American Architect* 123 (20 June 1923): 574–578; 124 (26 September 1923): 293–299; 124 (21 November 1923): 459–463.

Sykes, Earl F. "Modern Bibliography of School Design." *Architectural Record* 79 (June 1936): 487.

"Symposium: 'International Style' Exhibition of Modern Architecture, Museum of Modern Art." *Shelter,* April 1932, 6.

Tafuri, Manfredo. *Architecture and Utopia: Design and Capitalist Development.* Cambridge, Mass., 1976.

Tafuri, Manfredo, and Francesco Dal Co. *Modern Architecture.* 2 vols. New York, 1986.

Taut, Bruno. *Die Stadtkrone.* Jena, 1919.

Tautel, Georges, ed. *L'influence du Bauhaus sur l'architecture contemporaine.* Colloquium Etienne, 7 November 1975. Etienne, 1976.

Taylor, Robert. "Gropius Expressed 'America' in Works, Ideal." *Boston Globe,* 7 July 1969.

"Third Dimension's Fourth Estate: Review of Periodicals." *Architectural Forum* 68 (April 1938, suppl.): 12.

"Thirteen Housing Developments." *Architectural Forum* 56 (March 1932): 261–284.

Tompkins, Jane P. *Reader-Response Criticism: From Formalism to Post-Structuralism.* Baltimore, 1980.

"Towards Internationalism in Art." *The Freeman* 2 (22 September 1920): 43.

Towndrow, Frederic E. *Architecture in the Balance: An Approach to the Art of Scientific Humanism.* London, 1933.

Trachtenberg, Marvin, and Isabelle Hyman. *Architecture, from Prehistory to Postmodernism: The Western Tradition.* New York, 1986.

"Transition in German Architecture." *Architectural Forum* 58 (1933): 136–152.

Trommler, Frank. *Amerika und die Deutschen.* Opladen, 1986.

Turkel-Deri, Flora. "Berlin Letter." *Art News* 31 (31 December 1932): 8.

Turkel-Deri, Flora. "Exhibition of Architectural Designs, 'Architektenhaus.'" *Art News* 28 (10 May 1930): 14.

Turkel-Deri, Flora. "Weimar Museum Shelves Moderns." *Art News* 29 (17 January 1931): 6.

"Two Houses in Church Street, Chelsea; 1: Designed by Walter Gropius and Maxwell Fry; 2: by Mendelsohn and Chermayeff." *Architects' Journal* 84 (24 December 1936): 869–874.

Vaget, Hans. "Edgar Hoover's Thomas Mann." Lecture at the symposium "The Fame of German Writers in America." University of South Carolina, Columbia, 5–7 April 1990.

Villard, Oswald G. "Issues and Men, Words and Houses: Will Action Come?" *The Nation* 138 (30 May 1934): 609.

Vogelsang, Shepard. "Copying versus Creating." *Architectural Forum* 50 (January 1929): 97.

Vogelsang, Shepard. "Peter Behrens, Architect and Teacher." *Architectural Forum* 52 (May 1930): 715–721.

Von Wilpert, Gero. *Sachwörterbuch der Literatur.* 5th ed. Stuttgart, 1969.

Walker, Ralph T. "The Relation of Skyscrapers to Our Life." *Architectural Forum* 52 (May 1930): 689–695.

"Wall Sheathings—The Craftsman's Portfolio." *Architectural Review* 75 (January 1934): 27.

"Walter Baermann." *The News and Observer,* Raleigh, N.C., 24 January 1965.

Wängberg-Eriksson, Kristina. "Josef Frank im Exil auf Manhattan, 1942–46." In Boeckl, ed., *Visionäre und Vertriebene.*

"Wartime Housing Estate in Pennsylvania." *Architectural Review* 77 (May 1935): 188–192.

Wasmuth, Ernst, ed. *Frank Lloyd Wright. Ausgeführte Bauten und Entwürfe.* Portfolio. Berlin, 1911.

Watkin, William W. "The Advent of the New Manner in America: Impressions of Modern Architecture III." *Pencil Points* 12 (July 1931): 523–531.

Watkin, William W. "The New Manner in France and Northern Europe: Impressions of Modern Architecture II." *Pencil Points* 12 (June 1931): 421–429.

Watkin, William W. "The Search for a Direct Manner of Expression in Design: Impressions of Modern Architecture I." *Pencil Points* 12 (May 1931): 355–362.

Watson, Forbes. "The Arts Club of Chicago." *The Arts* 6 (December 1924): 341–347.

Weaver, Lawrence. "The Need for More Art in Industry." *Magazine of Art* 19 (June 1928): 316–318.

Weltge Wortmann, Sigrid. *Bauhaus Textiles: Women Artists and the Weaving Workshop.* London, 1993.

Werner, Alfred. "Bauhaus: An Impossible Dream." *Arts* 44 (December-January 1970): 24–28.

Werner, Johannes. "Die Kathedrale des Sozialismus. Erinnerung an eine Utopie." *Zeitschrift für Ästhetik und allgemeine Kunstwissenschaft* 31, no. 2 (1986): 264–275.

White, Norval. *The Architecture Book.* Encyclopedia. New York, 1976.

Whitford, Frank. *Bauhaus.* London, 1984.

Wilkes, Joseph A., ed. *The American Institute of Architects Encyclopedia of Architecture, Design, Engineering and Construction.* New York, 1989.

Wingler, Hans M. *Bauhaus in Amerika. Resonanz und Weiterentwicklung.* Berlin, 1972.

Wingler, Hans M., ed. *Das Bauhaus, 1919–1933: Weimar, Dessau, Berlin.* Bramsche, 1962.

Wingler, Hans M., ed. *The Bauhaus: Weimar, Dessau, Berlin, Chicago.* Cambridge, Mass., 1986.

Wolfe, Tom. *From Bauhaus to Our House.* New York, 1981.

Wolsdorff, Christian. "Die Architektur am Bauhaus." In Bauhaus-Archiv Berlin, *Experiment Bauhaus,* 310–348.

Wood, Edith E. *The Housing of the Unskilled Wage Earner.* New York, 1919.

Woodbridge, Frederick J. "Ideas from European Schools." *Architectural Forum* 55 (September 1931): 725–730.

Wright, Frank Lloyd. "In the Cause of Architecture." *Architectural Record* 62 (August 1927): 163–166; (October 1927): 318–324.

Wurster, Catherine B. "The Social Front of Modern Architecture in the 1930s: More than a 'Style'? Promising Principles Unfulfilled." *Journal of the Society of Architectural Historians* 24 (March 1965): 48–52.

Württembergischer Kunstverein. *50 Years Bauhaus.* Ex. cat. Stuttgart, 1968.

Wyer, Raymond. "Germany and Art." *International Studio* 66 (December 1918): 16f.

Yerbury, Francis R. *Modern European Buildings.* New York, 1928.

Yorke, Francis R. S. *The Modern House.* London, 1934.

Yorke, Francis R. S. "To-day." *Architectural Review* 76 (July 1934): 9–16.

Yountz, Philip N. "America Emerges from the Stone Age." *Creative Art* 10 (January 1932): 16–21.

Zuckmayer, Carl. *Als wär's ein Stück von mir. Horen der Freundschaft.* Frankfurt, 1966.

Zukowsky, John, ed. *The Many Faces of Modern Architecture: Building in Germany between the World Wars.* Munich, 1994.

Zukowsky, John, ed. *Mies Reconsidered: His Career, Legacy, and Disciplines.* Chicago, 1986.

Film *Josef Albers.* Videotape, March 1992, Josef Albers Museum, Bottrop, Germany.

Government Files United States Department of the Army. United States Army Intelligence and Security Command. Statement of Vigo von Moltke. Copy of the transcript, 17 February 1947. Walter Gropius File.

United States Federal Bureau of Investigation. Marcel Breuer File.

United States Federal Bureau of Investigation. Walter Gropius File.

United States Federal Bureau of Investigation. Ludwig Mies van der Rohe File.

United States Federal Bureau of Investigation. László Moholy-Nagy File.

Interviews George Edson Danforth. 26 April 1992, Chicago.

Harwell Hamilton Harris. 26 February, 5 March, 11 March, 22 April, 27 July 1990, Raleigh, N.C.

Helmut Jahn. 21 June 1990 (telephone).

Philip Johnson. 16 October 1990, 31 July 1991 (telephone); 21 September 1992, New York.

Henry L. Kamphoefner. 13 September 1990, Raleigh, N.C.

Dirk Lohan. 30 May, 21 June 1990, Chicago; 21 and 26 November 1991 (telephone).

Anthony Lord. 22 March 1990 (telephone).

Gerhard Richter. 30 May 1991, Durham, N.C.

Ulrich Schumacher. 24 January 1992, Bottrop, Germany.

Index